DRACOPEDIA

A Guide to Drawing the Dragons of the World

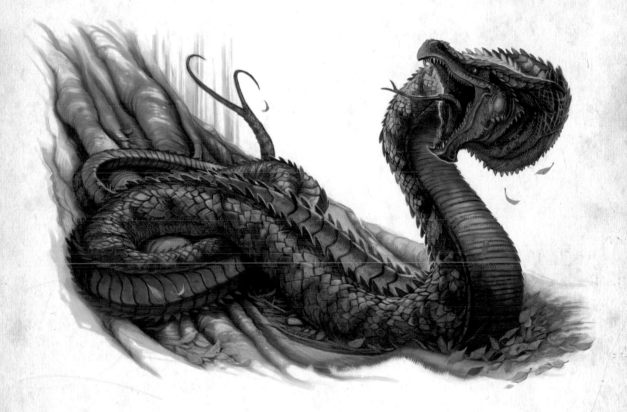

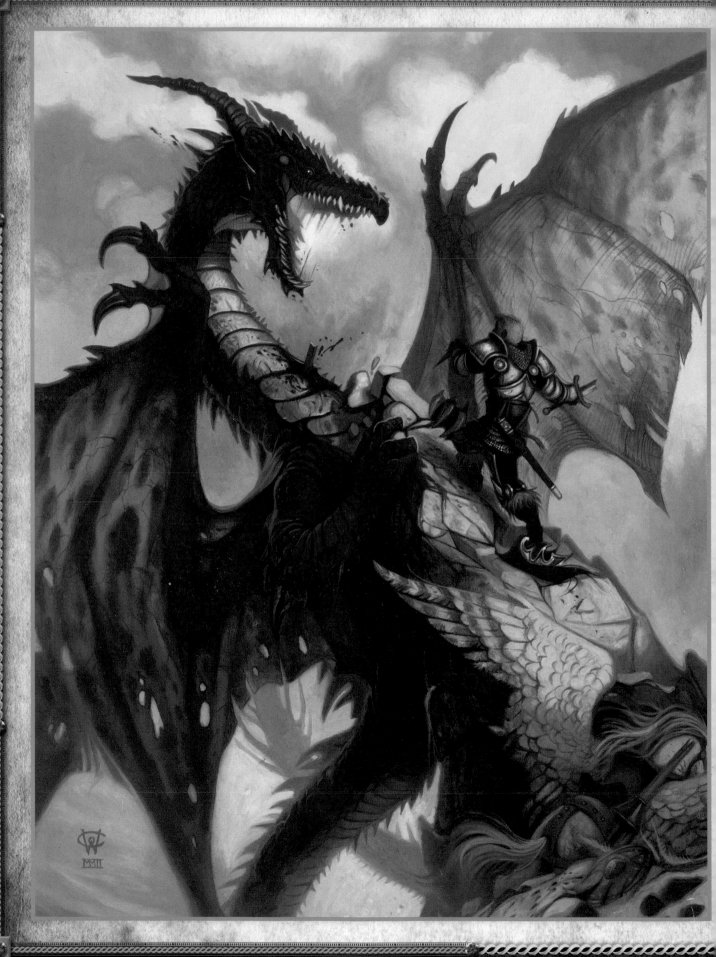

DRACOPEDIA

A Guide to Drawing the Dragons of the World

William O'Connor

IMPACT
CINCINNATI, OHIO
www.impact-books.com

Art from page 2:

Valor's Peak
Oil on paper
18" × 14" (46cm × 36cm)
2002

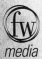

Other fine IMPACT Books are available from your local bookstore, art supply store or direct from the publisher at www.fwmedia.com.

13 12 11 10 09 5 4 3 2 1

DISTRIBUTED IN CANADA BY FRASER DIRECT
100 Armstrong Avenue
Georgetown, ON, Canada L7G 5S4
Tel: (905) 877-4411

DISTRIBUTED IN THE U.K. AND EUROPE BY DAVID & CHARLES
Brunel House, Newton Abbot, Devon, TQ12 4PU, England
Tel: (+44) 1626 323200, Fax: (+44) 1626 323319
Email: postmaster@davidandcharles.co.uk

DISTRIBUTED IN AUSTRALIA BY CAPRICORN LINK
P.O. Box 704, S. Windsor NSW, 2756 Australia
Tel: (02) 4577-3555

Library of Congress Cataloging-in-Publication Data
O'Connor, William
 Dracopedia : a guide to drawing the dragons of the world / William O'Connor. -- 1st ed.
 p. cm.
 Includes index.
 ISBN-13: 978-1-60061-315-9 (hardcover : alk. paper)
 ISBN-10: 1-60061-315-2 (hardcover)
 1. Dragons in art. 2. Drawing--Technique. I. Title. II. Title: Guide to drawing the dragons of the world.
 NC825.D72O26 2009
 743'.87--dc22
 2009020514

Edited by Kelly C. Messerly
Designed by Clare Finney
Production coordinated by Matt Wagner

Art on page 49 from *Mythological and Fantastic Creatures CD-ROM & Book* © 2002 Dover Publications, Inc.

Art on page 18 from *Gesner's Curious and Fantastic Beasts CD-ROM & Book* by Konrad Gesner © 2004 Dover Publications, Inc.

Art on page 29 from *Dragons and Wizards CD-ROM & Book* by Marty Noble and Eric Gottesman © 2003 Dover Publications, Inc.

Art on pages 26, 59 and 141 from *Monsters and Dragons CD-ROM & Book* by Ernst and Johanna Lehner © 2005 Dover Publications, Inc.

Art on page 71 from *Heraldic Designs CD-ROM & Book* © 1999 Dover Publications, Inc.

Art on page 153 from *120 Italian Renaissance Paintings CD-ROM and Book* by Carol Belanger Grafton © 2007 Dover Publications, Inc.

Art on pages 71 and 117 from *The Complete Woodcuts of Albrecht Dürer*, Dr. W. Kurth (ed) © 1963 Dover Publications, Inc.

Art on page 141 from *159 Celtic Designs* by Amy Lusebrink © 1993 Dover Publications, Inc.

Art on page 129 from *Doré's Illustrations for Ariosto's "Orlando Furioso"* © 1980 Dover Publications, Inc.

Art on pages 50 and 105 from *Animals: 1,419 Copyright-Free Illustrations of Mammals, Birds, Fish, Insects, etc.*, Jim Harter (ed) © 1979 Dover Publications, Inc.

Adobe and Photoshop are either registered trademarks or trademarks of Adobe Systems Incorporated in the United States and/or other countries.

Corel® and Painter™ are trademarks or registered trademarks of Corel Corporation and/or its subsidiaries in Canada, the United States and/or other countries.

METRIC CONVERSION CHART

To convert	to	multiply by
Inches	Centimeters	2.54
Centimeters	Inches	0.4
Feet	Centimeters	30.5
Centimeters	Feet	0.03
Yards	Meters	0.9
Meters	Yards	1.1

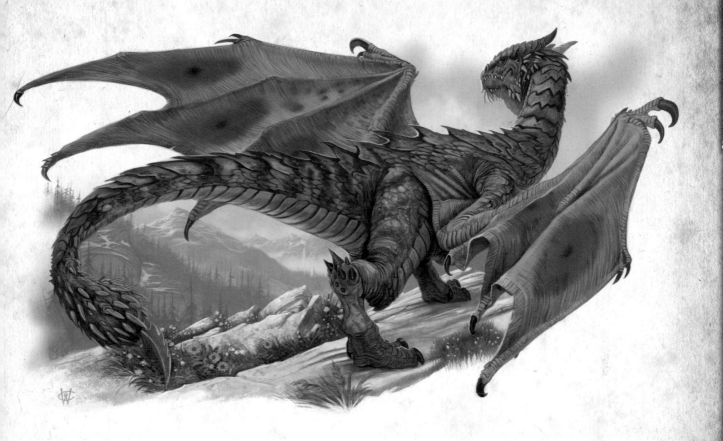

Acknowledgments

To Sam. Thanks for the coffee and waffles.

A special thanks goes to Jeff Menges and Dover Publications for access to their excellent archive of historical dragon art. This book would not have been possible without their invaluable assistance. For more information visit www.doverpublishing.com.

About the Author

William O'Connor began drawing and painting as a child. Monsters and myths were inspirational to driving him to study visual arts. The writings of Tolkien, the Athurian Romances, as well as Dungeons and Dragons formed a fascination with dragons and the fantasy genre that lasted all his life. William attended Alfred University for fine arts, graduating in 1992 and become a full-time freelance illustrator. William has produced over three thousand images for publication for such companies as Wizards of the Coast, Blizzard Entertainment, Lucasfilms, HarperCollins, Doubleday and many more.

For more information about William O'Connor and to see his portfolio, visit: www.wocstudios.com.

TABLE OF CONTENTS

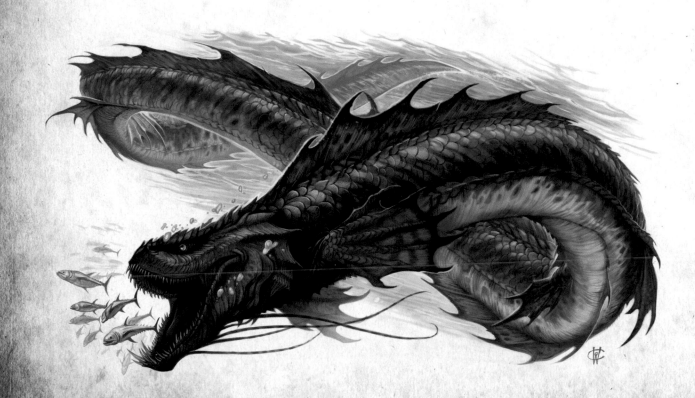

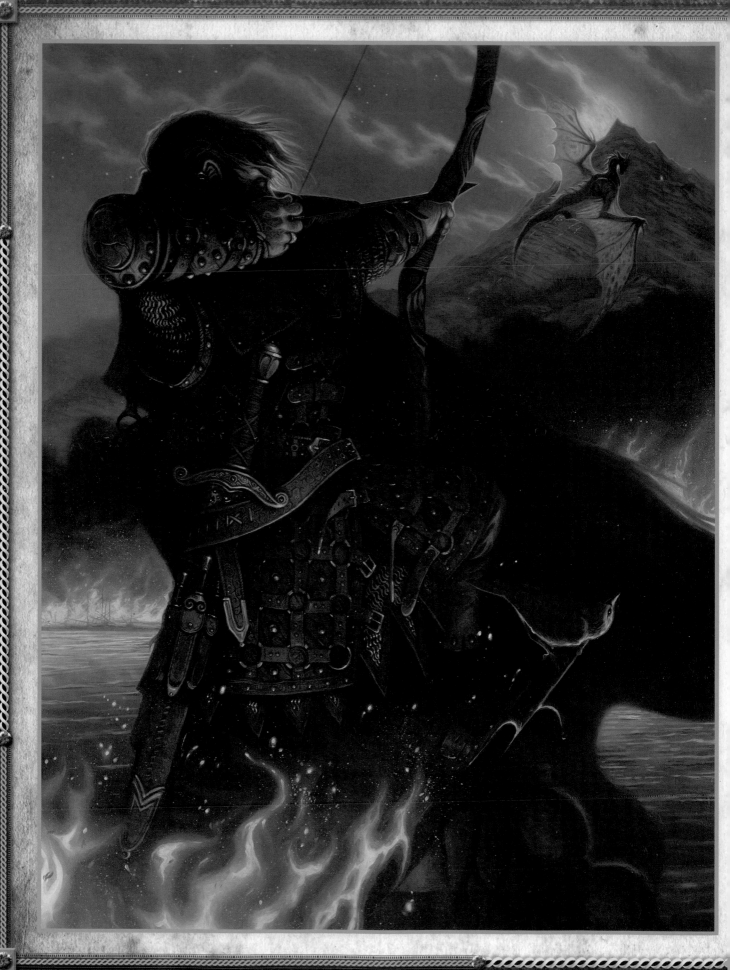

INTRODUCTION

 DRAGONS HAVE FILLED THE IMAGINATIONS of human-kind since the beginning of history. Fables, mythology and folklore are populated with the winged, scaly beasts that both frighten and delight us. Throughout history this amazing creature has captivated the minds of artists all over the world. Today the power and majesty of dragons are as fascinating as ever, and tales of dragons and their kind dominate the novels of authors, the canvases of artists and the screens of animators.

Dracopedia is an approach to the study and understanding of these amazing creatures from an artist's point of view. Anatomical studies, gesture sketches and painting demonstrations are all a part of the *Dracopedia*, as well as a natural and cultural history of dragons. For years artist William O'Connor has traveled all over the world studying dragons in their natural environment. Now this work is compiled for the first time into a single encyclopedic compendium.

HOW TO USE THIS BOOK

For thousands of years dragons have been depicted in paintings, drawings, woodcuts, sculptures and every form of art imaginable, and in every culture. The dragon is the most universal creature in history. Dragons are the most well-known creature in the world, and yet, they only exist in the mind of the artist.

Dracopedia is an artist's reference guide and workbook for creating, design-ing and visualizing all types of dragons. By examining thirteen individual dragon families, the concepts, design drawings, stages of the painting process, and by using historical and natural references as a guide, it is my hope that artists of all experience levels, gamers, writers and dragon enthusiasts alike will find inspiration and ideas of their own in these pages.

Each chapter in the work is divided into two parts. The first part involves the concept stage, where through a series of pencil-and-paper sketches, designs, historical reference and environmental studies, the dragon is worked out in detail. Once this is completed, a full-color painting demonstration is executed of the animal. Although these paintings are executed digitally, the concepts contained with them apply to all artists using any medium or application.

Fire and Water
Oil on panel
36" × 24"
(91cm × 61cm)
2004

Drawing Materials

The most important tools are no more than a simple notebook and pen or pencil. With these you can perform anatomy studies of any of the animals contained in the *Dracopedia*, as well as begin drawing your own designs. I start out all my drawings using an HB lead pencil.

Selecting a Pencil

Pencil leads come in different degrees of hardness. Select pencil leads with an H designation if you want a hard lead. Select pencil leads with a B designation if you want a soft lead. The nice thing about an HB lead is that it's right in the middle—it's neither too hard nor too soft—and will be visible through transparent color or easily be covered with opaque colors.

There are also a variety of pencil types. You can get mechanical pencils, which allow you to use a variety of lead thicknesses. You could also use a lead holder, which is similar to a mechanical pencil, but holds a thicker lead that can be sharpened to a fine point with sandpaper and a craft knife. Of course, there are also the traditional wooden pencils. These can also be sharpened with sandpaper and a craft knife for a very sharp point, or you can use a pencil sharpener.

Using an Eraser

I consider erasers as an additional drawing tool. I prefer to use a white vinyl eraser because it doesn't mar the paper, despite repeated corrections. Eraser pens are readily available. The ends can be cut into points and used to create highlights.

Selecting a Surface

There are a variety of surfaces you can draw on, though I prefer to draw on bristol board because it's thicker than plain white or notebook paper, and it easily accepts the

Practice Your Drawing Technique
When designing dragons of your own, you will need to spend a lot time drawing. Whether you choose to work digitally or traditionally, the drawing is the most important stage because this is where you determine the dragon's overall look and design.

Pencil Leads

The softer your pencil lead, the darker your mark and the easier it is to blend. If your lead is too soft, the pencil can easily smear, making your drawing look dirty. However, if the pencil lead is too hard, you will have to apply more pressure to the pencil to draw. This can mar your paper's surface. I usually work with a range of leads to achieve different effects, but experiment with different lead hardnesses to find one that works best for you.

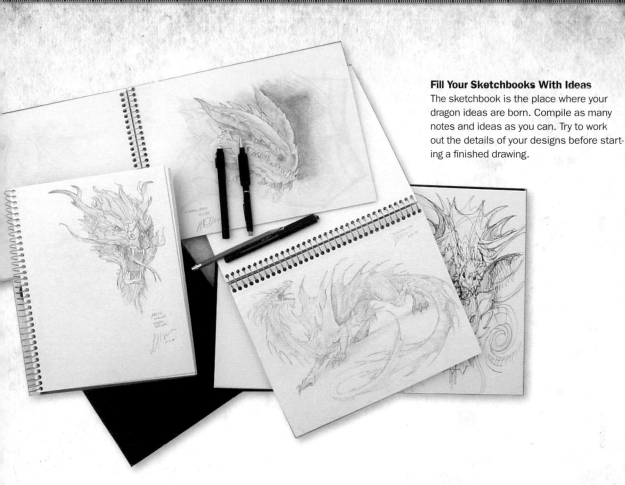

Fill Your Sketchbooks With Ideas
The sketchbook is the place where your dragon ideas are born. Compile as many notes and ideas as you can. Try to work out the details of your designs before starting a finished drawing.

pencil lead and allows for marks to be easily erased. I work with bristol board that's 14" × 22" (36cm × 56cm) and has a vellum surface. Bristol board comes in pads, which are well suited for doing your final drawing before adding paint or scanning into the computer, as the sheets can easily be removed.

Drawing Supplies
Pencil on a smooth-surfaced large paper allows me to render high detail, and make changes fairly easily. The most important thing is to be patient. Take your time and don't rush.

It's also very important to get a sketchbook. I believe the sketchbook is the artist's best tool. This is where all of your ideas and observations are jotted down, and the the real creativity happens. Sketchbooks are also a good way to document and store your ideas. You never know when an old idea might spark a new concept. A simple doodle with notes might lead you to your best creation.

USE REFERENCE MATERIAL

Going to your library or bookstore and searching online will allow you to see the wide variety of dragons that other artists have created. In combination with natural history books, these can be a helpful inspiration for getting started.

© RESPECT COPYRIGHTS
It's OK use other people's photos as a reference to get ideas, to see the pattern of a snake, for instance, but unless you have permission from the owner of that image, it is not acceptable to copy that image directly.

Digital Painting

For the dragon demonstrations in this book, I scanned my pencil drawings into the computer, then painted them using Adobe® Photoshop®. The digital painting instructions in this book are based on Adobe Photoshop, but you can use any painting program that has layers capability, such as Corel® Painter™ X, Corel© Painter™ Essentials, and Adobe® Photoshop® Elements. If price is a factor, check out the powerful freeware package GIMP, available at www.gimp.org. You can also paint with traditional mediums such as oil, acrylic, watercolor and colored pencil.

Whether you paint digitally or traditionally, the painting process is as follows:

1. *Start with one or more thumbnail sketches.* Thumbnails help you work out your ideas as well as the dragon's form and how it relates to the setting.

2. *Do a final drawing.* Do the final pencil drawing with an HB pencil on bristol board. If you're going to paint digitally, scan your final drawing into the computer. Scan in RGB color mode at 100 percent of the original size and 300ppi so that your painting can be used in print at a later date should the opportunity arise.

3. *Establish the underpainting.* Using transparent colors and large brushes, do a monochromatic underpainting that sets the stage for later colors and details. (In Photoshop, do the underpainting on a new layer that is set to Multiply mode.)

4. *Refine the forms and begin adding details.* Begin modeling the forms of the dragon and its setting, using semiopaque colors and smaller brushes.

5. *Add details and finishing touches.* With opaque colors and your smallest brushes, apply remaining details.

Brushes

Whether they're traditional or digital, the brushes you use dictate the types of marks you will make. The digital brush shapes on this page are among my favorites; all are adaptations of default Photoshop brush shapes that I created by modifying brush parameters such as Shape Dynamics, Scattering and Wet Edges. Take time to experiment with brush parameters and come up with your own favorite brushes (see page 32 for more on customizing brushes).

Layer Modes

With the layering feature, you can paint each stage of a painting on its own layer (like an acetate overlay sheet), then control each layer independently.

In Photoshop, create a new layer by choosing Layer menu > New to set each layer to any of several blending

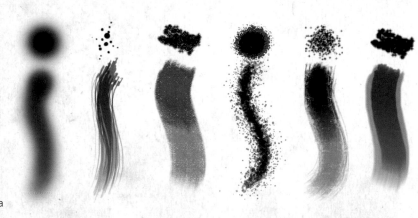

Photoshop Brushes
Photoshop provides myriad brush shapes, and there are numerous brush parameters you can alter. Shown here are some of my favorite custom brushes that I made by modifying default brush shapes. Brushes like these can simulate the texture of grass, stone, or hair on a dragon's hide.

modes that govern how its colors blend with those on other layers. You can also hide a layer temporarily by clicking its "eye" icon. The layer modes I use in this book are:

- *Normal layer mode.* This is the default and simplest mode. On a layer in Normal mode, painting with a 100% opaque brush covers up whatever is on the base layer; painting with a lower-opacity brush allows the new color to blend with the base color the way you would expect traditional paint colors to blend.

- *Multiply layer mode.* On a layer in Multiply mode, the color of the base layer gets multiplied by the new color, resulting in a color that is always darker than the base color. Brushing repeatedly on the same area produces a progressively darker color, rather like repeated strokes of a marker.

Normal mode at 100% opacity

Multiply mode at 100% opacity

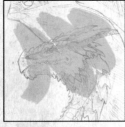

Normal mode at 50% opacity

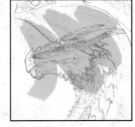

Multiply mode at 50% opacity

Brush Opacity vs. Layer Opacity
Each layer in a Photoshop document has an opacity setting, which is separate from brush opacity. All four of the gray brushstrokes shown here were painted with a brush set to 100% opacity. The brushstrokes are on a new layer atop the background layer which contains the pencil drawing. By changing the mode and opacity of the top layer, I can control how much of the base layer shows through. These settings simulate the effect of transparent or opaque paints.

SPECIFYING COLOR IN PHOTOSHOP

Photoshop comes with a default set of swatches (Window menu > Swatches); you simply click a swatch to use it. An artist's color palette is subject to a great deal of personal taste, but you will almost certainly want some hues that aren't included in the default swatch set, and you'll probably need multiple tonal variations of your hues. Two ways to choose your own colors are:

- *The Eyedropper tool.* Click the Eyedropper on an image to sample a color straight from a specific spot on a painting or photo.

- *The Color Picker tool.* To open the Color Picker, choose Window menu > Tools, then click one of the color squares on the Tools palette. The upper square is the foreground color; the lower square sets the background color.) In the Color Picker, you can click the desired spot on a spectrum of colors, or you can specify numeric values for R, G and B (red, green and blue). The numeric values are useful if you want to know exactly what a color is so that you can use it again later or communicate it to someone else.

Whichever method you use, you can save your custom color as a swatch for easy reuse as follows: Choose Window menu > Swatches, click the triangle button to open the Swatches menu, then choose New Swatch.

Palette of Color Swatches
In my digital palette, I've arranged my custom swatches from light to dark horizontally. I can choose any hue, and sixteen tonal variations are immediately available. By moving vertically through the palette, I can change hues without altering the tone.

Draco amphipteridae

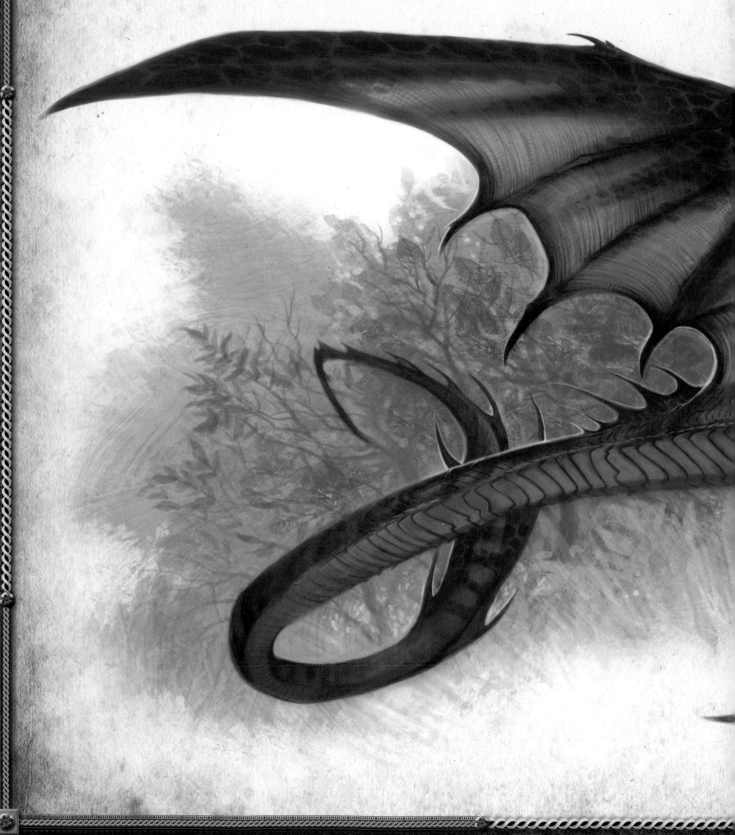

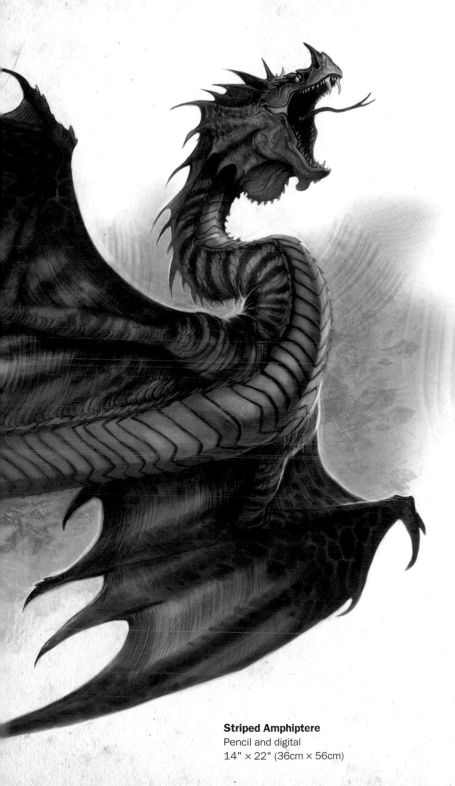

Striped Amphiptere
Pencil and digital
14" × 22" (36cm × 56cm)

SPECIFICATIONS

Size: 6" to 6' (15cm to 183cm)

Wingspan: 6" to 10' (15cm to 305cm)

Recognition: Serpent body with batlike wings. Pattern and color vary by region and species

Habitat: Temperate to tropical climates, wooded and forested regions

Common names: Swallowtail amphiptere, firewing amphiptere, vulcan amphiptere, mothwing amphiptere, starburst amphiptere, golden amphiptere, striped amphiptere, rock amphiptere, garden amphiptere

Also known as: Winged serpent, flying serpent

BIOLOGY

The winged serpent is a common dragon consisting of a legless serpent with leather wings. Ranging in size from tiny 6" (15cm) garden asps to larger specimens of 6' (183cm). The batlike wings of the amphiptere allow the creature a range of large distances, but the amphiptere does not usually soar like a bird; rather, it uses short flying and gliding to cover its ground. The amphiptere's coloration varies greatly from species to species, and it feeds primarily on small creatures such as insects, bats, birds and mice. Coming in hundreds of varieties, in various sizes, colors and shapes, and ranging in habitat all over the world, the winged serpent is one of the most common wild members of the dragon class. The amphiptere is found in all temperate to tropical countries (except Ireland). Today, amphiptere are commonly kept as pets. Rare and beautiful species of winged serpents with exotic patterns are popular in the black markets of Malaysia and India and imported to Europe and North America. This illegal trade has introduced amphiptcridae into ecosystems not intended to support them.

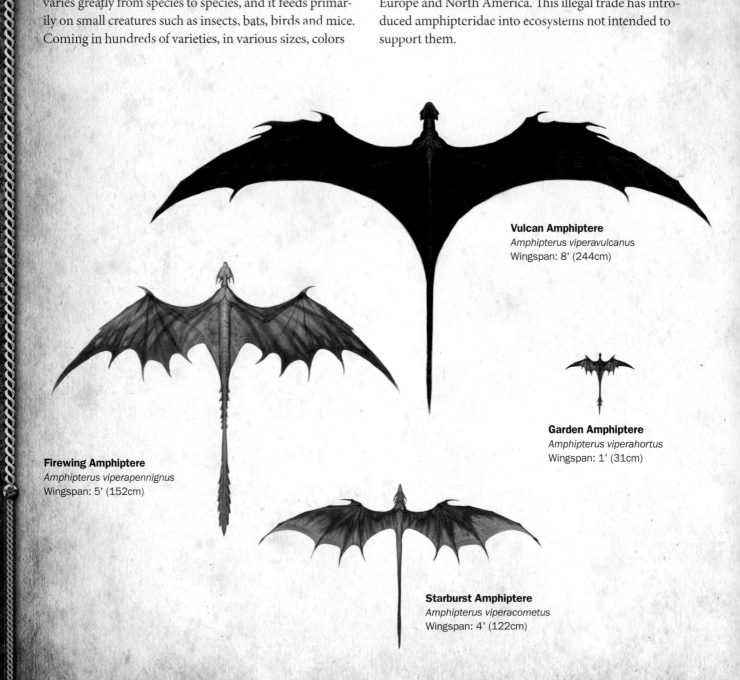

Vulcan Amphiptere
Amphipterus viperavulcanus
Wingspan: 8' (244cm)

Firewing Amphiptere
Amphipterus viperapennignus
Wingspan: 5' (152cm)

Garden Amphiptere
Amphipterus viperahortus
Wingspan: 1' (31cm)

Starburst Amphiptere
Amphipterus viperacometus
Wingspan: 4' (122cm)

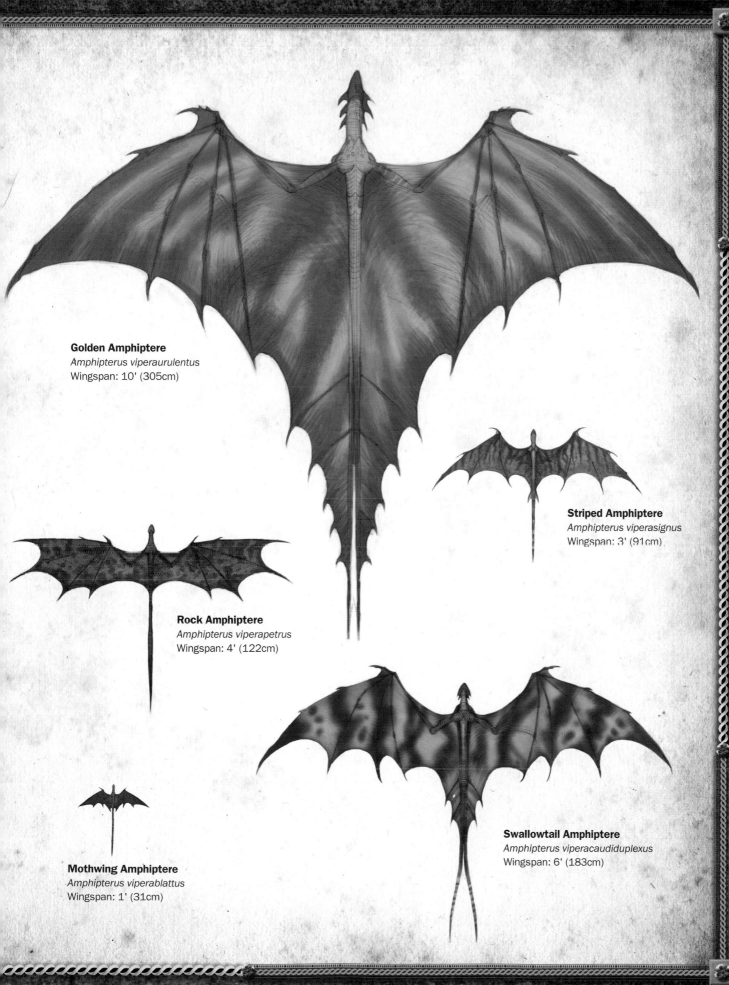

Golden Amphiptere
Amphipterus viperaurulentus
Wingspan: 10' (305cm)

Striped Amphiptere
Amphipterus viperasignus
Wingspan: 3' (91cm)

Rock Amphiptere
Amphipterus viperapetrus
Wingspan: 4' (122cm)

Swallowtail Amphiptere
Amphipterus viperacaudiduplexus
Wingspan: 6' (183cm)

Mothwing Amphiptere
Amphipterus viperablattus
Wingspan: 1' (31cm)

Behavior

Amphipteridae spend most of their lives in trees and forests. Nesting in high branches, the amphiptere glides between trees, catching insects and small rodents. In this respect the amphiptere is a welcome creature to most farmers. Unfortunately, some amphiptere will find their way into the nests of other birds, looking for eggs. In the hen-houses of domesticated chickens, often cross-fertilization will occur, which can result in the hatching of a half amphiptere, half chicken, known commonly as a cockatrice.

Amphiptere Egg, 4" (10cm)
The amphiptere makes its nests high in trees, but also has been known to use the nests of other birds.

Amphiptere Habitat
Deep woods and forests are the natural habitat of the amphiptere, but some may also be found living in urban environments.

History

The amphiptere has historically been regarded as a creature of mixed fortune, and today it's a greatly mis-understood animal. Since they live on a diet of ver-min, the amphiptere is a welcome addition in cities, and there are many amphiptere that live in New York City, making their nests in the high perches of skyscrapers. The endless supply of rats, mice and pigeons help keep urban areas free of the diseases that are spread by vermin.

However, the crossbreeding of the amphiptere with domesticated fowl is responsible for the cockatrice, which is viewed as a scourge and killed on sight all over the world. Its terrible appearance is responsible for the mythology that its gaze can paralyze its prey to stone, thus erroneously placing it in close relationship to the basilisk (see pages 44–53).

Amphiptere were commonly depicted in bestiaries of the middle ages.

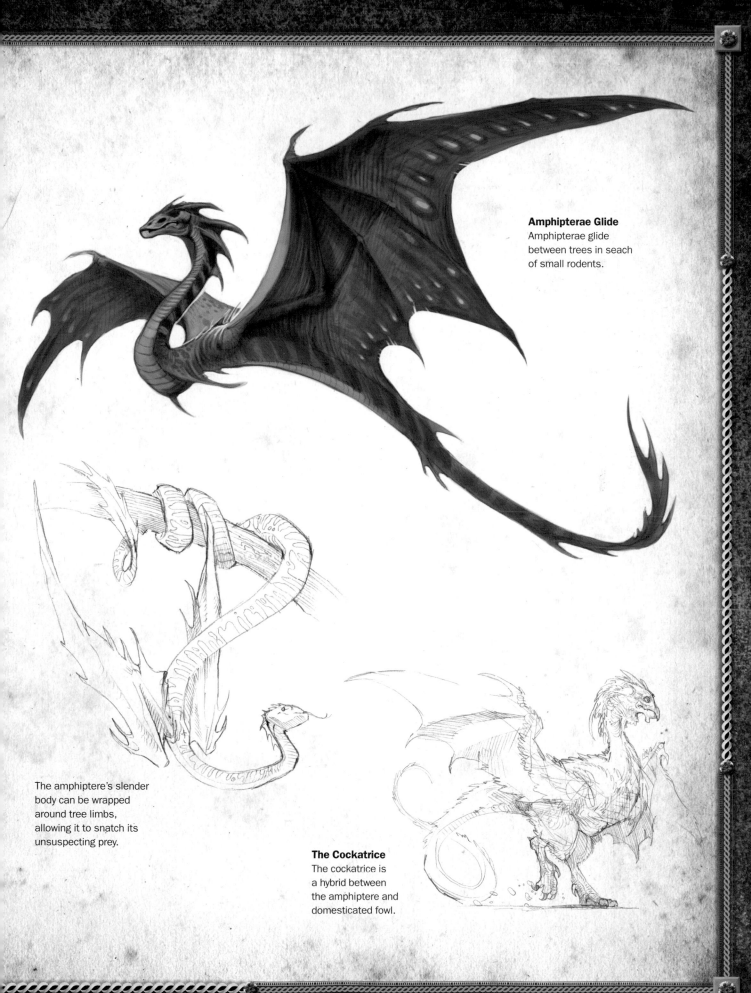

Amphipterae Glide
Amphipterae glide between trees in seach of small rodents.

The amphiptere's slender body can be wrapped around tree limbs, allowing it to snatch its unsuspecting prey.

The Cockatrice
The cockatrice is a hybrid between the amphiptere and domesticated fowl.

DEMONSTRATION
STRIPED AMPHIPTERE

The amphiptere is a beautiful and elegant animal with colorful patterning. When designing a painting of an amphiptere, refer to your references and the field sketches that you've made. Remember, the amphiptere has:

- A snake body
- Colorful wing patterns
- Live in a forest landscape

1 Sketch the Composition
Make a rough design sketch of the amphiptere to properly establish the elements of the composition. The curving shape of the amphiptere helps suggest movement.

2 Create a Finished Drawing
Do a fresh final drawing with an HB pencil on bristol board. Use an eraser to lift out tone and clean up stray lines, then scan the drawing.

3 Establish the Underpainting
Open the scanned drawing in your paint program. Create a new layer in Multiply mode (see "Layer Modes," page 12), then do a monochromatic underpainting. Using Multiply mode allows the drawing to show through this layer.

I did my underpainting using a range of lighter and darker greens from my palette. When you use Multiply mode for the underpainting layer, brushing repeatedly over the same area darkens the color; use this to help create the shadows.

This is also the time to start blocking in textures. For instance, I created the background texture of leaves using a brush with the Scattering option turned on (Window menu > Brushes). In a traditional medium, you might use a sponge or stencil to create texture.

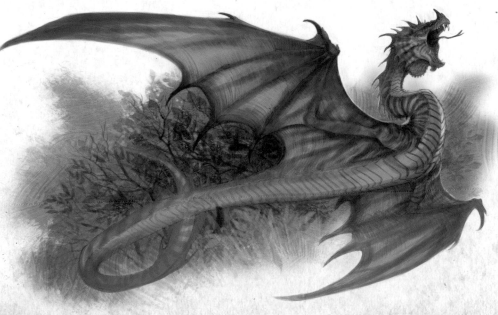

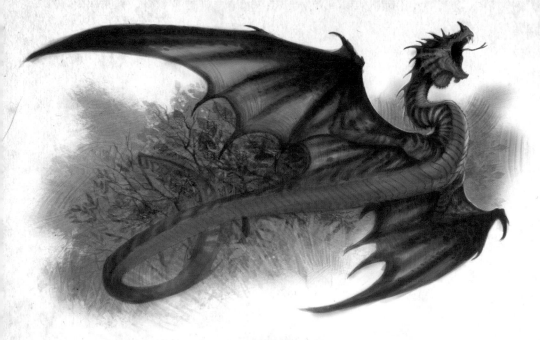

4 Refine the Color

Create a new layer in Normal mode with an opacity setting of 50%. Refine the colors and details of the amphiptere and its background using semiopaque brushes. Introduce bright colors in the face to attract the viewer's attention to that area. Use the markings of birds and reptiles as design ideas.

Even with the semiopaque brushes, this step will obscure the underpainting a bit, but that's why it's called an underpainting. Don't worry too much about details at this point; much of the painting you do in this step will be painted over as well.

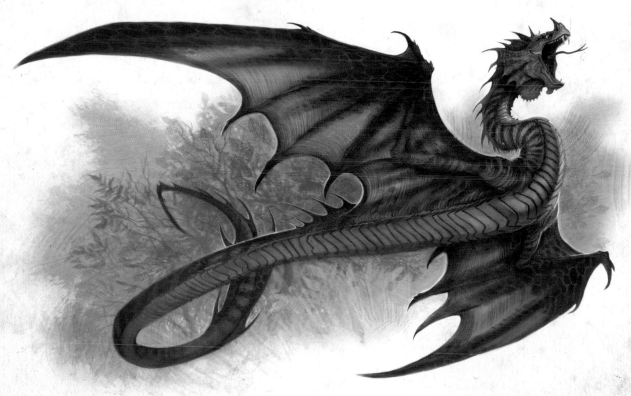

UNDERSTANDING OPACITY

I often refer in this book to a color's opacity. With traditional paint, opacity is controlled by mixing in more or less medium, be that water, turpentine or an oil. The analogous adjustment in Photoshop is the opacity setting of the brush you are using. This setting is located in the Options bar (Window menu > Options) whenever the Brush tool is selected. You can also change the setting quickly using the number pad on the keyboard: 1 = 10%, 2 = 20%, and so on.

5 Add the Final Details

Finish the painting by adding a red wing pattern to create more visual interest. Since red and green are complementary colors, the amphiptere will stand out against the background.

ARCTIC DRAGON

Draco nimibiaquidae

SPECIFICATIONS

Size: 8' to 24' (244cm to 7m)

Wingspan: None

Recognition: Serpentine, flightless dragon with heavy fur. Coloration and patterning vary by species

Habitat: Arctic, northern Alpine areas and polar regions

Common names: Cook's dragon, cloud dragon, storm dragon, luck dragon, zmey dragon, kilin

Also known as: Polar dragon, snow serpent, ice dragon, frost drake, temple dog

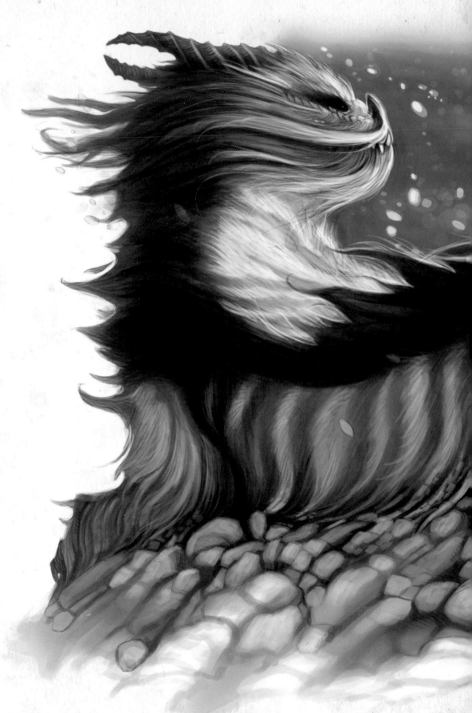

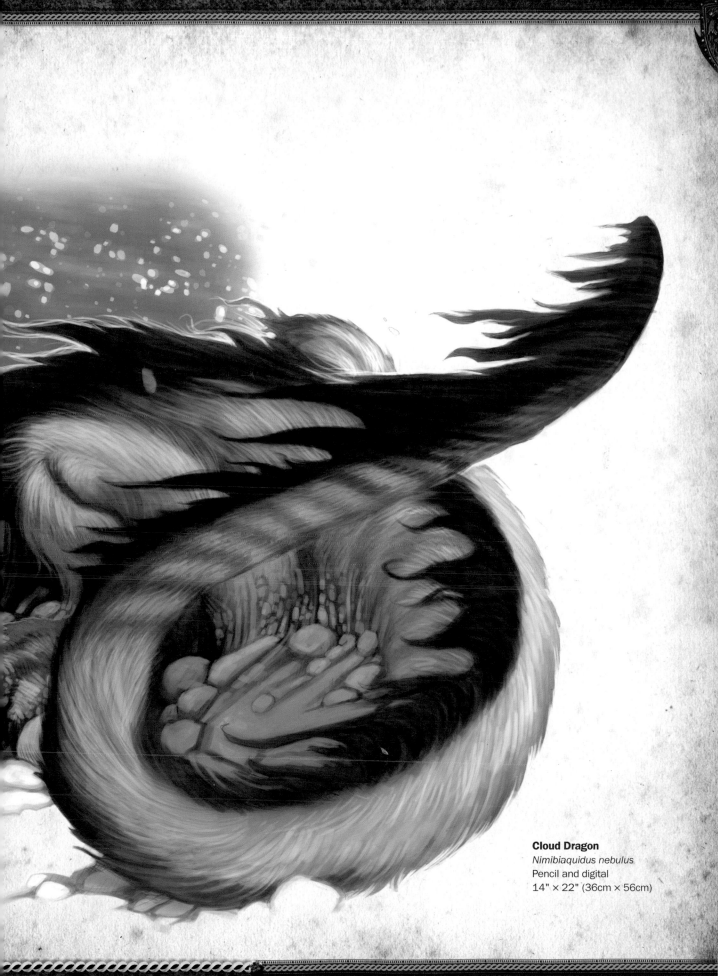

Cloud Dragon
Nimibiaquidus nebulus
Pencil and digital
14" × 22" (36cm × 56cm)

BIOLOGY

The *Nimibiaquidae* family of dragons includes all of the northern, flightless, furred dragon species. They are serpentine creatures that ply the frozen wastes north of the Arctic circle, hunting seals, small whales and even polar bears. Although greatly resembling the Asian dragon species (see pages 34–43), Arctic dragons differ significantly in their biology in that they all grow fur, and do not have the wing frills particular to the Asian dragon. Covered in a sheath of thick fat and a coat of fur, the Arctic dragon blends into its environment to ambush its prey. Despite fur covering all Arctic dragon species, they, too, have a hide of intricate scales common to all dragons. Ranging across the globe, the Arctic dragon species are found from northern Canada and the tundras of Siberia and migrating as far south as China and the northern United States.

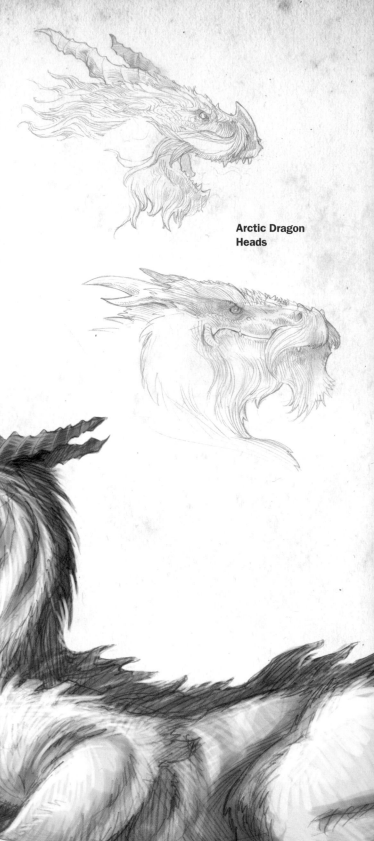

Arctic Dragon Heads

Cloud Dragon
Nimibiaquidus nebulus, 35' (11m)

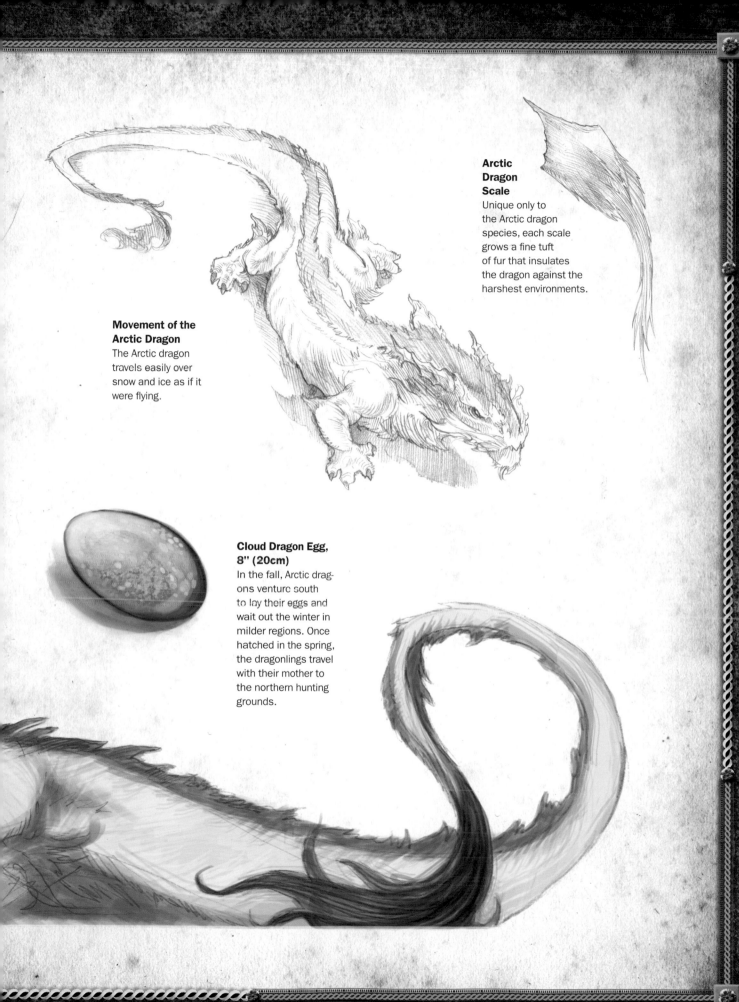

Arctic Dragon Scale
Unique only to the Arctic dragon species, each scale grows a fine tuft of fur that insulates the dragon against the harshest environments.

Movement of the Arctic Dragon
The Arctic dragon travels easily over snow and ice as if it were flying.

Cloud Dragon Egg, 8" (20cm)
In the fall, Arctic dragons venture south to lay their eggs and wait out the winter in milder regions. Once hatched in the spring, the dragonlings travel with their mother to the northern hunting grounds.

The Kilin

The kilin (or kylin, quilin) genus of Arctic dragons more greatly resemble bighorn sheep in size and habitat, and are particular only to the continent of Asia. The kilin is often referred to as the Chinese unicorn.

The kilin species of Arctic dragon will migrate south, following the food supply from the eastern provinces of Russia and into China and Mongolia. Staying high in their Alpine mountains for safety, kilin are adept mountain climbers, leaping agilely from promontories in pursuit of food, or evading larger predators. This behavior is believed to have created the imagery of the kilin's flight. Kilin are one of the few dragon species that live in herds, often gathering in tight groups on high mountains for warmth.

Kilins Migrate
Herds of kilin can migrate hundreds of miles to winter in milder climates.

History of the Kilin

Since the kilin species of Arctic dragons migrate south in winter, their contact with human civilization is fairly common. Although they are a shy and elusive animal, they are seen as good luck by many Asian communities. The kilin are also famous as being the traditional mounts or familiars of wizards in Asia. This probably holds some historical truth. Since sorcerers, monks, or hermits would live secluded in the mountains, they would come in contact with kilin, and would domesticate them in rare instances. Today, kilin herds are reduced in Northern Asia and Russia, but in the fall, they can still be seen leaping in the mountain passes.

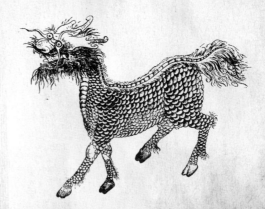

An example of a kilin from Chinese art.

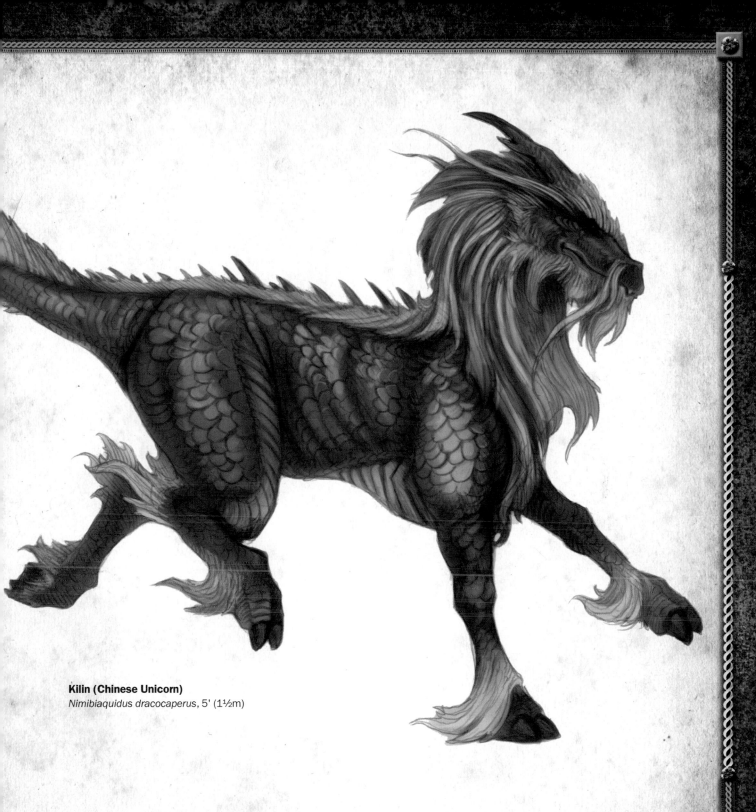

Kilin (Chinese Unicorn)
Nimibiaquidus dracocaperus, 5' (1½m)

Behavior

Survival in the northern climates of the Arctic is harsh. Most species of the Arctic dragon are omnivorous to take advantage of any food available. The larger species of Arctic dragons will hibernate in the winter, burrowing deep into the polar snows to make its lair. Snow serpents are cunning hunters, artfully using the concealment of Arctic fog and cloud-shrouded peaks to camouflage itself. With reduced eyesight, snow serpents hunt by smell and the feel of their long whiskers. This allows the animals to hunt effectively, even in blizzard conditions. This ability to seemingly float silently through the clouds has lead to many of the beautiful images of Arctic dragons in Asian art.

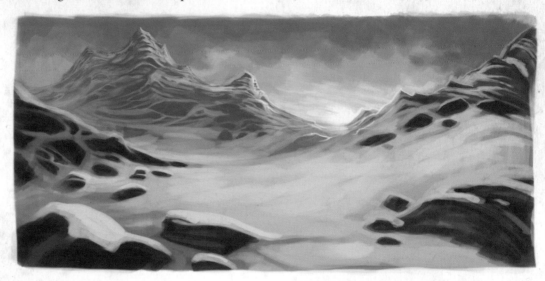

Arctic Dragon Habitat
The frozen wastes of northern China, Russia and America are the Arctic dragon's natural home.

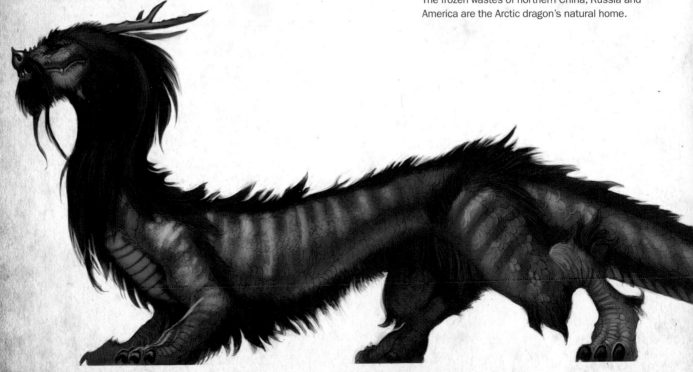

HISTORY

The fur of the Arctic dragon is prized for its beauty, softness and ability to insulate. Northern tribes, particularly Inuit cultures, throughout the world have elevated the Arctic dragon to supernatural status. In China, the storm dragon is believed to bring prosperity and good luck because their presence frightens off other large predators such as wolves and wyverns. Arctic dragons have played prominently in pop culture. Falkor the Luck Dragon in *The NeverEnding Story*, as well as Appa in the animated series *Avatar*, could be Arctic dragons. Despite these roles as pets or companions, the Arctic dragon is one of the most dangerous animals in the world.

The storm dragon is considered good luck in China and is prominent in Chinese art.

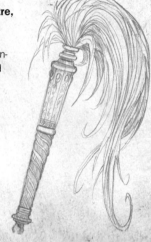

Manchurian Sceptre, Circa 1750
The fur of the Arctic dragon has been considered magical and prized for its beauty and warmth.
Courtesy of Beijing Museum of Natural Science.

Storm Dragon (Chinese Dragon)
Nimibiaquidus tempestus, 50' (15m)
Common in Asian art, the storm dragon is a symbol of prosperity, good fortune and the Chinese emperor. Today the storm dragon is extremely rare in the wild.

CLOUD DRAGON

Before starting on a complicated painting, make a list of all the most important elements that should be included, such as:

- Arctic habitat
- Serpentine body
- Fur

In this painting, the color is very monochromatic. Compared with some other dragons, the cloud dragon is white set against a white environment. The limited palette is expanded by using a warm light against the cool shadows, enhancing the dimension and depth of the painting.

Artist's Note

Dragons with fur are unique in the dragon world and offer the possibility of a wide variety of species with interesting manes, markings and colorations. Use the Internet and your public library to research animals with interesting fur and hair, then try creating your own Arctic dragon. Remember, each element you design needs to have a reason for having evolved in your dragon.

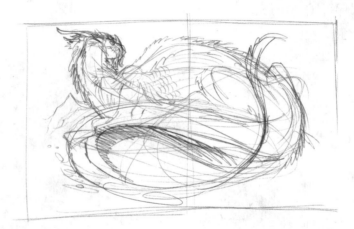

1 Complete Thumbnail Sketches

Do a series of thumbnail sketches like this one to work out the composition.

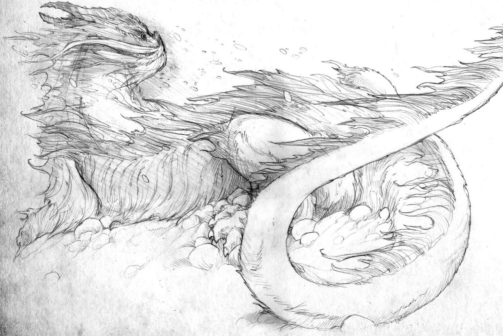

2 Draw the Finished Composition

Using your thumbnail sketches as a reference, do a fresh, final drawing with an HB pencil on bristol board. Use an eraser to lift out tone and/or clean up stray lines, then scan the drawing. The windswept fur accentuates the harsh environment of the cloud dragon and shows how the fur behaves, creating a sense of movement.

3 Start the Underpainting

Create a new layer in Multiply mode. Begin an underpainting using large-diameter, soft-edged brushes set to 100% opacity. I used cool blue hues to create the feeling of a frigid climate.

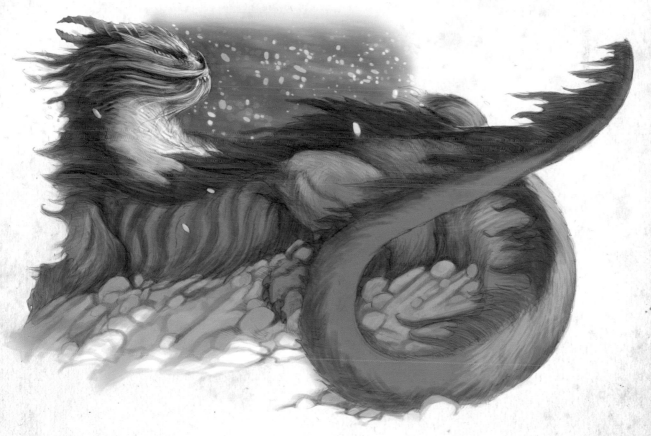

4 Complete the Underpainting

Using somewhat smaller and harder-edged brushes, finish the underpainting. Be sure your placement of lighter colors clearly indicates the direction of the light source. Keep the background soft to contrast against the more defined dragon and the rocky foreground.

TRY THE SMUDGE TOOL

If you're using Photoshop, try using the Smudge tool to soften the edges of the fur areas. Click and drag from the colored area outward. (To create realistic wind-blown fur, be sure to drag the Smudge tool in the same direction and at the same approximate angle throughout.)

5 Refine the Color and Add Texture

The final details in this painting are only a matter of textures. Use different types of brushes (see sidebars) to simulate the textures of the Arctic dragon's fur. As you work, add warm grays for highlights and cool grays to refine the shadow areas.

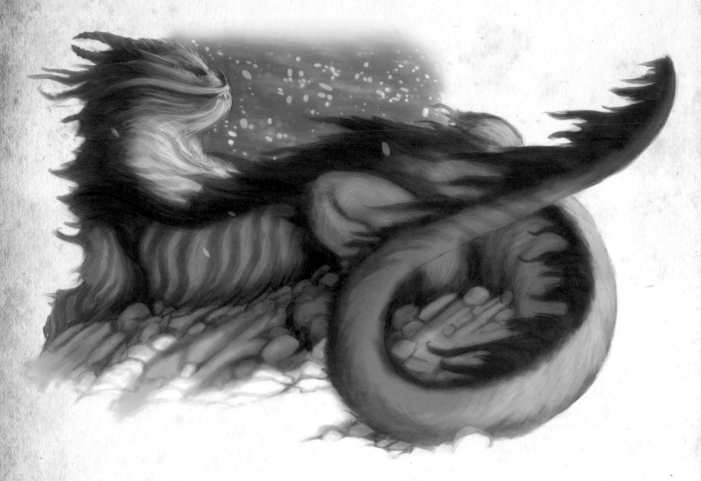

MAKE YOUR OWN CUSTOM BRUSH SHAPES IN PHOTOSHOP

Depending on the type of brush you select from your Brush palette, you'll be able to create different textures to simulate the look of the dragon's fur. These are brushes I've customized in Photoshop. To make your own brushes in Photoshop:

1. Open the image you want to make a texture from. It could be anything: a digital photo, a digital painting, or even a handmade texture that you draw, stamp or paint yourself and then scan.

2. Convert the image to gray scale (Image menu > Mode > Gray scale).

3. Using the rectangular Marquee tool, select a square area to turn into a custom brush. Some tips:
 - To easily select a square, hold down the Shift key while selecting. (If you select an area that isn't square, it may get stretched into a square, which might not be what you want.)
 - The area you select can be as large as 2500 × 2500 pixels.
 - The selection will stay the same size when turned into a brush, so if you want the brush to be smaller, copy and paste the selection into a new grayscale document, then scale it down to the size you want (Edit menu > Transform > Scale).

4. Define the selection as a brush by choosing Edit menu > Define Brush Preset.

5. Select the Brush tool, then open the Brush Preset Picker (the little drop-down menu in the Brush Options bar just under the menu bar). Scroll to the bottom and click your new preset to start using it.

6. If desired, choose Window menu > Brushes and tweak the brush parameters. To save this customized version, click the little round menu button and choose New Brush Preset.

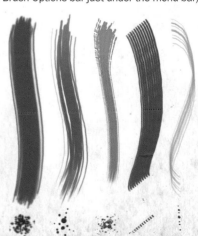

Painting Hair and Fur

1. Create a monochromatic dark base, using a soft-edged semitransparent brush. Make multiple brushstrokes to achieve the look of built-up transparent color.

2. Choose or create a hair-shaped brush that's slightly more opaque and lighter colors, rough in the texture. As you go, pay attention to the direction the hairs lie on the animal and think about the direction of the light source. Begin to create shadow and highlight areas.

3. Choose a finer brush that's nearly opaque. Using progressively lighter colors on successive layers, brush repeatedly to create the look of fur. (Save the lightest color for the final step.) Keep in mind where the shadow and highlight areas are.

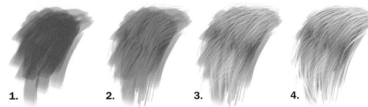

1. **2.** **3.** **4.**

4. Choose a very fine opaque brush and your lightest highlight color, then create just a few individual strands of hair to complete the illusion of fur.

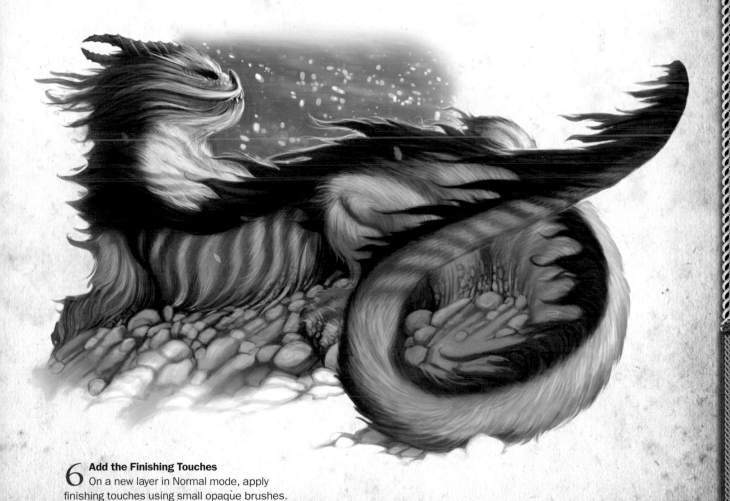

6 **Add the Finishing Touches**
On a new layer in Normal mode, apply finishing touches using small opaque brushes.

Draco cathaidae

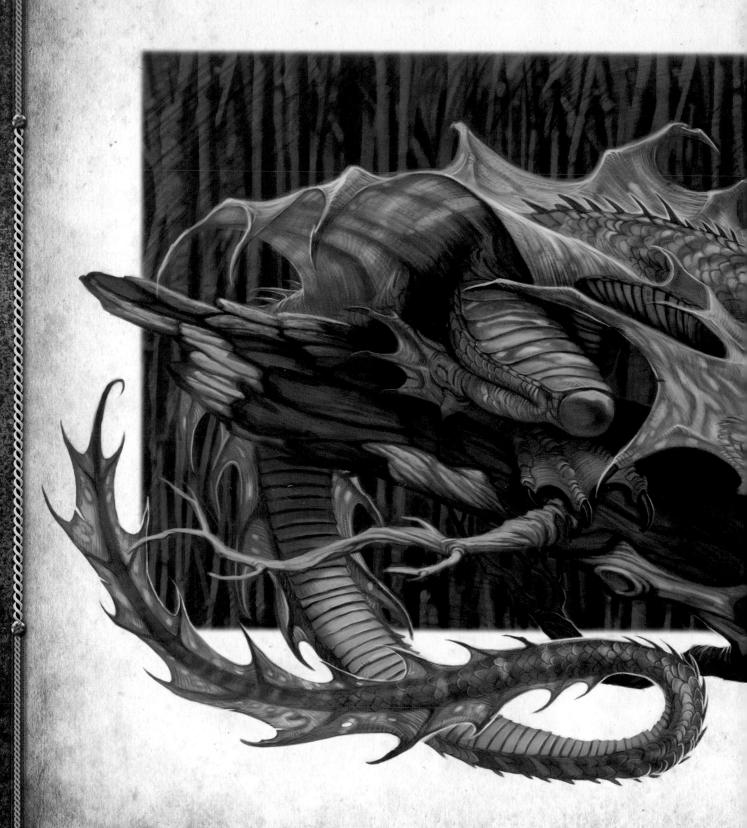

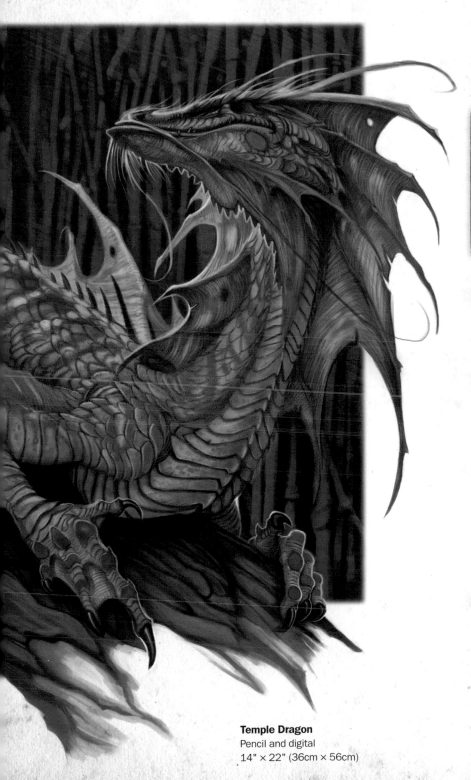

Temple Dragon
Pencil and digital
14" × 22" (36cm × 56cm)

SPECIFICATIONS

Size: 2' to 50' (61cm to 15m)

Wingspan: None*

Recognition: Long, serpentine quadrupedal body, prehensile tail, wing frill, markings and coloration differ by species

Habitat: Temperate to tropical climates, mountains to lowlands, jungles to open plains. Contained to Asia and surrounding islands

Known species: Korean dragon, temple dragon, spirit dragon, imperial dragon, bonsai dragon, jade dragon, Himalayan dragon, Fuji dragon

*Asian dragons are able to glide

BIOLOGY

The Asian dragon family includes a wide variety of long, serpentine, four-legged dragons with prehensile tails. Asian dragons are unique, in that they are in the order of flightless dragons (*Terradracia*) like drakes (see pages 90–99), but are capable of limited flight. The reason for this is because they do not possess dedicated appendages for flight, like dragons and dragonettes; rather, an Asian dragon uses a unique construction of frills along its body to glide short distances through the air.

Asian dragons come in a wide variety of colors, sizes and shapes, and can live, depending on their species, in a wide range of habitats, from mountains in the Tibetan Himalayas, to the jungles of Vietnam, and the islands of the Philippines and into India.

Because of the Asian dragon's similarity to the Arctic dragon (see pages 22–33), many species are often miscategorized. This mistake is understandable since the Asian and Arctic dragon species share some habitats in Asia

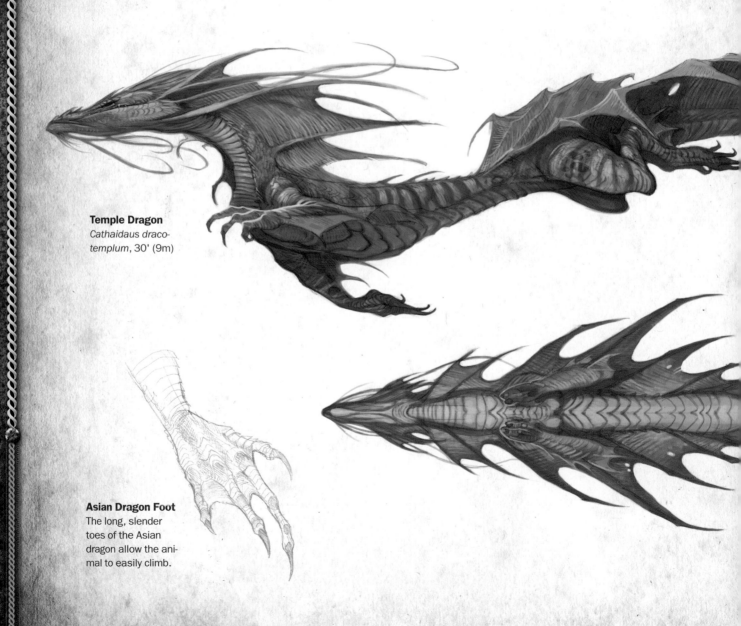

Temple Dragon
Cathaidaus draco-templum, 30' (9m)

Asian Dragon Foot
The long, slender toes of the Asian dragon allow the animal to easily climb.

and are often depicted interchangeably in classical Asian art. The two families are, however, very different. Asian dragons do not grow fur, nor do they live above the arctic circle. Arctic dragons, in turn, do not have the gliding ability of the Asian species, or a prehensile tail.

Asian dragons are omnivores, eating fruits, bamboo and meat, as it is available. In the winter in the northern areas of their range, the Asian dragon will migrate to warmer climates.

Asian Dragon Head
Asian dragons have keen eyesight to give them excellent vision in the dark rain forests of Asia. The long whiskers give additional perception.

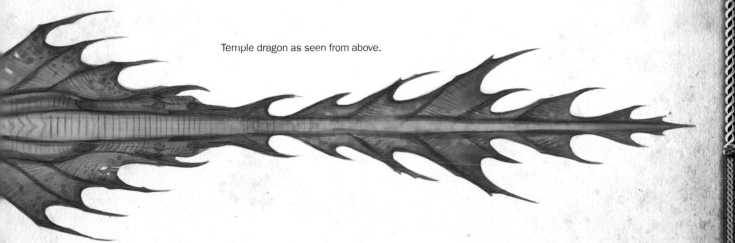

Temple dragon as seen from above.

BEHAVIOR

Although there are a great number of species, the Asian dragon is a solitary and remote creature keeping to uninhabited areas of deep forest. It lives in the jungles of Asia where there is an ample food supply of small animals and fruits to choose from, allowing the Asian dragon to grow up to 50' (15m) in length. The main rival of this predator is the tiger and other large cats. The Asian dragon is an agile and powerful fighter. Its long, serpentine body is able to constrict around an enemy, similar to the wyrm (see pages 136–145). Its four legs are equipped with sharp talons for fighting, it has a jaw full of sharp teeth and a few species even possess the ability to spit a caustic expectorant to frighten enemies. If the Asian dragon was not so reclusive and shy, it would be far more dangerous to humans. As such, there are very few injuries reported due to the Asian dragon.

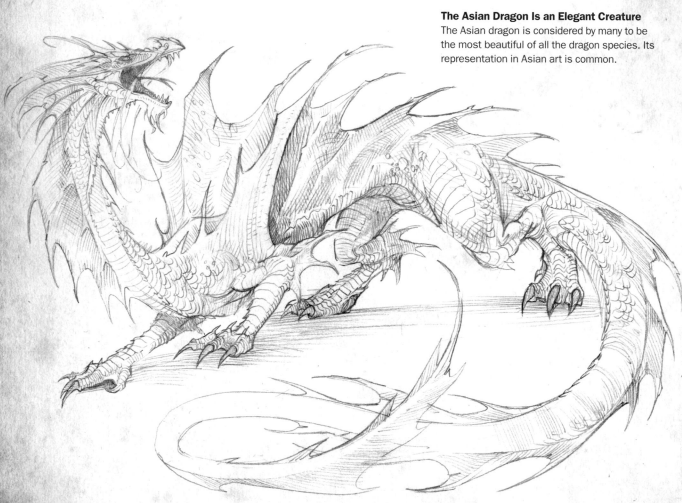

The Asian Dragon Is an Elegant Creature
The Asian dragon is considered by many to be the most beautiful of all the dragon species. Its representation in Asian art is common.

Asian Dragon Egg, 8" (20cm)
The egg of the Asian dragon is revered as a magical object, and is believed to be the source of the myths involving a golden egg.

Asian Dragon Habitat
The dense and remote forests of Asia and India are the natural habitat of the Asian dragon.

HISTORY

A beautiful and elegant creature, the Asian dragon is revered in many eastern countries and is heralded as sacred animals in the Shinto, Hindu and Buddhist religions. The depictions of the Asian dragon in art, architecture, clothing and craft is extensive throughout all Asian countries, and reference in libraries and museums is easily available.

The smaller variants of the Asian dragon, such as the bonsai and temple species, have long been kept and bred in Asian cultures, making traditional companions to emperors and powerful warlords. Today small dragons are still kept as pets, allowing them to be transported to Europe and America.

The Asian dragon is commonly depicted in Continental art. Notice the wing frills in this particular illustration.

DEMONSTRATION
TEMPLE DRAGON

Imagining new dragons is a challenge since so many illustrations have been done throughout history. Try not to copy drawings you have already seen. Instead, develop your own creature using the dragons in this book as an example. There are many real-life animals that live in habitats similar to the Asian dragon and have similar behaviors, so research them when designing a dragon of your own. Consider using:

- A serpentine body
- Iridescent coloring
- Asian jungle environment
- Wing frills

1 Create a Thumbnail Sketch
Plan out your design with thumbnail sketches to be certain that everything you want to include fits into your format. Sometimes you'll need to do several thumbnails before settling on a final design.

2 Complete the Drawing
Begin the final drawing simply, starting with the basic shapes of the dragon. Rough in the details to properly place the dragon on the page, using the thumbnail sketches as a guide. Complete the drawing. I prefer to draw all the scales and the texture of the log. I find this saves time later; however you may wish to save these small details until you're ready to add the finishing touches to the painting.

3 Establish the Underpainting
Create a new layer in Multiply mode and name it "Underpainting." (Work this entire step in the Underpainting layer, for reasons you will see in the next step.) Block in the underpainting using broad, bold strokes to establish the basic silhouette of the dragon and the branch it's resting on. Use colors of gold and orange for your underpainting. These colors lend themselves to creating the Asian dragon's iridescent sheen.

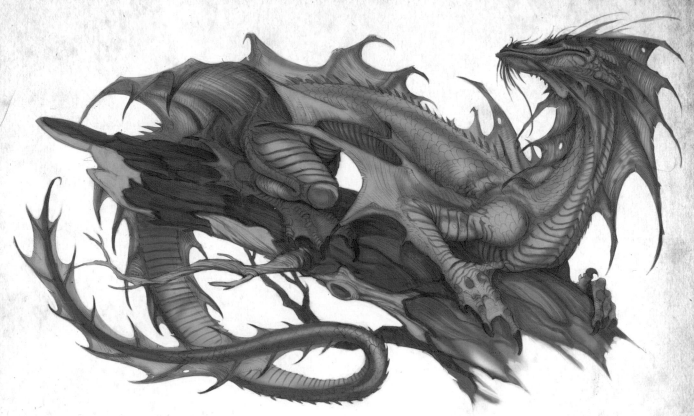

4 Create a Mask for the Dragon's Outline, Then Finish the Underpainting

You should now have the pencil sketch on the background layer, and above that, the underpainting layer in Multiply mode.

At this time, the dragon's outline is fuzzy around the edges. You can use the Eraser tool to clean up the edges or you can make a mask. Referring to "Make a Mask" below, create a layer mask on the Underpainting layer to give the dragon a nice hard-edged outline. (It will be easiest to make the mask now, before any more layers get added).

Continue refining the underpainting, sticking to the same gold/orange monochromatic scheme. (Notice that because of the mask on the underpainting layer, you can paint freely past the edges of the dragon without ruining the smooth silhouette.) Refine the underpainting until you've determined the bulk of the light, shadows and details—that way, you have a map of sorts for light and form, and the rest of the painting will go more smoothly.

MAKING A MASK

Sometimes you want your dragon to have a hard-edged silhouette so that you can "float" him on white or merge him with a background later on. To do this, make a dragon-shaped mask that hides fuzzy edges and unwanted background areas. The mask will also allow you to paint freely past the edges of the dragon without depositing any color in the background.

1. Click the Underpainting layer in the Layers window to make sure it's the active layer.

2. Choose the Magic Wand tool and make sure the Contiguous option is unchecked.

3. Experiment with the Tolerance setting of the Magic Wand until one click of the wand in the white area around the dragon selects the white area plus just a little bit of the dragon's fuzzy edges. If there is white background space "trapped" inside the dragon shape (such as inside a looped tail), using the Magic Wand without the Contiguous option should select those inside spaces as well as the white areas outside the dragon. If you need to add any trapped white spaces to the selection, do so by holding down the Shift key and clicking the Magic Wand on them.

4. Once you have a satisfactory selection, choose Layer menu > Layer Mask > Hide Selection. The background and the fuzzy edge are now hidden, leaving a smoothly silhouetted dragon.

5 Refine the Color

Create a new layer in Normal mode with an opacity setting of 50%. If you created a mask, look in the Layers window, and you'll see a black-and-white thumbnail on the Underpainting layer representing the layer mask you created in Step 4. Hold down the Alt key (Mac: Option key), then drag that mask thumbnail and drop it onto the thumbnail for the new layer. Your dragon mask has now been copied from the Underpainting layer to the new layer. (For the remainder of this demo, repeat this process for each new painting layer you create.)

Using broad brushes, block in the rest of the colors you plan to use in the painting . Settle on the overall color scheme of your painting at this stage; it's easier to make color adjustments now, before more details get added.

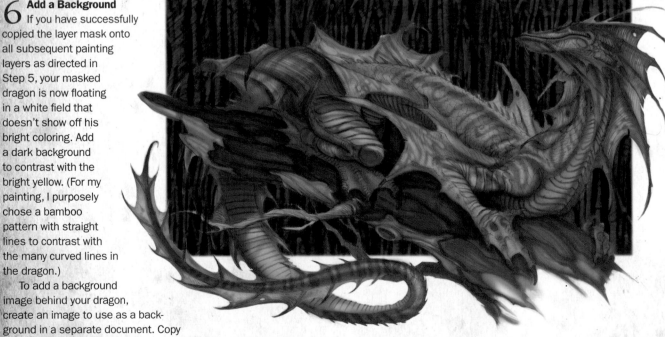

6 Add a Background

If you have successfully copied the layer mask onto all subsequent painting layers as directed in Step 5, your masked dragon is now floating in a white field that doesn't show off his bright coloring. Add a dark background to contrast with the bright yellow. (For my painting, I purposely chose a bamboo pattern with straight lines to contrast with the many curved lines in the dragon.)

To add a background image behind your dragon, create an image to use as a background in a separate document. Copy and paste your background image into the dragon document. It will automatically be placed on a new layer above the other layers. Crop, scale or otherwise manipulate the background image as necessary, then position it where you want it. Now drag this layer downward in the Layers window until it's at the bottom. The dragon is now resting atop the background.

7 Refine the Foreground

Paint the log, using a variety of hard-edged brushes. With the Eyedropper tool, sample the colors from the background and use these colors to inform your color choices on painting the log.

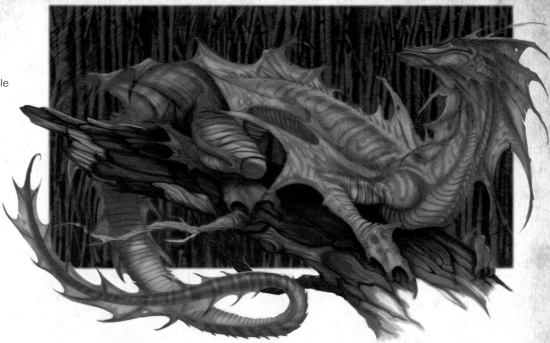

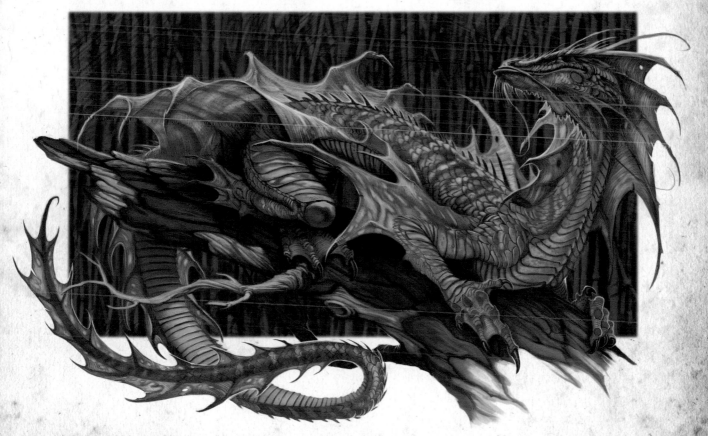

8 Add the Finishing Touches

Refine the tail and the log using detail brushes and opaque colors. Continue the detail work in the foreground until you're satisfied with the painting. Patience is key.

BASILISK

Draco lapisoculidae

SPECIFICATIONS

Size: 1' to 12' (31cm to 4m)

Wingspan: None

Recognition: Multi-limbed reptilian body. Broad, bright markings vary by species

Habitat: Deserts and volcanic craters

Genuses: *Draco lapisoculidae* (stone-eye dragon), *Draco vulcanilacertidae* (fire-god lizard)

Known species: Sahara basilisk, Sonora basilisk, Gobi basilisk, salamander basilisk, strzelecki basilisk, thar basilisk

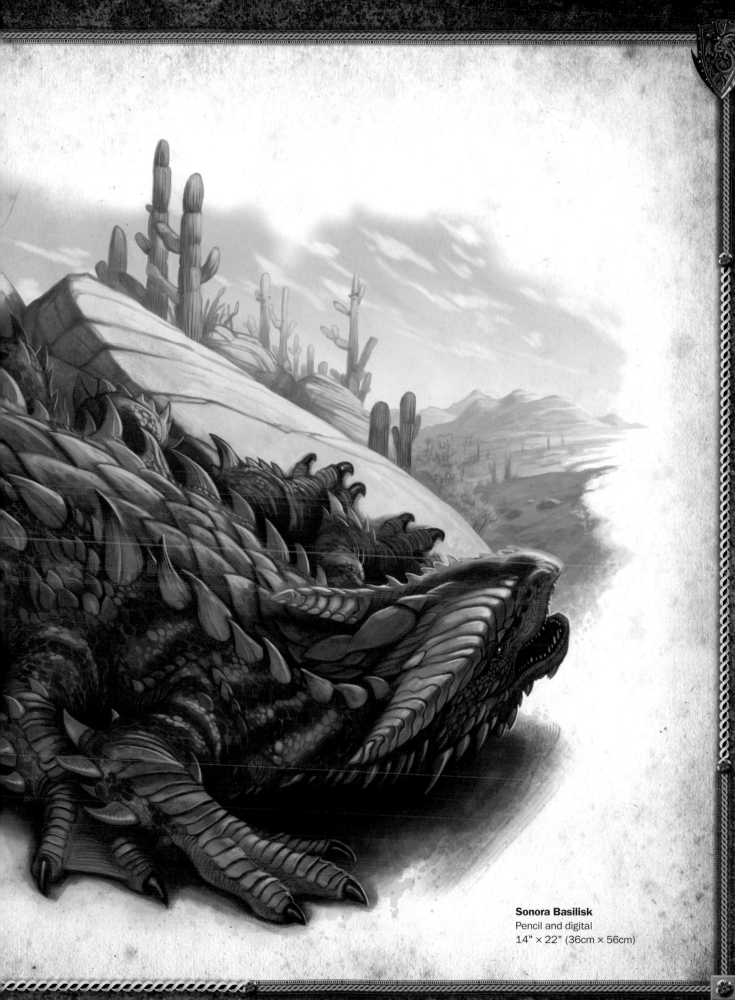

Sonora Basilisk
Pencil and digital
14" × 22" (36cm × 56cm)

BIOLOGY

The basilisk is a member of the *Terradracia* order, or flightless dragons. A multi-limbed reptilian beast of about 10 feet (3m) that's famous for its ability to petrify anyone who gazes into its eyes. This magical power has been much dramatized in literature and mythology over the centuries, but actually, it is not the animal's gaze that petrifies, nor is there any magic involved. The basilisk is able to shoot a jet of neurotoxin from a gland in the corner of its eyes (not unlike the horned toad of North America). This toxin has the ability to paralyze the basilisk's prey, rendering it defenseless.

The salamander basilisk is contained within the genus *Vulcanilacertidus*. It's a small basilisk, usually not exceeding 1 foot (31cm) in length and commonly lives in environments of extreme heat such as volcanoes. With modern technology it has been possible to explore the salamander's habitat. We now understand that a salamander basilisk can withstand temperatures up to 800° F (427°C). It is believed that these temperatures allow the creature to live in environments where predators are unable to enter, leaving the salamander basilisk in relative safety. It scavenges for food that has died in the harsh environment. When wandering into human habitations, the salamander basilisk will move into the campfires and stoves of people, and scavenge off the remains of the grill. Species include the Fuji salamander, Aetna salamander, Kilauea salamander and the Vesuvious salamander.

The dragon species of basilisk are not to be confused with the South American species of lizards within the family Basilicus. These small reptiles are related to the iguana in the order of Reptilia.

Basilisk Feet
The basilisk has four sets of powerful, broad feet that allow it to quickly burrow in the sandy soil of its habitat. It's been documented that it can excavate up to 3 cubic feet (85L) of soil a minute, creating elaborate lairs and tunnels under the desert.

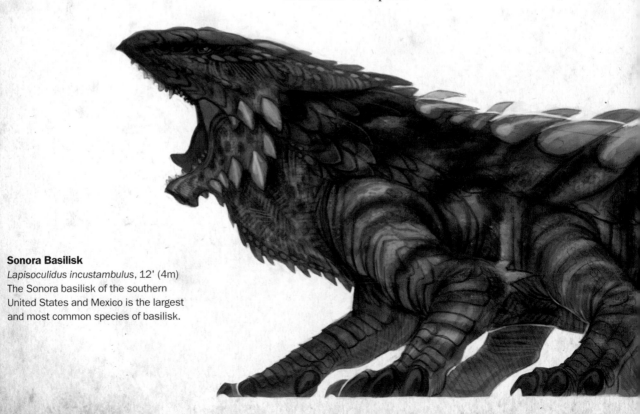

Sonora Basilisk
Lapisoculidus incustambulus, 12' (4m)
The Sonora basilisk of the southern United States and Mexico is the largest and most common species of basilisk.

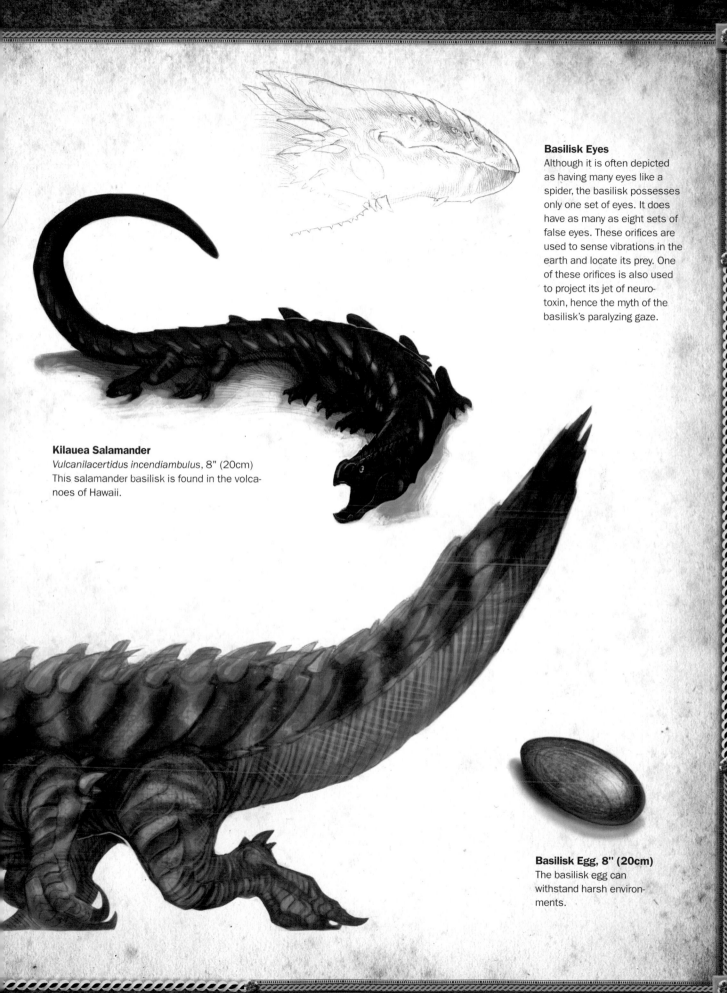

Basilisk Eyes
Although it is often depicted as having many eyes like a spider, the basilisk possesses only one set of eyes. It does have as many as eight sets of false eyes. These orifices are used to sense vibrations in the earth and locate its prey. One of these orifices is also used to project its jet of neurotoxin, hence the myth of the basilisk's paralyzing gaze.

Kilauea Salamander
Vulcanilacertidus incendiambulus, 8" (20cm)
This salamander basilisk is found in the volcanoes of Hawaii.

Basilisk Egg, 8" (20cm)
The basilisk egg can withstand harsh environments.

Behavior

Because of its multiple limbs, the basilisk is a lumbering and slow-moving animal. The legs allow for adept burrowing of its underground lairs, where it is able to lie in wait to ambush its prey with its paralyzing attack. These underground burrows also allow the basilisk to withstand the harsh temperatures of its environment. Despite the legends of its famous gaze, the basilisk has terrible eyesight and is practically blind. Lying in wait for its prey usually during the cool night when animals are more active in the desert, the basilisk senses its prey with its sensitive nasal orifices.

The bite of the basilisk is also dangerous, containing the same neurotoxins from the eye glands. This highly poisonous and dangerous animal is brightly colored in broad stripes, indicating itself to larger predators as poisonous. The heavy armor further protects the basilisk from enemies. The basilisk is a solitary creature. The female basilisk can lay up to six eggs at a time with an average life span of twenty years.

A common sight in the American Southwest. This sign warns people of basilisks in the area.

The Basilisk Can Sense Its Prey's Movement
Lying in wait for its prey, the basilisk can sense movement in the soil up to 328' (100m). Extreme caution must be taken while hiking in the desert.

Basilisk Habitat
Basilisks can be found in caves and outcroppings in desert regions from Southern California and Texas to Central America, as well as deserts around the world.

HISTORY

Being a creature from the remote deserts of Arabia and Africa, classical and medieval European reports of the creature are sporadic and unreliable. Bestiaries of this time relate the basilisk to the cockatrice (see pages 18–19); this mistake is even made in accounts as recently as the early twentieth century.

The basilisk's habitat was once a remote and inhospitable land. Now with the intrusion of humans upon the desert landscape, attacks from basilisks have become more common. Along the border between the United States and Mexico in Big Bend National Park, Texas, there are nearly 100 reported fatalities a year from basilisk attack. Park rangers assert that the number is probably much higher since attacks in the back country usually go unreported.

Throughout history, basilisks have been depicted in an array of forms. This image shows a basilisk with crablike legs, since the artist's only reference was probably crustaceans or insects.

SONORA BASILISK

There are many aspects to the basilisk that make it unique within the *Dracopedia*. When designing a full scale painting of such an exotic creature, it is important to try to include all of the elements that define it. When starting a painting, revisit the designs you have developed, along with your notes and reference and begin with a list of all the things that the image should include. This way you can be sure not to leave anything out such as:

- Multiple legs
- Desert landscape
- Spined armor
- Bright markings

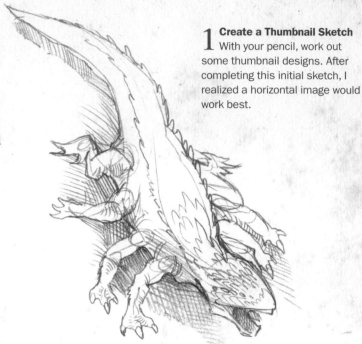

1 Create a Thumbnail Sketch
With your pencil, work out some thumbnail designs. After completing this initial sketch, I realized a horizontal image would work best.

Artist's Note

To design a desert dragon like the basilisk, there is a lot of inspirational reference that is available. Looking at the horned lizards of America, as well as Gila monsters, and even armadillos and armored dinosaurs, it becomes apparent that some designs are common to all desert creatures. Food is so scarce in this harsh climate and competition so intense that most animals develop bizarre armor to fend off predators. Visit the library and even your pet store to see some of the amazing creatures that have evolved. Study how they live and survive when developing your own creations.

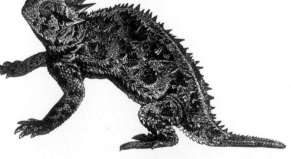

Some reference of horned lizards used to develop the Sonora basilisk.

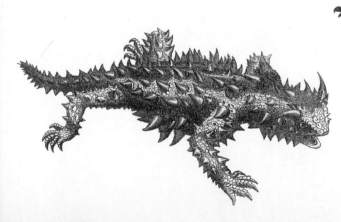

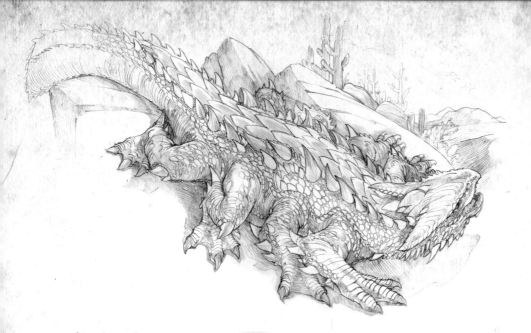

2 Create a Final Drawing

Working from your concept sketches, references and notes, work out a detailed final drawing for the painting. Work as large as possible, as this will allow for the necessary details to be rendered.

In this drawing notice that the angle of this view is slightly from above. This allows the drawing to show the eight legs.

3 Establish the Underpainting

Create a new layer in Multiply mode and do the underpainting, using a warm golden palette to emulate the glow from the hot desert sun. The underpainting is the most important step of the painting process. It establishes the lighting, texture and mass of the image. Be as loose as you wish at this stage since most of this work will be painted over. Use a variety of brushes, and feel free to make a mess.

4 Complete the Underpainting

Finish the underpainting by darkening the areas in shadow, using your finished drawing as a guide.

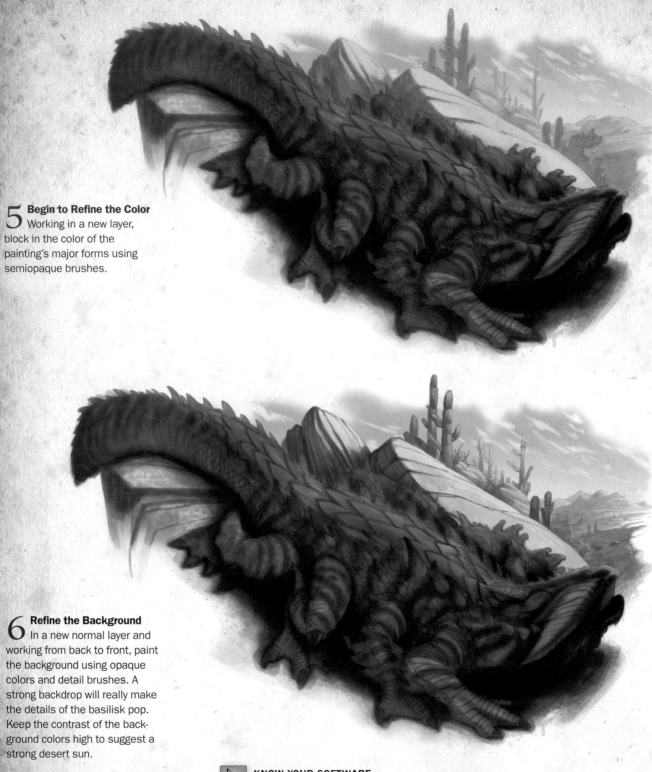

5 Begin to Refine the Color
Working in a new layer, block in the color of the painting's major forms using semiopaque brushes.

6 Refine the Background
In a new normal layer and working from back to front, paint the background using opaque colors and detail brushes. A strong backdrop will really make the details of the basilisk pop. Keep the contrast of the background colors high to suggest a strong desert sun.

KNOW YOUR SOFTWARE
It pays to become well acquainted with all the painting tools and options your software offers. For example, Photoshop users should be sure to open the brush preset menu (choose Window menu > Brushes, then click the small triangle button) and look into the many other brush sets that are available beyond the default set.

Another great feature of Photoshop is that all of your custom brush profiles can also be used with other tools such as Eraser, Dodge, Burn, Smudge and the Stamp tools.

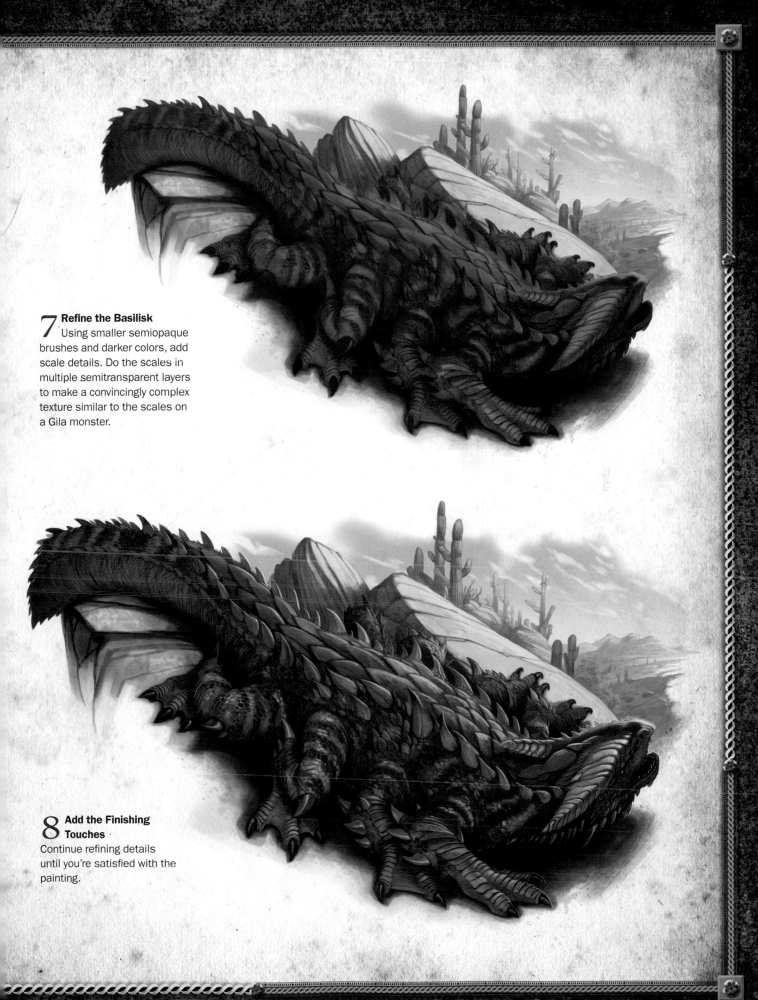

7 Refine the Basilisk

Using smaller semiopaque brushes and darker colors, add scale details. Do the scales in multiple semitransparent layers to make a convincingly complex texture similar to the scales on a Gila monster.

8 Add the Finishing Touches

Continue refining details until you're satisfied with the painting.

COATYL

Draco quetzalcoatylidae

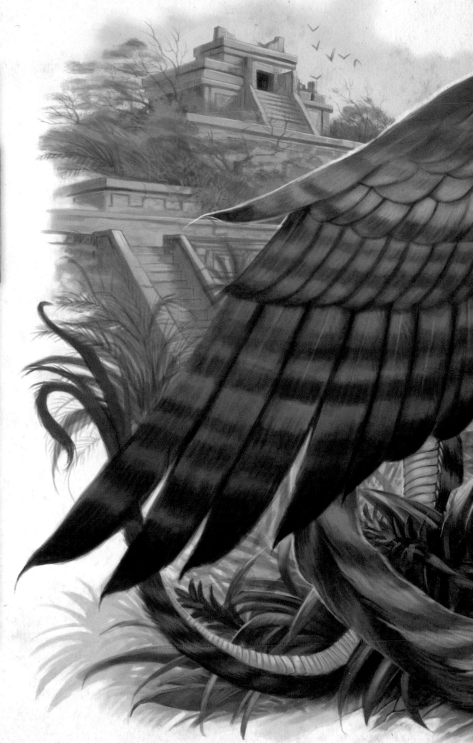

SPECIFICATIONS

Size: 6' to 10' (183cm to 3m)

Wingspan: 8' to 12' (244cm to 4m)

Recognition: Snake body with brightly colored feather wings

Habitat: Tropical jungles, desert oases, ancient ruins

Species: Aztec coatyl, phoenix, Egyptian coatyl, Egyptian serpent, *hai riyo*

Also known as: Coatl, dragon bird

Pronunciation: /kwä·tǝl/

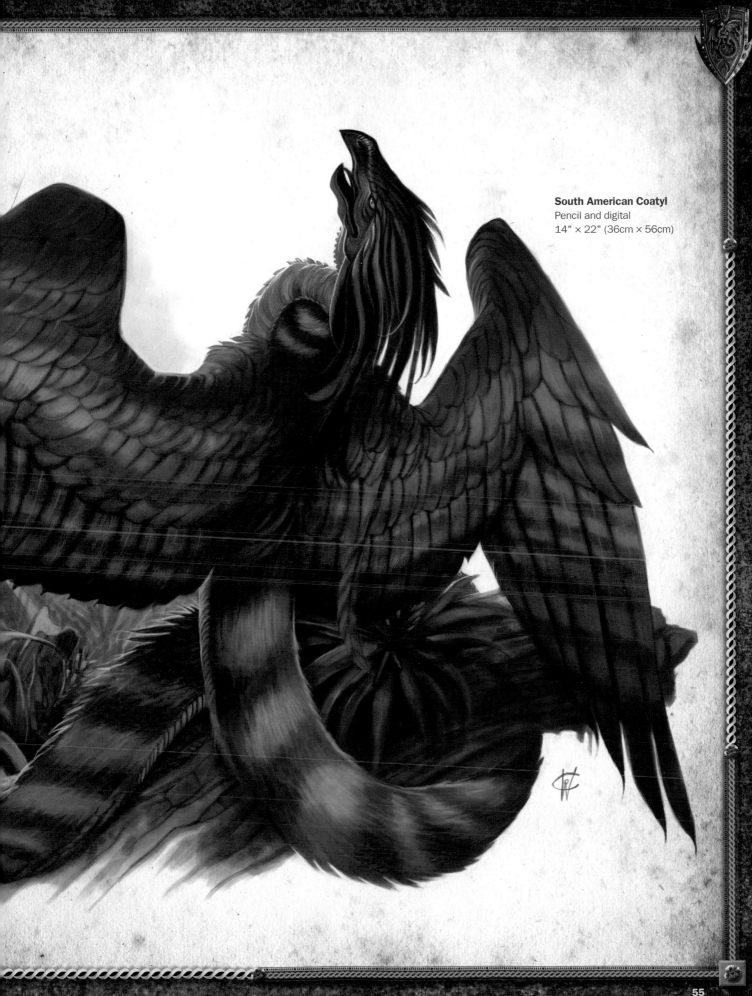

South American Coatyl
Pencil and digital
14" × 22" (36cm × 56cm)

BIOLOGY

The coatyl is of the order of feathered dragon (*Pennadraciformes*). Long believed to be a purely mythological creature, the coatyl is revered as a holy animal to the native people of its habitats. The coatyl family is one of the smallest in the *Dragonia* class, consisting of only a few of the feathered, limbless dragons.

The South American coatyl has a large 6' (183cm) serpentine body that's surmounted by 8' (244cm) colorful wings. It makes its habitat in the ancient ruins and jungles of the South American continent.

The Egyptian coatyl or serpent also lives in and around the ancient ruins of Giza and has four brightly colored gold and turquoise wings.

The phoenix, which makes its habitat in the monuments and temples of Persia and Mesopotamia, is bright crimson with breathtaking ruby feathers. The eggs of the phoenix are unique in that they have a very thick shell to protect the chicks from the desert heat and predators. This shell is also impenetrable to the baby phoenix. The heat of fire, however, cracks the shell open, releasing the newborn phoenix,

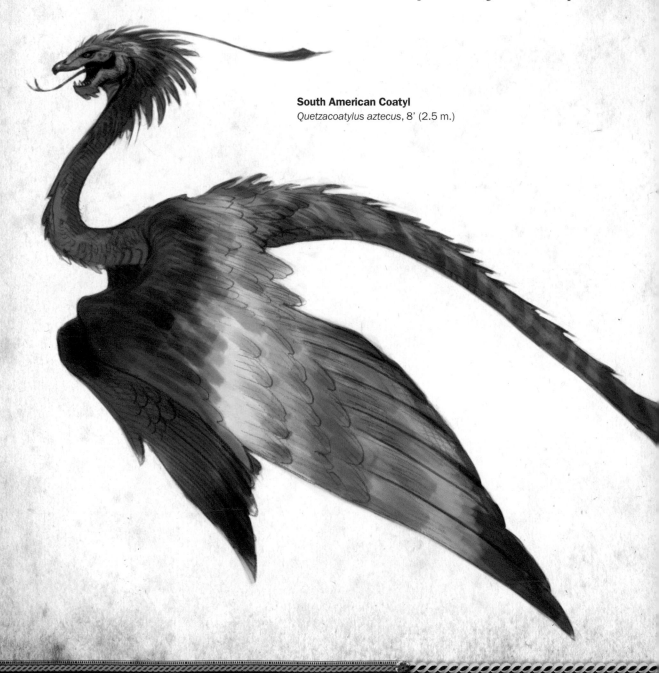

South American Coatyl
Quetzacoatylus aztecus, 8' (2.5 m.)

as if it was born out of the flames. The parent phoenix may refuse to leave the nest, becoming consumed in the fire. Because of this dangerous birthing technique, the phoenix is extremely rare, and some believe extinct.

Coatyl Feather
Ancient kings were known to decorate their crowns with these rare feathers. Today, the trading of coatyl feathers is illegal.

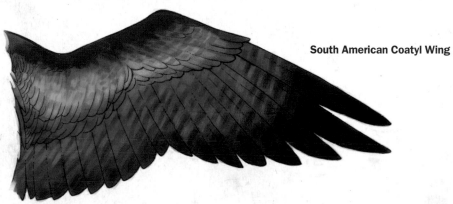

South American Coatyl Wing

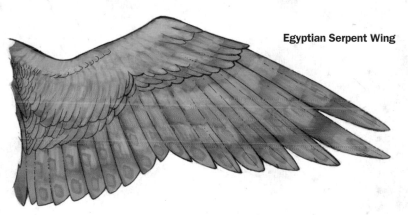

Egyptian Serpent Wing

Phoenix Wing

Behavior

Since it makes its nests in the rocky overhangs and crevices of ancient Aztec and Inca ruins from Belize to Peru, the coatyl is said to have a magical relationship with the peoples of Central and South America. Now biologists understand that the various coatyl species actually live in a symbiotic relationship with humans. Humans feed and protect the coatyl, revering it as a spiritual animal while the species, in turn, keep out vermin.

Only the male coatyl possesses the colorful feathered wings that have become so prized by poachers over the centuries and have led to their decline in numbers. The coatyl only lays one egg at a time, and the average life span is fifty years.

The habits of the phoenix and the Egyptian serpent are similar in that they live in the ancient stone temples of the Middle East. The millennia-old symbiotic relationship with humans is unique, but centuries of war and development have destroyed the coatyl's ancient habitats, leading to the near extinction of the coatyl species.

Coatyl Habitat
The South American coatyl makes it habitat in the deep South American jungles. This seclusion has allowed for the relative saftey of the species.

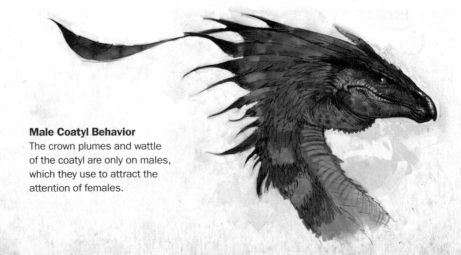

Male Coatyl Behavior
The crown plumes and wattle of the coatyl are only on males, which they use to attract the attention of females.

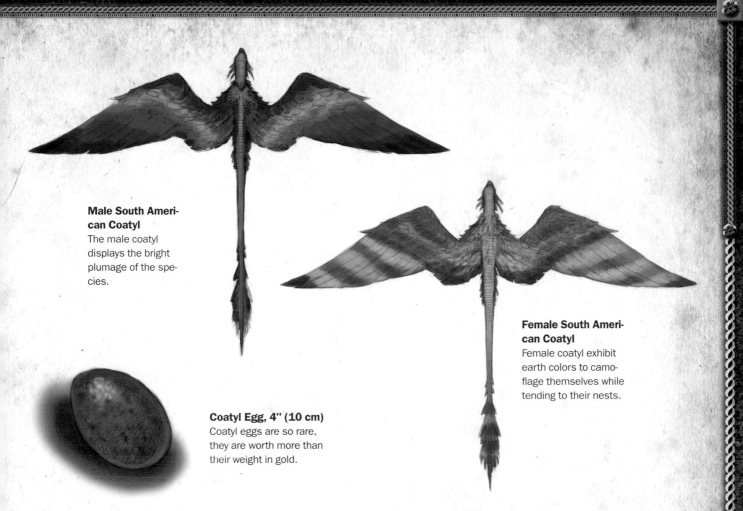

Male South American Coatyl
The male coatyl displays the bright plumage of the species.

Female South American Coatyl
Female coatyl exhibit earth colors to camoflage themselves while tending to their nests.

Coatyl Egg, 4" (10 cm)
Coatyl eggs are so rare, they are worth more than their weight in gold.

HISTORY

For millennia, the coatyl was always considered to be a mythological creature. First discovered by Spanish conquistador Diego Velázquez de Cuéllar in 1513, the last South American coatyl in captivity died in 1979 at the Lima Zoo. The coatyl is believed by many Aztecan religions to be the earthly embodiment of the god Quetzalcoatyl, which is the root of the family's Latin name. The coatyl also refers to the massive Late Cretaceous pterosaur, *quetzalcoatlus*, discovered in Texas in 1971.

Once populating the kingdoms of the Aztec and Inca people in vast numbers, the introduction of European animals and diseases in the sixteenth century decimated the species, along with the magnificent culture they inhabited.

Egyptian Serpent
The phoenix and Egyptian serpent are also extremely rare with the last phoenix reportedly being sighted in 1991 in Iraq. Today the International Coatyl Fund (ICF) works to return this ancient creature to its former glory.

SOUTH AMERICAN COATYL

As you begin to work out the design for a painting of the coatyl, collect your references, concept drawings and notes. These will help you develop a strong idea of what your dragon is going to look like. Think carefully about what aspects of the coatyl make it unique and interesting and then be sure to include those elements in your painting. Some typcial coatyl features are:

- Colorful, feathered wings
- Jungle habitat
- Serpentine body
- Avian features

For the background and foreground details, I used reference materials on bromeliad flowers, jungle plants and South American ruins from the library to accurately depict these features.

1 Create a Preliminary Sketch
With a pencil, sketch out several possible positions for the coatyl to be sure your design is complete. Here, I've decided to show the coatyl from behind with its wings extended to best illustrate its beautiful plumage.

2 Create the Finished Drawing
With an HB pencil, render the full-size drawing, using all of your references for additional details and inspiration. I used photos of Aztec ruins and tropical flowers for ideas about the coatyl's setting.

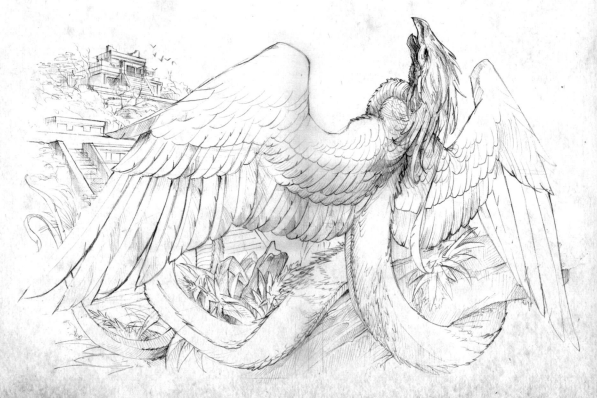

3 Establish the Underpainting

Paint in the basic forms of the image using broad strokes and simple colors to establish the underpainting.

4 Complete the Underpainting

Continue the underpainting, keeping the monochromatic color scheme, until all of the elements have been sufficiently rendered.

A WORD ABOUT COLOR MODE, GAMUT AND CREATING ARTWORK FOR PRINT
I recommend that you work in RGB color mode. RGB stands for red, green, and blue, the three colors of light that combine to produce all the other colors on television and computer screens.

Digital images generally start out in RGB mode and are converted to CMYK mode for printing. If you expect or aspire to see your work in print, be aware that the RGB gamut or color space is larger than the CMYK gamut, meaning some RGB colors can't be reproduced in CMYK. Watch for the Color Picker's "out of gamut for printing" icon, which looks like a black exclamation point inside a gray triangle. When that icon appears, the chosen color won't be as vivid if converted to CMYK. Click the little box underneath the warning icon, and the nearest printable color will be selected for you.

5 Refine the Colors

Create a new layer in Normal mode with an opacity of 50%. Using the thumbnail sketches from your concept designs as a guide, block in the basic colors over the underpainting. Use semiopaque, broad flat brushes.

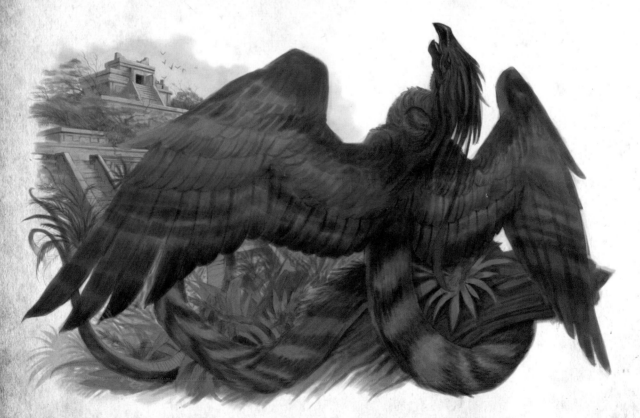

6 Refine the Background

Starting with the background, apply colors that are more opaque from those used in Step 5. Use detailed brushes to render the setting as a backdrop for the coatyl. Keep the colors and contrasts low. This will allow the bright colors and deep shadows you will develop on the coatyl to stand out.

7 Punch Up the Contrasts

Create a new layer in Normal mode with an opacity of 100%, and, moving forward from the background, paint the log and the bromeliad flowers. The bright red petals of the plant give a visual "pop" that separates foreground from background.

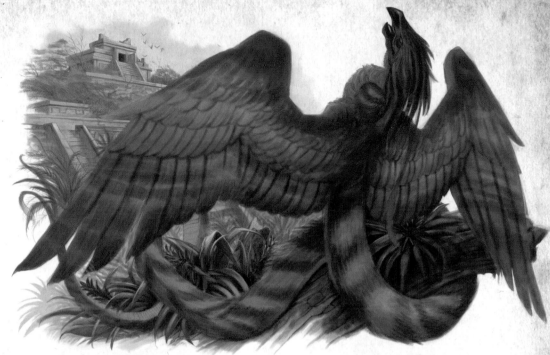

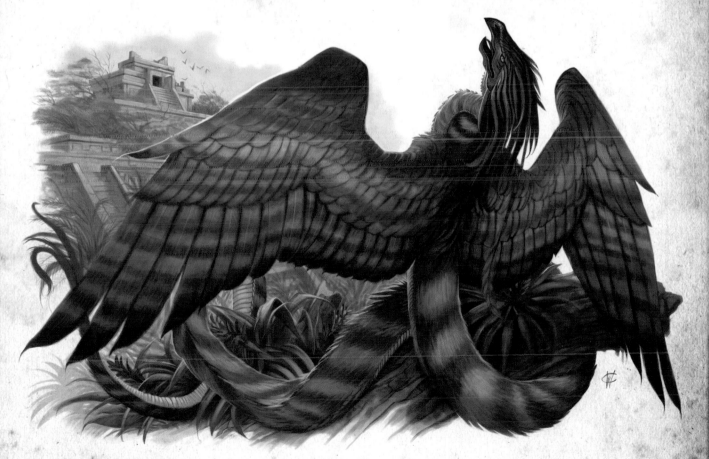

8 Add the Final Touches

Working with 100% opaque brushes, punch up the colors, darken the shadows and sharpen the edges. Use detail brushes to finish the painting. The sharp detail and vibrant color makes this coatyl eye-catching.

DRAGON

Draco dracorexidae

Size: 75' to 100' (25m to 31m)

Wingspan: 100' (31m)

Recognition: Quadrupedal serpentine body, large bat-like wings. Colors, markings and crests vary by species

Species: American Acadian green dragon, great Icelandic white dragon, Ligurian black dragon, great Welsh red dragon, great Norwegian blue dragon, great Chinese gold (yellow) dragon, Elwha brown dragon

Habitat: Temperate to subtropical climate. Maritime locales

Also known as: Great dragons, true dragons

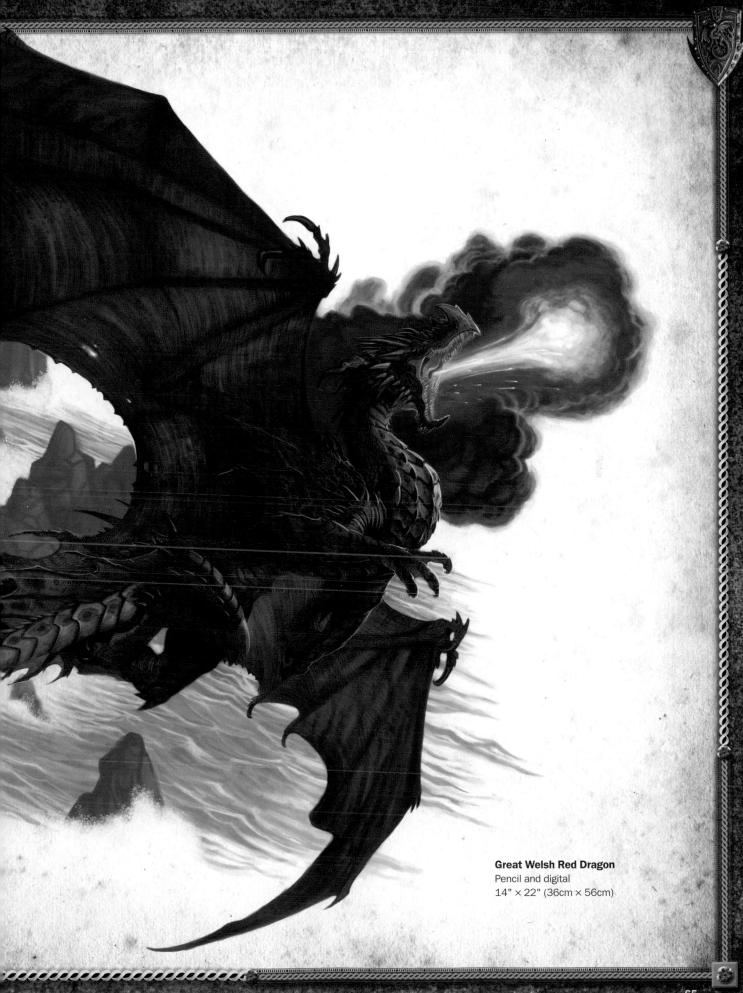

Great Welsh Red Dragon
Pencil and digital
14" × 22" (36cm × 56cm)

BIOLOGY

The dragon is by far the most feared and famous creature in the history of the world, even though it is one of the rarest (second only to the coatyl, see page 54). With 100' (31m) wingspans and the ability to "breathe" fire, it is the largest and most powerful terrestrial animal that has ever lived. The dragons come in a wide variety of species and range all over the world, from the rocky shores of the Pacific Northwest to the Mediterranean Sea. Revered by every culture and in every region, today there are few surviving specimens. The bright colors of each species are more pronounced in the males than the females.

Although there are many species of the dragon, the most famous is the Welsh red dragon. Consisting of a large quadrupedal body, a long tail, a serpentine neck, scaled armor, surmounted by massive bat-like leather wings, highly intelligent, and able to breathe fire, the dragon is the most enigmatic and fascinating creature alive. Although dragons are unable to speak, they have a long and revered relationship with the people of their territory.

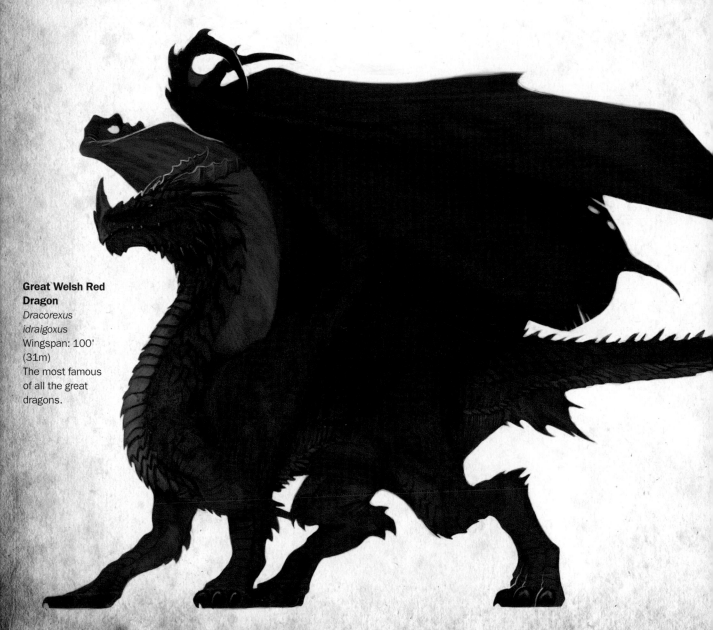

Great Welsh Red Dragon
Dracorexus idraigoxus
Wingspan: 100' (31m)
The most famous of all the great dragons.

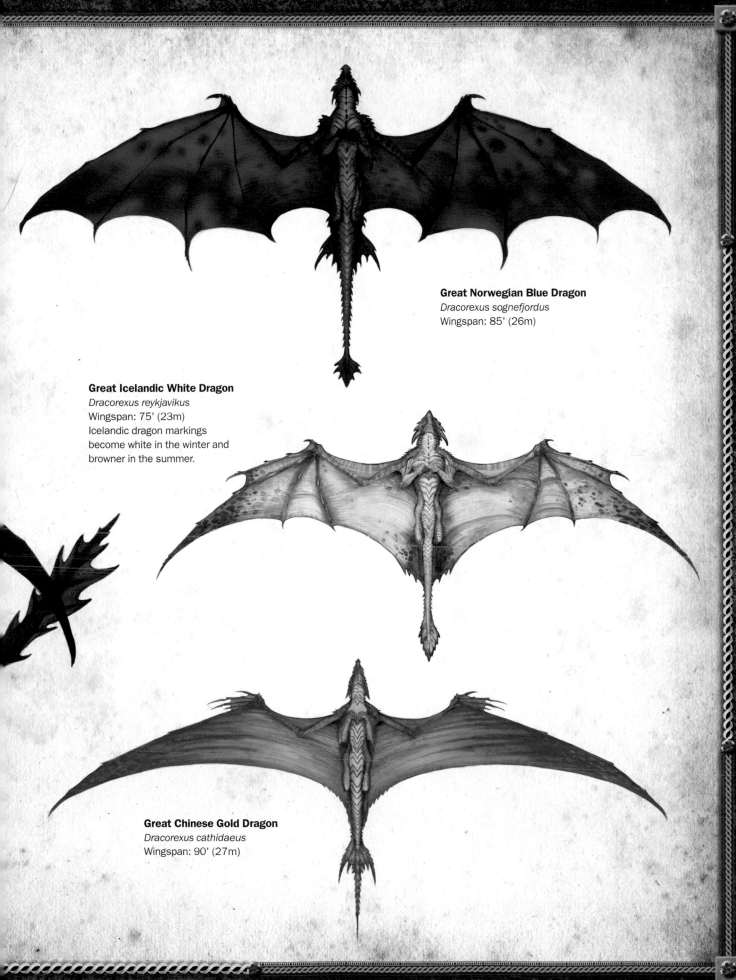

Great Norwegian Blue Dragon
Dracorexus sognefjordus
Wingspan: 85' (26m)

Great Icelandic White Dragon
Dracorexus reykjavikus
Wingspan: 75' (23m)
Icelandic dragon markings
become white in the winter and
browner in the summer.

Great Chinese Gold Dragon
Dracorexus cathidaeus
Wingspan: 90' (27m)

DRAGON ANATOMY

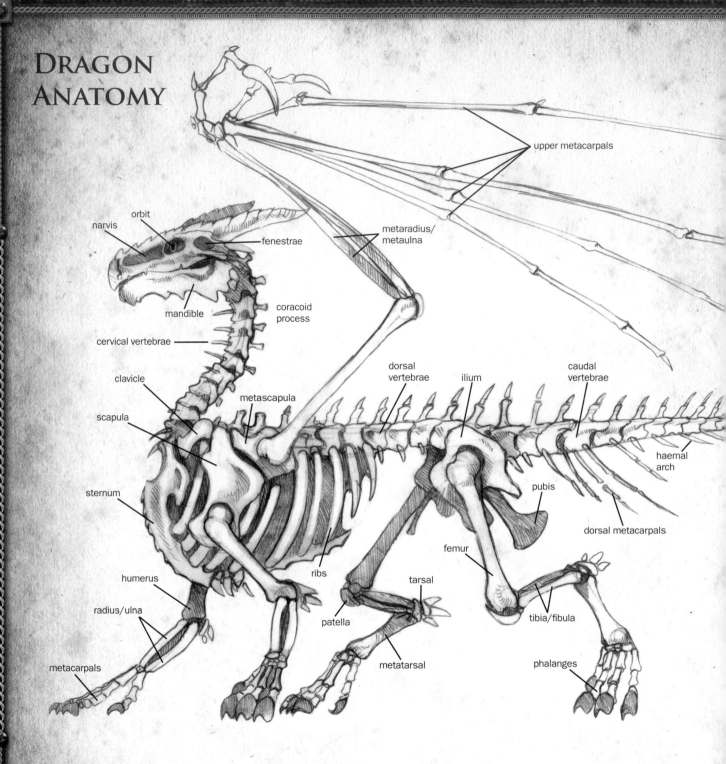

upper metacarpals

orbit

narvis

fenestrae

metaradius/
metaulna

mandible

coracoid
process

cervical vertebrae

dorsal
vertebrae

ilium

caudal
vertebrae

clavicle

metascapula

scapula

haemal
arch

sternum

pubis

dorsal metacarpals

femur

ribs

tarsal

humerus

patella

tibia/fibula

radius/ulna

metatarsal

phalanges

metacarpals

Skeleton of Great Red Welsh Dragon

Hollow bones like those of a bird are common to all dragon species. This reduces their weight by thirty percent, aiding in flight.

It is believed that Leonardo da Vinci's extensive sketches of wing designs are based on those of the great dragon.

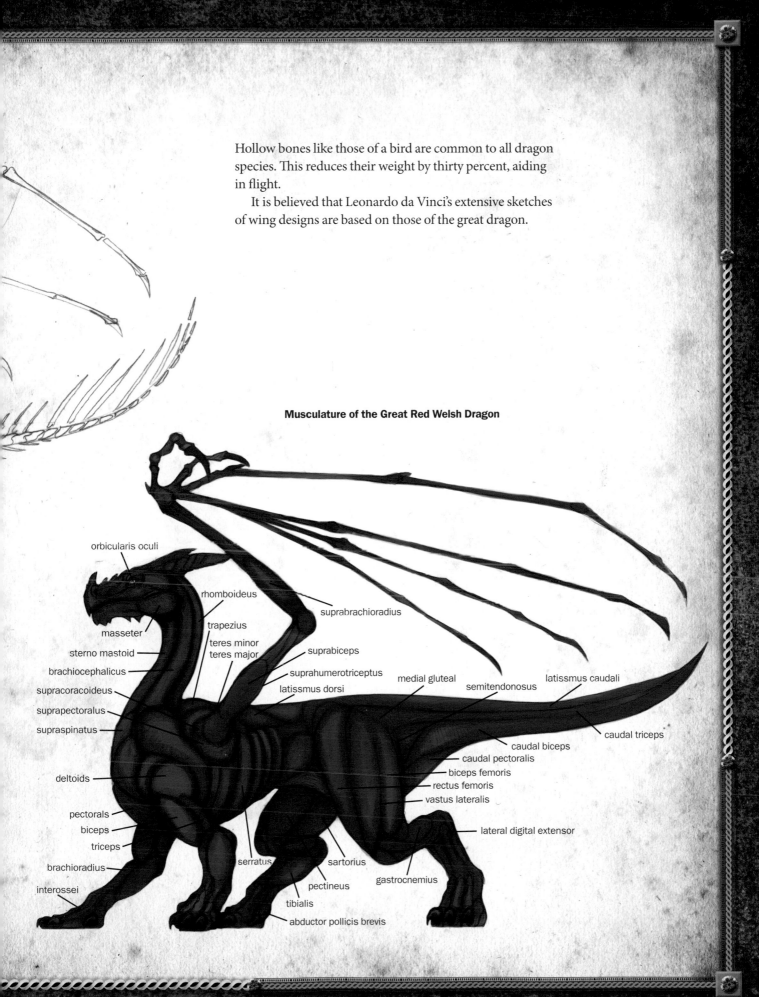

Musculature of the Great Red Welsh Dragon

orbicularis oculi

rhomboideus

suprabrachioradius

masseter

trapezius

teres minor
teres major

suprabiceps

sterno mastoid

brachiocephalicus

suprahumerotriceptus

medial gluteal

latissmus caudali

supracoracoideus

latissmus dorsi

semitendonosus

suprapectoralus

supraspinatus

caudal triceps

caudal biceps

caudal pectoralis

deltoids

biceps femoris

rectus femoris

vastus lateralis

pectorals

biceps

lateral digital extensor

triceps

brachioradius

serratus

sartorius

interossei

pectineus

gastrocnemius

tibialis

abductor pollicis brevis

BEHAVIOR

Dragons are highly territorial and antisocial, even to other dragons. They prefer high cliffs and rocky outcroppings, making their homes along tall palisades overlooking the sea. These lofty and remote vantage points allow for clear observation of their territory, safety from enemies and the ability to take flight. The seaside also allows the dragon to feed from the ocean, snatching tuna, porpoises and even small whales from the water, and then bring it back to its lair. Despite their massive size, dragons do not range very far from their lairs and only move if the food near their lairs disappears, or if they are threatened by human encroachment.

Human-dragon interaction is actually quite rare, since they do not usually share the same territory. The only natural enemies to the dragon are humans and wyverns. Once reaching adulthood, a dragon will leave its mother's lair and find its own nest. Here the male dragon will begin to prepare for a female. Collecting shiny objects to line the nest, the male dragon will attract a female using calls and fire displays. Once the eggs are laid, the male dragon will leave the lair to find new territory, leaving his land and home to his offspring. Dragons can lay up to as many as four eggs at a time and can live in excess of five hundred years. They are also capable of hibernating for long periods of time. Waking a sleeping dragon is not recommended.

American Acadian Green Dragon
Dracorexius acadius
Acadia National Park in Maine is now home of the nature preserve that protects the green dragon.

It is believed that the ancient American Acadian green dragon, Mowhak, was alive before the American Revolution.

Dragon Habitat
Supplying abundant quantities of food, constant strong winds and seclusion, the seaside cliffs of the world are the natural habitats of the dragon.

HISTORY

In recent history, the relationship between humans and dragons have been almost symbiotic, with much care being given to the needs of dragons. Human sacrifices were once regarded as necessary, but that

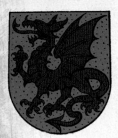

practice has all but been abandoned in the western world, and actual accounts of human deaths by dragon attack are extremely rare. The oldest and most ancient dragon on record is the venerable Tong Long Huo, the ancient gold dragon of China, who is reputed to be over five hundred years old.

The Dragon Is a Common Symbol
The dragon is a common beast of heraldry, symbolizing power, strength and majesty. King Arthur of Camelot used a red dragon as his standard. Henry V and Edward I of England also bore dragon banners.

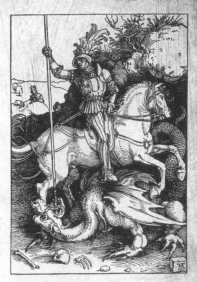

Dragon Depections Vary
The vast majority of people never had seen a dragon and their renderings are based on secondhand accounts and hearsay.

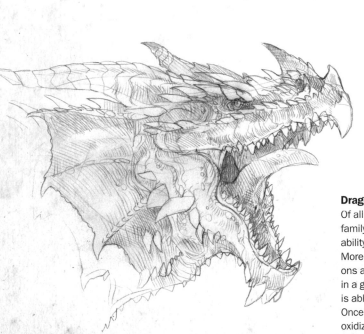

Red Welsh Dragon Egg, 16" (41cm)
Finding unattended red dragon eggs are extremely rare.

Dragon Fire
Of all the dragon species only the *Dracorexus* family is able to "breathe" fire. The dragon's ability to breathe fire is actually a misnomer. More accurately, the dragon spits fire. Dragons are able to secrete a highly volatile liquid in a gland behind the mandible. The dragon is able to spit this liquid up to 100' (31m). Once in contact with oxygen, the liquid quickly oxidizes and bursts into flame. This attack is only possible about once a day, and usually as a last resort defense, allowing the dragon to escape a dangerous situation.

GREAT WELSH RED DRAGON

Gather up as much reference as you can for your painting before you begin. Make a list of each of the elements you want to include:
- Massive wingspan
- Maritime habitat
- Breathing fire
- Coloration and markings
- Body design and wing anatomy

I have always envisioned dragons as animals that could fly. Use references of large birds like the albatros to conceptualize how they would look while flying.

1 Sketch the Composition
Plan your painting with a series of rough thumbnail sketches. I settled on a view from the side and slightly underneath to show off this dragon's muscular body as well as its fire-spitting ability.

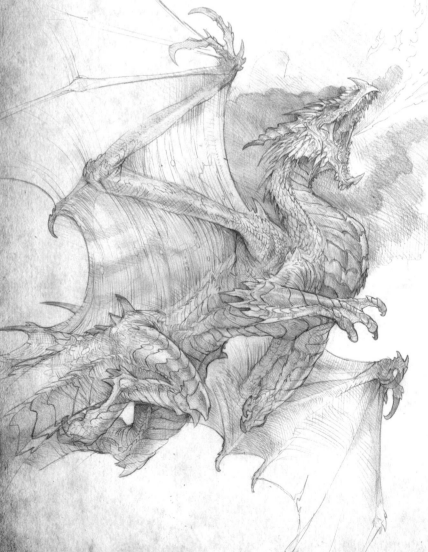

2 Complete a Detailed Drawing
Do a detailed final drawing with an HB pencil on bristol board. As you work, pay attention to how each element works with the overall anatomy, and strive for a natural look. Using reference photos of other animals, such as bats and birds such as herons, may help you with both inspiration and accuracy.

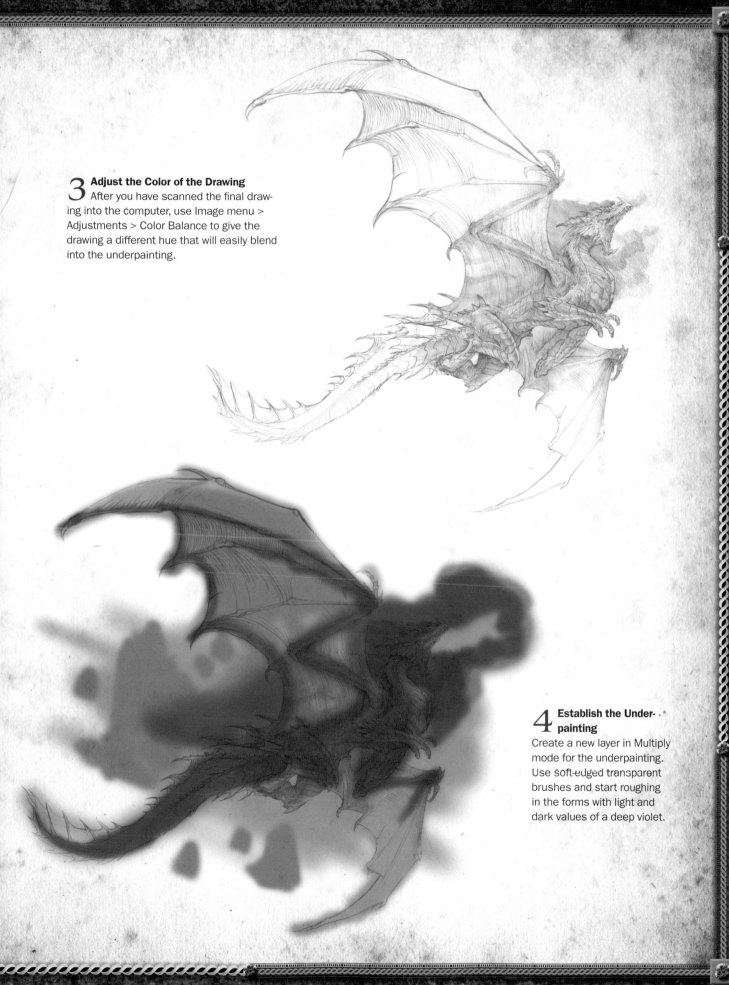

3 Adjust the Color of the Drawing
After you have scanned the final drawing into the computer, use Image menu > Adjustments > Color Balance to give the drawing a different hue that will easily blend into the underpainting.

4 Establish the Underpainting
Create a new layer in Multiply mode for the underpainting. Use soft-edged transparent brushes and start roughing in the forms with light and dark values of a deep violet.

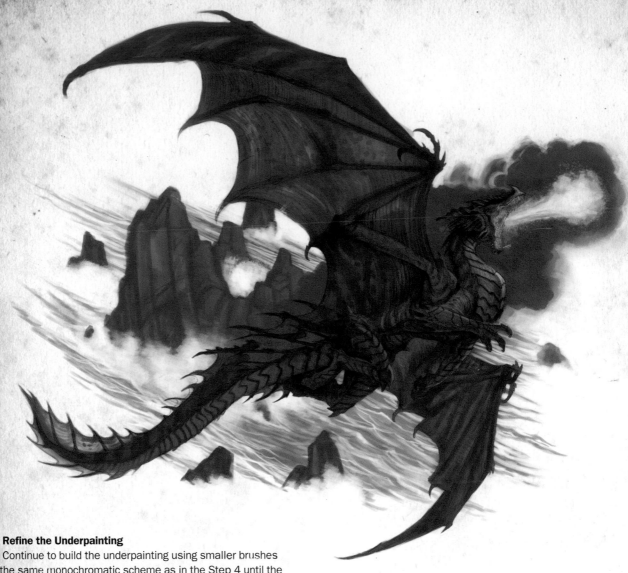

5 Refine the Underpainting
Continue to build the underpainting using smaller brushes and the same monochromatic scheme as in the Step 4 until the level of detail is sufficient to define the form, space and lighting. It's best to get these key elements correct now, as they are the basis for the remainder of the painting

As you can see, the area of greatest contrast involves the head and the fire, making this area the focal point. The dark smoke further adds contrast and makes the fire appear brighter. Add some reflected light to the dragon's breast to define the shape.

What Color Is a Dragon?

Like the colors and patterning of a dinosaur, dragon coloration is open to interpretation, and there are a lot of references you can take coloring cues from. In looking at traditional heraldry, you'll notice the dragon is usually depicted as a single color, with red being the most popular choice. Think about why your dragon is the color it is. Its coloration could help it blend into its surroundings, it could indicate it is a poisonous creature or it could be used to attract a mate.

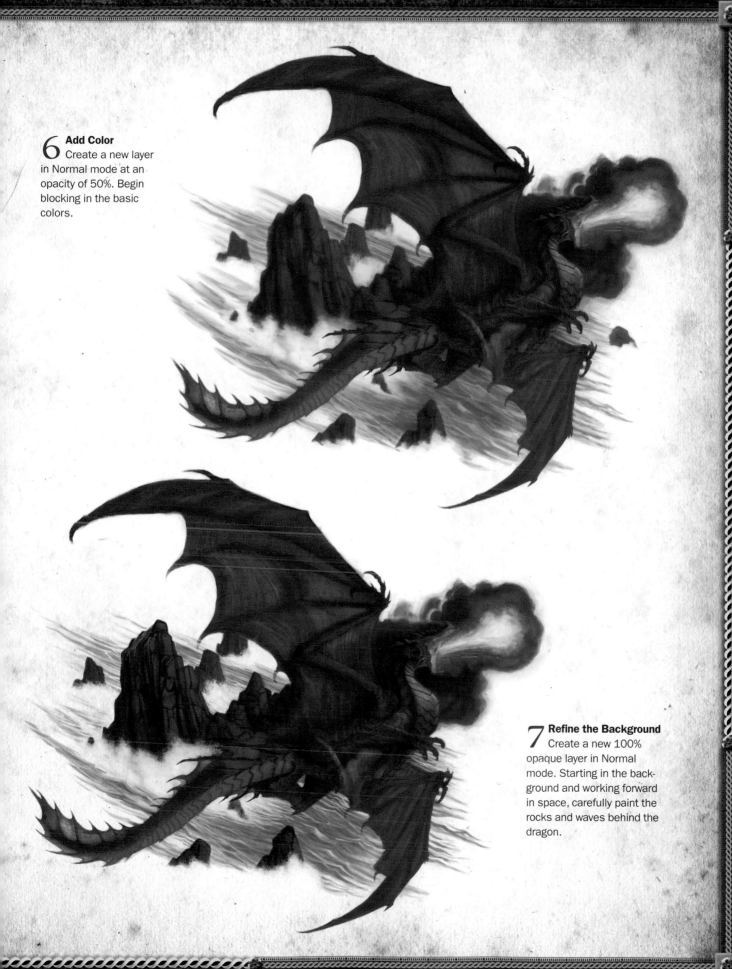

6 Add Color
Create a new layer in Normal mode at an opacity of 50%. Begin blocking in the basic colors.

7 Refine the Background
Create a new 100% opaque layer in Normal mode. Starting in the background and working forward in space, carefully paint the rocks and waves behind the dragon.

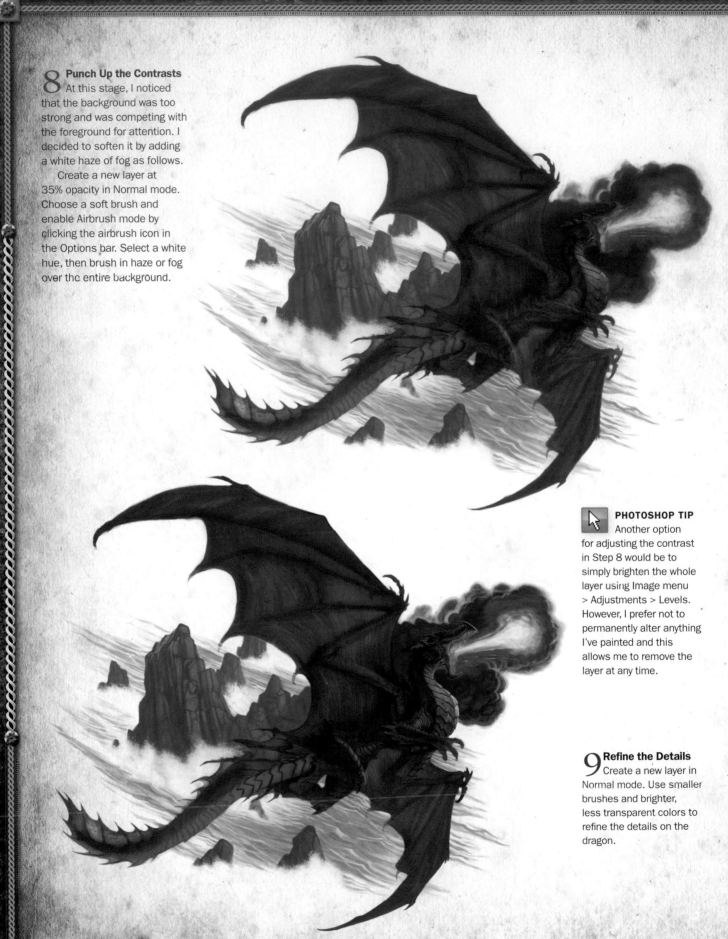

8 Punch Up the Contrasts
At this stage, I noticed that the background was too strong and was competing with the foreground for attention. I decided to soften it by adding a white haze of fog as follows.

Create a new layer at 35% opacity in Normal mode. Choose a soft brush and enable Airbrush mode by clicking the airbrush icon in the Options bar. Select a white hue, then brush in haze or fog over the entire background.

PHOTOSHOP TIP
Another option for adjusting the contrast in Step 8 would be to simply brighten the whole layer using Image menu > Adjustments > Levels. However, I prefer not to permanently alter anything I've painted and this allows me to remove the layer at any time.

9 Refine the Details
Create a new layer in Normal mode. Use smaller brushes and brighter, less transparent colors to refine the details on the dragon.

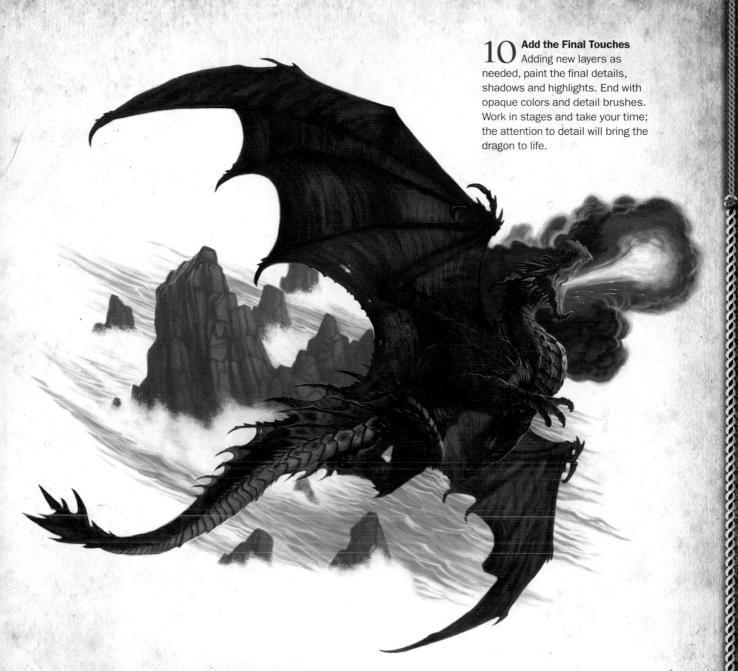

10 **Add the Final Touches**
Adding new layers as needed, paint the final details, shadows and highlights. End with opaque colors and detail brushes. Work in stages and take your time; the attention to detail will bring the dragon to life.

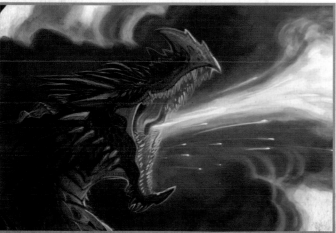

11 **Detail the Head**
Remember to zoom in to add the fine details to the head. Notice the reflected light of the fire reflecting back into the dragon's mouth, lips and even neck.

DRAGONETTE

Draco volucrisidae

SPECIFICATIONS

Size: 3' to 16' (91cm to 5m)

Wingspan: 6' to 25' (183cm to 8m)

Recognition: Bipedal torso, large hind legs, broad wings, avian head

Habitat: Temperate to tropical climates, including plains and grasslands

Species: English spitfire dragonette, American Appaloosa dragonette, Abyssinian dragonette, messenger dragonette, Waynesford dragonette

Also known as: Dragonelle, dragonel, dragonet

British Spitfire Dragonette
Pencil and digital
14" × 22" (36cm × 56cm)

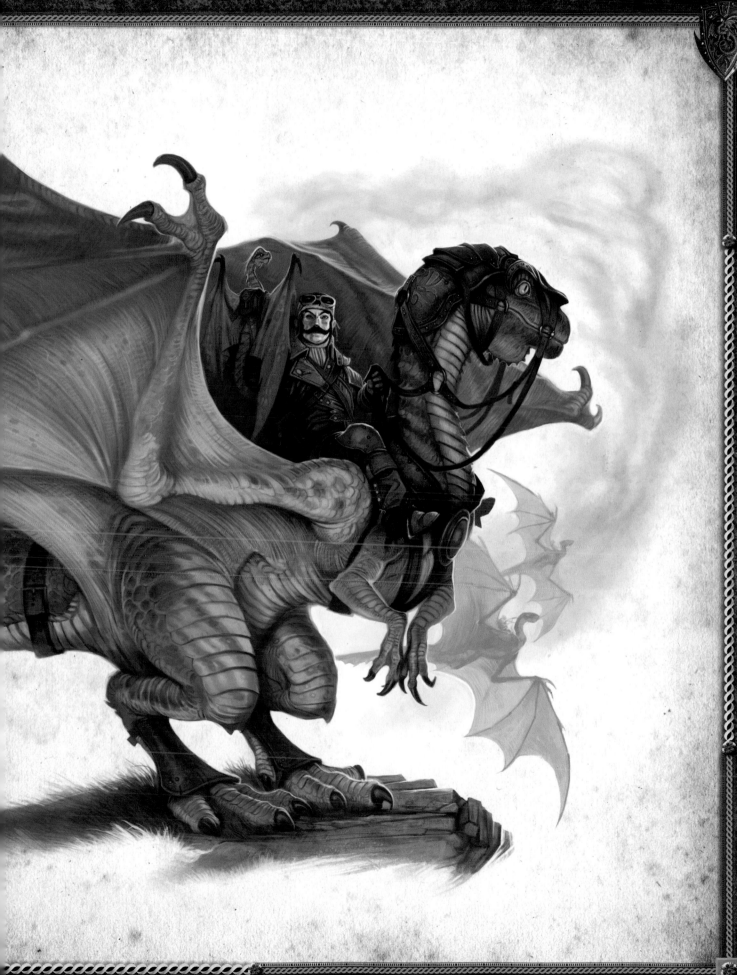

BIOLOGY

Few images evoke more romance and excitement than that of the dragon rider on his "steed." For centuries the dragonette has been bred by civilizations all over the world for a variety of purposes, from the diminutive courier dragonette to the powerful war dragonettes.

A bipedal dragon with powerful back legs and small front legs used for digging and nest building with expansive batlike wings for graceful and agile flying. The dragonette usually stands about 6' (183cm) at the shoulder, and is 12' (4m) feet in length with a 20' (6m) wingspan. A vegetarian herd species from the open plains, and much less intelligent than their larger dragon cousins, the dragonette has been domesticated by early civilizations and today is common throughout most of the world. Bred into many hundreds of breeds, the dragonette can be found in a variety of patterns and sizes to fit their many functions.

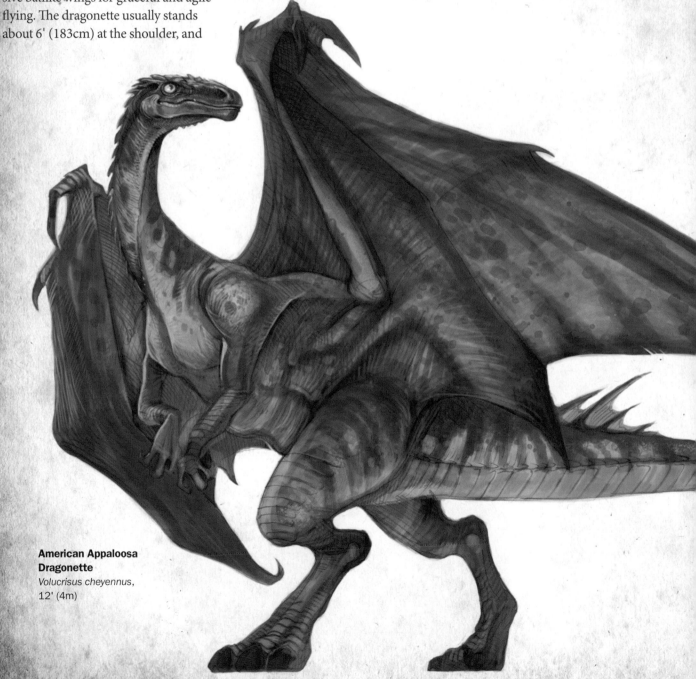

American Appaloosa Dragonette
Volucrisus cheyennus,
12' (4m)

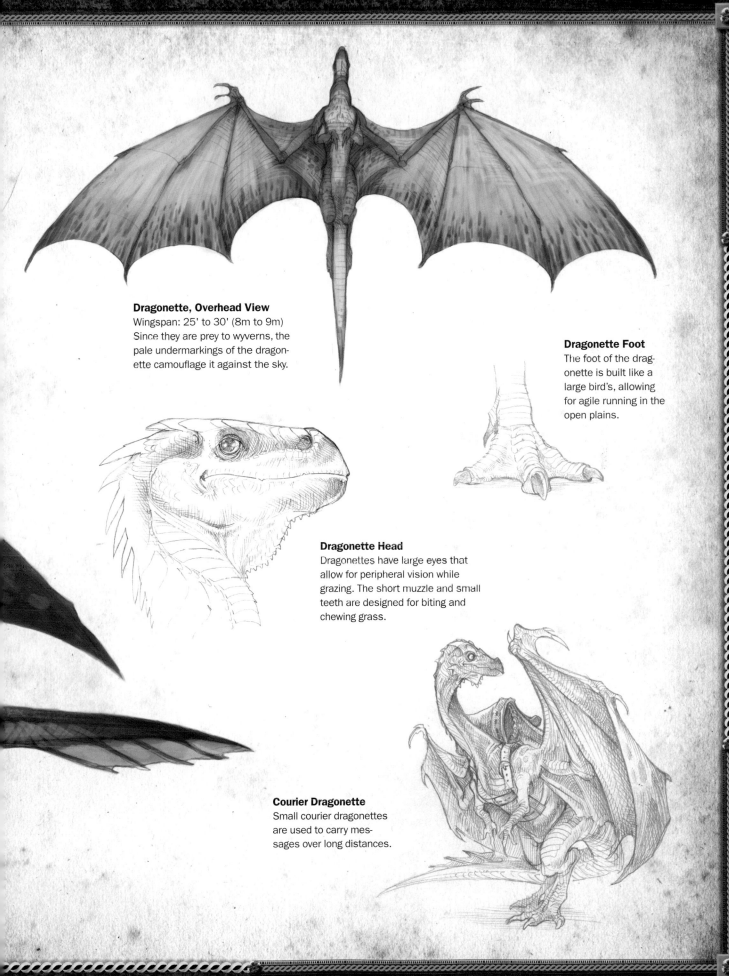

Dragonette, Overhead View
Wingspan: 25' to 30' (8m to 9m)
Since they are prey to wyverns, the
pale undermarkings of the dragon-
ette camouflage it against the sky.

Dragonette Foot
The foot of the drag-
onette is built like a
large bird's, allowing
for agile running in the
open plains.

Dragonette Head
Dragonettes have large eyes that
allow for peripheral vision while
grazing. The short muzzle and small
teeth are designed for biting and
chewing grass.

Courier Dragonette
Small courier dragonettes
are used to carry mes-
sages over long distances.

BEHAVIOR

Dragonettes are unique within the dragon class in that they are a vegetarian herd animal living within flocks (or flights) that can grow into thousands of animals. A very social and docile creature, they commonly build their nests on the high plateau mesas of the central United States, eastern Europe and Australia. A whole flight of dragonettes may migrate thousands of miles between seasons to follow the food supply and reach their breeding grounds.

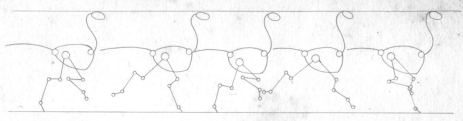

Dragonette Locomotion
This sequence of wire-frame drawings illustrates how the dragonette runs on its powerful hind legs. Notice how its center of gravity is kept over its knees.

**Dragonette Eggs 10"
25cm), 1½" (38mm)**

A Dragonette Flight
Dragonettes gather in large flights, containing hundreds of individual animals for protection along the tall cliffs in the plains.

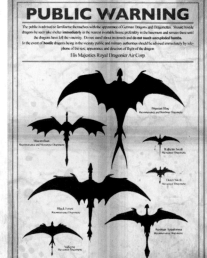

Dragonettes Are Easily Trained
During World War I, the German Drachwaffe became such a threat to English civilians that advisories such as this one were commonly displayed throughout much of the country. Notice the wide variety of dragonettes that were developed and try imagining all of the possible wing designs.

HISTORY

Varieties and breeds of the dragonette can be found in almost all regions of the world and the dragonette ranges in size from the small (3' [91cm]) to the large working breeds, (16' [5m]). Although not as intelligent or easy to train as horses, dragonettes have long been used for transportation and military use, allowing for a flying cavalry in use in ancient Egypt and the American Civil War. Famous legions of dragoniers include Napoleon's Dragoniers, the British Royal Dragon Guard, the German Drachwaffe and the American Dragon Express Mail Service.

Most dragonettes have been used by military commanders to survey the battlefield and carry messages, although using bombs dropped from the air has been attempted from the Chin Dynasty in China up to World War I. After WWI, the dragonette was replaced by the airplane, and today the dragonette is solely kept by breeders and racers. For more information visit the International Dragonette Breeders Association (IDBA).

Wild dragonettes in their native habitats are rare, but attempts to reintroduce the animal to these areas are currently under way by conservation societies.

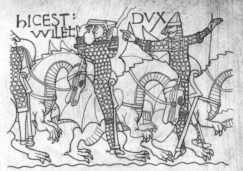

Dragonettes have been used in the military for centuries. Here you see William Duke of Normandy and his knights astride dragonettes during the Battle of Hastings in 1066.

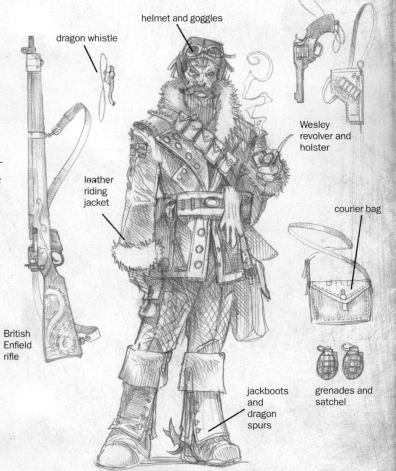

dragon whistle

helmet and goggles

Wesley revolver and holster

leather riding jacket

courier bag

British Enfield rifle

jackboots and dragon spurs

grenades and satchel

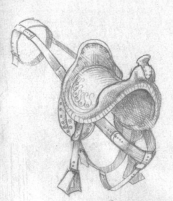

A typical western-style dragonette saddle.

WWI British Dragonier, Circa 1915
The apex of the dragon rider took place in the late 19th and early 20th centuries. The advent of airplanes and technology made the dragonier obsolete. This illustration shows all the gear and clothing of a WWI-era British dragonier officer.

BRITISH SPITFIRE DRAGONETTE

The dragonette is a complex animal with many possible variations. The painting needs to show these variations to best illustrate its uniqueness. For this image, I decided to highlight the following details:
- The ability of the dragonette to be ridden
- The tack and harness needed
- The gear worn by the dragonier
- The camouflage
- The use of dragonettes in groups
- The range of dragonettes in size and function.

Designing the dragonette's color and markings should begin in the concept stage. I was inspired by raptors and warplanes, which are camouflaged against the ground from above and against the sky from below. The markings on the dragonette are very similar to those seen on World War I German airplanes.

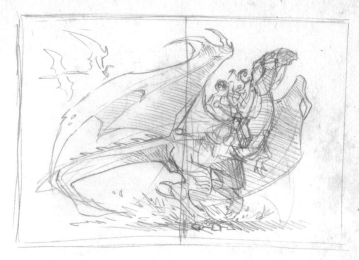

1 Sketch the Composition
Develop several thumbnail sketches in your sketchbook that include all the elements you want in the image.

Establishing Proper Anatomy and Posture

The human dragonier and the two with the two dragonettes of different sizes may make this drawing seem complicated. Reduce the possibility of confusion by creating an armature to establish the figures' basic structure and form. An armature is the foundation the drawing (or sculpture) will be built upon. In this case, the rough, skeletal outline of the dragonette serves as the armature for the drawing.

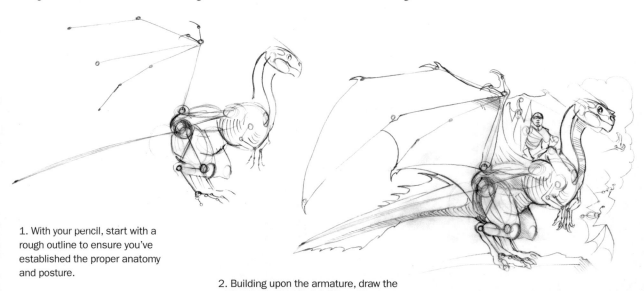

1. With your pencil, start with a rough outline to ensure you've established the proper anatomy and posture.

2. Building upon the armature, draw the muscles of the dragonette, using the basic anatomical diagram of a dragon on page 69.

2 Complete a Final Drawing

Do the final drawing with an HB pencil on bristol board, using your thumbnail sketches and armature drawings to guide you. Scan the drawing.

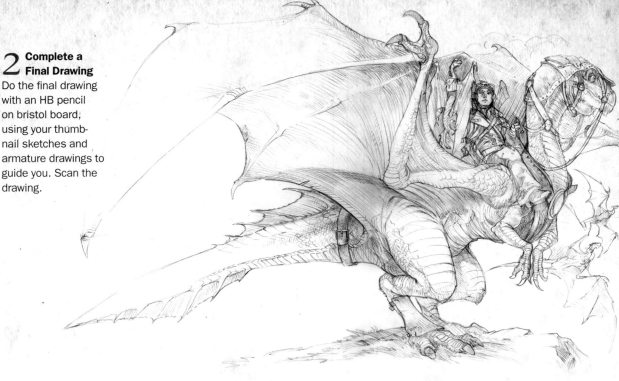

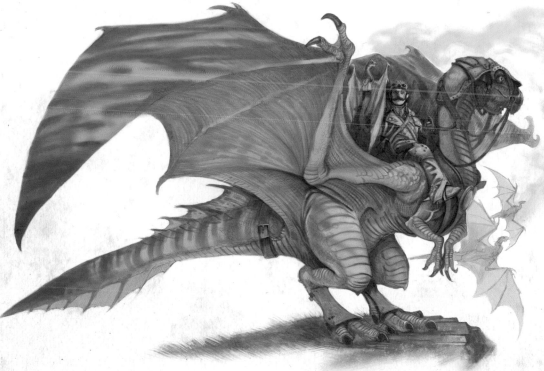

3 Establish the Underpainting.

Create a new layer in Multiply mode for the underpainting. Block in the underpainting using transparent brushes and a monochromatic green color scheme. Establish the forms and lighting. Keep the background elements lighter than the foreground dragonettes and rider. This will add depth to the painting.

4 Add the Color

Create a new layer in Normal mode with an opacity setting of 50%. Following the patterns and colors established in the drawing and underpainting, punch up the colors of the dragonette everywhere except the underside, where the colors should remain lighter and duller. Paint the small carrier dragonette red so it stands out against the dark green background, and reinforces the wide range of colors and markings dragonettes could be. Paint the dragonier and the dragonette's harness and saddle using smaller semitransparent brushes.

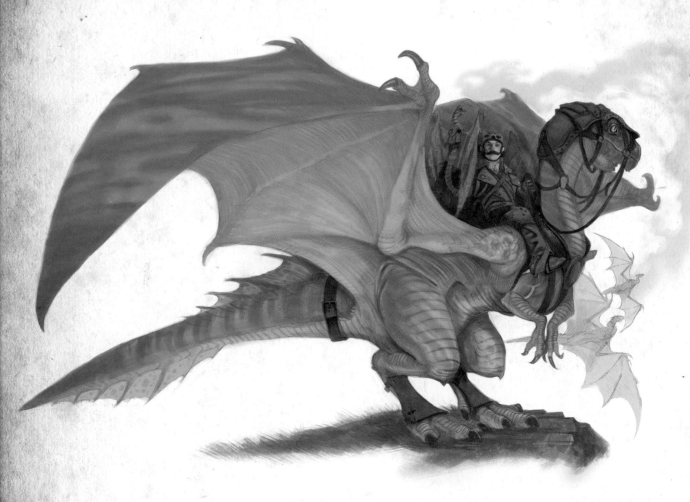

REVISIONS IN PHOTOSHOP
If you find that you'd like to rework an area where you've added a brushstroke or a color, you can simply just apply the new color or brushstroke right over the old one. Because the previous color or brushstroke will not show through, you can easily work out the color of your composition at this stage.

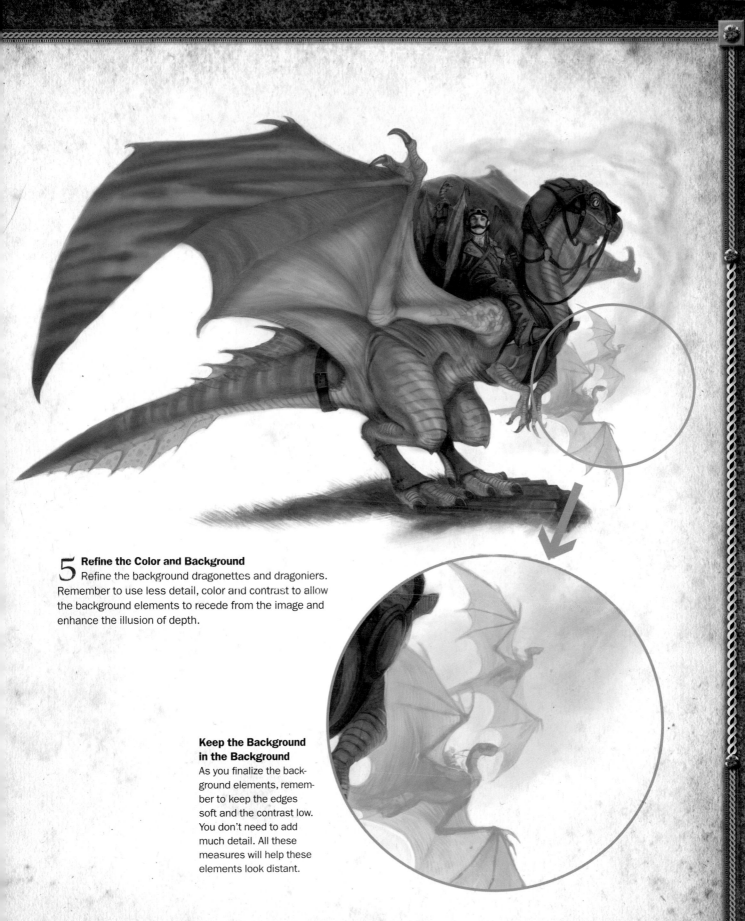

5 Refine the Color and Background

Refine the background dragonettes and dragoniers. Remember to use less detail, color and contrast to allow the background elements to recede from the image and enhance the illusion of depth.

Keep the Background in the Background

As you finalize the background elements, remember to keep the edges soft and the contrast low. You don't need to add much detail. All these measures will help these elements look distant.

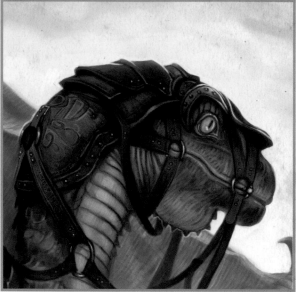

6 Refine the Dragonier and Red Dragonette

Using smaller brushes and more opaque colors, apply the greatest amount of detail to the rider and messenger dragonette. Add bright, saturated blues along the dragonette's body and wings for interest. Add oranges to the red wings and wattle, creating the appearance of light shining through a thin membrane.

Refine the dragonier, developing his ruddy appearance and adding highlights and shadows to suggest the texture of his jacket, scarf and leather straps.

7 Refine the Dragonette's Head

Refine the dragonette's head, adding reds and oranges to make the face stand out. As in Step 6, create the appearance of light shining though the wattle with orange. Add bright, sharp highlights on the rivets and rings on the riding gear. Add vibrant colors around the eyes, and gold inlay on the leather bridle. Add a few highlights to make the bridle shine.

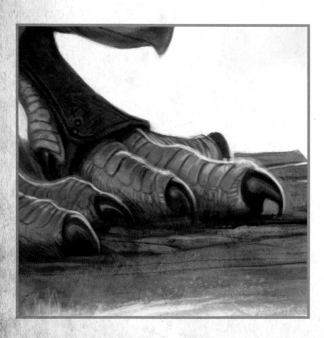

8 Refine the Feet

Use a variety of brush textures to create the dragonette's feet. Brushes that resemble traditional, painterly techniques such as splattering, scumbling and drybrushing will create interesting marks and textures on the dragonette. Add highlights to the scales and claws to create the appearance of shiny, reptilian skin.

9 Add the Finishing Touches

Using small brushes and opaque color, add the remaining details to the composition. Use bright blue-green and orange-yellow to refine the green dragonette's ridges. Touch up the scales. Notice how much more detail is rendered in the face compared to the wing behind it.

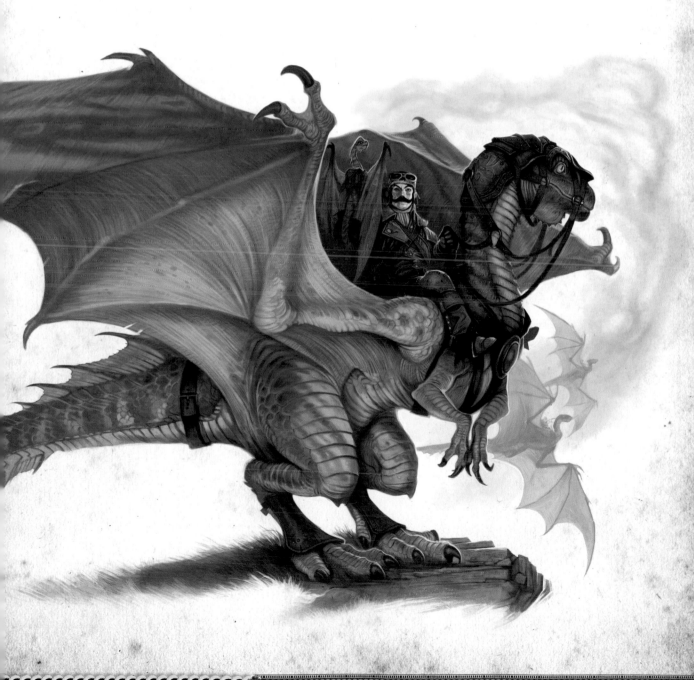

Draco drakidae

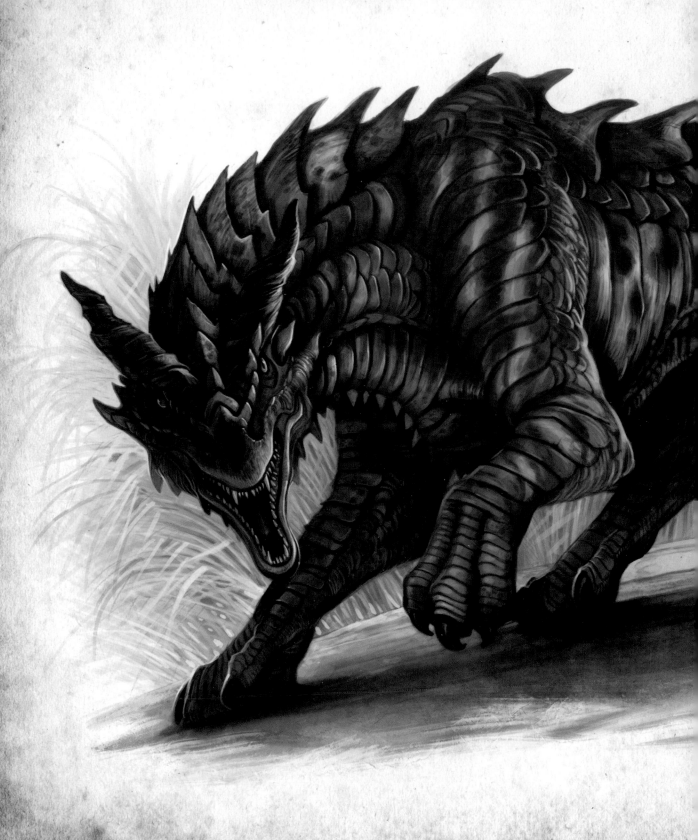

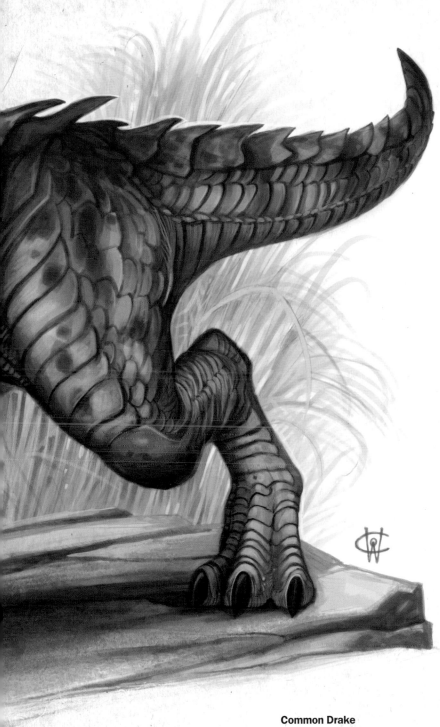

SPECIFICATIONS

Size: 3' to 12' (91cm to 4m)

Wingspan: None

Recognition: Quaduripedal stocky body; flightless

Habitat: Temperate to tropical climates and open plains

Species: St. Cuthbert's drake, pit drake, racing drake, draft drake, Wyeth's drake, Pyle's drake, war (siege) drake, Ishtar drake (extinct)

Also known as: Gargoyle, drakoyle, gorgon, draggonne, drak

Common Drake
Pencil and digital
14" × 22" (36cm × 56cm)

BIOLOGY

The drake is a common, flightless dragon that was domesticated by many early civilizations. The drake comes in hundreds of species and breeds, but all are four-legged animals with short, compact bodies allowing for swift running. The great advantage to the drake is its ability to adapt to its environment and create hundreds of subspecies that are specially designed for almost any function. The drake's powerful jaws and sharp teeth are designed to effectively capture and kill its prey.

Racing Drake
Drakus properitus, 6' (183cm)
Small, swift racing drakes are still bred today. Their speeds can rival those of a cheetah.

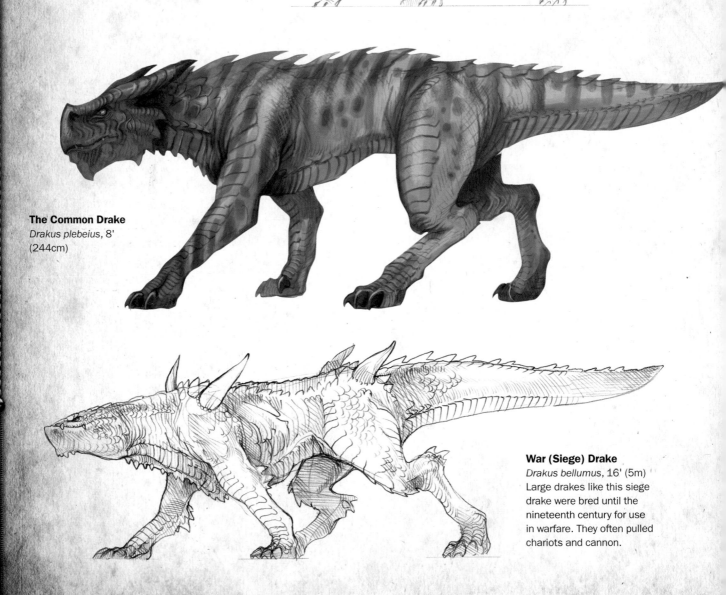

The Common Drake
Drakus plebeius, 8' (244cm)

War (Siege) Drake
Drakus bellumus, 16' (5m)
Large drakes like this siege drake were bred until the nineteenth century for use in warfare. They often pulled chariots and cannon.

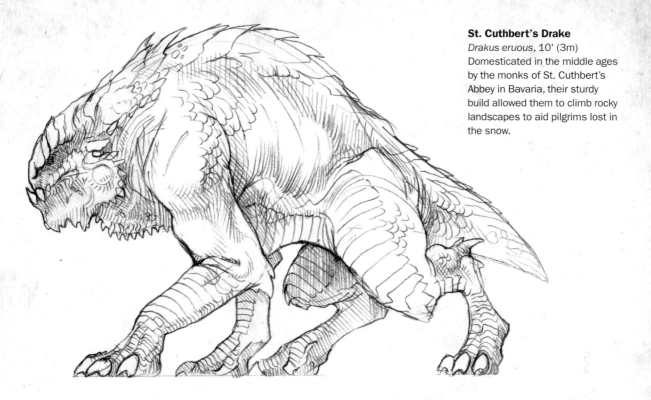

St. Cuthbert's Drake
Drakus eruous, 10' (3m)
Domesticated in the middle ages
by the monks of St. Cuthbert's
Abbey in Bavaria, their sturdy
build allowed them to climb rocky
landscapes to aid pilgrims lost in
the snow.

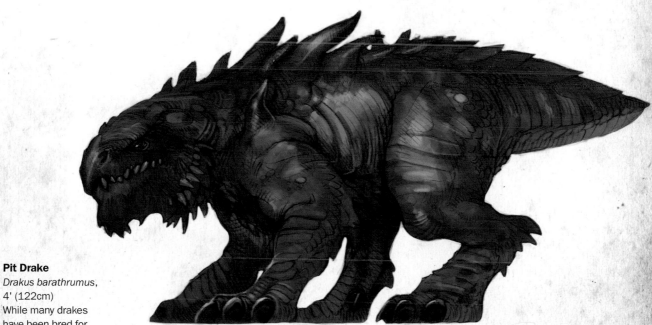

Pit Drake
Drakus barathrumus,
4' (122cm)
While many drakes
have been bred for
fighting, the pit drake
is the most nortori-
ous. It is illegal to
breed pit drakes in
many countries.

Behavior

Drakes are naturally a pack-hunting animal living in the grasslands and open savannahs around the world. Groups of drakes can grow to several dozen, bringing down large game such as elk, moose and dragonettes. Today there are very few wild species of drake in the world, having been hunted to near extinction. Yet, the drake is a very popular animal amongst breeders, and there are hundreds of breeds throughout the world.

A common drake at rest.

Drake Habitat

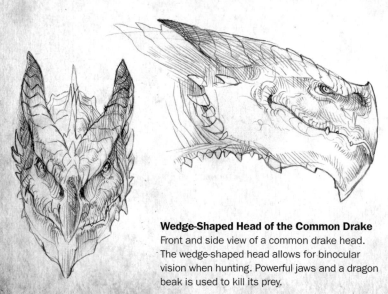

Wedge-Shaped Head of the Common Drake
Front and side view of a common drake head. The wedge-shaped head allows for binocular vision when hunting. Powerful jaws and a dragon beak is used to kill its prey.

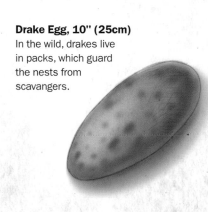

Drake Egg, 10" (25cm)
In the wild, drakes live in packs, which guard the nests from scavangers.

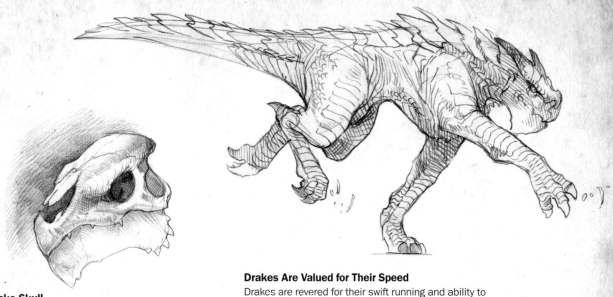

Drake Skull
A drake's skull has large areas for the attachment of jaw muscles and ligaments for their powerful bite.

Drakes Are Valued for Their Speed
Drakes are revered for their swift running and ability to bring down powerful game.

HISTORY

Originally domesticated by Egyptian and Babylonian cultures, hundreds of drake breeds have been developed over the centuries, from small toy drakes no more than 12" (30cm) long, to the massive siege drake over 20' (6m) long.

Because of their common usage as guard animals, drakes in art routinely graced architecture from Mesopotamia, Egypt and Asia. During the Middle Ages the drake became such a symbol of protection and ferocity that their likeness was used on cathedrals and churches as downspouts and to help deter nesting pigeons. These "gurglers" became known as gargoyles, and today the term is synonmous with the drake in many parts of the world.

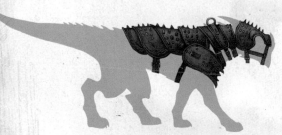

Drake Armor
For centuries, drakes have been used as hunting animals and as guards. Armor like this is still used today in many parts of the world.
Courtesy Dresden Museum of Natural History

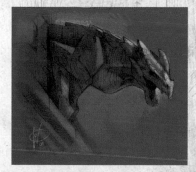

Gargoyle
Used as waterspouts on gothic cathedrals in Europe, gargoyles depicted dragons of all types, but drakes are the most common.
Courtesy St. Margaret's Cathedral, Carcassonne, France

DEMONSTRATION
COMMON DRAKE

Approaching a painting of a drake is, in many ways, similar to painting a large cat or dog. Work with references of tigers, bears and wolves to approximate a drake's anatomy. The specific type of drake you design will have specific details that you'll want to focus on such as:

- Powerful hunter
- Strong jaw
- Stocky, muscular body
- Grassy habitat
- Camouflage patterning

1 Complete a Thumbnail Sketch
Begin with several thumbnail sketches to work out the designs for your painting. Be sure to include the elements you've deemed important.

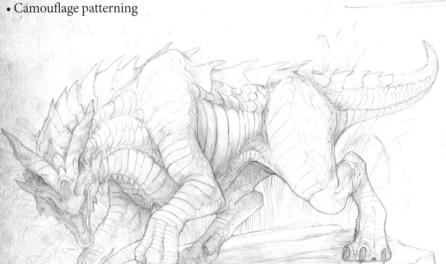

2 Do a Final Drawing
Do the final drawing with an HB pencil on bristol board. Get the anatomy right before you start adding scales and other details. Scan the drawing.

Underlying Structure Is Important

When working on a drawing of a dragon, always remember that there's a moving skeleton inside the body. The internal structure supports and in many ways dictates the external design, so get the structure right before you worry too much about drawing surface details.

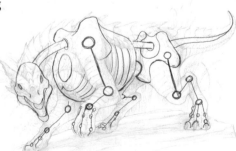

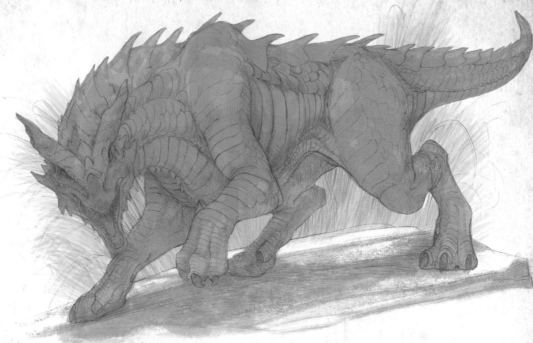

3 Establish the Underpainting

Create a new layer in Multiply mode. Use large transparent brushes and tan to establish the basic forms and colors.

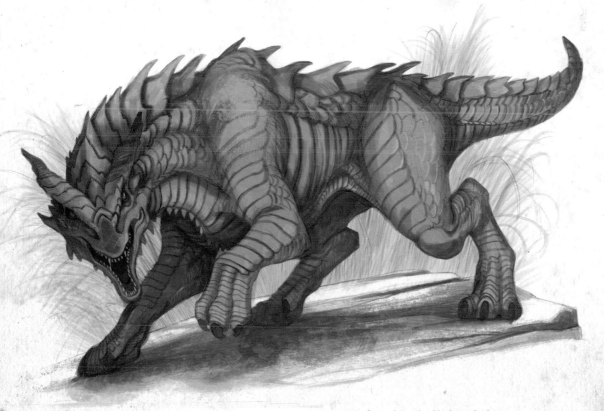

4 Complete the Underpainting

Continuing in the same layer with the same colors, develop the details. Establish the shadows and highlights, following those in the drawing. With smaller brushes, add details to the face. The eyes and teeth should be the lightest color in the underpainting.

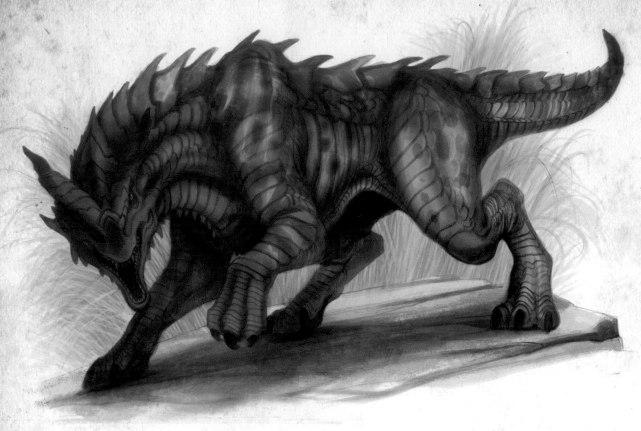

5 Refine the Color

As you can see in the concept design for the common drake on page 96, this creature has brown stripes as camouflage to help it blend into its surroundings. That means our painting will be relatively monochromatic. Since you can't depend on color to distinguish one part of the body from the next, try using different brush textures on them instead.

Using smaller brushes, refine the details in the face, using reds and yellows to define the eyes and teeth.

COLOR AND TEXTURE
I created these textures using different brushes in Photoshop. Experiment with different brush shapes to make unique textures of your own.

1. Smooth texture used for the patterns on the drake's hide.

2. Mottled effect to add additional texture to the hide.

3. Multiple thin lines suggest the background grasses.

4. Pebbled effect to create the ground's texture.

1.

2.

3.

4.

6 Add Details to the Hide

Add purple reflected light to illuminate the underside of the drake. This reflected light is created by the main light source bouncing off the rocks in the shadows and reflecting back onto the drake. This helps add a lot of dimension to your painting. Usually the reflected light is the complementary color of the main light (in this case, purple is the complement of yellow).

7 Add Detail to the Face

With your smallest brushes, add the finishing touches to the face. As you work, zoom in on the image so you can easily add details such as highlights on the teeth.

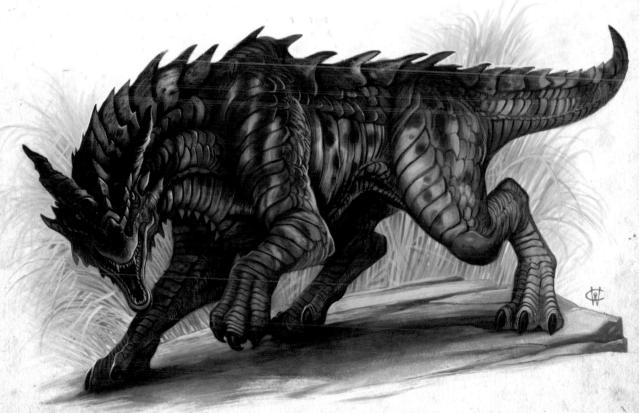

8 Add the Finishing Touches

With your smallest brushes, add opaque details and highlights.

FEYDRAGON

Draco dracimexidae

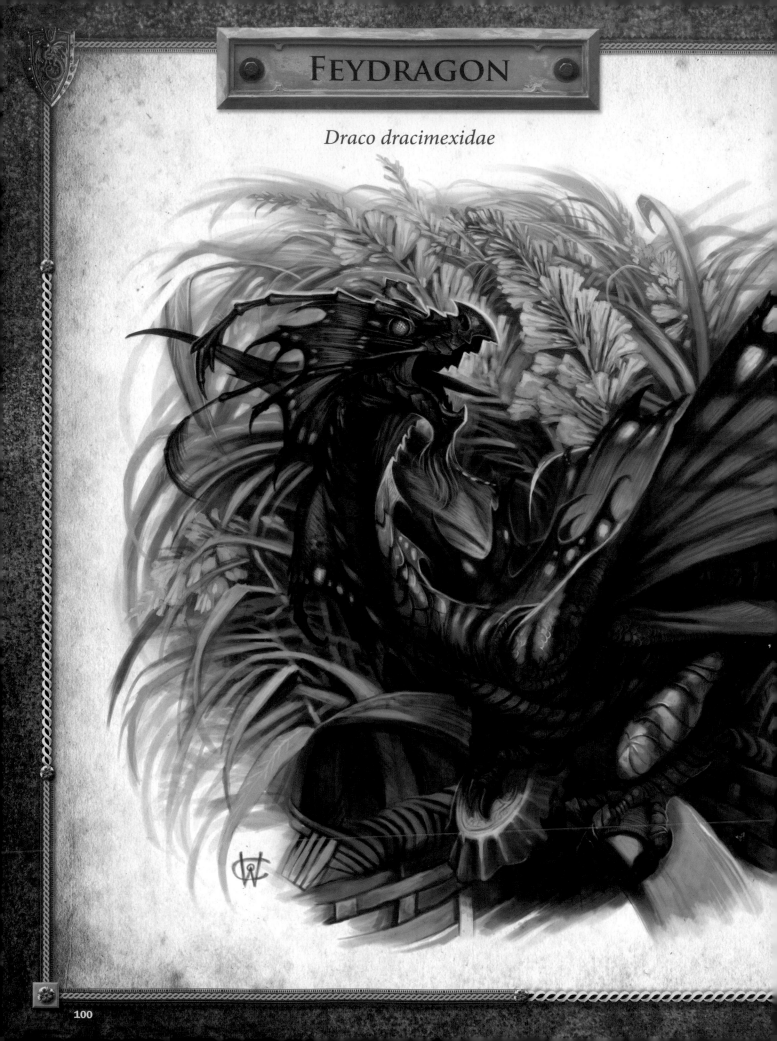

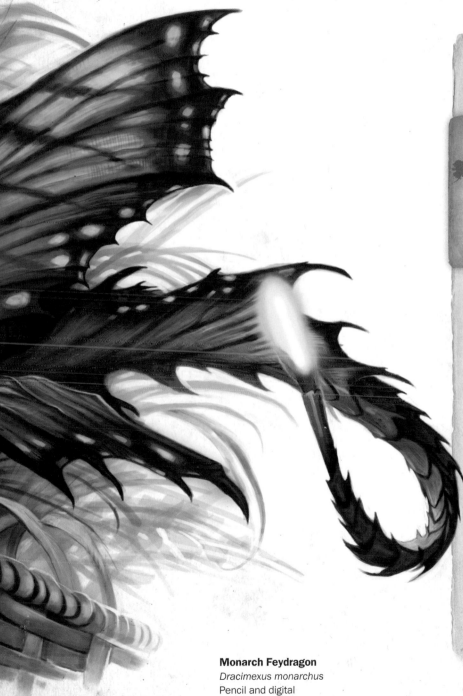

SPECIFICATIONS

Size: 6" to 9" (15cm to 23cm)

Wingspan: 10" to 14" (25cm to 36cm)

Recognition: Four brightly colored wings; wide variety of colors and patterns

Habitat: Temperate to tropical climates, forests and woods

Species: Queen Mab feydragon, monarch feydragon, swallowtail feydragon, cardinal feydragon, leafwing feydragon (jabberwocky)

Also known as: Faerie dragon, fairy dragon, fey dragon, pixie wyrm, jabberwocky

Monarch Feydragon
Dracimexus monarchus
Pencil and digital
14" × 22" (36cm × 56cm)

BIOLOGY

Anyone with a flower garden
is familiar with the feydragon.
Despite many misconceptions,
and its Latin name, the feydragon is
not an insect, but actually belongs in the
dragonia class. Its forearms have evolved into
a second set of wings, and the legs and feet have
developed long digits for grappling with prey and
holding onto small limbs.

The feydragon flies like an insect or hummingbird,
rather than like a dragon. Its wings flap so quickly, that
it is able to hover in midair
like a helicopter. Its four
wings give it the ability to
move in any direction.

A wide variety feydragons
species exist throughout the
world in an equally wide range of colors and shapes.
This carnivorous creature primarily eats insects, but
will also go after larger prey such as dragonflies and
even hummingbirds.

Feydragon Tail
The prehensile tail of the feydragon
is capable of wrapping around
objects to give it better balance.

**Leafwing Feydragon
(Jabberwocky)**
*Dracimexus pennafoliu-
mus*, 10" (25cm)
The jabberwocky (called
so for its jabbering chit-
ter) is found in many
Northwestern European
countries.

Feydragon Wings
The four wings of the feydragon act like the rotors
of a helicopter, allowing the creature to hover
and move in all directions. At rest the wings fold
against the body like fans.

Feydragon Feet
The feet of the
feydragon are long
and slender so that
it may perch on slim
branches.

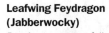

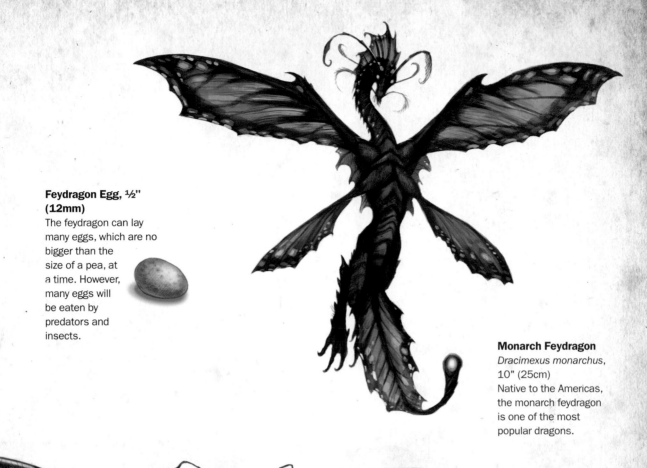

**Feydragon Egg, ½"
(12mm)**
The feydragon can lay
many eggs, which are no
bigger than the
size of a pea, at
a time. However,
many eggs will
be eaten by
predators and
insects.

Monarch Feydragon
Dracimexus monarchus,
10" (25cm)
Native to the Americas,
the monarch feydragon
is one of the most
popular dragons.

Swallowtail Feydragon
Dracimexus furcaudus, 8" (20cm)
Native to the African continent,
the swallowtail is one of the most
exotic-looking dragons.

Artist's Note

With hundreds of recorded feydragons,
and hundreds more that have never
been discovered, it is possible to create
a species of all different sizes, shapes
and colors. The feydragon is open to
as much creativity as you have. Go out
into your yard or neighborhood park
and explore the types of animals that
live there, then decide what type of
feydragon might fit in.

Behavior

Although the tiniest of the dragon species, feydragons have many of the same habits of their larger cousins. Hunting insects in the evening and early morning hours, feydragons will build nests in rocky overhangs or trees to lay their eggs, but prefer to live in the cool, dark woods. Northern breeds of feydragon will not migrate in the winter, but rather hibernate. Feydragons mate in flight, using their brightly colored wings and phosphorescent tails to lure a partner. Like their much larger cousins, the great dragons (see pages 64–77), the feydragon will steal small shiny objects to line its nest.

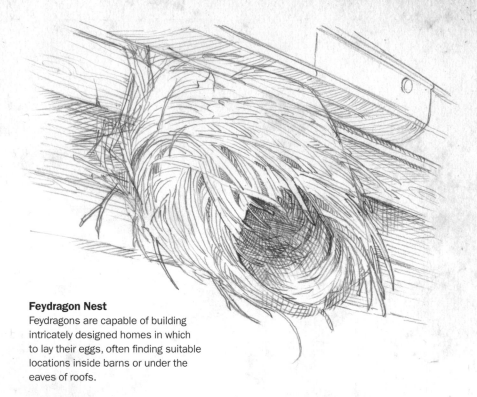

Feydragon Nest
Feydragons are capable of building intricately designed homes in which to lay their eggs, often finding suitable locations inside barns or under the eaves of roofs.

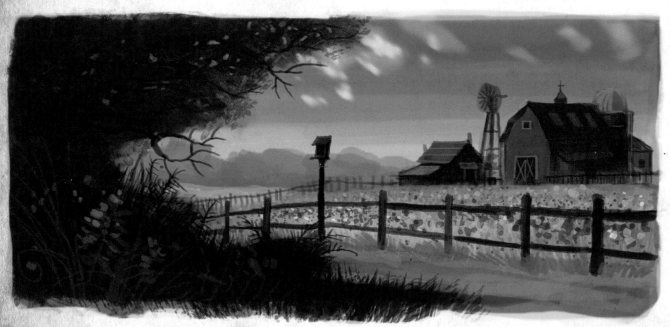

Feydragon Habitat
The feydragon is one of the few dragon families that can live in close proximity to humans without any fear of danger.

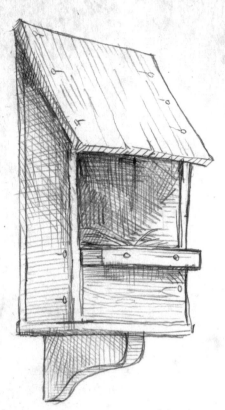

Feyhouse
Building feyhouses is a popular hobby for community garden clubs and Boy Scout troops. Feyhouses are best located in the shady areas of a garden.

History

The feydragon is considered to be the inspiration of almost all fairy and elf tales around the world. Will o'-the-wisps, brownies, pixies and the like, are all attributed to the playful, colorful and mischievous feydragon. In almost every culture it is considered good luck to have a feydragon move into your garden, and many people leave out small offerings of shiny buttons or coins for the diminutive creatures to take.

Historians assert that this traditional offering goes back to the pagan rites of making human sacrifices to the much larger true dragons.

Once believed to be a member of the Mantis family, it was later discovered that feydragons were actually in the Dragonia class and not Insectia. The praying mantis can be a fierce rival to the feydragon.

Feydragon Trap
Although the feydragon is a protected animal in most western countries, in Asia and Africa it is trapped in baskets such as this one and sold as a delicacy.

MONARCH FEYDRAGON

When approaching an image of the feydragon, it's important to design a composition that will show the animal's best qualities. Incorporating all of these aspects will make the illustration more interesting. Consider: Where does your feydragon live? How big is it? What color is it? Each of these aspects is important when coming up with a design. List these qualities so that you will not forget them, as I have done here:

- Small size
- Brightly colored
- Lives among the flowers
- Has four wings
- Collects shiny objects

1 Complete Preliminary Thumbnail Sketches
Draw quick thumbnail sketches like these to establish your layout and composition. As you can see here, I had initially thought to place the feydragon on a watering can before settling on the basket.

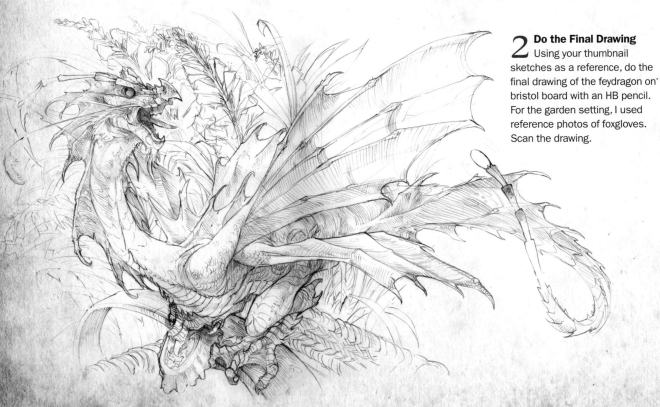

2 Do the Final Drawing
Using your thumbnail sketches as a reference, do the final drawing of the feydragon on bristol board with an HB pencil. For the garden setting, I used reference photos of foxgloves. Scan the drawing.

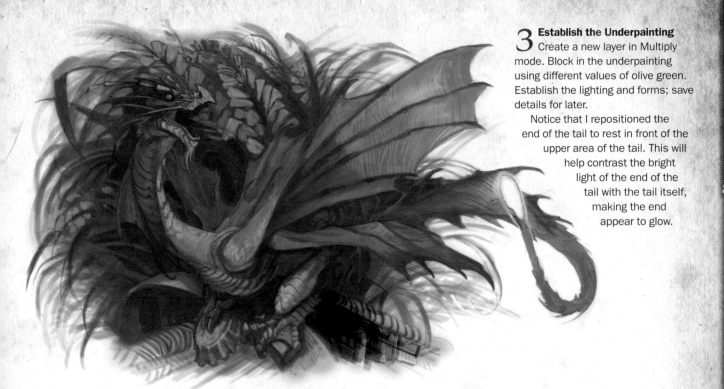

3 Establish the Underpainting

Create a new layer in Multiply mode. Block in the underpainting using different values of olive green. Establish the lighting and forms; save details for later.

Notice that I repositioned the end of the tail to rest in front of the upper area of the tail. This will help contrast the bright light of the end of the tail with the tail itself, making the end appear to glow.

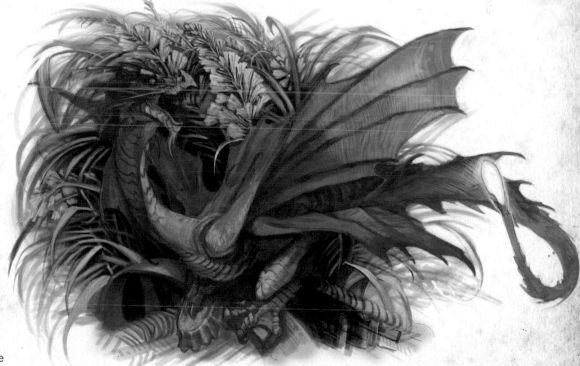

4 Add Color

Block in the basic colors on a new semiopaque layer in Normal mode. Begin with the background elements before moving onto the dragon itself. This garden scene will create crucial backdrop for the painting, producing a green textured "curtain" that will contrast against the oranges of the feydragon. The details in the background do not need to be precise; just creating the impression of flowers in the background are all that's needed here.

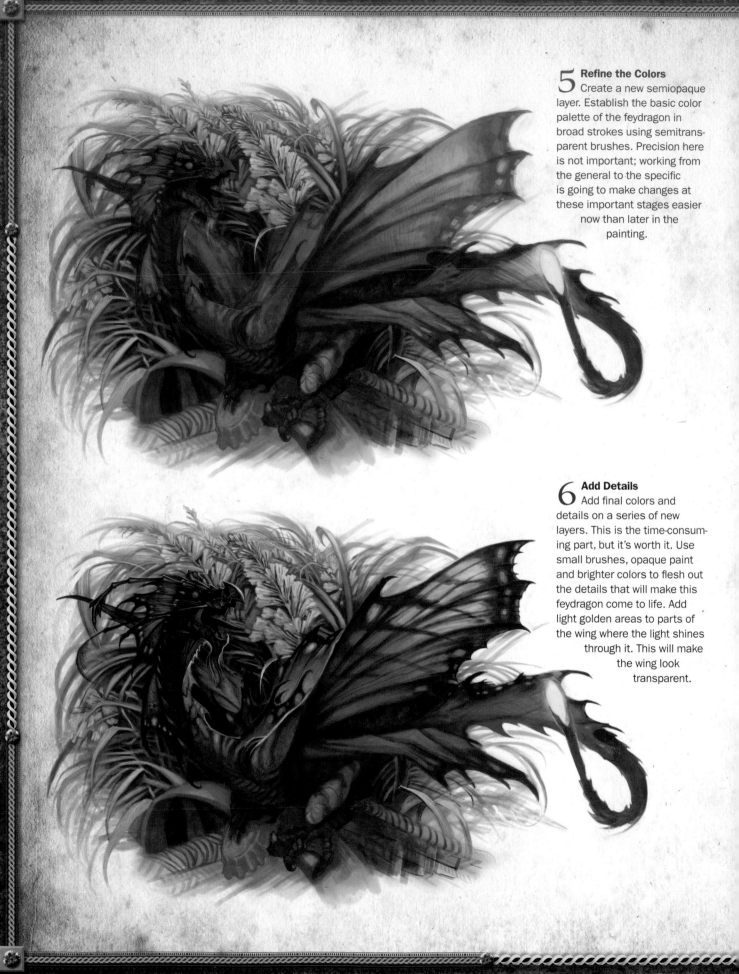

5 Refine the Colors
Create a new semiopaque layer. Establish the basic color palette of the feydragon in broad strokes using semitransparent brushes. Precision here is not important; working from the general to the specific is going to make changes at these important stages easier now than later in the painting.

6 Add Details
Add final colors and details on a series of new layers. This is the time-consuming part, but it's worth it. Use small brushes, opaque paint and brighter colors to flesh out the details that will make this feydragon come to life. Add light golden areas to parts of the wing where the light shines through it. This will make the wing look transparent.

The Middle Ground

1. Use hard, transparent brushes to establish the grass.

2. With smaller brushes and a darker color, refine the grass's shadows.

3. Using a semiopaque green, add some brighter color for interest and depth. Add some yellow to indicate the ground.

4. With small, opaque brushes, add the flowers.

5. Refine the details with your smallest brushes.

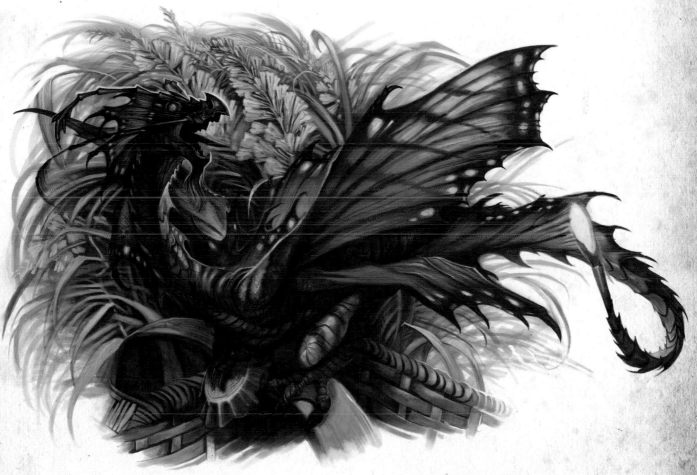

7 Add the Finishing Touches
With small opaque brushes, make any final adjustments to the painting such as the deep shadows in the basket and the highlights on the wings.

HYDRA

Draco hydridae

SPECIFICATIONS

Size: 30' (9m)

Wingspan: None

Recognition: Serpentine body with multiple heads; markings vary by species

Habitat: Temperate to tropical climate, waterways and wetlands

Known species: European bull hydra (Rhone hydra), Lernaen hydra, Japanese hydra (*Yamata-no-orochi*), naga (Indian hydra), Northern bull hydra, cerebrus hydra, medusan hydra, winged hydra

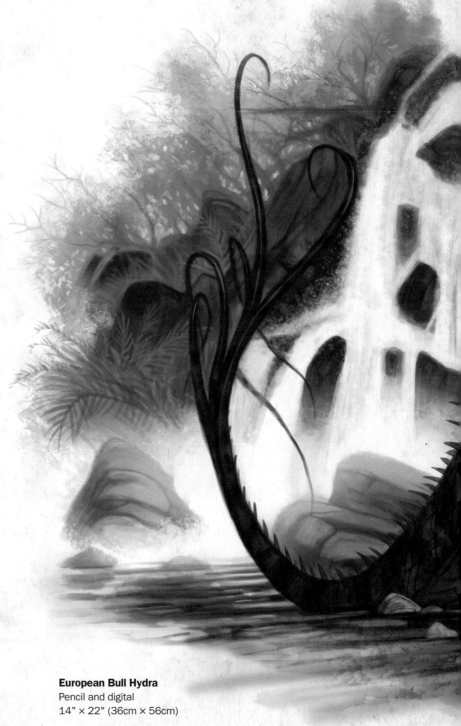

European Bull Hydra
Pencil and digital
14" × 22" (36cm × 56cm)

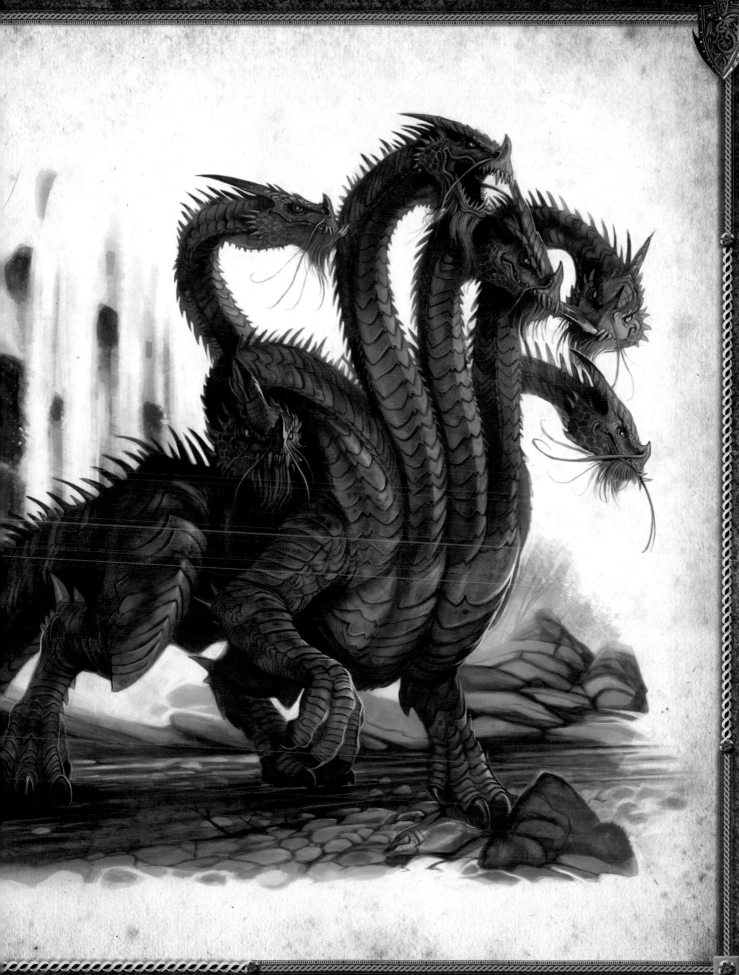

BIOLOGY

By far the most unusual family in the Dragonia class, the hydra is an order of dragon consisting of families and species that possess multiple serpentine necks and heads known as *Hydradraciformes*. The hydra is born with only two heads, and as the creature grows in size, it sprouts new heads that allow it to feed more effectively. If heads are damaged or destroyed, new heads are capable of growing back. The image of heads sprouting back like magic is an exaggeration; rather, a new hydra head usually takes one year to grow in. The hydra's habitat is located around bodies of water, where its many heads are used to hunt fish and small game.

The Lernaen hydra is much smaller, only 10' to 20' (3m to 6m), and has no legs, a serpentine body and is often referred to as a wyrm (see pages 136–145), but is actually in the *Hydridae* family.

Yamata-no-orochi, or Japanese hydra, along with the Indian hydra, or naga, live by the sea, hunting shellfish in saltwater tidal flats and up rivers.

The cerebrus hydra is a smaller species, usually confused with a drake (see pages 90–99) or even a canine, but is, in fact, a hydra. It hunts small game

Hydra Egg, 10" (25cm)
Hydra do not care for their young. They lay a small clutch of eggs and abandon them to their fate. Hydra hatchlings will often kill one another looking for food. This harsh parenting and childhood accounts for the scarcity of hydra.

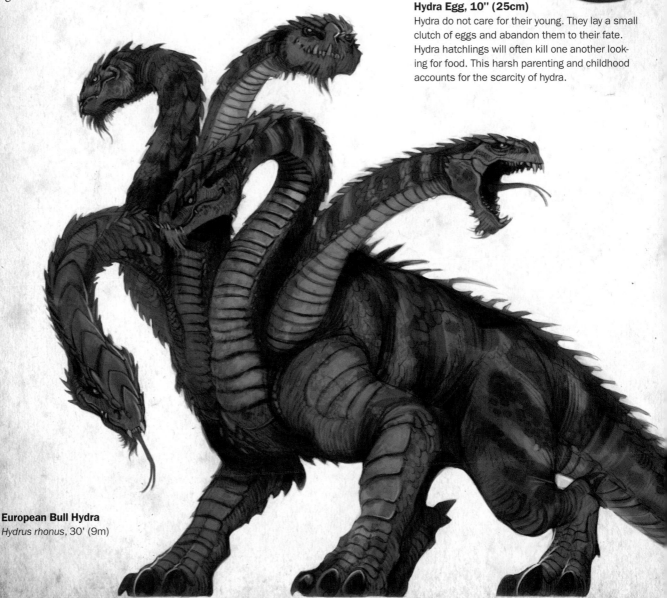

European Bull Hydra
Hydrus rhonus, 30' (9m)

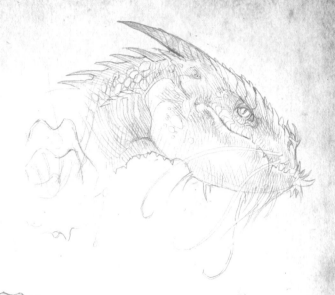

in open grasslands, and is often captured to be used as a guard animal. Tethered near a portal or gate, its three heads are always alert, and unlike the other hydra species, it is able to growl and bark like a hound to alert the inhabitants. The cerebrus is unique in that it is born with three heads and is unable to grow in new ones.

The aero hydra, or winged hydra, has never been documented and it is considered unlikely that such an ungainly creature as the hydra would ever function in the air. Yet, hydra specialists are constantly on the lookout for the elusive winged hydra.

The Heads of the Hydra

The hydra lives in deep murky swamps and has terrible eyesight. Often hunting at night in order to catch its prey, the head is equipped with long tendril-like whiskers that it uses to sense the environment around it.

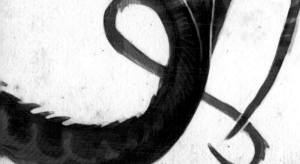

Hydra Feet

The soft muddy ground of the hydra's habitat requires a broad, flat webbed foot to support the bulky creature's massive weight. Its sturdy claws are used to overturn logs and rocks, looking for shellfish and small animal burrows.

ADDITIONAL MEMBERS OF THE
HYDRA FAMILY

The hydra family is one of the most unusual and diverse memebers of the Dragonia class.

Medusan Hydra (right)
Hydrus medusus, 10' (3m)
The medusan hydra lives in swamps and tidal basins.where it burrows itself into the mud, concealing its large body. The heads enable it to catch eel, crawfish and small animals as they pass by.

Lernaen Hydra
Hydrus lernaeus, 20' (6m)
The Learnaen hydra lives in the boughs of trees, allowing its heads to drape down catching small rodents, fish and birds.

Naga (Indian Hydra)

Hydrus gangus, 30' (9m)
The Indian naga is regarded as a sign of fertility and prosperity throughout much of the Indian subcontinent and Southeast Asia. This is probably because a healthy river with plentiful food attracts hydra.

Cerebrus Hydra

Hydrus cerebrus, 10' (3m)
Although sometimes believed to be in the drake family, the cerebrus hydra has a history, going back to classical antiquity. Born with three heads and never growing more, the cerebrus is an agile hunter. Since one of its heads is always awake, the cerebrus is often domesticated as a guard or a ratter.

Behavior

Hunted with extreme prejudice since ancient times to protect people and livestock, the hydra has disappeared from its classical habitats such as the Nile River Delta, and the Mediterranean islands. Larger specimens are known to attack live-stock, but usually the hydra is an angler, hunting easy prey that comes within the grasp of its ten-tacle-like necks. The large, bulky body is armored to protect against other predators such as croco-diles, but this makes the hydra a ponderous animal that may not move from its lair for weeks.

The hydra is notoriously unintelligent, with the individual brains of each head being minuscule in caparison to their body size. The heads are capable of autonomous actions, allowing some heads to rest while others continue feeding, allowing the hydra to sustain itself. The hydra will attack anything that moves within the path of its heads as it lays in wait along riverbanks and inland seas. It has been

Hydra Habitat
Most commonly found making its dens near large rivers around the world, the hydra has become an endangered creature as much of its habitat has been destroyed by development of human settlements, and the construction of dams.

Hydra in the Process of Eating
With multiple heads all striking with lightning speed, the hydra is able to consume the necessary food to sustain its large body.

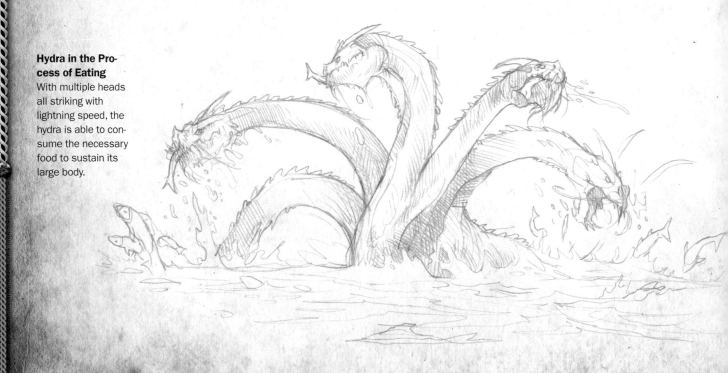

observed that hydra heads will often fight one another, resulting in injury, or the death of one of the heads.

In the winter months the Northern bull hydra will burrow underground and hibernate, while the subtropical and tropical Lernaen hydra, naga and Japanese hydra remain active year round.

Swimming Hydra
Despite being ungainly on land, hydra are excellent swimmers. Moving around their territory requires frequent river crossings. The hollow bones common to all dragons make them extremely buoyant.

HISTORY

The hydra is one of the most commonly depicted dragons in art history and is ubiquitous in almost all cultures. The hydra has been depicted thousands of times in Grecian urns, classical mosaics, Islamic scrolls and sculpture, Buddhist murals, and medieval illuminated manuscripts, paintings and engravings.

The Lernaen hydra is most famous for its classical battle against Hercules, but there are other accounts of multiheaded dragons. In Japanese mythology, the sea god Susanoo battles an eight-headed hydra by getting it drunk on sake. In India, the god Vishnu dances on the head of a naga. In the Christian faith, the famous seven-headed beast of the apocalypse is assumed to be inspired by the European bull hydra.

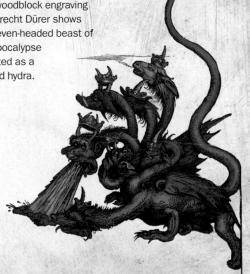

Depictions of Winged Hyrdas Are Common
This woodblock engraving by Albrecht Dürer shows the seven-headed beast of the apocalypse depicted as a winged hydra.

DEMONSTRATION
EUROPEAN BULL HYDRA

Painting a hydra is a complicated undertaking. The intertwining heads and necks all need to behave as a unit, as well as individually. The more heads you create, the more complicated the design becomes.

Once you have done all of the preliminary concept design work on your hydra, create a finished painting that communicates all of the ideas you have developed. In this example, create a short list of hydra qualities you need to include:

- Multiple heads
- River habitat
- Armored body

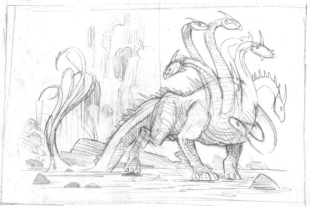

1 Create Thumbnail Sketches
Complete rough thumbnail designs of the painting to experiment with the layout of the painting. Figure out the arrangement of the many heads and necks and how they're attached to the body.

2 Draw the Composition
Using an HB pencil, complete a detailed rendering that includes all of the necessary details for the painting. Scan the drawing.

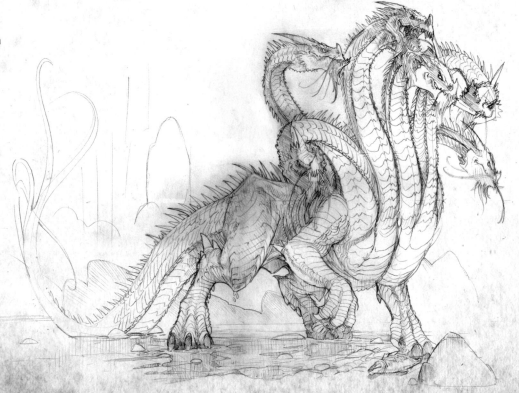

3 Establish the Underpainting

Create a new layer in Multiply mode for the underpainting. Using transparent brushes and different values of green, block in the lights and darks to establish shape and form.

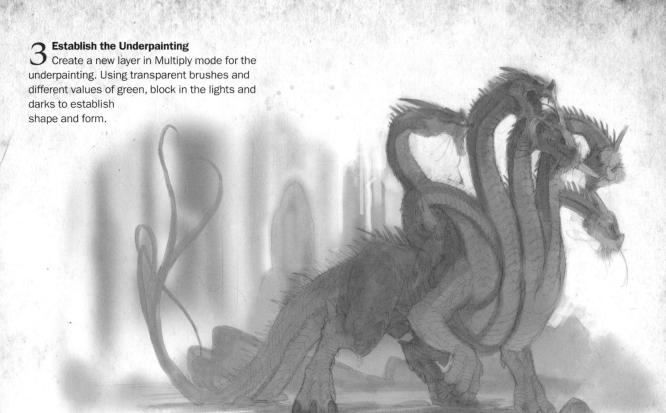

4 Complete the Underpainting

Continue the underpainting stage, using smaller brushes and deeper contrasts until you've established most of the details and lighting.

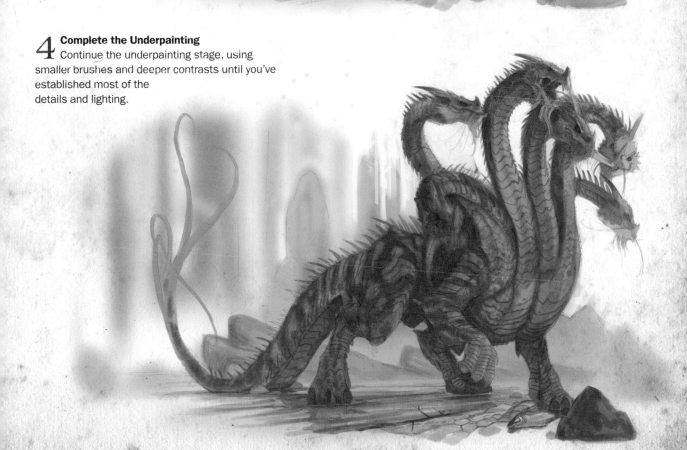

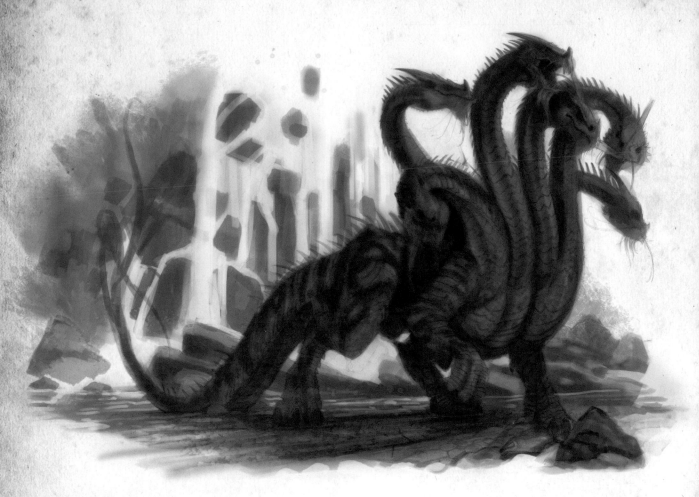

5 Add Color

Using semiopaque brushes and broad strokes, block in the colors of all of the objects in the painting. Don't worry about neatness at this stage; just focus on establishing the local color of the objects. Most of this information will be worked over in later stages in new layers.

Artist's Note

Local color is the actual color of an object before it's affected by atmospheric conditions such as haze. For instance, the local color of a lemon is yellow; however, when seen at a distance or when seen at evening, the lemon will appear less vividly yellow. Once you've established the local color of a painting, you can then alter the colors and details from there.

6 Refine the Background and Details

Working on the background first, use opaque paint in more detail, refining the image carefully with smaller brushes. Allow the previous work to show through where you can because the areas in more detail will appear to come forward. The areas of the composition that are less defined will seem to recede.

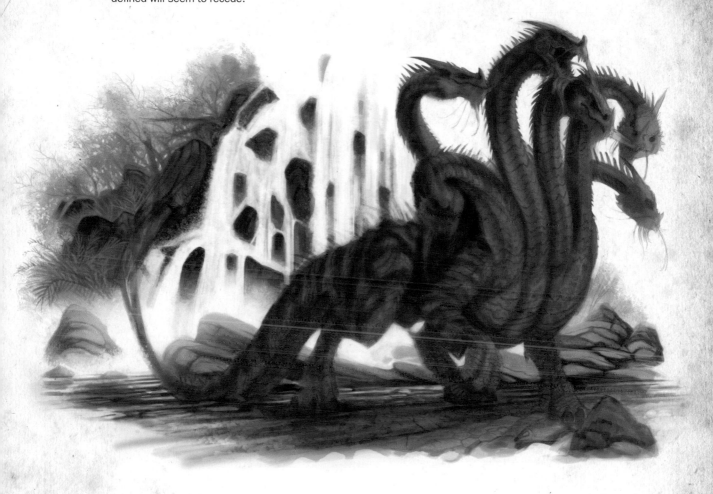

7 Add Detail to the Lower Hydra Head

Even though this head of the hydra is lower than the others, it's important to refine the details with small brushes and opaque color since it's in the foreground.

8 Refine the Other Hydra Heads

The lighter colors used on these heads draw the viewer's attention. The red color of the flesh the two heads are fighting over also helps draw the viewer's eye to this area since red is a complementary color of green.

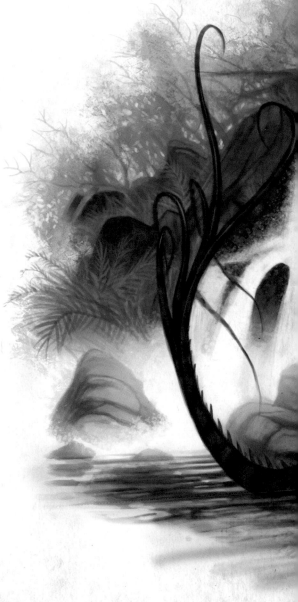

9 Refine the Hydra Background

Keep the textures and edges of the background soft to contrast against the crisp edges and strong contrast of the hydra.

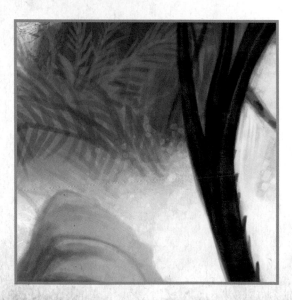

10 **Add the Finishing Touches**
Using the smallest brushes
and opaque color, refine any areas of
the painting that need touching up.

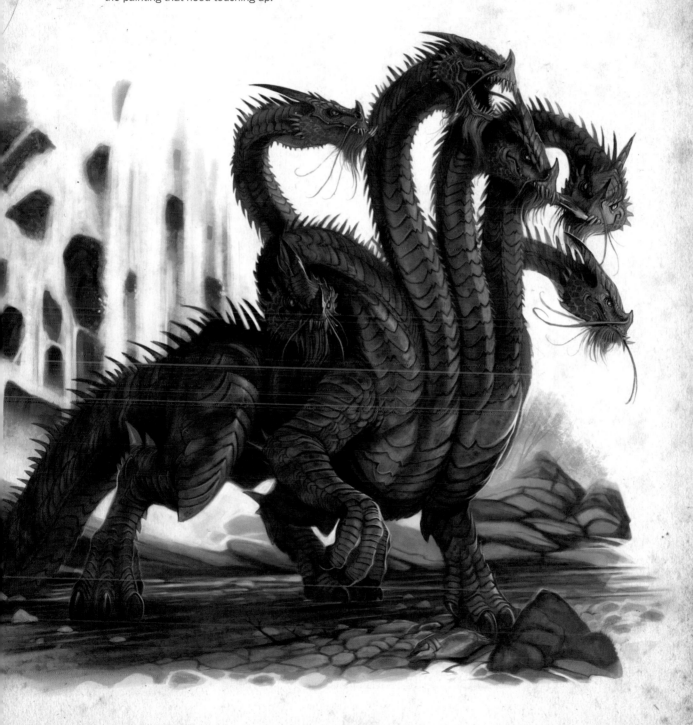

Draco orcadraciforme

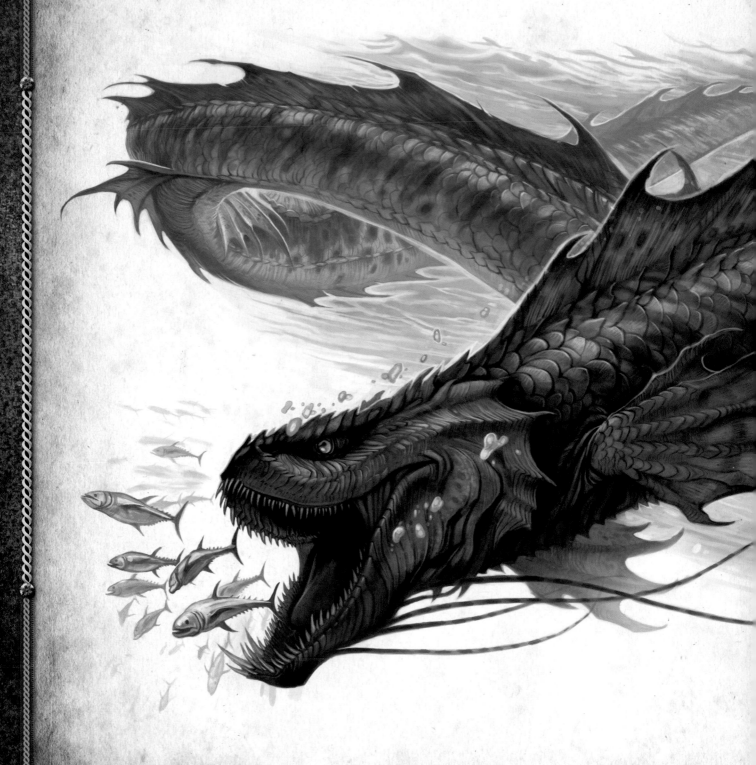

Faeroe Seaorc
Pencil and digital
14" × 22" (36cm × 56cm)

Size: 10' to 300' (3m to 91m)

Wingspan: None

Recognition: Serpentine body with finlike appendages. Wide range of species and forms

Habitat: Deep seas and lakes of the world

Families: *Cetusidae, Dracanguillidae*

Species: Scottish sea orc, sea serpent, Yangtze orc, striped sea dragon, faeroe sea orc, hammerhead sea dragon, sea tiger, sea leopard, frilled sea orc, sea lion, electric sea orc

Also known as: Leviathan, sea serpent, sea dragon

Biology

Evolving from the land species of dragons millions of years ago, the sea orc exists in two family groups: The *Dracanguillidae* (dragon eel), a snakelike species that have been reputed to grow to titanic lengths in excess of 300' (91m), and the *Cetusidae* (sea lion), a smaller, more terrestrial family, growing to 50' (15m).

Since seventy-five percent of the surface of the earth is water, sea orcs are the most varied and numerous of the draconia class of animals. Dozens of species have been documented, others are nearly extinct and still today rare species have never been seen. Primarily feeding on fish, seals, shellfish and other sea creatures, all sea orcs must return to the surface to breathe. Once a year, the female sea orc crawls to shore, or into the shallows, to lay her eggs. This vulnerable time is responsible the majority of fatalities to both adults and young. Orclings are tiny when born, but quickly grow to adulthood.

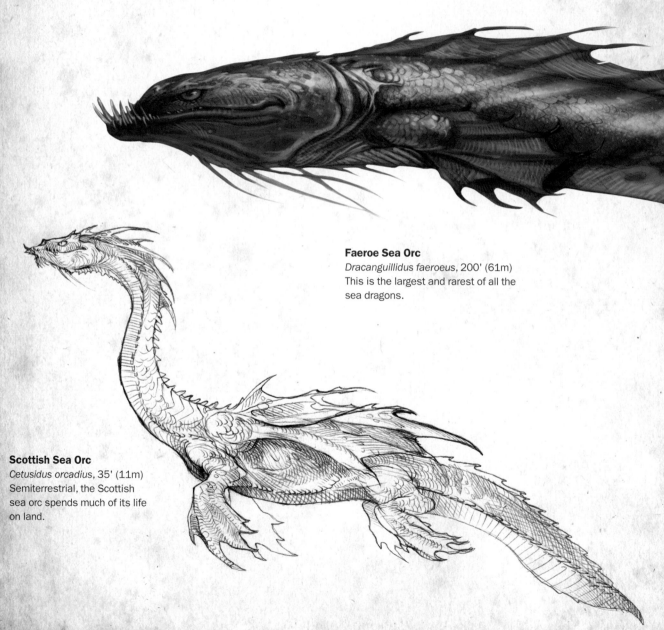

Faeroe Sea Orc
Dracanguillidus faeroeus, 200' (61m)
This is the largest and rarest of all the sea dragons.

Scottish Sea Orc
Cetusidus orcadius, 35' (11m)
Semiterrestrial, the Scottish sea orc spends much of its life on land.

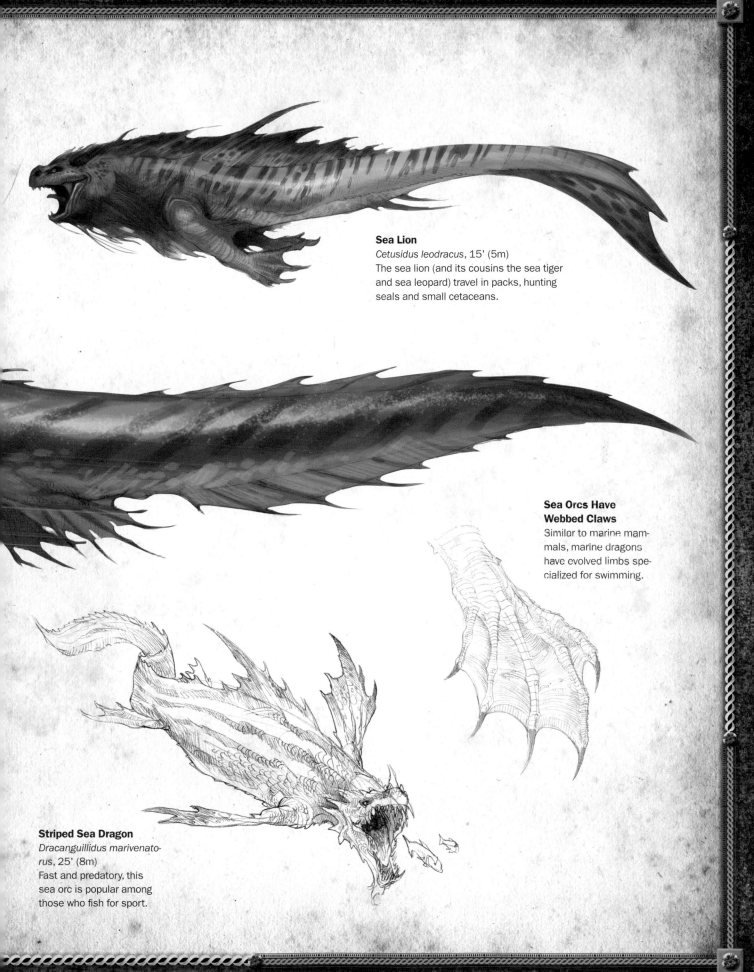

Sea Lion
Cetusidus leodracus, 15' (5m)
The sea lion (and its cousins the sea tiger and sea leopard) travel in packs, hunting seals and small cetaceans.

Sea Orcs Have Webbed Claws
Similar to marine mammals, marine dragons have evolved limbs specialized for swimming.

Striped Sea Dragon
Dracanguillidus marivenatorus, 25' (8m)
Fast and predatory, this sea orc is popular among those who fish for sport.

Behavior

The habitat of the Atlantic faeroe sea orc ranges in the northern waters, stretching from Cape Cod, Massachusetts, to the Irish Sea and Fjords of Norway. In the winter, the sea orc migrates south to take up its hunting grounds in the Bahamas. The saltwater variety of sea orcs has been reported to have attacked ships, plying the northern sea lanes since the fifteenth century. Some accounts of sea orc attacks in the southern Atlantic have been accredited to the mystical disappearance of ships in the Bermuda Triangle. Today the Atlantic faeroe sea orc is a rare find, having been hunted to near extinction throughout the nineteenth and twentieth centuries. It is now protected as an endangered species. Able to dive to tremendous depths, sea orcs are the natural enemies of the giant squid, sperm whales and large sharks.

Orcling
Although there are no species of sea orc alive in captivity, marine biologists have studied them for centuries. This faeroe sea orc orcling is 36" (91cm) and was caught off the Canary Islands in 1927.
Courtesy of Vanderhaute Oceanographic Institute, Center harbor, New York

Sea Orc Nesting Grounds
The sandy beaches of the oceans are the common nesting grounds of the sea orc.

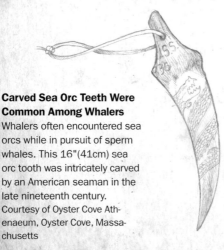

Carved Sea Orc Teeth Were Common Among Whalers
Whalers often encountered sea orcs while in pursuit of sperm whales. This 16"(41cm) sea orc tooth was intricately carved by an American seaman in the late nineteenth century.
Courtesy of Oyster Cove Athenaeum, Oyster Cove, Massachusetts

Artist's Note

Imagining different species of sea dragons allows for a wide array of creatures to be designed. With over forty different species of whales, more than three hundred species of sharks and no less than twenty-eight thousand species of fishes, add to this number the extinct species of marine dinosaurs and plated fish and you can begin to try to imagine how many kinds of sea dragons might exist.

HISTORY

The word *orc* comes from the Latin *orcus*, which means both whale and underworld. This is where the killer whale gets its name orca. It is not in fact a goblin-like monster. The most famous sea orc is, of course, the Loch Ness monster which is a Scottish sea orc. A similar account of the Scottish sea orc is in the epic poem *Orlando Furioso*, by Ariosto, where maidens Angelica and Olympia were to be sacrificed to a sea orc in the Isle of Skye in Scotland. The creature was stopped by the hero Orlando when he wedged a ship's anchor into the creature's mouth. Although some marine biologists suggest that the famous kraken of ancient mythology was a sea orc, it is believed that the kraken was, in fact, a giant squid. Leviathan is also often mistaken to be a sea orc, but it is believed that that titanic animal is actually a cetacean.

The largest specimen of a saltwater sea orc is at the British Maritime Institute in Bangor, Wales. This 225' (69m) specimen was killed in the Irish Sea by the frigate HMS Pertinacious in 1787.

In this illustration by Gustave Dore, done in 1880, the hero Orlando saves Olympia from being sacrificed to a sea orc.

Faeroe Sea Orc Egg, 6" (15cm)
A sea orc clutch usually consists of twenty eggs. Once born, the tiny orclings will race to the sea for safety.

Powerful Jaws Allow Sea Orcs to Consume Massive Prey
This skull shows how this powerful animal can easily feed on even the largest whales and squids in the oceans. The long interlocking teeth allow for snatching at fish.

FAEROE SEA ORC

When approaching a painting of a creature as powerful
and fearsome as a sea orc, there are several elements of the
design that will need to be illustrated. In the case of the
massive faeroe sea orc, the following qualities are impor-
tant, and need to be included in the illustration:

- Underwater habitat
- Swift, eellike movement
- Large mouth for catching prey
- Iridescent coloration

In this illustration, I am drawing inspiration from a host
of large predatory fish, such as sharks, eels, barracuda and
sailfish. All of these animals attack their prey with lightning
speed in the deep water.

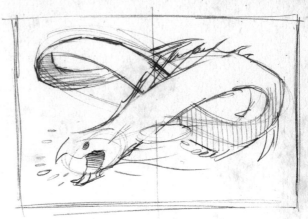

1 Thumbnail Design
Using the reference of other animals such as eels,
begin your illustration with a thumbnail sketch. Try to incor-
porate all of the elements listed into this one illustration.

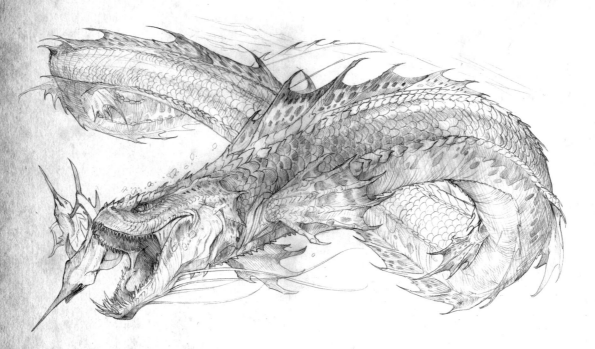

2 Complete the Finished Drawing
Using an HB pencil, complete a detailed
rendering that includes all of the necessary
details for the painting. Scan the drawing.

Artist's Note

When trying to depict movement, always show
the shapes looping back on themselves. Whether
this is cloth, rope, or a serpent, a looping shape
is far moore suggestive of undulation than a stiff,
straight line.

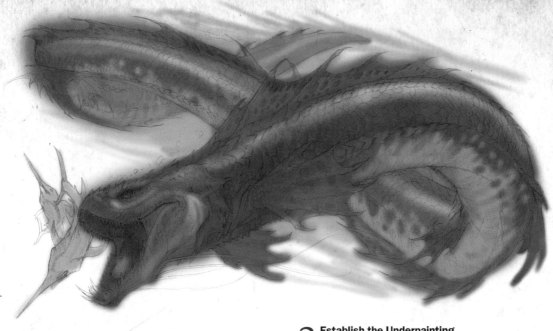

3 Establish the Underpainting

In a new layer in Multiply mode, begin the underpainting by roughly blocking in the shapes to quickly establish the silhouette of the composition. Also establish the lights and shadows at this point. Here, the light is coming from above and will strike the shiny scales towards the top.

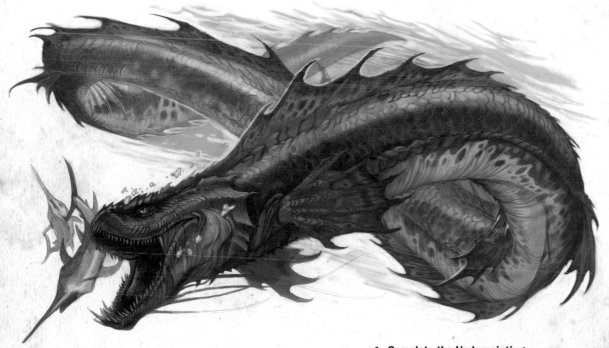

4 Complete the Underpainting

Using transparent brushes, complete the underpainting, outlining all of the details of the creature. Add more details to the areas you want to appear to come forward and keep the background details less defined. With smaller brushes, add patterns to the scales and refine the facial features.

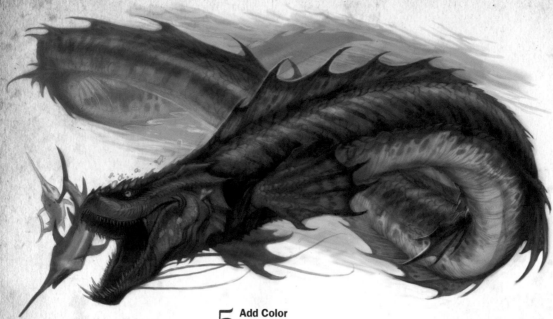

5 Add Color

Using broad strokes and general shapes, rough in the color scheme on a new semi-transparent layer over the underpainting. Touch up the swordfish the sea orc is chasing. Bring in some greens and light browns for the scales in the front and middle sections of the sea orc. These colors will contrast against the light blue underbelly and make it appear shimmery. With small brushes, color the eyes and teeth using yellows and reds.

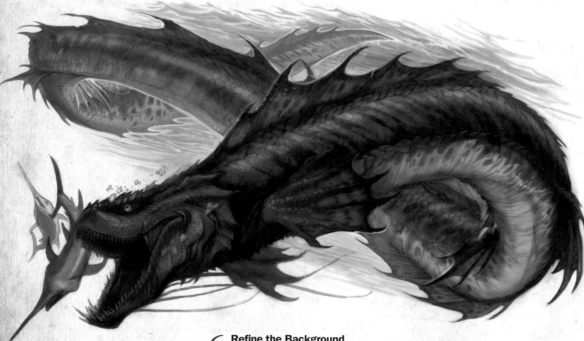

6 Refine the Background

To enhance the large size and sense of movement, recede the tail of the sea orc into the murky water so the sharp detail of the head is in stark contrast to the the softness of the tail. This optical illusion is an effective way of foreshortening such a long creature without losing the impact of its size.

Bring in some of the sea orc's color from step 4 into the waves using semiopaque color. Lengthen the trail of bubbles escaping from the orc's mouth to enhance the appearance of quick movement.

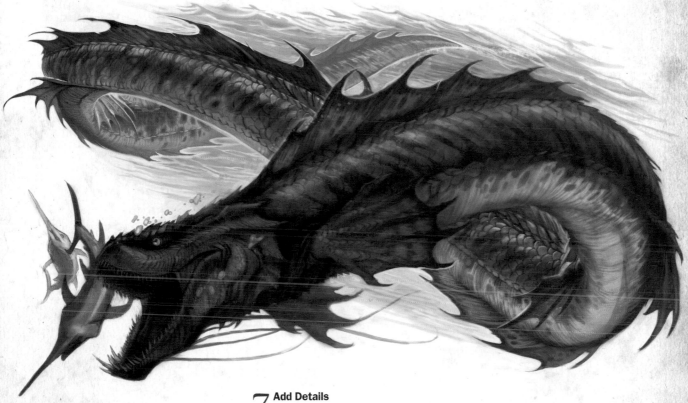

7 Add Details

Starting in the background and slowly working forward, carefully add the highlights of the sea orc. Take your time at this stage; the details are what will make the image convincing. Pay special attention to the middle section of the sea orc's body. Punch up the contrast between the blue and gray color in this area and use small semiopaque brushes to refine each of the scales.

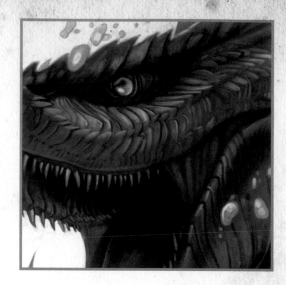

8 Refine the Head and Mouth

With your smallest brushes and opaque color, refine the sea orc's face and mouth. Carefully add shadows and highlights to the scales surrounding the face. Then sharpen color and detail of the eyes, mouth and teeth.

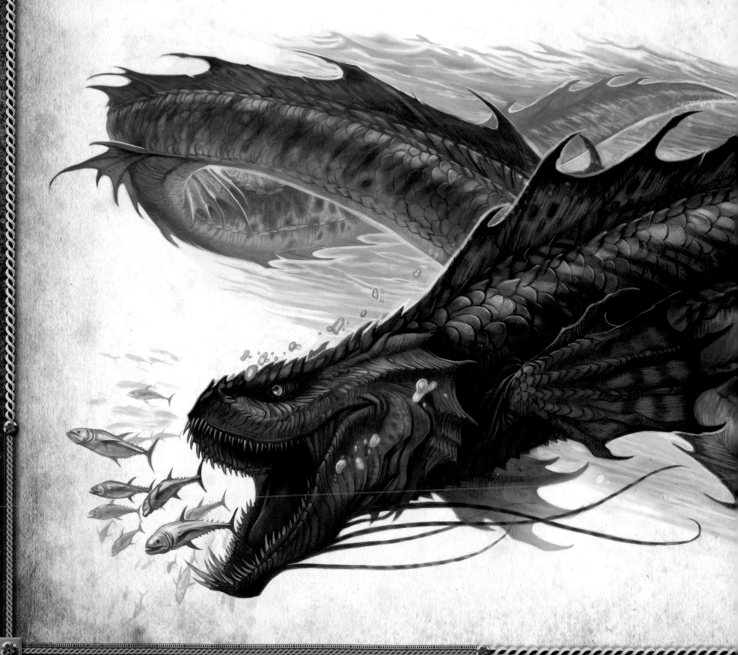

9 Refine the Front Scales
Add a brighter blue and a light highlight along the front of the sea orc's body. This highlight will make the scales appear to shimmer and will help definte the orc's form.

10 Adjust the Middle Scales
Lighten the scales toward the middle and back of the orc's body. This will help the front section of the body stand out even more.

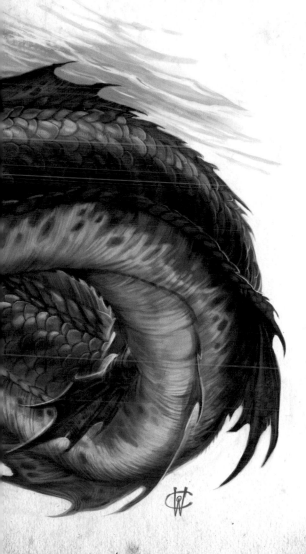

11 Alter the Background Fish and Add the Final Touches
Using the smallest brushes and opaque color, refine any areas of the painting that need touching up. I didn't like the look of the swordfish, so I created a new layer in Normal mode with an opacity setting of 100%. I then created the new fish design directly over the earlier version.

WYRM

Draco ouroboridae

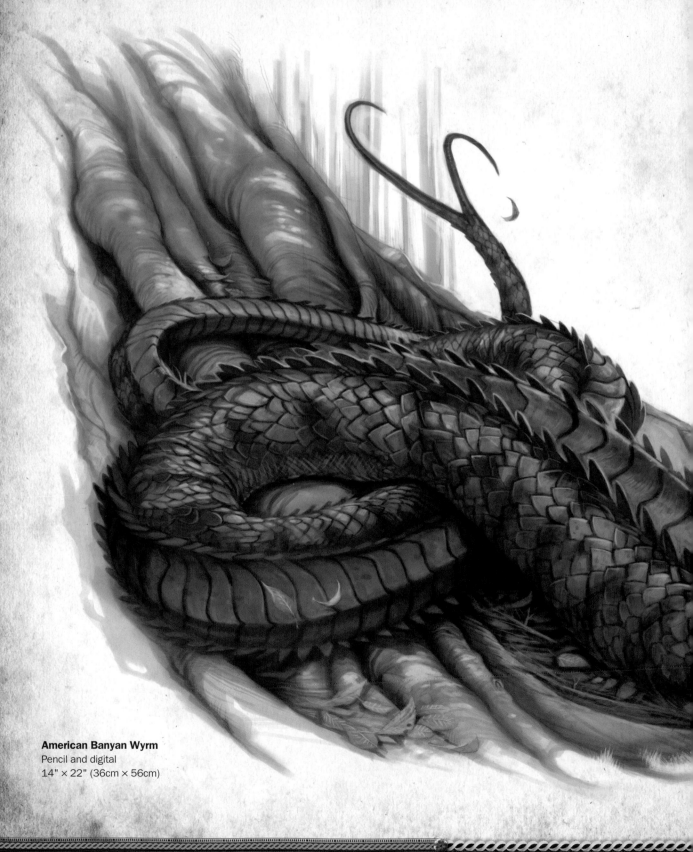

American Banyan Wyrm
Pencil and digital
14" × 22" (36cm × 56cm)

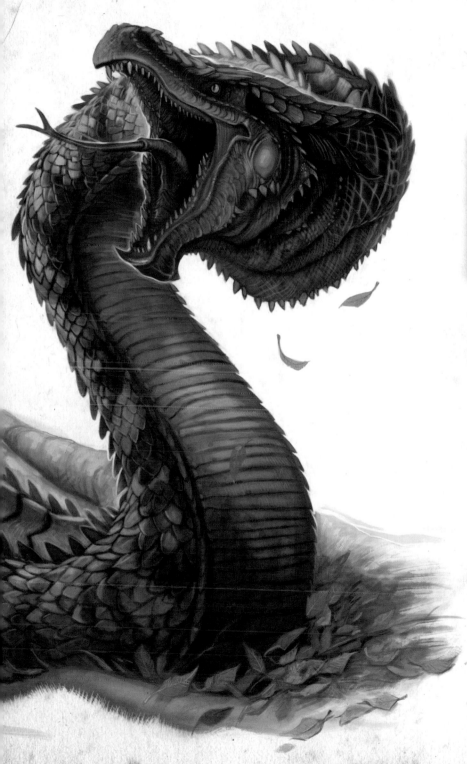

SPECIFICATIONS

Size: 50' (15m)

Wingspan: None

Recognition: Scaled snake-like body. Camouflage patterning varies by species

Habitat: Temperate to tropical climates, especially lowlands and wetlands

Species: African striped wyrm, American banyan wyrm, Asian marsh wyrm, European lindwyrm, Indian drakon

Also known as: Worm, serpent, lindwyrm, lyndwyrm, lindworm, wurm, worm king, ouroborus, drakon, drakonne

Biology

One of the most infamous families in the dragon class, the wyrm has been perhaps the most feared creature throughout all human cultures. The wyrm is distinguished by both its lack of wings and legs, although the lindwyrm species do have small vestigial legs. Looking much like an armored snake, wyrms can reach tremendous sizes of more than 50' (15m), although the average wyrm only reaches 25' (8m) due to harsh hunting practices that have cut down their populations drastically. Natural enemies of alligators, crocodiles and hydra, wyrms live along swampy riverbanks and saltwater tidal basins, hunting large animals such as boar and deer. Although not able to breathe fire, the wyrm is able to spray a cloud of misted poison that can paralyze and blind its prey, allowing the animal to swallow its quarry whole.

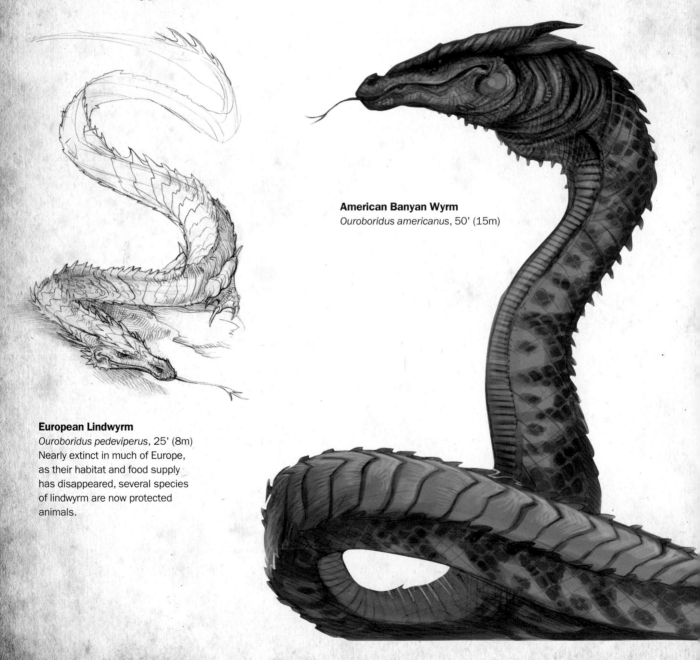

American Banyan Wyrm
Ouroboridus americanus, 50' (15m)

European Lindwyrm
Ouroboridus pedeviperus, 25' (8m)
Nearly extinct in much of Europe, as their habitat and food supply has disappeared, several species of lindwyrm are now protected animals.

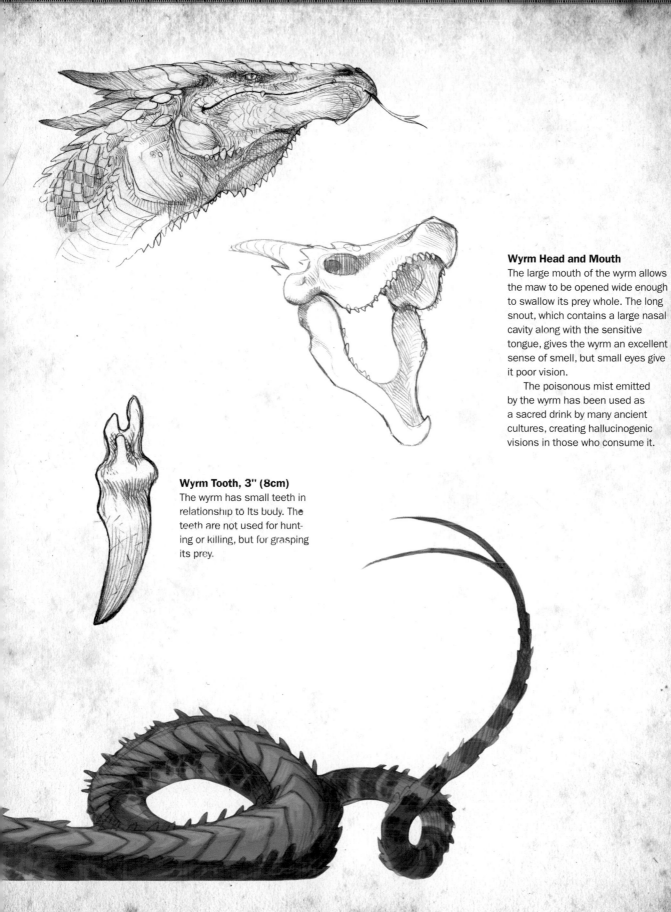

Wyrm Head and Mouth
The large mouth of the wyrm allows the maw to be opened wide enough to swallow its prey whole. The long snout, which contains a large nasal cavity along with the sensitive tongue, gives the wyrm an excellent sense of smell, but small eyes give it poor vision.

The poisonous mist emitted by the wyrm has been used as a sacred drink by many ancient cultures, creating hallucinogenic visions in those who consume it.

Wyrm Tooth, 3" (8cm)
The wyrm has small teeth in relationship to its body. The teeth are not used for hunting or killing, but for grasping its prey.

Behavior

The wyrm is a solitary and viciously territorial animal that makes its lairs under the roots of large trees along rivers and lakes. Lying in wait for prey to come to the water to feed, the wyrm sprays a plume of noxious gas that paralyses or dazes its prey, giving the wyrm time to capture and coil around the animal. Using its powerful body muscles, the wyrm constricts around its prey, suffocating and crushing the animal to death. The wyrm then typically swallows its prey whole. The eastern species of wyrm typically hide in the trees branches and dangle down waiting for prey to pass by. Large specimens of wyrm have been discovered with the remains of cattle in their stomachs. One report actually claims that an Indian drakon (*Ouroboridus marikeshus*) was discovered at more than 100' (30m) and contained the remains of an elephant.

Movement of the Wyrm
The coiling, serpentine motion of the wyrm can be seen in these sketches, where the body movement resembles that of a whip.

Wyrm Egg, 10" (25cm)
A clutch of four to five wyrm eggs laid in the roots of a tree will be intensely guarded by the mother.

Wyrm Habitat
Wyrms tend to live in temperate to tropical climates, especially in lowlands and wetlands where they lie in wait for their prey.

HISTORY

Almost every culture in the world has a long mytho-logical history of giant serpents. The famous accounts of Python, who was slain by Apollo in classical mythology, Nidhogg of ancient Norse mythology and the serpent in the Garden of Eden are all assumed to have been wyrms. Such creatures would have been a terrible threat to early human cultures whose survival relied upon settlements along rivers. Other fables that are accredited to wyrms are the Questing Beast of King Arthur and the dragon that swallowed Saint Margaret. The wyrm possesses spiritual symbolism in many ancient religions in the form of the serpent eating its own tail, or ouroboros, symbolizing infinity or the circle of life, from which is derived the wyrm's family name.

Ouroborus
The ouroborus was a symbol used in medieval European alchemy to illustrate the concept of infinity. It is the precursor to the infinity symbol (∞) used today.

Wyrms and Ancient Celts
Nowhere was the serpent more revered than in Celtic art. Symbolizing the labyrinthian maze of life, the coiling circles of a Celtic knot were inspired by the wyrm. Once a fearsome foe to Irish natives, there are today no species of wyrm living on the island, said to have been driven off by Saint Patrick.

American Banyan Wyrm

The wyrm has been depicted in many cultures throughout history. In order to capture the essence of this animal, there are certain qualities that are necessary to include in the painting. From the conceptual and historical references for the wyrm in the previous pages, it's important to try to incorporate all of these qualities into one image:

- Solitary habits
- Inhabits swampy marshes around trees
- Coils in complex circles
- Swallows its prey whole

Exploring of different kinds of scales found on snakes and lizards will help you come up with a unique yet believable pattern. Look at reference materials for the banyan trees and their leaves to get the environment accurate.

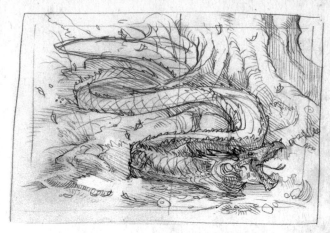

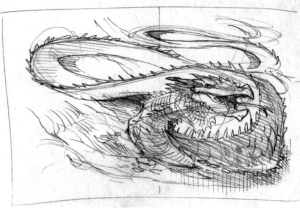

1 Thumbnail Design Sketches

Beginning with compositional design sketches, experiment with several ideas for the wyrm's position and placement. I rejected these early design drawings because they didn't demonstrate the coiling power of the wyrm to the best effect. A position where the creature is rearing up and creating loops produces more drama and looks more like the infinity symbol discussed in the sidebar on page 141.

Working Out the Kinks

The coiling shape of the wyrm can get confusing, so establish the structural framework with basic shapes. The form of the wyrm acts like a stretched-out Slinky.® Here you can see the angle of the internal structure and the arrows that indicate the direction all the scales need to follow.

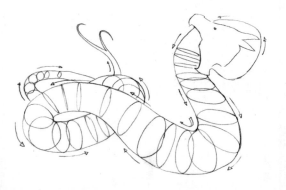

2 Do the Final Drawing

Draw the composition with an HB pencil on bristol board, referring to your thumbnail sketches. As you work, keep in mind the wyrm's anatomy (refer back to the sidebar on page 142) and its directional flow. The scale pattern you use is completely up to you; I chose to draw thick, pointed, armored scales like those on a rattlesnake.

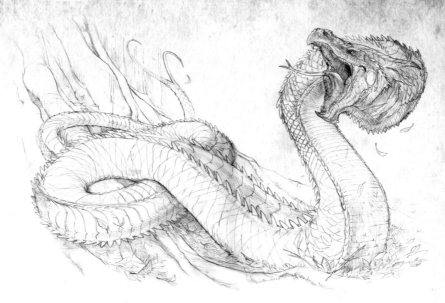

3 Establish the Underpainting

In a new layer in Multiply mode, block in the basic shapes and forms using a single mono chromatic color. Keep the color transparent and begin with simple shapes and develop more detail as you work. Don't work in too many details at this point, since this work is the foundation of later work to be done over this. Notice how the scale patterning is merely indicated, allowing for alterations to occur as the painting progresses.

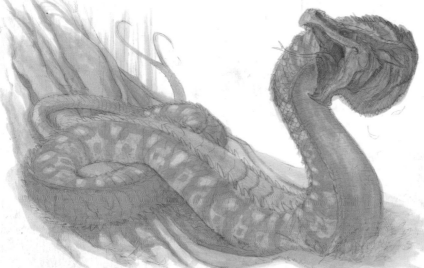

4 Complete the Underpainting

In a new layer and still using transparent colors, complete the underpainting by outlining all of the details of the wyrm. Add more details to the areas you want to appear to come forward and keep the background details less defined. With smaller brushes, add patterns to the scales and refine the facial features.

Feel free to experiment at this stage. Since you're working in a new layer, you won't damage the work done in earlier layers.

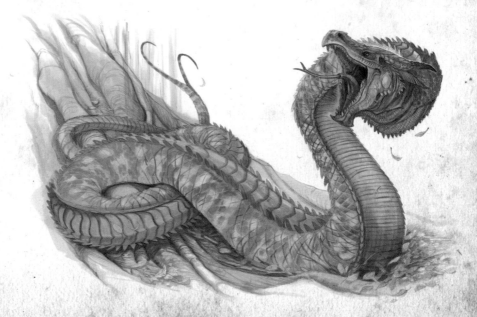

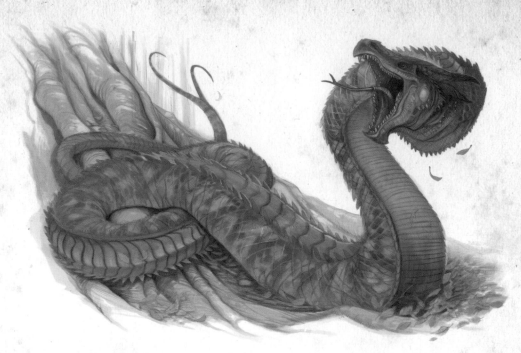

5 Add Color

In a new layer in Normal mode with 50% opacity and using broad strokes, block in the basic colors of the wyrm. Work loosely here since the colors will change as the painting develops. Add dappled light falling over the tree trunk and warm, golden leaves to contrast with the cool colors of the wyrm.

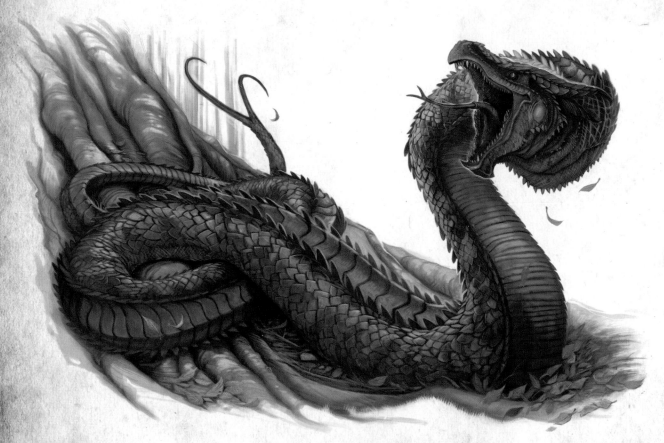

6 Refine the Background and Add Details

Working with smaller brushes and opaque color, complete the details of the wyrm. Add a turquoise blue to make the wyrm's hide pop against the background and refine the eyes, mouth and teeth with reds and yellows. Punch up the color and texture of the tree bark and leaves.

Detail of Leaves
With small brushes add highlights to the golden leaves. The complementary golden tone of the leaves will help the blue color of the wyrm stand out.

Detail of Reflected Light
Add cool, reflected light splashing across the back of the wyrm to give more volume and dimension to the wyrm's form.

Detail of Scales
Paint each scale with your smallest brushes, varying the color and pattern of the hide. Your patience will be rewarded.

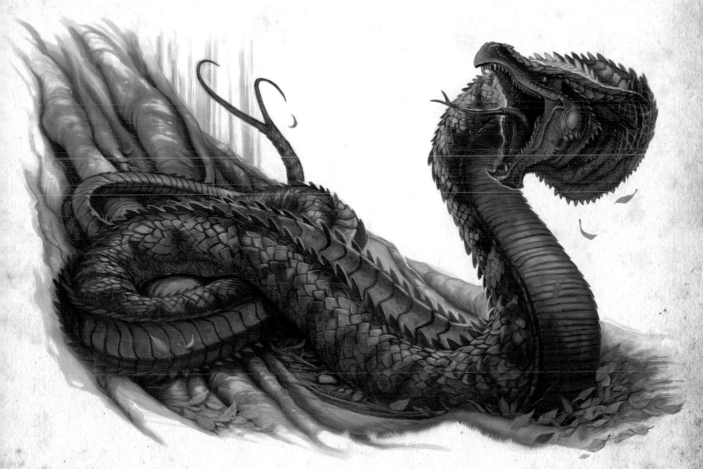

7 Add the Finishing Touches
Working with smaller brushes and opaque colors, complete the details of the wyrm.

Wyvern

Draco wyvernae

SPECIFICATIONS

Size: 30' (9m)

Wingspan: 30' (9m)

Recognition: Red eye spots on wings (male); brown and green markings (female); large, spiked club on tail

Habitat: Alpine and mountainous regions in the Northern Hemisphere

Species: Asian wyvern, European wyvern (extinct), golden wyvern, North American wyvern, sea wyvern

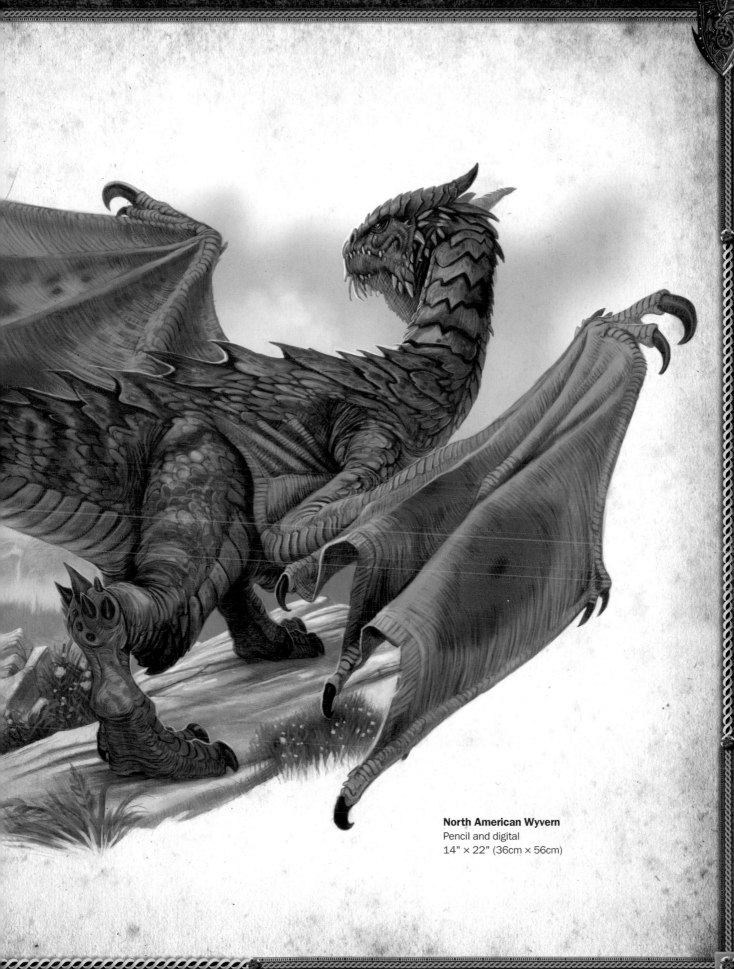

North American Wyvern
Pencil and digital
14" × 22" (36cm × 56cm)

BIOLOGY

By far one of the most dangerous and ferocious members of the dragon class, the wyvern is sometimes referred to as the dragon wolf.

Averaging 30' (9m) long with a 30' (9m) wingspan, the wyvern has two legs and a spiny tail surmounted by a poisonous stinger. Their durable hides of armored scales gives wyverns ample protection to fight off other predators and even larger dragons when fighting in a pack. Although the wyvern does not possess a breath weapon, his poisonous stinger, powerful body and ferocious maw of razor-sharp teeth make it a formidable foe.

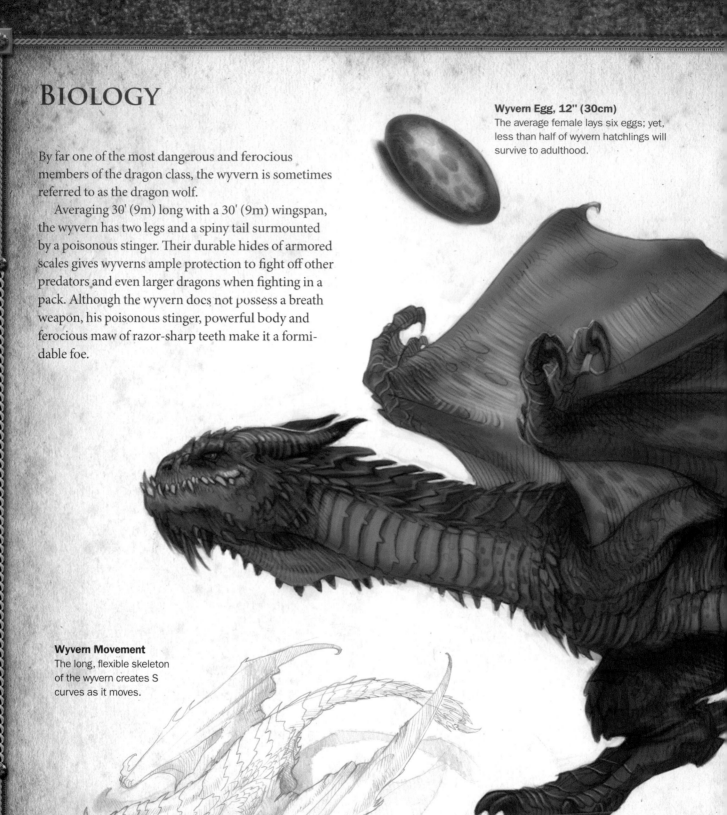

Wyvern Egg, 12" (30cm)
The average female lays six eggs; yet, less than half of wyvern hatchlings will survive to adulthood.

Wyvern Movement
The long, flexible skeleton of the wyvern creates S curves as it moves.

North American Wyvern
Wyvernus morcaudus, 30' (9m)

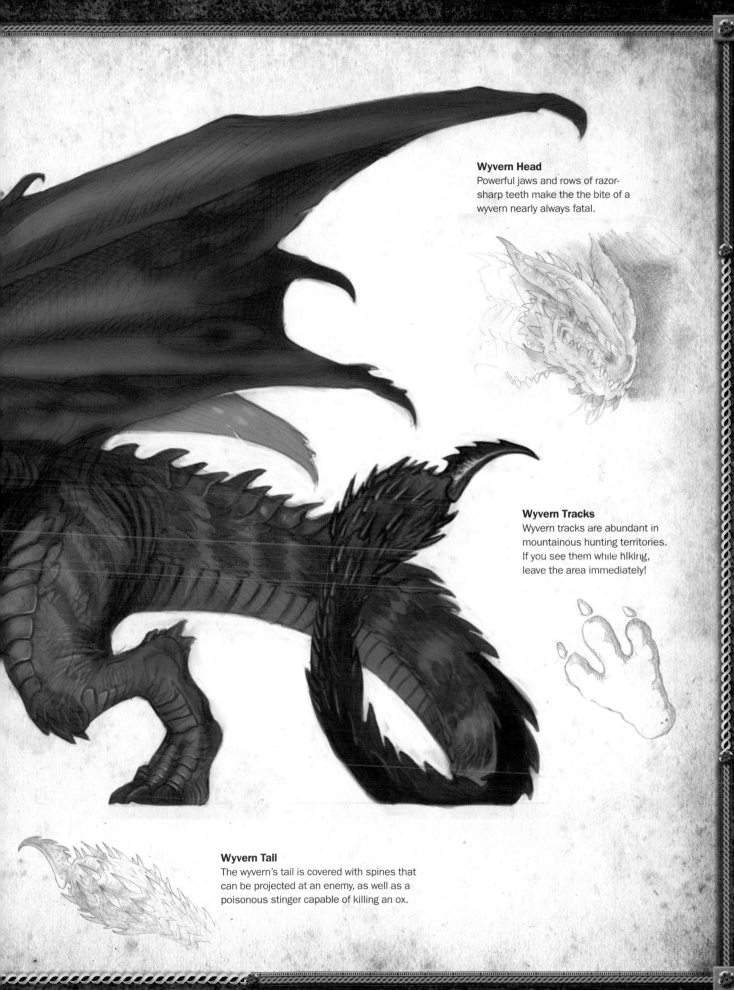

Wyvern Head
Powerful jaws and rows of razor-sharp teeth make the the bite of a wyvern nearly always fatal.

Wyvern Tracks
Wyvern tracks are abundant in mountainous hunting territories. If you see them while hiking, leave the area immediately!

Wyvern Tail
The wyvern's tail is covered with spines that can be projected at an enemy, as well as a poisonous stinger capable of killing an ox.

WYVERN FLIGHT ABILITIES

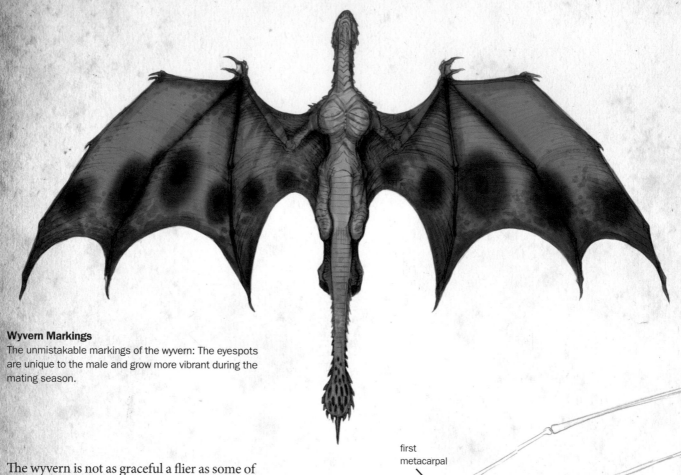

Wyvern Markings
The unmistakable markings of the wyvern: The eyespots are unique to the male and grow more vibrant during the mating season.

The wyvern is not as graceful a flier as some of its cousins. The large tail and bulky plates make it ungainly in the air.

What the wyvern lacks in agility it makes up for with brute force and power. Hunting in packs and using its poisonous clubbed tail allow the wyvern to be the only natural enemy of the great dragon (see pages 64–77).

first metacarpal

second metacarpal

third metacarpal

terminus mortis

Wyvern Skeletal Structure

In early paleontology, dragon skeletons and dinosaur skeletons were often confused. It was not until 1913 that Dr. Francis H. Kellerman discovered that dragons, like birds, diverged from the dinosaurs some time around one hundred million years ago.

The hollow bones of the dragon were one of the key factors in the classification of all the dragon species and gives them a class of their own. Today dragons are studied around the world in universities and colleges. Close studies of predatory dragons like the wyvern are common, with many draconologists tagging species to study their migration and behavioral habits. Tourists also like to go on dragon safaris to see these dangerous and other wild creatures up close.

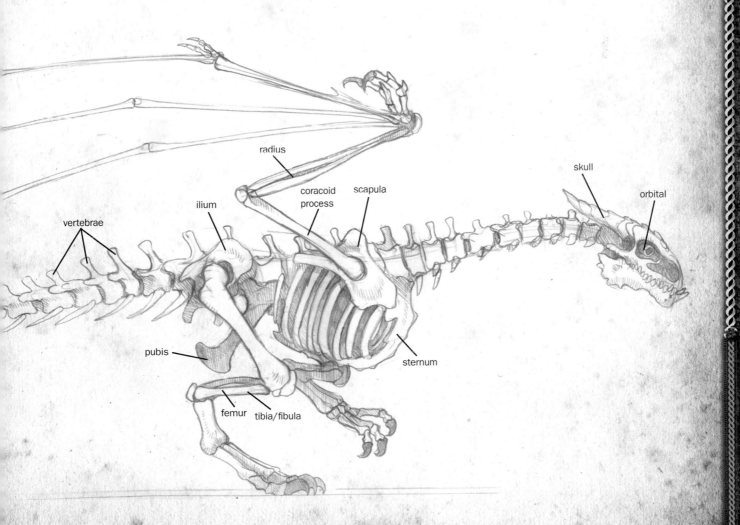

BEHAVIOR

The wyvern is a social animal that lives in packs of up to twelve individuals, ranging over a territory many hundreds of miles in area. Hunting in packs allows for more successful attacks on prey, which include animals such as the moose, elk, bear, caribou and (its favorite) the dragonette. Pack society also enables the wyvern to fight off other packs of wyverns competing for hunting territory.

During the rutting season in the fall, the wyvern male wing patterning becomes vibrant in order to attract a female. The competition between males is fierce, often resulting in the death of rivals. The wyvern, like other temperate climate dragon species, hibernates through the winter when food is scarce.

Fearsome Fighter
Feared throughout all cultures, wyverns are ferocious fighters.

Expert Hunter
Hunting over large expanses of wilderness, the wyvern is a danger to people and their animals.

History

The wyvern is the beast responsible for most of the injuries throughout history reported as dragon attacks. It is believed by contemporary accounts and period artwork that the beast slain by Saint George was, in fact, a wyvern and not a dragon.

The European wyvern went extinct in the 1870s. The last known specimen was placed on tour with P. T. Barnum's circus until 1898 and is now in permanent exhibit at the Chicago Museum of Natural History.

The Asian and other wyvern species are still flourishing and many casualties are reported each year as new developments encroach upon their habitat.

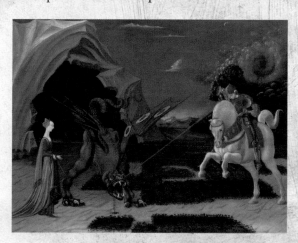

European Wyvern
The European wyvern was a common enough sight in medieval Europe to influence the work of many of the Old Masters. *Saint George and the Dragon*, Paulo Uccello, 1456, National Gallery, London

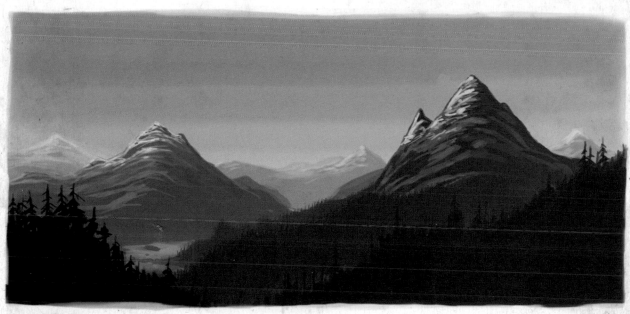

Wyvern Habitat
Wyvern habitat ranges all over the world's alpine regions. Although extinct in the Alps, the Asian wyvern is moving westward.

NORTH AMERICAN WYVERN

The North American wyvern's habitat is particular to the Rocky Mountains of the United States and its colorations are unique to its species. As with the other dragons in the *Dracopedia*, make a list of your wyvern's attributes that will be explored in your work before getting started:

- Two legged
- Alpine habitat
- Rugged build
- Bright wingspots on males
- Spiked and clubbed tail

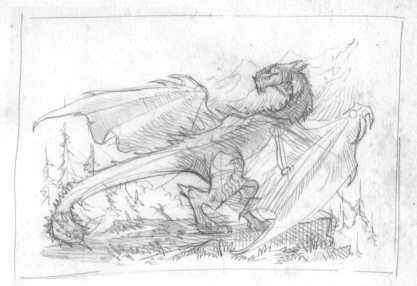

1 Create a Thumbnail Sketch
Work out the details that will go into your finished painting by completing some thumbnail sketches. Since the wyvern's spiked tail is the most fascinating feature, place it in the foreground. The patterned wings, musculature and scales also should be showcased. Placing the animal against a backdrop of the Rocky Mountains illustrates its habitat.

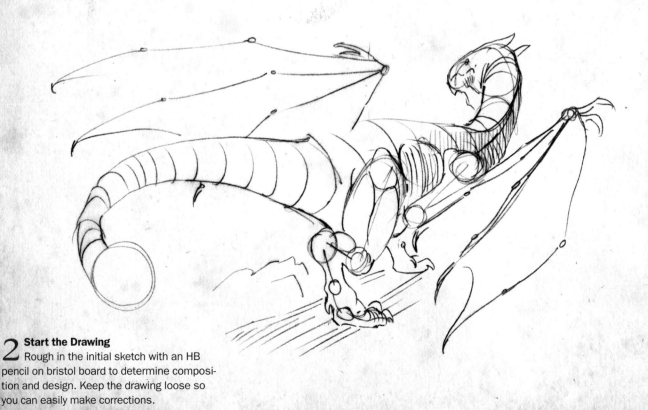

2 Start the Drawing
Rough in the initial sketch with an HB pencil on bristol board to determine composition and design. Keep the drawing loose so you can easily make corrections.

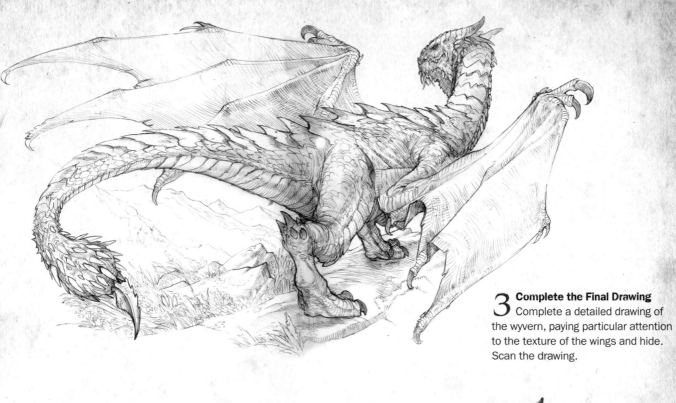

3 Complete the Final Drawing

Complete a detailed drawing of the wyvern, paying particular attention to the texture of the wings and hide. Scan the drawing.

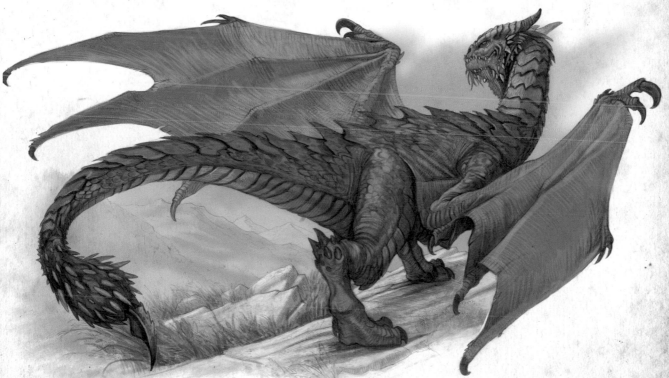

4 Establish the Underpainting

Create a new layer in Multiply mode. Establish the basic texture, lighting and depth of the painting using the full value range of a single hue. This step will give a great deal of mass and volume to the subject. Whether you work traditionally or digitally, keep your work loose and transparent to allow the sketch to show through.

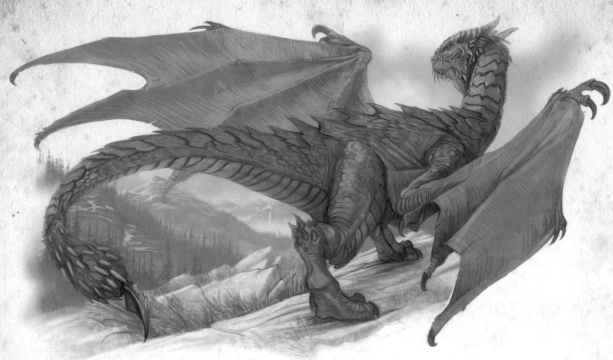

5 Add Color

Create a layer in Normal mode with an opacity of 50%. Continue to refine the painting, working from the back to the front. Using consecutively deeper shades of blue creates a rolling vista that disappears into the horizon, giving the illusion of great depth. Increasing the detail as the image moves closer also enhances this illusion.

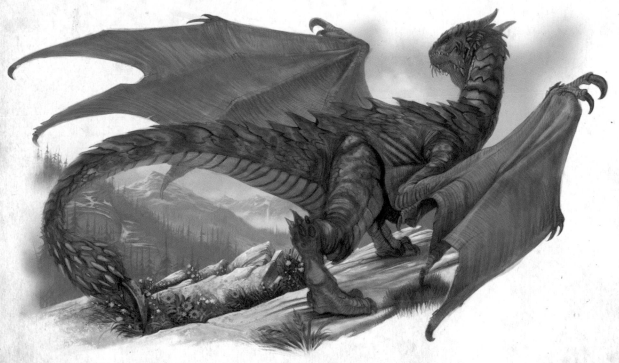

6 Refine the Details

Work on the middle ground and foreground areas of the painting (see sidebar below). Contrast the rocks and flowers with the soft background by making their colors more vibrant and adding more detail. Using roughly textured brushstrokes on the rocks, along with light rocks and vibrant flowers, helps to create a sense of distance between the foreground and the hazy ridge line.

The Hide

Building up the texture in layers adds depth and complexity. This technique is similar to the rendering of the flowers on page 109.

1. Complete the drawing.

2. Add the underpainting.

3. Place the colors.

4. Render the details.

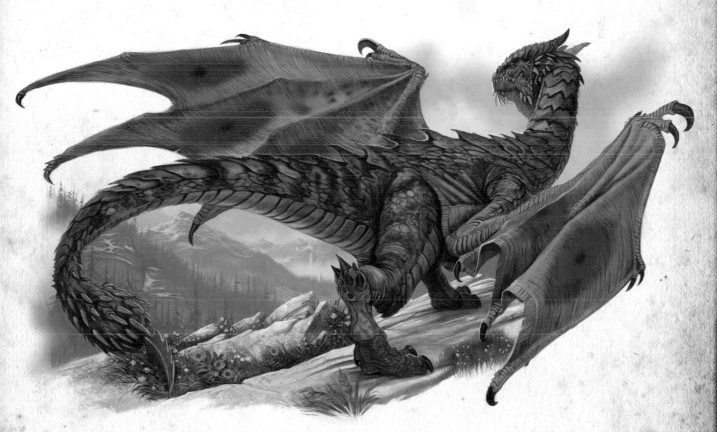

7 Apply the Finishing Touches
Make any last revisions, as necessary.

INDEX

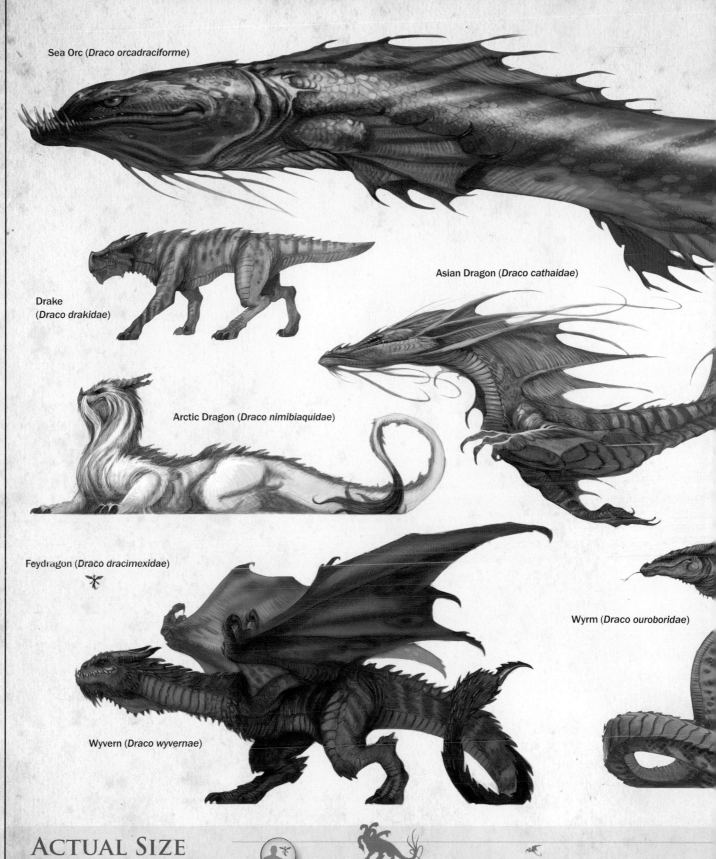

Sea Orc (*Draco orcadraciforme*)

Drake
(*Draco drakidae*)

Asian Dragon (*Draco cathaidae*)

Arctic Dragon (*Draco nimibiaquidae*)

Feydragon (*Draco dracimexidae*)

Wyrm (*Draco ouroboridae*)

Wyvern (*Draco wyvernae*)

ACTUAL SIZE COMPARISON

This chart shows the actual size*
comparison of all the dragons.
*The sea orc is shown at a mid-size of
200" (61m), but can be found at an
unbelievable 300" (91m).

Hydra, 30' (9m)

Amphiptere, 6' (183cm)

Feydragon, 9"
(23cm)

Arctic Dragon,
24' (7m)

Human, 6'
(183cm)

Coatyl, 10' (3m)

Asian dragon

DRAGONS OF THE WORLD

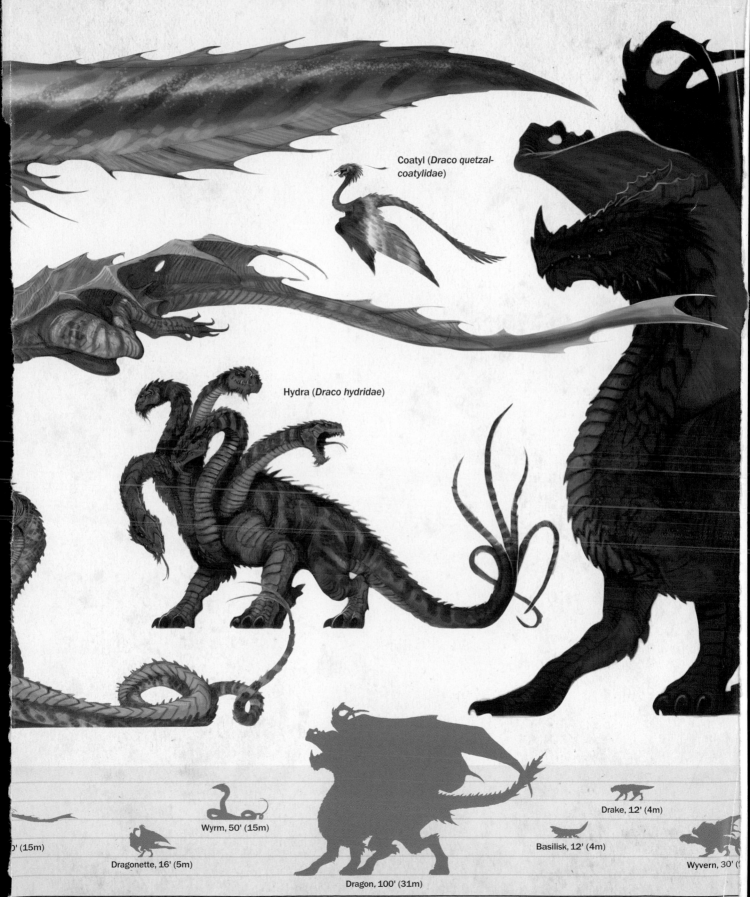

Coatyl (*Draco quetzal-coatylidae*)

Hydra (*Draco hydridae*)

Wyrm, 50' (15m)

Drake, 12' (4m)

0' (15m)

Dragonette, 16' (5m)

Basilisk, 12' (4m)

Wyvern, 30' (

Dragon, 100' (31m)

Basilisk (*Draco lapisoculidae*)

Amphiptere (*Draco amphipteridae*)

Dragon (*Draco dracorexidae*)

Dragonette (*Draco volucrisidae*)

Sea Orc,* 200ᶠᵗ (61m)

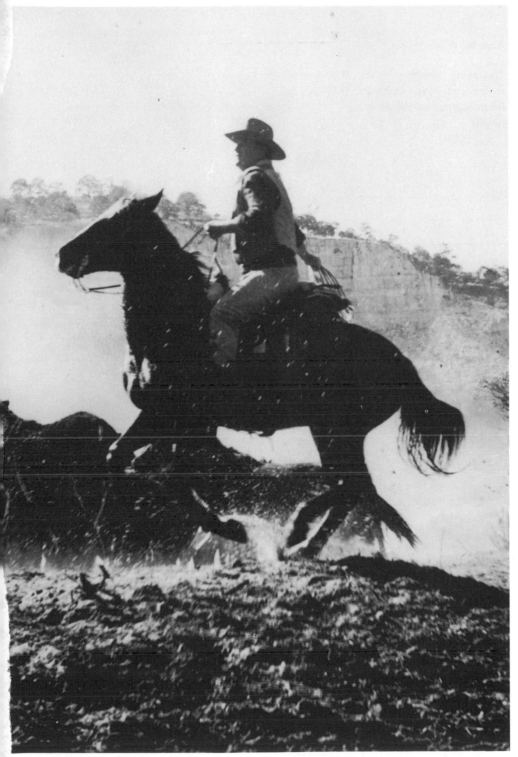

JOHN WAYNE in THE SONS OF KATIE ELDER

The Western

Also by Allen Eyles:

The Marx Brothers: Their World of Comedy
Hollywood Today (with Pat Billings)
John Wayne and the Movies
Bogart

THE
WESTERN

Allen Eyles

South Brunswick and New York: A. S. Barnes and Company
London: The Tantivy Press

A. S. Barnes and Co., Inc.
Cranbury, New Jersey 08512

The Tantivy Press
108 New Bond Street
London W1Y OQX, England

Library of Congress Cataloging in Publication Data

Eyles, Allen.
 The Western.

 Includes index.
 1. Western films—-Pictorial works. 2. Western
films—Catalogs. I. Title.
PN1995.9.W4E9 1975 016.79143′0909′32 72-9941
ISBN 0-498-01323-5

SBN 0-904208-65-6 (U.K)
PRINTED IN THE UNITED STATES OF AMERICA

Contents

Introduction: *page 9*
The Westerners: *page 11*
consisting of—

Film Index: *page 153*

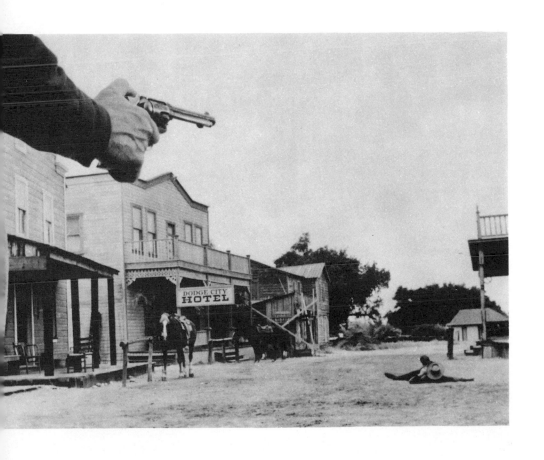

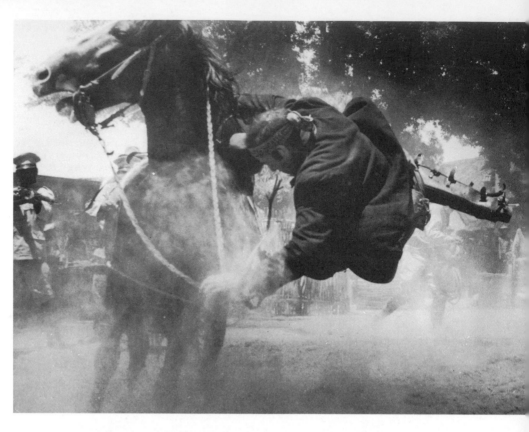

Above: THE WILD BUNCH. Below: FIRECREEK

Introduction

It is several years since the first edition of this book appeared. This new edition has been thoroughly updated and includes all Westerns that were released or known to be in production by the summer of 1974. I'm glad to say that it has also been possible to extend the number of artists covered by the book and there are sixty new names (including more of the legendary figures of the old West with a record of their screen portrayals) while the index now covers some 3,500 titles including those used for British release and American TV screening.

As a result, I hope the book focuses on the Western work of most of the artists that any fan of the *genre* could want to know about. I have aimed to make the listings as complete as possible where film titles are concerned; since it is impossible to research exhaustively such an enormous number of careers, some omissions are inevitable but they should be of a minor nature. In making the basic choice of entries for the book, I was well aware of a number of supporting players and minor Western stars that might have also been included, but in most instances it would be a difficult task for even their keenest fans to compile a semi-complete list of their work.

It must be made clear that this book is only about the Western. The filmographies here cover work associated with this one *genre* and exclude everything else. I have, however, sought to include films that relate to an artist's Western work even when they have a very tenuous connection with the *genre* or are clearly outside it except in one particular. Wherever a film has been outside the conventional, unarguable definition of what a Western is, I have indicated its differences in brackets after the title so that only those films that are unannotated in this way are "pure" examples of the *genre*. (With some of the longest entries, covering series work, it has not been possible to mark every film that has a modern setting or musical content, although a general note is given.)

All the work in this book has been freshly researched but I have obviously taken advantage of research done on the same artists in such magazines as "Films in Review," "Views and Reviews" and "Filmograph" as a means of checking and extending my own work. In addition, the American Film Institute Catalog of feature films that appeared between 1921 and 1930 has proved indispensable. Beyond that, I remain most grateful for the assistance that Pat Billings and Christopher Wicking provided for the original edition, and further thank Pat Billings for the stream of corrections and additions (especially of uncredited appearances) that he has directed my way ever since, as well as John Brooker for some last-minute assistance.

Stills are used by courtesy of: C.I.C., Columbia, Columbia-Warner, Fox-Rank, MGM, Paramount, Rank, 20th Century-Fox, United Artists, Warner-Pathe, with special thanks to Pat Suckling and Tom Vallance.

APACHE

The Westerners

In the following entries, the letter W is used to represent the word Western. Dates of birth and death are given where it has been possible to find them (and several dates are given where it has been impossible to resolve contradictions in year of birth). Films are listed as far as possible in order of their appearance (rather than the order in which they were made), and the dates of the first and last film in each entry are given.

Where a film's title was changed for release in Britain, the new title is given after the original American one with a stroke intervening, e.g. *Ride the High Country/Guns in the Afternoon*. Many films have had their titles changed for showing on American television and these new titles are usually shown after the old one in the following fashion: *Rawhide* (TV: *Desperate Siege*). Normally, these changes of title do not occur when the films are shown on British television. Films made for American television and seen on British cinema screens are listed with the annotation (TV) after their titles.

The following abbreviations are used:

ep.: episode
(s): serial
N-W: North-Western, i.e. one located in Canada or Alaska
dir.: directed
prod.: produced
2r.: 2 reels

In entries relating to screenwriters:
St.: story
Sc.: screenplay
Co—: collaboration with one other credited writer
Adap.: adaptation
Add. dia.: additional dialogue

And in entries relating to cameramen:
* denotes work in colour
† denotes work in 'scope

1 ACOSTA, Rodolfo (also Rudy, Rodolpho, Rudolfo). Lean, usually mean, a familiar "malevolent Mexican", also at ease as a nasty Indian, he began his screen career in Mexican pictures in 1946, and came to Hollywood in 1950 where his accent and looks quickly found him a comfortable niche. Died 1974.
Pancho Villa Returns (Mexican W) (50), *Horizons West, San Antone, City of Bad Men, Wings of the Hawk* (Mexico), *Hondo, Passion* (early California), *Drum Beat, The Proud Ones, Bandido* (modern Mexico), *Trooper Hook, Apache Warrior, From Hell to Texas/Manhunt, Walk Like a Dragon, Flaming Star, One Eyed Jacks, Posse from Hell, The Second Time Around* (comedy), *How the West Was Won* (ep. "Outlaws"), *Savage Sam, Rio Conchos, The Sons of Katie Elder, The Reward* (modern), *Return of the Seven,*

RODOLFO ACOSTA in *Bandido*

JULIA ADAMS with Joel McCrea
in *The Gunfight at Dodge City*

*Young Billy Young, Flap/The Last
Warrior* (comedy), *The Magnificent
Seven Ride!* (72).

2 ADAMS, Gerald Drayson (1900–
). Canadian screenwriter, former
export executive and literary agent,
his best work is his studies of Indians,
especially his basically factual treat-
ment of *The Battle at Apache Pass*.
 Co-sc. *Old Los Angeles* (48), co-
sc. *The Plunderers,* sc. *The Gallant
Legion,* co-sc. *The Lady from
Texas,* st. sc. *Flaming Feather,* st. sc.
The Battle at Apache Pass, st. co-sc.
The Duel at Silver Creek, part sc.
Untamed Frontier, novel basis *Wings
of the Hawk* (Mexico), st. sc. *Three
Young Texans,* st. adap. *Taza Son
of Cochise,* st. co-sc. *Chief Crazy
Horse/Valley of Fury,* st. *Tomahawk
Trail/Mark of the Apache,* st. co-sc.
Gun Brothers, sc. *War Drums,* st. co-
sc. *Gun Fight,* st. sc. *The Wild
Westerners* (62).

3 ADAMS, Julia (also Betty,
Julie) (1926–). Pleasant, attrac-
tive, rosy-cheeked actress who began
her career as Betty Adams in very
minor Lippert Ws, then made a fresh

start at Universal in bigger vehicles.
Now in TV.
 The Dalton Gang (TV: *The Out-
law Gang*) (49), *Hostile Country*
(TV: *Outlaw Fury*), *West of the
Brazos* (TV: *Rangeland Empire*),
Marshal of Heldorado (TV: *Blazing
Guns*), *Colorado Ranger* (TV: *Guns
of Justice*), *Crooked River* (TV:
The Last Bullet), *Fast on the Draw*
(TV: *Sudden Death*), *Bend of the
River/Where the River Bends, The
Treasure of Lost Canyon, Horizons
West, The Lawless Breed, The Man
from the Alamo, Wings of the Hawk*
(Mexico), *The Stand at Apache
River, Slim Carter* (modern W film-
making comedy), *The Gunfight at
Dodge City* (59).

4 AGAR, John (1921–). He
played the likable young cavalry lieu-
tenant in two John Ford Ws, one of
them (*Fort Apache*) with then wife
Shirley Temple. Recently part of the
A. C. Lyles team of veteran faces,
now a regular with John Wayne.
 Fort Apache (48), *She Wore a
Yellow Ribbon, Along the Great
Divide, Woman of the North Country,*

JOHN AGAR in *Waco*

The Lonesome Trail, Star in the Dust, Flesh and the Spur, Ride a Violent Mile, Frontier Gun, Law of the Lawless, Stage to Thunder Rock, Cavalry Command (Philippino W), *Young Fury, Waco, The Undefeated, Chisum, Big Jake* (71).

CLAUDE AKINS in *Waterhole No. 3*

5 AKINS, Claude (1918–). Former Broadway actor who has been a frequent and lively trouble-maker in Ws but has yet to make it as a really outstanding "heavy."

Seminole (53), *Bitter Creek, The Raid, Man with the Gun/The Trouble Shooter, Johnny Concho, The Burning Hills, The Lonely Man* (in role miscredited to Leo Gordon), *Joe Dakota, Yellowstone Kelly, Frontier Rangers* (TV), *Rio Bravo, Comanche Station, A Distant Trumpet, Ride Beyond Vengeance, Incident at Phantom Hill, Return of the Seven, Waterhole No. 3* (comedy), *The Great Bank Robbery* (comedy), *Sledge/ A Man Called Sledge, Flap/The Last Warrior* (comedy) (70).

6 ALBERT, Marvin H. Prolific novelist with several *noms de plume* who specialises in crime and Ws and has also written directly for the screen. (Work under pseudonyms unknown.)

Novel basis *The Law and Jake Wade* (58), novel basis *Bullet for a Badman,* novel basis ("Apache Rising") and co-sc. *Duel at Diablo,* novel basis ("The Man in Black") and co-sc. *Rough Night in Jericho,* novel basis ("The Bounty Killer") *The Ugly Ones* (68).

7 ALBRIGHT, Lola (1925–). Agreeable heroine of several minor Ws, capable of more demanding chores but rarely given the opportunity.

Sierra Passage (51), *The Silver Whip, Treasure of Ruby Hills, Pawnee/Pale Arrow, Oregon Passage, Seven Guns to Mesa, The Way West* (67).

8 ALDRICH, Robert (1918–). Pugnacious, controversial director who made his name via the rollicking Mexican adventure *Vera Cruz* (54) and the notably sympathetic study of the Indian, *Apache.* His subsequent ventures West have been less noteworthy: *The Last Sunset, Four for Texas* (comedy); but his more recent

LOLA ALBRIGHT with Richard
Widmark in *The Way West*

Ulzana's Raid showed a return to
form. His production company made
the offbeat *The Ride Back* (57).

9 ANDERSON, G. M. (Broncho
Billy) (1881–1971). The first cow-
boy star, who made several hundred
one and two reel Broncho Billy ad-
ventures between 1910 and 1916.
He earlier appeared in the first im-
portant W, *The Great Train Robbery*,
later became a writer and director of
most of his work, founded Essanay
Studios (=S&A, A for Anderson),
and made one isolated guest appear-
ance in the sound era after progress
had passed him by.

The Great Train Robbery (03),
Life of (or *Adventures of*) *an
American Cowboy, The Western
Stage Coach Hold-Up, Trapped by
Nat Pinkerton, The Hold-Up of the
Leadville Stage, The Train Wreckers,
Bandit King* (also sc. dir.), *The Girl
from Montana* (also sc. dir.),
Western Justice (also sc. dir.), *The
Indian Trailer, The Ranchman's
Rival, A Western Maid, A Tale of
the West, A Mexican's Gratitude,
Away Out West, The Sheriff's Sacri-
fice, The Cowpuncher's Ward, The*

G. M. BRONCHO BILLY ANDERSON

*Cowboy and the Squaw, The Flower
of the Ranch, The Mistaken Bandit,
The Outlaw's Sacrifice, The Ranch-
man's Feud, The Heart of a Cowboy,
Western Chivalry. The Bandit's Wife,
The Bad Man's Last Deed, Trailed
by the West, The Desperado, The
Deputy's Love Affair, The Pony
Express Rider, Patricia of the Plains,
The Bearded Bandit, A Westerner's
Way, The Badman's Christmas, The
Marked Trail, A Gambler of the
West, A Cowboy's Vindication, The
Tenderfoot Messenger, Broncho Billy
and the Baby* (first of series), *Bron-
cho Billy's Redemption, The Border
Ranger, On the Desert's Edge, The
Faithful Indian, The Deputy's Duty,
Frontier Marshal, Under Western
Skies, Broncho Billy's Adventure,
Broncho Billy and the Burglar,*

Broncho Billy's Reputation, Broncho Billy's Last Spree, Broncho Billy and the Schoolmistress, The Sheriff's Brother, Broncho Billy Outwitted (also dir. this and all following titles but last two), *Broncho Billy's Narrow Escape, The Boss of the Katy Mine, Broncho Billy's Promise, The Reward for Bronco Billy, Broncho Billy and the Bandits, Broncho Billy's Last Hold-Up, Broncho Billy's Gunplay, Broncho Billy's Brother, The Making of Broncho Billy, Broncho Billy's Oath, Broncho Billy and the Redskin, Why Broncho Billy Left Bear Country, The Making of Broncho Billy, The Treachery of Broncho Billy's Pal, Broncho Billy Outlaw, Broncho Billy's Last Deed, The Redemption of Broncho Billy, Broncho Billy and the Escaped Bandit, Broncho Billy and the Sisters, Broncho Billy and the Claim-jumpers, Broncho Billy and the Greaser Deputy, Broncho Billy's Sentence, Broncho Billy's Vengeance, Broncho Billy Well Repaid, Broncho Billy and the Posse, Broncho Billy's Protégé, Broncho Billy and the Lumber King, Broncho Billy and the*

Card Sharp, Broncho Billy's Mexican Wife, Broncho Billy and the Navajo Maid, Broncho Billy and the Sheepman, The Escape of Broncho Billy, Broncho Billy's Love Affair, Broncho Billy and the Maguire Gang, Broncho Billy and the Revenue Agent (N.B. sample listing of series only—many other titles), *The Son of a Gun, The Bounty Killer* (guest) (65).

10 ANDERSON, John. Tall, wiry character actor with strong screen presence: one of the dirty Hammond clan in *Ride the High Country,* the officer who orders the massacre in *Soldier Blue.*

Last Train from Gun Hill (59), *Texas John Slaughter* (TV), *Geronimo, Ride the High Country/Guns in the Afternoon, The Hallelujah Trail* (comedy), *Welcome to Hard Times/ Killer on a Horse, Day of the Evil Gun, A Man Called Gannon, Heaven with a Gun, 5 Card Stud, Young Billy Young, The Great Bank Robbery* (comedy), *Soldier Blue, The Animals/Five Savage Men, Man and Boy, Molly and Lawless John* (72).

11 ANDREWS, Dana (1912–). A somewhat stiff and inexpressive performer, best remembered for his

DANA ANDREWS in *Comanche*

JOHN ANDERSON in
The Hallelujah Trail

non-W work with Preminger, but a sturdy, reliable lead in the saddle.

Lucky Cisco Kid (40), *Kit Carson, The Westerner, Belle Starr, The Ox Bow Incident/Strange Incident, Canyon Passage, Three Hours to Kill, Smoke Signal, Strange Lady in Town, Comanche, Town Tamer, Johnny Reno* (66).

12 ANSARA, Michael (1922–). Actor from stage background who is a familiar face among the Indian/ Mexican ranks as well as from many an Arabian adventure. TV star of *Tales of the Plainsman* and, taking over from Brian Keith, *The Westerner* (as an Indian lawman), also Cochise in *Broken Arrow*.

Fury at Furnace Creek (48), *Only the Valiant, Brave Warrior, The Lawless Breed, Three Young Texans, Pillars of the Sky/The Tomahawk and the Cross, The Ox Bow Incident* (TV), *Gun Brothers, The Lone Ranger, Last of the Badmen, The Tall Stranger, Quantez, The Comancheros, Texas Across the River, And Now Miguel* (modern outdoors), *Guns of the Magnificent Seven, Powderkeg* (TV) (72).

13 ARLEN, Richard (1900–). Minnesota-born, a lightweight actor who drifted into the movies in 1920, became a star from the silent period onwards and has most recently been seen as a bit-part player in A. C. Lyles' nostalgic round-ups of veterans for his B film series at Paramount.

The Enchanted Hill (26), *Under the Tonto Rim, The Virginian, The Light of Western Stars* (TV: *Winning the West*), *The Border Legion, The Santa Fe Trail, The Conquering Horde, Gun Smoke, Caught, Helldorado, The Calling of Dan Matthews, Secret Valley, Call of the Yukon* (N–W), *The Man from Montreal* (Canada), *Men of the Timberland* (W elements), *The Big Bonanza, Return of Wildfire/Black Stallion, Grand Canyon* (modern film-making comedy), *Kansas Raiders, Flaming Feather, Silver City/*

RICHARD ARLEN in *Red Tomahawk*

High Vermilion, Hidden Guns, Warlock, Cavalry Command (Philippino W), *Law of the Lawless, Young Fury, Black Spurs, The Bounty Killer, Town Tamer, Apache Uprising, Johnny Reno, Waco, Red Tomahawk, Fort Utah, Buckskin* (68).

14 ARMENDARIZ, Pedro (1912–63). A major star of Mexican pictures who also made his mark in Hollywood: memorable as one of the bandits in *Three Godfathers*. Has son, Pedro Armendariz Jr., active in American films.

Fort Apache (48), *Three Godfathers, Border River, The Wonderful Country* (Mexico), *The Bandit* (*La Cucaracha*) (Mexican W), *Soldiers of Pancho Villa* (*Pancho Villa y la Valentina*) (Mexican W) (as Villa) (60).

15 ARMSTRONG, R. G. Heavily built, balding, middle-aged character actor who usually exudes villainy and wields a heavy fist. Will be remembered as the puritanical father, Joshua Knudsen, in *Ride the High Country*.

From Hell to Texas/Manhunt (58), *No Name on the Bullet, Ten Who Dared, Six-Gun Law* (TV), *Ride the High Country/Guns in the Afternoon, He Rides Tall, Major Dundee, El Dorado, The Ballad of Cable Hogue* (comedy), *The Mc-Masters, J. W. Coop* (modern rodeo), *The Great Northfield Minnesota Raid, Pat Garrett and Billy the Kid* (73).

16 ARNOLD, Jack (1916–). Director whose reputation rests on his contributions to science-fiction but who has also done some competent Ws.
 The Man from Bitter Ridge (55), *Red Sundown, The Man in the Shadow/Pay the Devil* (modern), *No Name on the Bullet* (also co-prod.) (59).

R. G. ARMSTRONG in *El Dorado*

JEAN ARTHUR as
Calamity Jane in *The Plainsman*

17 ARTHUR, Jean (1905–). A delightful comedienne, she has also been a plucky Calamity Jane for Cecil B. DeMille and an anxious, emotionally torn homesteader's wife in the classic *Shane*. Her early work included many Ws of less distinction.
 Biff Bang Buddy (24), *Fast and Fearless, Bringin' Home the Bacon, Thundering Romance, Travelin' Fast, Drug Store Cowboy* (modern W film-making comedy), *The Fighting Smile, Tearin' Loose, A Man of Nerve, Hurricane Horseman, Thundering Through, Under Fire, Born to Battle, The Fighting Cheat, Double Daring, Lightning Bill* (modern), *Twisted Triggers, The Cowboy Cop* (modern), *Winners of the Wilderness* (Colonial period), *Stairs of Sand, The Plainsman* (as Calamity Jane), *Arizona, A Lady Takes a Chance* (modern comedy), *Shane* (53).

18 AUTRY, Gene (1907–). A Texan who sang for radio and discs in the late Twenties and a few years later became the first successful singing star in W series, dominating this form of light entertainment until

losing ground to Roy Rogers in the mid-Forties. He almost always used his own name on screen, had as much music as action in his early films, and often appeared in modern settings. No great claims for Autry's artistry have ever been made but his personality was obviously an ingratiating one. Horse: Champion. Sidekicks include Smiley Burnette, Sterling Holloway, Pat Buttram. A frequent heroine of later films was Gail Davis.

In Old Santa Fe (bit) (34), *Mystery Mountain* (s) (bit), *The Phantom Empire* (s – feature version: *Radio Ranch*), *Tumbling Tumbleweeds*, *Melody Trail*, *The Sagebrush Troubadour*, *The Singing Vagabond*, *Red River Valley* (or *Man of the Frontier*), *Comin' Round the Mountain*, *The Singing Cowboy*, *Guns and Guitars*, *Oh Susannah!*, *Ride Ranger Ride*, *The Big Show*, *The Old Corral/Texas Serenade*, *Round-Up Time in Texas*, *Git Along Little Dogies/ Serenade of the West*, *Rootin' Tootin' Rhythm/Rhythm on the Ranch*, *Yodelin' Kid from Pine Ridge/Hero of Pine Ridge*, *Public Cowboy No. 1*, *Boots and Saddles*, *Manhattan Merry- Go-Round/Manhattan Music Box* (guest star), *Springtime in the Rockies*, *The Old Barn Dance*, *Gold Mine in the Sky*, *The Man from Music Mountain*, *Prairie Moon*, *Rhythm of the Saddle*, *Western Jamboree*, *Home on the Prairie* or *Ridin' the Range*, *Mexicali Rose*, *Blue Montana Skies*, *Mountain Rhythm*, *Colorado Sunset*, *In Old Monterey*, *Rovin' Tumbleweeds*, *South of the Border* (or *South of Texas*), *Rancho Grande*, *Shooting High* (as a W cowboy star), *Gaucho Serenade*, *Ride Tenderfoot Ride*, *Carolina Moon*, *Melody Ranch*, *Ridin' on a Rainbow*, *Back in the Saddle*, *The Singing Hill*, *Sunset in Wyoming*, *Under Fiesta Stars*, *Down Mexico Way*, *Sierra Sue*, *Cowboy Serenade/Serenade of the West*, *Heart of the Rio Grande*, *Home in Wyomin'*, *Stardust on the Sage*, *Call of the Canyon*, *Bells of Capistrano*, *Sioux City Sue* (W film-making),

GENE AUTRY

Trail to San Antone, *Twilight on the Rio Grande*, *Saddle Pals*, *Robin Hood of Texas*, *The Last Round-Up*, *The Strawberry Roan/Fools Awake*, *Loaded Pistols*, *The Big Sombrero*, *Riders of the Whistling Pines*, *Rim of the Canyon*, *The Cowboy and the Indians*, *Riders in the Sky*, *Sons of New Mexico/The Brat*, *Mule Train*, *Cow Town/Barbed Wire*, *Beyond the Purple Hills*, *Indian Territory*, *The Blazing Sun*, *Gene Autry and the Mounties*, *Texans Never Cry*, *Whirlwind*, *Silver Canyon*, *Hills of Utah*, *Valley of Fire*, *The Old West*, *Night Stage to Galveston*, *Apache Country*, *Barbed Wire/False News*, *Wagon Team*, *Blue Canadian Rockies*, *Winning of the West*, *On Top of Old Smoky*, *Goldtown Ghost*

Riders, Pack Train, Saginaw Trail, Last of the Pony Riders (53).

19 BALLARD, Lucien (1908–). Along with Clothier, one of the stalwarts of W cinematography at the present time, a far cry from his training under von Sternberg and subsequent mastery of intricate interior lighting. *Ride the High Country* and *Will Penny,* for example, have period lighting and raw colour vivacity that contribute much to the atmosphere of both films.

Thundering West (39), *Texas Stampede, The Outlaw* (part uncredited), *Return of the Texan* (modern), *The Raid, *†White Feather, *†The Proud Ones, *†The King and Four Queens, *Buchanan Rides Alone, *†Ride the High Country/Guns in the Afternoon, *Six Gun Law* (TV), *†The Sons of Katie Elder, *An Eye for an Eye, *†Nevada Smith, *†Hour of the Gun, *Will Penny, *†The Wild Bunch, *True Grit, *The Ballad of Cable Hogue* (comedy), *A Time for Dying, *†Junior Bonner* (modern rodeo) (72).

20 BANCROFT, George (1882–1956). He was Curly, the kindhearted lawman of *Stagecoach*. A former Broadway star with several Ws in the silent period, he became more associated with gangster films from the mid-Twenties.

Teeth (24), *The Deadwood Coach, Code of the West, The Rainbow Trail, The Pony Express, The Splendid Road, The Enchanted Hill, White Gold* (W elements), *Stagecoach, When the Daltons Rode, North West Mounted Police, Texas* (41).

21 BARKER, Lex (1919–73). An ex-Tarzan who successfully swung out onto the wide open spaces, then even more successfully climbed aboard the European W bandwagon to play German author Karl May's character Old Shatterhand. Early Ws were bit roles.

Under the Tonto Rim (47), *Re-turn of the Badmen, Battles of Chief Pontiac, Thunder Over the Plains, The Yellow Mountain, The Man from Bitter Ridge, War Drums, The Deerslayer* (Colonial period), *The Treasure of Silver Lake* (*Der Schatz im Silbersee*). *Apache Gold/Winnetou the Warrior* (*Winnetou part 1*), *Last of the Renegades* (*Winnetou II*), *Apaches Last Battle* (*Old Shatterhand*), *The Desperado Trail* (*Winnetou III*), *Winnetou und das Halbblut Apanatschi, A Place Called Glory* (*Un Lugar Llamado Glory*), *Winnetou und Shatterhand im Tal der Toten* (70).

22 BASS, Sam (? –1878). One of the West's best remembered highwaymen, his reputation rests more on his skill in evading arrest than the amounts he stole before he died from gunshot wounds at the age of twenty-seven Screen coverage would appear to be relatively scanty.

Nestor Paiva *Badman's Territory* (46), Howard Duff *Calamity Jane and Sam Bass,* William Bishop *The Texas Rangers,* Leonard Penn *Outlaw Women,* Rex Marlow *Deadwood '76* (71).

23 BAXTER, Anne (1923–). Spirited actress who portrayed the classic character of Cherry Malotte in the 55 version of *The Spoilers* but whose best W work was as the tomboy heroine of *Yellow Sky* and the sharpshooting deputy marshal of *Ticket to Tomahawk.*

Twenty Mule Team (40) (*début*), *Smoky* (modern horse), *Yellow Sky, A Ticket to Tomahawk* (comedy), *The Outcasts of Poker Flat, The Spoilers* (N–W), *Three Violent People, Cimarron, The Tall Women* (*Frauen, die durch die Hölle gehen*) (66).

24 BAXTER, Warner (1892–1951). A rugged, firm-jawed W star (despite his strong fear of horses) who brought a Latin dash to his heroes. His Cisco Kid is the best of the batch.

A Son of His Father (25), Drums of the Desert, Ramona (Indian/Spanish love story), In Old Arizona (as the Cisco Kid), Romance of the Rio Grande (Mexico), The Arizona Kid (Cisco Kid), The Squaw Man/The White Man, The Cisco Kid (as Cisco Kid), The Robin Hood of El Dorado (Spanish period), The Return of the Cisco Kid (as Cisco Kid) (39).

Paul Newman as ROY BEAN in
The Life and Times of Judge Roy Bean

25 BEAN, (Judge) Roy (c1825–c1903). A colourful W character whose passions for the law, whisky and English entertainer Lily Langtry have made splendid screen material on occasion. Not to be confused with the notorious Isaac Charles Parker, "The Hanging Judge." Edgar Buchanan played Bean in a TV series. (Lily Langtry in brackets.)

Walter Brennan *The Westerner* (Lilian Bond) (39), Victor Jory *A Time for Dying* (none), Paul Newman *The Life and Times of Judge Roy Bean* (Ava Gardner) (72).

26 BEAUCHAMP, D. D. (1908–). Writer, principally associated with Ws and costume romances.

Co-sc. *The Wistful Widow of Wagon Gap/The Wistful Widow* (comedy) (47), st. sc. *The San Francisco Story*, st. sc. *Gunsmoke*, part sc. *Law and Order*, co-sc. *Son of Belle Starr*, co-sc. *The Man from the Alamo*, adap. *Ride Clear of Diablo*, co-sc. *Rails into Laramie*, st. sc. *Jesse James' Women*, co-sc. *Destry*, co-sc. *Man Without a Star*, part sc. *Tennessee's Partner*, co-adap. *The Rawhide Years*, sc. *Massacre*, co-sc. *Yaqui Drums*, co-sc. *Shoot-Out at Medicine Bend*, co-sc. *Alias Jesse James* (comedy), st. co-sc. *Daniel Boone Frontier Trail Rider* (TV), part sc. *A Man Called Gannon* (re-make use of work on *Man Without a Star*) (69).

27 BEDOYA, Alfonso (1904–1958). The quintessence of Mexican banditry with a mouthful of teeth beaming mock-friendliness from his tubby frame. A villain, etc., in over 150 Mexican films, best remembered though for his bandit leader in *Treasure of the Sierra Madre*.

Streets of Laredo (49), *California Conquest* (W elements), *The Man in the Saddle/The Outcast*, *The Stranger Wore a Gun*, *Border River*, *Ten Wanted Men*, *The Big Country* (58).

ALFONSO BEDOYA in *The Big Country*

28 BEERY, Wallace (1889–1949). Coarse, jovial and expansive, he ultimately specialised in big-hearted bad guys with a mile-wide streak of sentimentality.

The Round-Up (comedy) (20), *Last of the Mohicans* (Colonial period), *The Mollycoddle* (modern, part-W), *The Golden Snare* (Mounties), *The Last Trail, The Sagebrush Trail* (or *Ridin' Wild*), *The Man from Hell's River* (Mounties), *I am the Law* (Mounties), *The Great Divide, The Pony Express, Stairs of Sand, Billy the Kid* (TV: *The Highwayman Rides*) (as Pat Garrett), *Viva Villa* (Mexico—as Pancho Villa), *The Bad Man of Brimstone, Stand Up and Fight, The Man from Dakota/Arouse and Beware* (Civil War comedy), *Twenty Mule Team, Wyoming/Bad Man of Wyoming, The Bad Man/Two Gun Cupid, Jackass Mail, Barbary Coast Gent, Bad Bascomb, Big Jack* (Colonial period) (49).

29 BELLAH, James Warner. Undoubtedly the best writer about the U.S. cavalry out West, building rich,

LYLE BETTGER with Jane Russell in *Johnny Reno*

touching legend on a bedrock of facts gained by work as a military historian. His short stories and direct writing for John Ford have provided some of the greatest Ws ever made while his non-Ford *A Thunder of Drums* demonstrates his independent skill as a dramatist of the old West. Son Jim Bellah carries on the tradition as a writer on *The Legend of Nigger Charley.*

Story basis ("Massacre") *Fort Apache* (48), story basis ("The Big Hunt" and "War Party") *She Wore a Yellow Ribbon,* story basis ("Mission With No Record") *Rio Grande,* novel basis ("The White Invader") *The Command,* co-st. co-sc. *Sergeant Rutledge,* st. sc. *A Thunder of Drums,* co-sc. *The Man Who Shot Liberty Valance* (61).

30 BENNETT, Bruce (1909–). This soft-voiced, dignified actor hardly seems the outdoors type at first glance but as a former Olympic athlete, U.S. shot-put champion, logger and oilman, as well as a screen Tarzan, he has every right to his numerous W appearances. The quietly desperate, unlucky prospector of the W-like *Treasure of the Sierra Madre* is perhaps his most memorable achievement.

The Lone Ranger(s) (as Herman Brix, his real name) (38), *Blazing Six Shooters, West of Abilene/The Showdown, Cheyenne* (TV: *The Wyoming Kid*), *Silver River, The Younger Brothers* (as Jim Younger), *The Great Missouri Raid, The Last Outpost, Robbers' Roost, Hidden Guns, The Three Outlaws, Daniel Boone Trail Blazer* (in title role), *Love Me Tender, Three Violent People, Flaming Frontier* (58).

31 BERNSTEIN, Elmer (1922–). Prolific composer whose work on *The Magnificient Seven* resulted in one of the classic W themes.

Battles of Chief Pontiac (52), *Drango, The Tin Star, The Magnificent Seven, The Comancheros, Hud* (modern), *The Sons of Katie*

Elder, The Hallelujah Trail (comedy), *The Reward* (modern), *Return of the Seven, The Scalphunters, Guns of the Magnificent Seven, True Grit, Cannon for Cordoba, Big Jake, The Magnificent Seven Ride!, Cahill: United States Marshal/Cahill* (73)

32 BETTGER, Lyle (1915–). Blue-eyed, blond-haired villain, good at expressing intense hatred through clenched teeth.

Denver and Rio Grande (52), *The Vanquished, The Great Sioux Uprising, Drums Across the River, Destry, The Lone Ranger, Showdown at Abilene, Gunfight at the O.K. Corral* (as Ike Clanton), *Guns of the Timberland, Town Tamer, Johnny Reno, Nevada Smith, Return of the Gunfighter, The Fastest Guitar Alive* (Civil War musical comedy) (67).

33 BICKFORD, Charles (1889–1967). Hearty actor who liked to work with strong emotions. His biggest W role was as one of the feuding ranchers in *The Big Country;* he concluded his career on TV as the owner of Shiloh on the long-running *Virginian* series.

CHARLES BICKFORD in
The Big Country

Hell's Heroes (30), *River's End* (Mounties), *The Squaw Man/The White Man, Rose of the Rancho, Thunder Trail, The Plainsman, Valley of the Giants* (timber), *Stand Up and Fight, Romance of the Redwoods* (timber), *Queen of the Yukon* (N–W), *Riders of Death Valley* (s), *Duel in the Sun, Four Faces West/ They Passed This Way, Branded, The Last Posse, The Big Country, The Unforgiven, A Big Hand for the Little Lady/Big Deal at Dodge City* (W setting) (66).

BILLY THE KID—*see* BONNEY, William.

34 BISHOP, William (1918–1959). Busy W actor who never escaped from routine work. Numerous films with minor director Ray Nazarro.

The Romance of Rosy Ridge (comedy) (W elements) (47), *Adventures in Silverado/Above All Laws, Coroner Creek, Thunderhoof/ Fury* (horse), *Black Eagle* (horse), *The Untamed Breed, The Walking Hills* (modern), *The Tougher They Come* (timber), *The Texas Rangers* (as Sam Bass), *Cripple Creek, The Raiders* (TV: *Riders of Vengeance*), *The Redhead from Wyoming, Gun Belt, Overland Pacific, Wyoming Renegades, Top Gun, The White Squaw, The Phantom Stagecoach, The Oregon Trail* (59).

35 BLACKBURN, Tom W. (Wakefield). Novelist and short story writer who has made some worthwhile contributions to the W as a scenarist.

St. sc. *Colt .45* (TV: *Thunder Cloud*) (50), novel basis ("Range War") st. sc. *Short Grass,* part st. part sc. *Sierra Passage,* novel basis ("Raton Pass") co-sc. *Raton Pass/ Canyon Pass,* st. sc. *Cattle Town,* adap. *Cow Country,* sc. *Riding Shotgun,* st. *Cattle Queen of Montana,* st. sc. *Davy Crockett King of the Wild Frontier,* co-st. co-sc. *Davy Crockett and the River Pirates,* sc. *Westward Ho the Wagons!,* novel basis *Sierra Baron,* sc. *Santee* (73).

36 BLANKFORT, Michael (1907–
). Novelist, magazine writer, stage
director who became busy screen-
writer.
Co-st. part sc. *Texas* (41), sc.
Broken Arrow, sc. *Tribute to a Bad
Man,* sc. *The Plainsman* (66).

37 BOEHM, Sydney (1908–).
Former newspaper reporter who be-
came an expert and underappreciated
writer of crime thrillers and Ws. Also
later producer of his work.
Co-sc. *Branded* (51), sc. *The
Savage,* sc. *The Siege at Red River,*
sc. *The Raid,* co-sc. *The Tall Men,*
co-sc. *One Foot in Hell* (also prod.),
co-sc. *Rough Night in Jericho* (67).

38 BOETTICHER, Budd (1916–).
Director who escaped from mediocre
chores to bring a distinctive intelli-
gence to bear on a series of Randolph
Scott Ws mostly written by Burt
Kennedy—films of striking pictorial
composition and feel for remote set-
tings and eruptions of violence.
The Desperadoes (43) (asst. dir.
only), *Black Midnight, The Wolf
Hunters* (Mounties) (last two as
Oscar Boetticher Jr.), *The Cimarron
Kid, Bronco Buster* (rodeo), *Hor-
izons West, Seminole, The Man from
the Alamo, Wings of the Hawk*
(Mexico), *Seven Men from Now,
The Tall T, Decision at Sundown,
Buchanan Rides Alone, Ride Lone-
some, Westbound, Comanche Sta-
tion, A Time for Dying* (also st. sc.),
Two Mules for Sister Sara (st. only)
(70).

39 BOGART, Humphrey (1899–
1957). There are a few early W
appearances in a career otherwise
keyed to the contemporary world of
dark urban violence. First, a sup-
porting role in the modern *A Holy
Terror* (31), then a black-garbed
villain in *The Oklahoma Kid,* a half-
breed bandit in *Virginia City,* and
finally a gold prospector in the W-
like *The Treasure of the Sierra
Madre* (48).

40 BOND, Ward (1905 or 6–
1960). Burly character actor who
progressed from many bit roles, often
as a cop, to become an avuncular
figure in the John Ford stock com-
pany—soldier, sheriff, ranger, rev-
erend—before achieving TV stardom
in *Wagon Train.* His rather sullen,
otherwise anonymous personality in
many Thirties appearances opened
out into a bluff geniality.
The Big Trail (30), *White Eagle,
Hello Trouble, The Fighting Code,
Unknown Valley, Frontier Marshal,
Fighting Rangers, The Crimson Trail,
Fighting Shadows, Justice of the
Range, Western Courage, The Cattle
Thief, Avenging Waters, White Fang*
(N–W), *Park Avenue Logger* (TV:
Tall Timber) (timber comedy), *Gun
Law, Trouble in Sundown, The Law
West of Tombstone, Dodge City, The
Oklahoma Kid, Return of the Cisco
Kid, Drums Along the Mohawk*
(Colonial period), *Frontier Marshal,
The Cisco Kid and the Lady, Vir-
ginia City, Kit Carson, Santa Fe
Trail, Wild Bill Hickok Rides, Sin
Town, The Cowboy Commandos,
Tall in the Saddle, Dakota, Canyon
Passage, My Darling Clementine,
Fort Apache, Unconquered* (Colonial
period), *Three Godfathers, Singing
Guns, Wagon Master, The Great
Missouri Raid, Only the Valiant,
Hellgate, The Moonlighter, Hondo,
Johnny Guitar, A Man Alone, The
Searchers, Dakota Incident, Pillars
of the Sky/The Tomahawk and the
Cross, The Halliday Brand, Alias
Jesse James* (comedy) (guest), *Rio
Bravo* (59).

41 BONNEY, William H. (BILLY
THE KID) (1859–1881). Brooklyn-
born, he was taken West as a child
and became a cowhand working for
British immigrant, John H. Tunstall,
whose murder he avenged, making
him a wanted man who was even-
tually shot dead by sheriff Pat Gar-
rett. Legend has it that he had killed
a man for every year of his short
life. On screen, he is most often
treated sympathetically and has even

Johnny Mack Brown (left) as BILLY THE KID with Wallace Beery as Pat Garrett in *Billy the Kid* (1930)

been the hero of series Ws. The most subtle study of Billy was that by Paul Newman under Arthur Penn's direction in *The Left Handed Gun*. (See entry 168 for actors playing Garrett.)

Johnny Mack Brown *Billy the Kid* (TV: *The Highwayman Rides*) (30), Roy Rogers *Billy the Kid Returns*, Robert Taylor *Billy the Kid*, Jack Buetel *The Outlaw*, Audie Murphy *The Kid from Texas/Texas Kid Outlaw*, Don "Red" Barry *I Shot Billy the Kid*, Tyler MacDuff *The Boy from Oklahoma*, Scott Brady *The Law Versus Billy the Kid*, Nick Adams *Strange Lady in Town*, Anthony Dexter *The Parson and the Outlaw*, Paul Newman *The Left Handed Gun*, Jack Taylor *Billy the Kid (Fuera de la Ley)* (Spanish W), Johnny Ginger *The Outlaws Is Coming* (comedy), Chuck Courtney *Billy the Kid vs. Dracula*, Peter Lee Lawrence (i.e. Karl Hirenbach) *The Man Who Killed Billy the Kid (El Hombre Que Matao Billy El Nino)*, Geoffrey Deuel *Chisum*, Dean Stockwell *The Last Movie* (in film within film), Jean-Pierre Léaud *Une Aventure de Billy the Kid (A Girl Is a Gun)*, Michael J. Pollard *Dirty Little Billy*, Kris Kristofferson *Pat Garrett and Billy the Kid*.

Series use of character:

Bob Steele: *Billy the Kid Outlawed* (40), *Billy the Kid in Texas, Billy the Kid's Gun Justice, Billy the Kid's Range War, Billy the Kid's Fighting Pals, Billy the Kid in Santa Fe* (41).

Buster Crabbe: *Billy the Kid Wanted* (41), *Billy the Kid's Roundup, Billy the Kid Trapped, Smoking Guns* (TV: *Billy the Kid's Smoking Guns*), *Law and Order* (TV: *Billy the Kid's Law and Order*), *Mysterious Rider (Panhandle Trail), Sheriff of Sage Valley* (TV: *Billy the Kid, Sheriff of Sage Valley*), *The Kid Rides Again, Fugitive of the Plains (Raiders of Red Rock), Western Cyclone (Frontier Fighters), The Renegade (Code of the Plains), Cattle Stampede, Blazing Frontier* (43).

42 BOONE, Daniel (1734–1820). An Eighteenth century frontiersman who has become the great hero of the Eastern pioneering era—a simple woodsman who is the most famous of the Kentucky pioneers and the basis

of James Fenimore Cooper's character "Leatherstocking."

Jack Mower *The Days of Daniel Boone* (23), Roy Stewart *Daniel Boone Thru the Wilderness,* Jay Wilsey *The Miracle Rider* (s), George O'Brien *Daniel Boone,* Wild Bill Elliott *The Return of Daniel Boone/The Mayor's Nest,* David Bruce *Young Daniel Boone,* Bruce Bennett *Daniel Boone Trail Blazer,* Fess Parker *Daniel Boone Frontier Trail Rider* (TV) (67).

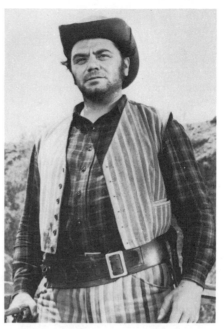

ERNEST BORGNINE in *Vera Cruz*

RICHARD BOONE in *Big Jake*

43 BOONE, Richard (1916–). Rugged character actor who works hard to invest his villains and other roles with some depth. Reputedly a fifth generation descendant of Daniel Boone, he was a former crack shot and gun expert in the navy during the Second World War, and entered films in 1950. Star of W TV series *Have Gun Will Travel* (1957–61).

Kangaroo (Australia) (52), *Way of a Gaucho* (Argentina), *Return of the Texan* (modern), *City of Bad Men, The Siege at Red River, The Raid* (Civil War), *Ten Wanted Men, Man Without a Star, Robbers' Roost, Star in the Dust, The Tall T, The Alamo* (as Sam Houston), *A Thunder of Drums, Rio Conchos, Hombre, Madron, Big Jake* (71).

44 BORGNINE, Ernest (1918–). Actor who escaped from hulking, sadistic, wild-eyed villainy to more varied work after playing gentle lead in love story *Marty.*

The Stranger Wore a Gun (53), *Johnny Guitar, The Bounty Hunter, Vera Cruz* (Mexico), *Run for Cover, The Last Command, Jubal, The Badlanders, Chuka, The Wild Bunch, Vengeance Is Mine* (*Quei disperati che puzzano di sudore e di morte*), *Hannie Caulder, The Revengers* (72).

45 BOWERS, William (1916–). A screenwriter since 1942, and a specialist in comedy with two fine W examples: *The Sheepman* and *Support Your Local Sheriff.* A quarter of his output has been under unrevealed pseudonyms.

Co-sc. *The Wistful Widow of Wagon Gap/The Wistful Widow* (comedy) (47), part sc. *Black Bart/Black Bart Highwayman,* co-sc. *The Gal Who Took the West,* co-st. *The Gunfighter,* co-sc. *The Sheepman* (comedy), sc. *The Law and Jake Wade,* co-sc. *Alias Jesse James* (comedy), co-sc. *Advance to the Rear/Company of Cowards?* (Civil War comedy), part sc. *The Ride to Hangman's Tree,* st. sc. *Support Your*

Local Sheriff (comedy) (also prod.)
(69).

46 BOWIE, Jim (c1790–1836).
The inventor of the deadly knife
named after him, a legendary figure
whose life in New Orleans has been
depicted in *The Iron Mistress* and
whose exploits out West, ending in
his death defending the Alamo from
the Mexican forces of Santa Anna,
have been told in other pictures.

Bob Fleming (*With*) *Davy Croc-
kett at the Fall of the Alamo* (26),
Hal Taliaferro *The Painted Stallion*
(s), (unidentified actor) *Heroes of
the Alamo*, Robert Armstrong *Man
of Conquest*, Macdonald Carey *Co-
manche Territory*, Alan Ladd *The
Iron Mistress* (non–W), Stuart Ran-
dall *The Man from the Alamo*, Ken-
neth Tobey *Davy Crockett King of
the Wild Frontier*, Sterling Hayden
The Last Command, Jeff Morrow
The First Texan, Richard Widmark
The Alamo (60).

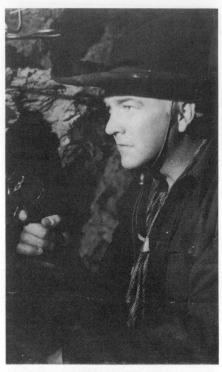

WILLIAM BOYD as Hopalong Cassidy

47 BOYD, William (1898–1972).
The screen's Hopalong Cassidy. Born
in Ohio, he was largely raised in
Oklahoma where he worked in oil;
he later found work as a film extra
and was befriended by Cecil B. De-
Mille. A big star of the Twenties, his
career declined in the early Thirties
to be revived by the Hopalong series,
before which he had been seen in
some Ws: *The Last Frontier, Jim the
Conqueror* (modern—W elements),
The Spoilers (N–W), *The Painted
Desert, Carnival Boat* (N–W). His
Hopalong series, based on a character
by writer Clarence E. Mulford, ex-
tended to sixty-six films of generally
above average merit, fairly realistic
in tone with Boyd a striking hero in
a dark outfit contrasting with his
white horse Topper and his white
hair. His screen sidekicks included
George Hayes, Jimmy Ellison, Rus-
sell Hayden, Andy Clyde (who also
worked with Boyd on a radio Hop-
along series), Brad King, Jay Kirby,
Jimmy Rogers, Rand Brooks. In the
early Fifties, Boyd took Hopalong
into TV. The last twelve Hopalong
features were produced by Boyd him-
self, with Harry Sherman earlier re-
sponsible for the series.

As Hopalong Cassidy: *Hop-a-long
Cassidy* (later *Hopalong Cassidy
Enters*) (35), *The Eagle's Brood,
Bar 20 Rides Again, Call of the
Prairie, Three on the Trail, Heart of
the West, Hopalong Cassidy Returns,
Trail Dust, Borderland, Hills of Old
Wyoming, North of the Rio Grande,
Rustler's Valley, Hopalong Rides
Again, The Texas Trail, Partners of
the Plains, Cassidy of Bar 20, Heart
of Arizona, Bar 20 Justice, Pride of
the West, In Old Mexico, Sunset
Trail, The Frontiersman, Silver on
the Sage, Renegade Trail, Range War,
Law of the Pampas* (South American
W), *Santa Fe Marshal, The Show-
down, Hidden Gold, Stagecoach War,
Three Men from Texas, Doomed
Caravan, In Old Colorado, Border
Vigilantes, Pirates on Horseback,
Wide Open Town, Secrets of the
Wasteland, Riders of the Timberline*
(timber), *Stick to Your Guns, Out-*

laws of the Desert/Arabian Desert Outlaws (Arabian setting), *Twilight on the Trail, Undercover Man, Lost Canyon, Border Patrol, Hoppy Serves a Writ, The Leather Burners, Colt Comrades, Bar 20, False Colors, Riders of the Deadline, Texas Masquerade, Lumberjack* (timber), *Mystery Man, Forty Thieves, The Devil's Playground, Fool's Gold, Unexpected Guest, Dangerous Venture, Hoppy's Holiday, The Marauders, Silent Conflict, The Dead Don't Dream, Sinister Journey, Borrowed Trouble, False Paradise, Strange Gamble* (48).

Other W work (35–): *Go Get 'Em Haines, The Greatest Show on Earth* (guest) (52).

48 BOYLE, Charles P. A first-rate cameraman of the great outdoors.

**Frontier Gal/The Bride Wasn't Willing* (comedy), **Duel in the Sun* (in collab.), **Three Godfathers* (2nd Unit), **She Wore a Yellow Ribbon* (2nd unit), **Saddle Tramp, *Apache Drums, *Tomahawk/Battle of Powder River, *The Lady from Texas, *The Cimarron Kid, *The Battle at Apache Pass, *Untamed Frontier, *Horizons West, *Gunsmoke, *Column South, *The Stand at Apache River, *Davy Crockett King of the Wild Frontier, *†The Great Locomotive Chase, *†Westward Ho the Wagons!, *Old Yeller* (W elements) (58).

49 BRACKETT, Leigh. Woman novelist (W, mystery, science fiction) who has often worked for Howard Hawks with generally distinguished results.

Co-sc. *Rio Bravo* (59), co-sc. *Gold of the Seven Saints*, sc. *El Dorado*, co-sc. *Rio Lobo* (70).

50 BRADY, Scott (1924–). Powerfully-built actor (ex-lumberjack, brother of Lawrence Tierney) who brought a certain brash arrogance to his work as a leading man; has more recently been one of A. C. Lyles's team in B Ws.

The Gal Who Took the West (49),

Kansas Raiders, Bronco Buster (modern rodeo), *Untamed Frontier, Montana Belle* (as Bob Dalton), *A Perilous Journey, Johnny Guitar, The Law versus Billy the Kid* (as Billy the Kid), *The Vanishing American, Mohawk* (Colonial period), *The Maverick Queen* (as Sundance Kid), *The Restless Breed, The Storm Rider, Ambush at Cimarron Pass, Blood Arrow, Stage to Thunder Rock, Black Spurs, Red Tomahawk, Fort Utah, Arizona Bushwhackers, Cain's Way, Five Bloody Graves* (70).

51 BRAND, Max (? –1944). The novelist best remembered for "Destry Rides Again" and also for creating Doctors Kildare and Gillespie. His work formed the basis for several Tom Mix and some Buck Jones Ws. Real name: Frederick Faust.

Novel basis *The Untamed* (20), novel basis ("The Night Horseman") *The Night Horsemen*, novel basis *Trailin'* (modern, W elements), novel basis ("Alcatraz") *Just Tony*, story basis ("Hired Guns") *The Gunfighter*, novel basis ("Gun Gentlemen") *Mile-a-Minute Romeo*, story basis ("Cuttle's Hired Man") *Against All Odds*, serial basis ("Señor Jingle Bells") *The Best Bad Man*, story basis ("Dark Rosaleen") *The Flying Horseman*, novel basis ("Untamed") *Fair Warning*, novel basis ("Trailin'") *A Holy Terror*, novel basis *Destry Rides Again* (32) (39), screen st. *The Desperadoes*, story basis ("Señor Coyote") *Rainbow Over Texas*, novel basis *Singing Guns*, novel basis ("Montana Rides Again" under pseud. Evan Evans) *Branded*, novel basis ("South of the Rio Grande") *My Outlaw Brother*, novel basis ("Destry Rides Again") *Destry* (55).

52 BRANDO, Marlon (1924–). Major actor who has seemingly avoided the "routine" world of the W, except that curiously his one venture as an actor-director was set

MARLON BRANDO in
The Appaloosa

out West: the brooding, monumental
One Eyed Jacks. He took the title
role in *Viva Zapata!* (52), Kazan's
slice of Mexican history, and has
also starred in *The Appaloosa/
Southwest to Sonora* (66).

53 BRENNAN, Walter (1894–
1974). One of the screen's finest char-
acter actors, three times an Academy
Award winner (including *The Wes-
terner*). Often cast in rather thankless
roles as garrulous oldtimers, jail-
keepers, villains, sidekicks, etc. but
breathes life into them every time.
In his more youthful, full-toothed
days, was often featured in Tim Mc-
Coy's Ws before his big break in
Barbary Coast; most recently made
highly popular W TV film *The Over
the Hill Gang* and sequel.
 Tearin' into Trouble (27), *The
Ridin' Rowdy, The Ballyhoo Buster,
Smilin' Guns, The Lariat Kid, The
Long Long Trail, Law and Order,
Texas Cyclone, Two Fisted Law,
Fighting for Justice, Man of Action,
Silent Men, The Prescott Kid, Law
Beyond the Range, Justice of the
Range, Northern Frontier* (Mounties),
Three Godfathers (TV: *Miracle in
the Sand*), *The Texans, The Cowboy
and the Lady* (modern), *Northwest*

Passage (Colonial period), *The Wes-
terner* (as Judge Roy Bean), *Da-
kota, My Darling Clementine* (as Old
Man Clanton), *Red River, Blood on
the Moon, Brimstone, Singing Guns,
A Ticket to Tomahawk* (comedy),
*Curtain Call at Cactus Creek/Take
the Stage* (comedy), *The Showdown,
Along the Great Divide, Best of the
Badmen, Return of the Texan* (mod-
ern), *Drums across the River, Four
Guns to the Border, The Far Country,
At Gunpoint/Gunpoint!, The Proud
Ones, Rio Bravo, How the West Was
Won* (ep. "Plains"), *Support Your
Local Sheriff* (69).

54 BRIAN, David (1914–). A
smooth performer, generally the well-
dressed gentleman villain.
 Fort Worth (51), *Springfield
Rifle, A Perilous Journey, Ambush
at Tomahawk Gap, Dawn at Socorro,
Timberjack, Fury at Gunsight Pass,
The First Traveling Saleslady* (com-
edy), *White Squaw, How the West
Was Won, The Rare Breed* (66).

55 BRIDGES, Lloyd (1913–).
Deep-set blue eyes give an intense
look to this actor's features while
his rugged build has put him in good
stead for W roles—of which the
best-known is the calculating deputy
of *High Noon*. Also starred in TV
W series *The Loner*. Son Jeff headed
West in *Bad Company*.
 North of the Rockies/False Clues
(41), *The Royal Mounted Patrol/
Giants A'Fire, Shut My Big Mouth*
(comedy), *Riders of the Northland/
Next in Line* (modern N–W), *Par-
don My Gun, Hail to the Rangers/
Illegal Rights, Saddle Leather Law/
The Poisoner, Abilene Town, Can-
yon Passage, Ramrod, Unconquered*
(Colonial period), *Red Canyon,
Calamity Jane and Sam Bass, Colt
.45* (TV: *Thunder Cloud*), *Little
Big Horn/The Fighting 7th, High
Noon, The Tall Texan, City of Bad
Men, Last of the Comanches/The
Sabre and the Arrow, Wichita,
Apache Woman, Ride Out for Re-
venge, Running Wild* (horse) (73).

LLOYD BRIDGES in
Ride Out for Revenge

56 BRITTON, Barbara (1920–).
Pleasant heroine who landed the role
of the schoolma'am in the 1946
version of *The Virginian*.

Secrets of the Wasteland (41)
(*début*), *The Virginian, Gunfighters/
The Assassin, Albuquerque/Silver
City, The Untamed Breed, Loaded
Pistols, I Shot Jesse James, The
Bandit Queen, The Raiders* (TV:
Riders of Vengeance), *Ride the Man
Down, The Spoilers* (N–W) (56).

57 BRONSON, Charles (1922–).
Beefy actor from a coal-mining family
whose early non-W work in bit roles
was as Charles Buchinski. Given the
big break of playing a Modoc Indian
chief in *Drumbeat,* he switched his
surname to Bronson and has become
one of the top box-office stars in
Continental Europe.

Riding Shotgun (54), *Apache,
Drumbeat, Vera Cruz* (Mexico),
*Jubal, Run of the Arrow, Showdown
at Boot Hill, The Magnificent Seven,
A Thunder of Drums, This Rugged
Land* (TV), *Guns of Diablo* (TV),
Four for Texas (comedy), *Villa
Rides* (modern Mexico), *Once Upon
a Time in the West* (*C'era una volta
il West*), *Red Sun* (*Soleil rouge*),
Chato's Land, Valdez the Halfbreed
(*Valdez il Mezzosangue*) (74).

58 BROWER, Otto (1895–1946).
Director of action Ws in the late
Twenties, he dropped to minor work
in the Thirties before turning to
second unit direction where his
chores included the superb gathering
of the cowboys in *Duel in the Sun.*

Avalanche (28), *Sunset Pass,
Stairs of Sand, The Light of Western
Stars* (co-dir.), *The Border Legion*
(co-dir.), *The Santa Fe Trail* (co-
dir.), *Fighting Caravans* (co-dir.),
*Clearing the Range, Hard Hombre,
Local Bad Man* (comedy), *Spirit of*

CHARLES BRONSON in *Valdez the Halfbreed*

the West, The Devil Horse (s), *Mystery Mountain* (modern; co-dir.) (s), *Gold, Fighting for Justice, Scarlet River, Crossfire* (part W), *Outlaw Deputy, Phantom Empire* (modern; co-dir.) (s), *The Gay Caballero, Buffalo Bill* (2nd Unit dir.), *Duel in the Sun* (2nd Unit dir.) (48).

59 BROWN, Harry (1917–). Writer more immediately associated with war films (*A Walk in the Sun, Sands of Iwo Jima*) but also active in Ws.

Co-sc. *Only the Valiant* (51), story basis ("Stand at Spanish Boot") *Apache Drums*, co-sc. *Bugles in the Afternoon*, co-sc. *Many Rivers to Cross* (pioneering era), co-sc. *The Fiend Who Walked the West*, novel basis ("The Stars in their Courses") *El Dorado* (67).

60 BROWN, Harry Joe (1893–1972). The director and supervisor of numerous Ws in the Twenties—mostly Ken Maynard's—he went on to become a very active producer in the late Forties and Fifties, almost exclusively concerned with Ws, a great many in association with actor Randolph Scott (Scott-Brown Productions).

As director: *Moran of the Mounted* (Canada) (26), *Land Beyond the Law, Gun Gospel, The Wagon Show, Code of the Scarlet* (Mounties), *The Lawless Legion, The Royal Rider* (Wild West Show), *The Wagon Master, Señor Americano, Parade of the West, Lucky Larkin, The Fighting Legion, Mountain Justice, Song of the Caballero* (early Calif.), *Sons of the Saddle* (30).

As producer/production manager/ associate producer: *The Mask of Lopez* (24), *North of Nevada, Galloping Gallagher, The Silent Stranger, The Dangerous Coward, The Fighting Sap, Senor Daredevil, Moran of the Mounted* (also dir.), *The Unknown Cavalier, The Overland Stage, Somewhere in Sonora, The Red Raiders, The Canyon of Adventure, The Upland Rider, The Glorious*

Trail, The Phantom City, Cheyenne, California Mail, Western Union, The Desperadoes, Gunfighters/The Assassin, Coroner Creek, The Untamed Breed, The Walking Hills, The Doolins of Oklahoma/The Great Manhunt, The Nevadan/The Man from Nevada, Stage to Tucson/Lost Stage Valley, Santa Fe, Man in the Saddle/The Outcast, Hangman's Knot, The Last Posse, The Stranger Wore a Gun, Three Hours to Kill, Ten Wanted Men, A Lawless Street, 7th Cavalry, The Guns of Fort Petticoat, The Tall T, Decision at Sundown, Buchanan Rides Alone, Ride Lonesome, Comanche Station, A Time for Killing/The Long Ride Home (67).

61 BROWN, Johnny Mack (1904–74). One of the most capable stars of B Western series, he was born in Alabama, a descendant of the first white settler there who married a Creek Indian princess. His prowess in football (on the All-American team in 1927) led to film offers and his fine physical shape later enabled him to handle much of the action in his Ws without doubles. He was signed by M-G-M, learned to act and develop a screen personality opposite Marion Davies, Garbo and Crawford but still seemed uncomfortable in modern dress vehicles: the early sound *Billy the Kid* (for which he was coached by William S. Hart in drawing a gun and mounting a horse) pointed the way Westwards, and he was soon embarked on twenty years of almost exclusive work in Ws for Supreme/Republic, Universal and later Monogram/Allied Artists. He was partnered at different times by Fuzzy Knight, Tex Ritter, Raymond Hatton, Bob Baker and James Ellison. Most frequent female leads: Jennifer Holt, Christine McIntyre.

Films: *The Bugle Call* (27) (bit); *Montana Moon* (modern comedy), *Billy the Kid* (title role) (TV: *The Highwayman Rides*), *The Great Meadow, Lasca of the Rio Grande; Vanishing Frontier, Fighting with Kit Carson* (title role) (S); *Rustlers of*

Red Dog (S); *Branded a Coward, Between Men, Courageous Avenger, Valley of the Lawless, The Desert Phantom, Rogue of the Range, Everyman's Law, The Crooked Trail, Undercover Man, Lawless Land, Bar Z Bad Men, The Gambling Terror, Trail of Vengeance, Guns in the Dark, A Lawman is Born, Wild West Days* (S), *Boothill Brigade, Born to the West* (later *Hell Town*), *Wells Fargo, Flaming Frontiers* (s), *The Oregon Trail* (s), *Desperate Trails, Oklahoma Frontier, Chip of the Flying U, West of Carson City, Riders of Pasco Basin, Bad Man from Red Butte, Son of Roaring Dan, Ragtime Cowboy Joe, Law and Order/Lucky Ralston* (re-make of *Wild West Days*), *Pony Post, Boss of Bullion City, Bury Me Not on the Lone Prairie, Law of the Range, Rawhide Rangers, The Man from Montana/ Montana Justice, The Masked Rider* (S. American W), *Arizona Cyclone, Stagecoach Buckaroo, Fighting Bill Fargo, Ride 'Em Cowboy* (modern comedy), *The Silver Bullet, Boss of Hangtown Mesa, Deep in the Heart of Texas, Little Joe the Wrangler, The Old Chisholm Trail, Tenting Tonight on the Old Camp Ground, The Ghost Rider, Cheyenne Roundup, Raiders of San Joaquin, The Stranger from Pecos, The Lone Star Trail, Six Gun Gospel, Outlaws of Stampede Pass, The Texas Kid, Raiders of the Border, Partners of the Trail, Law Men, Range Law, West of the Rio Grande, Land of the Outlaws, Law of the Valley, Ghost Guns, Navajo Trail, Gun Smoke, Stranger from Santa Fe, Flame of the West, The Lost Trail, Frontier Feud, Border Bandits, Drifting Along, The Haunted Mine, Under Arizona Skies, Gentleman from Texas, Shadows on the Range, Trigger Fingers, Silver Range, Raiders of the South* (TV: *South Raiders*), *Valley of Fear, Trailing Danger, Land of the Lawless, The Law Comes to Gunsight, Code of the Saddle, Flashing Guns, Prairie Express, Gun Talk, Overland Trails, Crossed Trails, Frontier Agent, Triggerman, Back Trail, The Fighting Ranger, The Sheriff of Medicine Bow, Gunning for Justice, Hidden Danger, Law of the West, Trails End, West of El Dorado, Range Justice, Stampede, Western Renegades, Fence Riders* (bit), *West of Wyoming, Over the Border, Six Gun Mesa, Law of the Panhandle, Outlaw Gold, Short Grass, Colorado Ambush, Man from Sonora, Blazing Bullets, Montana Desperado, Oklahoma Outlaws* (or *Oklahoma Justice*), *Whistling Hills, Texas Lawmen, Texas City, The Man from the Black Hills, Dead Man's Trail, Canyon Ambush, The Marshal's Daughter* (comedy, guest), *The Bounty Killer, Requiem for a Gunfighter, Apache Uprising* (66).

62 BRYNNER, Yul (1915–). Russian-born actor whose shaved head gave him a visual distinctiveness; was leader of the screen's "Magnificent Seven" but has never found as good a W role since.

The Magnificent Seven (60), *Invitation to a Gunfighter, Return of the Seven, Villa Rides!* (modern),

YUL BRYNNER in *Villa Rides!*

The Bounty Hunters (Indio Black, sai che ti dico: sei un gran figlio di . . .), Catlow, Westworld (as W robot) (73).

63 BUCHANAN, Edgar (1903 or 1910–). Missouri-born former dentist (who practised the profession in his favourite film, *Texas*), he is one of the W's outstanding character actors, often grizzly bearded, excellent at corrupt and/or drunken officials (judges, doctors, mayors) or knowledgable oldtimers. Generally invests his characters with an endearing quality even when they are rogues. Played old men from the start of his film career in 1940: "my voice put me in the character class." From his old, bearded, drunken judge in *Arizona* to his travelling official in *Welcome to Hard Times,* he has been a constant delight. Now much TV: played Roy Bean, the "hanging judge" in series, also member of *The Over The Hill Gang*.

Films: *When the Daltons Rode* (40), *Arizona, Texas, Tombstone the Town Too Tough to Die, Desperadoes, Buffalo Bill, Abilene Town, Renegades, Sea of Grass, Coroner Creek, Adventures in Silverado/ Above All Laws, The Untamed Breed, The Man from Colorado, The Walking Hills, Red Canyon, Lust for Gold* (modern), *Devil's Doorway, The Great Missouri Raid, Rawhide* (TV: *Desperate Siege*), *Cave of Outlaws, Silver City/High Vermilion, Flaming Feather, The Big Trees, Toughest Man in Arizona, Wild Stallion, Shane, Dawn at Socorro, Destry, Rage at Dawn, The Silver Star, Wichita, The Lonesome Trail, Spoilers of the Forest, Day of the Badman, The Sheepman* (comedy), *Devil's Partner* (W elements), *King of the Wild Stallion, Four Fast Guns, Cimarron, The Comancheros, Ride the High Country/Guns in the Afternoon, McLintock!* (comedy), *The Man from Button Willow* (W cartoon/voice only), *The Rounders* (modern), *Gunpoint, Welcome to Hard Times/Killer on a Horse* (67).

64 BUCKNER, Robert (1906–). As a Warner Bros. contract writer, he wrote the complete scripts for three Curtiz-Flynn Ws, *Dodge City, Virginia City* and *Santa Fe Trail*. Also a producer.

Westerns: co-sc. *Gold Is Where You Find It* (37) (W elements); part sc. *The Oklahoma Kid,* st. sc. *Dodge City;* st. sc. *Virginia City,* st. sc. *Santa Fe Trail;* prod. *San Antonio;* prod. *Cheyenne* (TV: *Wyoming Kid*); st. *The Man Behind the Gun;* sc. *Love Me Tender;* co-sc. prod. *From Hell to Texas/Manhunt;* co-st. sc. *Return of the Gunfighter* (67).

65 BUETEL, Jack (1917–). Texas-born, he began his film career with a promising performance as Billy the Kid in *The Outlaw* but was pushed aside by the long-delayed film's publicity campaign for Jane Russell; has portrayed more than his share of famous badmen for a mere handful of Ws.

The Outlaw (43/46, made 40), *Best of the Badmen* (as one of the Younger brothers), *The Half-Breed, Rose of Cimarron, Jesse James' Women* (as Frank James); *Mustang* (modern) (60).

66 BURNETT, W. R. (William Reilly) (1899–). Novelist and screenwriter, better known for his work on gangsters ("Little Caesar", "The Asphalt Jungle") than for his contributions to the W.

Novel basis ("Saint Johnson," suggested by Wyatt Earp) *Law and Order* (32) (40) (53) and *Wild West Days* (s), novel basis *The Dark Command,* co-st. co-sc. *San Antonio,* st. sc. *Belle Starr's Daughter,* st. *Yellow Sky,* novel basis ("Adobe Wells") *Arrowhead,* novel basis ("The Asphalt Jungle") *The Badlanders,* st. sc. *Sergeants 3* (comedy) (62).

67 BUSCH, Niven (1903–). Former magazine writer and editor; story editor for Samuel Goldwyn. As

novelist and screenwriter, he had a major part in the memorable emotional extravagances of *Pursued, Duel in the Sun* and *The Furies,* hothouse studies of dramatic conflict. Later producer. Part-time rancher, cattleman.

Co-sc. *The Westerner* (40), co-st. *Belle Starr;* st. sc. *Pursued,* novel basis *Duel in the Sun;* st. sc. prod. *The Capture* (modern), novel basis *The Furies,* st. co-sc. *Distant Drums,* co-st. *The Man from the Alamo,* st. sc. *The Moonlighter,* sc. *The Treasure of Pancho Villa* (Mexico) (55).

68 BUTTOLPH, David (1902–). Hollywood composer with a good sense of traditional W music, otherwise not ambitious. Scores often orchestrated by Maurice de Packh.

The Return of Frank James (40), *Western Union, In Old California, Buffalo Bill, Colorado Territory, Montana, Return of the Frontiersman, The Redhead and the Cowboy, Along the Great Divide, Fort Worth, Lone Star, Carson City, The Man Behind the Gun, Thunder Over the Plains, Riding Shotgun, The Bounty Hunter, The Lone Ranger, The Burning Hills, The Big Land/Stampeded,*

BRUCE CABOT in *The Undefeated*

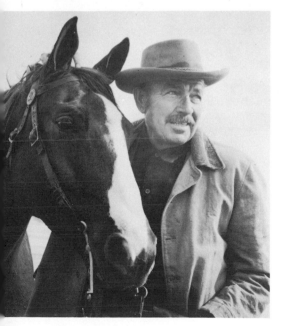

Westbound, The Horse Soldiers, Guns of the Timberland, The Man from Galveston (TV) (64).

69 CABOT, Bruce (1904–72). As a dashing hero he tackled King Kong and played Wild Bill Hickok but his good looks had a dark side that led him towards screen villainy (including the treacherous Magua of *Last of the Mohicans*) while in old age he gained a place among the veterans of A. C. Lyles's B film series and in John Wayne's pictures.

Robin Hood of El Dorado (early Calif.) (36), *Last of the Mohicans* (Colonial period), *The Bad Man of Brimstone, Dodge City, Wild Bill Hickok Rides* (as Hickok), *Pierre of the Plains* (N–W), *Smoky* (horse), *Angel and the Badman, Gunfighters/ The Assassin, The Gallant Legion,*

JAMES CAGNEY in *Run for Cover*

Rock Island Trail/Transcontinent Express, Fancy Pants (comedy—W elements), *Best of the Badmen, The Sheriff of Fractured Jaw* (comedy), *The Comancheros, McLintock!* (comedy), *Law of the Lawless, Black Spurs, Cat Ballou* (comedy), *Town Tamer, The War Wagon, The Undefeated, Chisum, Big Jake* (71).

70 CAGNEY, James (1904–). Pint-sized actor of incredible energy whose only W of his most dashing years was *The Oklahoma Kid* (39). Later: *Run for Cover, Tribute to a Bad Man*. He was also the uncredited narrator of *Arizona Bushwhackers* (68).

71 CALAMITY JANE (Martha Jane Burke or Canarray) (? –1903). The Wild West's most celebrated female: a tomboy in buckskin get-up who chewed tobacco, downed alcohol, drove mule teams, befriended Wild Bill Hickok, and ended up drifting around the West as a curiosity and trouble-maker.
Ethel Grey Terry *Wild Bill Hickok* (23), Louise Dresser *Caught,* Helen

Doris Day as CALAMITY JANE with Howard Keel as Wild Bill Hickok in *Calamity Jane*

Gibson *Custer's Last Stand* (s), Jean Arthur *The Plainsman,* Sally Payne *Young Bill Hickok,* Marin Sais *Deadwood Dick* (s), Frances Farmer *Badlands of Dakota,* Jane Russell *The Paleface* (comedy), Yvonne de Carlo *Calamity Jane and Sam Bass,* Evelyn Ankers *The Texan Meets Calamity Jane,* Doris Day *Calamity Jane* (musical comedy), Judi Meredith *The Raiders,* Gloria Milland *Seven Hours of Gunfire* (*Aventuras del Oeste*), Abby Dalton *The Plainsman* (66).

RORY CALHOUN in
Finger on the Trigger

72 CALHOUN, Rory (1922 or 24–). Sturdy leading man who entered films through a friendship with Alan Ladd after working at lumber camps, mines and ranches; was recently a principal backer of an ill-fated London stage show on Belle Starr.
Massacre River (49), *Sand* (modern horse), *A Ticket to Tomahawk* (comedy), *Return of the Frontiers-*

man; *Way of a Gaucho* (Argentina), *The Silver Whip, Powder River, The Yellow Tomahawk, River of No Return, Dawn at Socorro, Four Guns to the Border,* co-sc. *Shotgun* (not in cast), *The Treasure of Pancho Villa* (Mexico), *The Spoilers* (N-W), *Red Sundown, Raw Edge, Utah Blaine, The Hired Gun, The Domino Kid, Ride Out for Revenge, Apache Territory* (also co-prod.)*, The Saga of Hemp Brown, The Gun Hawk, Young Fury, Black Spurs, Finger on the Trigger, Apache Uprising* (66).

73 CALLEIA, Joseph (1897–). Maltese-born actor typecast into gangsters and bandits but invariably effective; was one of the writers of *Robin Hood of El Dorado* (early Calif.) (36) before settling down to screen acting.

The Bad Man of Brimstone (38), *My Little Chickadee* (comedy), *Wyoming/Bad Man of Wyoming, Four Faces West/They Passed This Way, The Palomino/Hills of the Brave* (horse), *Branded, The Iron Mistress*

(life of Jim Bowie), *The Treasure of Pancho Villa* (Mexico), *The Burning Hills, The Light in the Forest* (Colonial period), *The Alamo* (60).

74 CAMERON, Rod (1910 or 12–). Born in Alberta, this actor's massive 6 ft. 4 ins. build, granite features and inexpressive manners placed him naturally as a second rank star of the W after he had worked as a stunt double for Buck Jones (recognisably so in *Riders of Death Valley* (s), 40), stand-in for Fred MacMurray and played bit roles (including early titles in list).

North West Mounted Police (1940) (Mounties), *The Parson of Panamint, The Remarkable Andrew* (non-W; as Jesse James), *Deep in the Heart of Texas, The Kansan, Boss of Boomtown, Trigger Trail, Riders of Santa Fe/Mile a Minute, The Old Texas Trail/Stage Coach Line, Salome Where She Danced, Beyond the Pecos/Beyond the Seven Seas, Renegades of the Rio Grande/Bank Rob-*

ROD CAMERON (left) with John Ireland in *Southwest Passage*

bery, Frontier Gal/The Bride Wasn't Willing (comedy), *Panhandle, Belle Starr's Daughter, The Plunderers, Stampede, Brimstone, Dakota Lil, Short Grass, Stage to Tucson/Lost Stage Valley, Oh! Susanna, Cavalry Scout, Fort Osage, Wagons West, Woman of the North Country, Ride the Man Down, San Antone, Southwest Passage/Camels West, Santa Fe Passage, Yaqui Drums, Spoilers of the Forest, The Gun Hawk, The Bounty Killer, Requiem for a Gunfighter, Paths of Hate* (*I sentieri dell 'odio*), *Thunder at the Border* (*Winnetou und sein Freund Old Firehand*), *Die Letzten Zwei vom Rio Bravo, Ride the Wind* (TV), *The Last Movie* (as film actor playing Pat Garrett), *Evel Knievel* (non-W; as a modern rodeo rider) (72).

75 CANUTT, Yakima (Enos Edward) (1895–). The king of the stuntmen and recipient of a special Academy Award, he was the son of a rancher and became an all-round rodeo champion for many years, then went to work as a stunt rider and performer in Hollywood where he laboured exclusively in Ws for a great many years, achieving stardom in the late Twenties. In the sound period, he became a supporting player, double and stuntman in B Ws like those of John Wayne (the pair advanced the art of screen fisticuffs); did such famous stunts as the Ringo Kid reclaiming the reins in the Indian attack of *Stagecoach*, the wagon plunge in *The Dark Command*, and became a second unit director in charge of action sequences as well as overall director of some minor pictures.

Actor: *The Heart of a Texan* (22), *The Forbidden Range, Days of '49* (s) (feature version: *California in '49*), *Sell 'Em Cowboy* (comedy), *Ridin' Mad, The Desert Hawk, Branded a Bandit, The Cactus Cure* (comedy), *Romance and Rustlers, Scar Hanan, A Two-Fisted Sheriff, Ridin' Comet, Wolves of the Road, White Thunder, The Human Tornado, The Strange Rider, Desert*

YAKIMA CANUTT (hands up) with John Wayne (left), Jack Rockwell (holding gun) and George Hayes in *'Neath Arizona Skies*

Greed, The Fighting Stallion, The Devil Horse, The Vanishing West (s), *The Three Outcasts* (also co-prod., st. & co-sc. using pseud. Enos Edwards), *Bad Men's Money, Captain Cowboy, Riders of the Storm, A Texan's Honor, Firebrand Jordan, Ridin' Law, Bar L Ranch, The Lonesome Trail, Canyon Hawks, Westward Bound, Pueblo Terror, Hurricane Horseman, Last of the Mohicans* (s) (Colonial period), *Battling with Buffalo Bill* (s), *The Vanishing Legion* (s), *Cheyenne Cyclone, Two-Fisted Justice, The Last Frontier* (s) (as Wild Bill Hickok), *Wyoming Whirlwind, The Telegraph Trail, Law and the Lawless, Via Pony Express, Fighting Texans, Sagebrush Trail, The Lucky Texan, Texas Tornado, West of the Divide, Blue Steel, The Man from Utah, Randy Rides Alone, The Star Packer, Fighting Through, The Man from Hell, The Lawless Frontier, 'Neath Arizona Skies, Circle of Death, The Dawn Rider, Paradise Canyon, Westward Ho!, The Oregon Trail, Lawless Range, King of the Pecos, The Lonely Trail, Winds of the Wasteland, The Vigilantes Are Coming* (s) (early Calif.), *The Mysterious Pilot* (non–W, as an Indian), *Wildcat Trooper, Trouble in Texas, Roarin' Lead, Ghost Town Gold, Prairie Thunder, Hit the Saddle, Come on Cowboys!, The Painted Stallion* (s), *Range Defenders, Gunsmoke Ranch, Riders of the Whistling Skull, Riders of the Rockies, Wyoming Outlaw, The Kansas Terrors, Cowboys from Texas, Pioneers of the West, Ghost Valley Riders, Under Texas Skies, The Ranger and the Lady, Frontier Vengeance, Prairie Pioneers, Gauchos of Eldorado, Shadows on the Sage, Pride of the Plains, Hidden Valley Outlaws, The Showdown, Rocky Mountain* (50).

Second Unit Director: *The Devil Horse* (s) (in collab.) (32), *Man of Conquest* (in collab.), *The Dark Command* (in collab.), *In Old Oklahoma* (or *War of the Wildcats*), *Dakota, Angel and the Badman, Northwest Outpost/End of the Rainbow* (W elements), *The Doolins of Oklahoma/The Great Manhunt, The Great Missouri Raid, Last of the Comanches/The Sabre and the Arrow, Old Yeller* (W elements), *Westward Ho the Wagons!, Cat Ballou* (comedy), *Blue, A Man Called Horse, Rio Lobo* (70).

Director: *Sheriff of Cimarron* (45), *Oklahoma Badlands, Carson City Raiders, Sons of Adventure* (W filmmaking), *Dangers of the Canadian Mounted* (modern) (s) (co-dir.), *Adventures of Frank and Jesse James* (s) (co-dir.), *The Lawless Rider* (54).

Canutt performed stunts without credit in numerous other films like *Stagecoach* (39), as well as many of those in which he was credited in other capacities.

76 CAREY, Harry (1880–1947). "Bright star of the early Western sky" was the dedication John Ford gave his departed friend on the credits of *Three Godfathers* (49). The actor had some early experience as a real cowboy before taking up a screen career in 1910, making many films for D. W. Griffith, then joining Universal in 1915 where he worked very often with John Ford playing a W hero called "Cheyenne Harry." In later years he was usually a kindly, avuncular figure in supporting roles.

Shorts: *In the Aisles of the Wild, Heredity, My Hero, A Chance Deception* (all 12), *Broken Ways, The Sheriff's Baby, The Wanderer, The Ranchero's Revenge, Two Men of the Desert, The Battle at Elderbush Gulch, Gambler's Honor* (also st.) (all 13), *The Soul Herder, Cheyenne's Pal, The Last Outlaw* (19).

Features: *A Knight of the Range* (also sc.) (15), *Love's Lariat* (also co-prod.), *Straight Shooting, The Secret Man, A Marked Man, Bucking Broadway* (W elements), *The Phantom Riders, Wild Women, Thieves' Gold, The Scarlet Drop, Hell Bent, A Woman's Fool, Three Mounted Men, Roped* (comedy; W

elements), *A Fight for Love* (N–W), *Bare Fists*, *Riders of Vengeance*, *The Outcasts of Poker Flat*, *The Ace of the Saddle*, *The Rider of the Law*, *A Gun Fightin' Gentleman*, *Marked Men*, *Bullet Proof*, *Blue Streak McCoy*, *West Is West* (modern), *Desperate Trails*, *The Fox*, *The Freeze-Out*, *"If Only" Jim*, *The Wallop*, *Man to Man*, *The Kick Back*, *Good Men and True*, *Canyon of the Fools*, *Crashin' Thru*, *Desert Driven*, *The Miracle Baby*, *The Night Hawk*, *The Lightning Rider*, *Tiger Thompson*, *The Flaming Forties*, *Soft Shoes* (W elements) (also st.), *Silent Sanderson* (N–W), *Beyond the Border*, *The Texas Trail*, *The Bad Lands*, *The Prairie Pirate*, *The Man from Red Gulch*, *Driftin' Thru*, *The Seventh Bandit*, *The Frontier Trail*, *Satan Town*, *The Trail of '98* (N–W), *Burning Bridges*, *The Border Patrol*, *Cavalier of the West*, *The Vanishing Legion* (s), *Horse Hoofs*, *Devil Horse* (s), *Last of the Mohicans* (s), *Without Honors*, *Law and Order*, *Border Devils*, *Night Rider*, *Sunset Pass*, *Man of the Forest*, *The Thundering Herd* (TV: *Buffalo Stampede*), *Wagon Trail*, *Rustler's Paradise*, *Powdersmoke Range*, *Last of the Clintons*, *Wild Mustang*, *Ghost Town*, *The Last Outlaw*, *Sutter's Gold*, *Aces Wild*, *The Law West of Tombstone*, *The Spoilers* (N–W), *Duel in the Sun*, *Angel and the Badman*, *Sea of Grass*, *Red River* (48).

77 CAREY, Harry, Jr. (1921–). The red-headed son of Harry Carey who appeared in only one of his father's films, *Red River*, where they never met on screen; started off well as a likable kid for John Ford and others and somehow bypassed middle age to become a grizzled veteran in increasingly minor roles.

Pursued (47) (*début*), *Red River*, *Three Godfathers*, *She Wore a Yellow Ribbon*, *Wagonmaster*, *Rio Grande*, *Copper Canyon*, *Warpath*, *San Antone*, *Silver Lode*, *The Outcast/The Fortune Hunter*, *The Great*

HARRY CAREY

HARRY CAREY JR. (front) with Dean Martin in *Something Big*

Locomotive Chase, The Searchers, Gun the Man Down, 7th Cavalry, From Hell to Texas/Manhunt, Escort West, Rio Bravo, Noose for a Gunman, Texas John Slaughter (TV), *Two Rode Together, Gunfight at Sandoval* (TV), *Geronimo's Revenge* (TV), *The Raiders, Cheyenne Autumn, Taggart, Shenandoah, The Rare Breed, Billy the Kid vs. Dracula, Alvarez Kelly, The Way West, The Ballad of Josie, Bandolero!, Death of a Gunfighter, The Undefeated, Ride a Northbound Horse* (TV), *Dirty Dingus Magee* (comedy), *Big Jake, One More Train to Rob, Something Big* (comedy), *Trinity Is Still My Name (Continuavano a chiamarlo), A Man from the East (E poi lo chiamarono il magnifico), Cahill: United States Marshal/Cahill* (73).

78 CARRADINE, John (1906–). The gambler Hatfield in *Stagecoach,* this tall, gaunt actor has always enjoyed the opportunity to ham up a part but has been capable of more sensitive work on the rare occasions away from cheap horror and other B vehicles when restraint has been required. With his booming voice, he has enjoyed opportunities for screen oratory as in playing Major Cassius Starbuckle for Ford in *Liberty Valance*; and had one of his best opportunities for dastardly conduct as the Bob Ford who shot Jesse James in the back in the '39 *Jesse James.*

To the Last Man (TV: *Law of Vengeance*) (33) (as John Peter Richmond), *White Fang* (N–W), *Ramona* (Indian love story), *Daniel Boone* (pioneering), *Jesse James, Stagecoach, Frontier Marshal, Drums Along the Mohawk* (Colonial period), *The Return of Frank James, Brigham Young—Frontiersman, Western Union, Northwest Rangers* (N–W), *Silver Spurs, Barbary Coast Gent, Alaska* (N–W), *Thunder Pass, Johnny Guitar, Stranger on Horseback, The Kentuckian* (pioneering), *Hidden Guns, The True Story of*

Jesse James/The James Brothers, The Proud Rebel, Showdown at Boot Hill, The Oregon Trail, The Man Who Shot Liberty Valance, Cheyenne Autumn, Billy the Kid vs. Dracula (as Dracula), *Broken Sabre* (TV), *The Good Guys and the Bad Guys, Cain's Way, The McMasters, Five Bloody Graves, The Gatling Gun* (72).

79 CARSON, Kit (Christopher) (1809–1868). A fur-trapper, mountain man and army guide in the pioneering days whose modest contributions to the taming of the West have been inordinately exaggerated so that he ranks with Daniel Boone as one of the West's great heroes.

Guy Oliver *The Covered Wagon* (23), Jack Mower (*With*) *Kit Carson over the Great Divide,* Fred Warren *California,* Fred Thomson *Kit Carson,* Johnny Mack Brown *Fighting with Kit Carson* (s), Sammy McKim *The Painted Stallion* (s), (Wild) Bill Elliott *Overland with Kit Carson* (s), Jon Hall *Kit Carson* (40).

Series use of character (TV episodes released to British cinemas 1955): Bill Williams: *Bad Men of Marysville, Fury at Red Gulch, Law of the Six Gun, The Murango Story, The Prince of Padua Hills, The Range Masters, Return of Trigger Dawson, Riders of Capistrano, Roaring Challenge, The Teton Tornado, Thunder Over Inyo, Ticket to Mexico.*

80 CASSIDY, Butch (Robert or George LeRoy Parker) (1866–1908). This legendary outlaw was initiated into crime by a rustler he admired (whose name, Cassidy, he adopted), progressed to bank robbery, then train hold-ups, and finally concluded his career on similar lines in Bolivia. He was apparently an engaging rogue capable of acts of loyalty, quixotic gestures, and only a killer in a final defence of his life. Paul Newman's portrait of him uses mainly real incidents down to bowler and bicycle,

the others are more routine.

John Doucette *The Texas Rangers* (51), Gene Evans *Wyoming Renegades,* Howard Petrie *The Maverick Queen,* Neville Brand *The Three Outlaws,* Neville Brand *Badman's Country,* Arthur Hunnicutt *Cat Ballou,* John Crawford *Return of the Gunfighter,* Paul Newman *Butch Cassidy and the Sundance Kid* (69).

81 CASTLE, Peggie (1927–1973). Blonde actress from Virginia who had some active years as a heroine of lesser Ws. Was in W TV series *Lawman* (c1960).

Wagons West (52), *Cow Country, Son of Belle Starr, Overland Pacific, Yellow Tomahawk, Jesse James' Women, Tall Man Riding, Quincannon Frontier Scout/Frontier Scout, Oklahoma Woman, Two-Gun Lady, Hell's Crossroads* (57).

82 CASTLE, William (1914–). Former associate of Orson Welles who directed a series of glossy, routine Ws before settling down to a series of exploitation pictures and producing *Rosemary's Baby.*

Cave of Outlaws (51), *Fort Ti* (Colonial period), *Conquest of Cochise, Battle of Rogue River, Jesse James versus the Daltons, The Law versus Billy the Kid, Masterson of Kansas, The Americano* (Brazil), *The Gun that Won the West* (55).

83 CHANDLER, Jeff (1918–1961). His first W performance as the wise, peace-loving Indian chief Cochise of *Broken Arrow* was to be the highlight of his W career.

Broken Arrow (50), *Two Flags West, The Battle at Apache Pass* (as Cochise again), *Taza Son of Cochise* (as Cochise again), *The Great Sioux Uprising, War Arrow, Foxfire* (non-W, as modern half-Apache), *The Spoilers* (N–W), *Pillars of the Sky/ The Tomahawk and the Cross, Drango, Man in the Shadow/Pay the Devil* (modern), *Thunder in the Sun, The Jayhawkers, The Plunderers* (60).

84 CHASE, Borden (1900–1971). One of the most significant of W screenwriters, principally responsible for the writing of *Red River* and

JEFF CHANDLER in *Drango*

subsequently author of many Anthony Mann Ws; very concerned with themes of self-esteem and the individual's need for a place in the community.

Co-sc. *Flame of the Barbary Coast* (W elements) (45), st. *The Man from Colorado,* story basis (magazine serial/novel "The Chisholm Trail" or "Red River") co-sc. *Red River,* part sc. *Montana,* co-sc. *Winchester 73,* st. sc. *Lone Star,* sc. *Bend of the River/Where the River Bends,* st. *Vera Cruz,* st. sc. *The Far Country,* co-sc. *Man Without a Star,* sc. *Backlash,* sc. *Night Passage,* sc. *Ride a Crooked Trail,* novel basis ("Viva Gringo") co-st. part sc. *Gunfighters of Casa Grande,* part sc. *A Man Called Gannon* (use of sc. for *Man Without a Star*), st. sc. *Backtrack* (from TV eps. "The Virginian" and "Laredo", filmed 63) (69).

BUFFALO BILL—*see* CODY, William F.

Duncan Renaldo as THE CISCO KID with Leo Carrillo as his sidekick

85 CISCO KID, The. Character created by famed storyteller O. Henry in a 1907 short story and made by the movies into a dashing Robin Hood of the Southwest. Earliest screen use in *The Caballero's Way* (14) and *The Border Terror* (19) (2r) with actors untraced, then series use as follows.

Warner Baxter: *In Old Arizona* (29), *The Cisco Kid, The Return of the Cisco Kid* (39).

Cesar Romero: *The Cisco Kid and the Lady* (39), *Lucky Cisco Kid, Viva Cisco Kid, The Gay Caballero, Romance of the Rio Grande, Ride On Vaquero!* (41).

Duncan Renaldo: *Cisco Kid Returns* (45), *In Old New Mexico, South of the Rio Grande, The Valiant Hombre* (TV: *The Romantic Vaquero*), *The Gay Amigo, The Daring Caballero, Satan's Cradle, The Girl from San Lorenzo* (50).

Gilbert Roland: *The Gay Cavalier* (46), *South of Monterey, Beauty and the Bandit, Riding the California Trail, Robin Hood of Monterey, King of the Bandits* (47).

Mike Witney (top) as IKE CLANTON with Harris Yulin as Wyatt Earp in *Doc*

86 CLANTONS, The, i.e. N. H. (Old Man) Clanton and his three sons, well-known outlaws and rustlers, whose feud with Wyatt Earp erupted in the gunfight at the O.K. Corral.

Walter Brennan (Old Man), Grant Withers (Ike), John Ireland (Billy): *My Darling Clementine* (46), Lyle Bettger (Ike), Dennis Hopper (Billy), Lee Roberts (Finn): *Gunfight at the O.K. Corral,* Robert Ryan (Ike), Walter Gregg (Billy): *Hour of the Gun,* James Craig (Ike): *Arizona Bushwhackers,* Mike Witney (Ike), Bruce M. Fischer (Billy): *Doc* (71).

87 CLOTHIER, William H. (1903–). An aerial photographer of long standing who did much work abroad, finally broke into big-scale Hollywood production in the Fifties, quickly becoming a favourite cameraman of the tough veteran directors like Ford, Wellman, Walsh. Photographs most of John Wayne's Ws, and has established a strong rapport with the younger W directors like Andrew McLaglen.

*†*Track of the Cat* (W elements), *Seven Men from Now, Gun the Man Down, *†Dragoon Wells Massacre, Fort Dobbs, †Escort West, *The Horse Soldiers, *The Alamo* (Todd A–O), *†The Comancheros, *†The Deadly Companions, The Man Who Shot Liberty Valance, *†McLintock!* (comedy), *†A Distant Trumpet, *†Cheyenne Autumn, *Shenandoah* (Civil War), *†The Rare Breed, *†Stagecoach, *†The Way West, *†The War Wagon, *Firecreek, *†Bandolero!, *†The Undefeated, *†Chisum, *†The Cheyenne Social Club, *Rio Lobo, *†Big Jake, *†The Train Robbers* (73).

88 COBB, Lee J. (1911–). Volatile character actor whose first screen appearance was in a Hopalong Cassidy picture and who has lent his strength of personality to many Ws since, as well as several years on TV's "The Virginian" series.

LEE J. COBB in *Lawman*

North of the Rio Grande (37), *Rustler's Valley, Buckskin Frontier, The Tall Texan, The Road to Denver, Man of the West, How the West Was Won* (ep. "Outlaws"), *The Final Hour* (TV: "The Virginian"), *The Brazen Bell* (TV: ditto), *MacKenna's Gold, Macho Callahan, Lawman, The Man Who Loved Cat Dancing* (73).

89 COBURN, James (1928–). Tall, lean, sandy-haired actor of controlled poise and litheness who first attracted attention as the knife-slinger of *The Magnificent Seven.*

Ride Lonesome (début) (58), *Face of a Fugitive, The Magnificent Seven, The Man from Galveston* (TV), *Major Dundee, Waterhole #3, The Honkers* (modern rodeo), *Duck You Sucker!/A Fistful of Dynamite* (Mexico), *Pat Garrett and Billy the Kid* (as Garrett), *A Reason to Live A Reason to Die* (*Una ragione per vivere e una per morire*), *Bite the Bullet* (W elements) (75).

90 COCHISE (c1820–1874). The Apache chief who counselled peace and banished the warlike Geronimo. Jeff Chandler portrayed him with understanding in *Broken Arrow,* a

film with notable sympathy for the Indian cause.

Antonio Moreno *Valley of the Sun* (42), Miguel Inclan *Fort Apache,* Jeff Chandler *Broken Arrow,* Chief Yowlachie *The Last Outpost,* John Hodiak *Conquest of Cochise,* Jeff Chandler *The Battle at Apache Pass,* Jeff Chandler *Taza Son of Cochise,* Michael Keep *Forty Guns to Apache Pass* (67).

91 COCHRAN, Steve (1917–1965). An actor of under-appreciated ability, generally confined to bullying, insensitive roles, he came to films having been a cowpuncher among other occupations.

Dallas (50), *Raton Pass/Canyon Pass, The Lion and the Horse, Shark River* (W elements), *Back to God's Country* (Canada), *Quantrill's Raiders, The Deadly Companions* (61).

92 CODY, Iron Eyes. A real Indian (a Cherokee born in Oklahoma) and one of several to have made a career out of playing the redman on the screen. He has also very frequently acted as an advisor for Indian sequences. A skilled rider from childhood who went on to perform in Wild West shows, he long alternated this work with film chores; married to an anthropologist, he has become an expert in Indian objects and lore. No thorough listing of his film work is possible but known titles follow.

The Squaw Man (14) (as an Indian dancer), *The Covered Wagon, The Road to Yesterday* (non-W; as an Indian), *Wild West Days* (s), *Flaming Frontiers* (s), *The Oregon Trail* (s), *Crashin' Thru* (Mounties), *Union Pacific, Overland with Kit Carson* (s), *Pony Post, Kit Carson, North West Mounted Police* (Mounties), *Western Union, King of the Stallions, Valley of the Sun, Ride 'Em Cowboy* (modern comedy), *Bowery Buckaroos* (modern comedy), *Unconquered* (Colonial period), *Blood on the Moon, Indian Agent, The Paleface* (comedy), *Massacre*

River, Sand (modern horse), *Comanche Territory, Broken Arrow, Cherokee Uprising, California Passage, The Last Outpost, The Redhead and the Cowboy, Fort Defiance, Night Raiders, Fort Osage, Red Mountain, Son of Paleface, The Big Sky* (pioneering), *Montana Belle, Arrow in the Dust, Sitting Bull* (as Crazy Horse), *White Feather, The Wild Dakotas, Comanche, Westward Ho the Wagons, Gun for a Coward, Gun Fever, The Light in the Forest* (Colonial period) *Alias Jesse James* (comedy), *Heller in Pink Tights, The Great Sioux Massacre* (as Crazy Horse), *Nevada Smith, The Fastest Guitar Alive* (Civil War musical comedy), *El Condor, A Man Called Horse* (Colonial period) (70).

93 CODY, William Frederick (1846–1917). "Buffalo Bill" Cody gained his nickname hunting buffalo to feed railroad builders; had earlier served as a scout with the cavalry fighting Kiowa and Comanche; was made into a legend by a dime novelist called Ned Buntline and capitalised on public interest by creating a Wild West show. Fact and legend have been inextricably entwined and elaborated upon by numerous scriptwriters who have made Buffalo Bill one of the screen's most frequently represented real life Westerners.

Paul Panzer *Life of Buffalo Bill* (?), George Waggner *The Iron Horse,* John Fox Jr. *The Pony Express* (as a youth), Jack Hoxie *The Last Frontier,* Roy Stewart (*With*) *Buffalo Bill on the U.P. Trail,* William Fairbanks *Wyoming,* Wallace MacDonald *Fighting with Buffalo Bill* (s) (footage reused in *The Indians Are Coming* [s]), Tom Tyler *Battling with Buffalo Bill* (s), Douglas Dumbrille *The World Changes* (part W), Earl Dwire *The Miracle Rider* (s), Moroni Olsen *Annie Oakley* (as a showman), James Ellison *The Plainsman,* Carlyle Moore *Outlaw Express,* John Rutherford *Flaming Frontiers* (s), Ted Adams *Custer's Last Stand* (s), Roy Rogers

Young Buffalo Bill, Bob Baker *Overland Mail* (s) (as a boy), Joel McCrea *Buffalo Bill*, Richard Arlen *Buffalo Bill Rides Again*, Monte Hale *Law of the Golden West*, Louis Calhern *Annie Get Your Gun* (musical —as a showman), Dickie Moore *Cody of the Pony Express* (s), Tex Cooper *King of the Bullwhip*, Clayton Moore *Buffalo Bill in Tomahawk Territory*, Charlton Heston *Pony Express*, Marshall Reed *Riding with Buffalo Bill* (s), Malcolm Atterbury *Badman's Country*, James McMullan *The Raiders*, Rick van Nutter *Seven Hours of Gunfire* (*Aventuras del Oeste* or *Setti ore di fuoco*), Gordon Scott *Buffalo Bill* (*Buffalo Bill, l'eroe del Far West*), Guy Stockwell *The Plainsman*, Michel Piccoli *Touche Pas La Femme Blanche* (satire) (74).

94 CONNORS, Chuck (1921–). Former baseball star whose build stands him in good stead for playing W and athletic roles.

Tomahawk Trail/Mark of the Apache (57), *The Hired Gun, Old Yeller, The Big Country, Geronimo* (in title role), *Broken Saber, Ride Beyond Vengeance, Kill Them All*

CHUCK CONNORS with Burl Ives (left) in *The Big Country*

and Come Back Alone (*Ammazzali tutti e torna solo*), *Proud Damned and Dead* (South American W), *The Deserter* (*La spina dorsale del diavolo*), *Support Your Local Gunfighter* (comedy), *Pancho Villa* (Mexico) (72).

ELISHA COOK JR. in
The Lonely Man

95 COOK, Elisha, Jr. (1907–). Character actor much loved for the sympathy he engenders for sometimes weak, sometimes stubborn, small and often rather comical figures. He is perhaps more readily associated with gangster films (he came late to the W), but his Southern sodbuster of *Shane* is just one of several fine W performances and another of the actor's tragic "losers."

Shane (53), *Thunder Over the Plains, Drumbeat, The Outlaw's Daughter, Timberjack* (timber), *The Indian Fighter, The Lonely Man, Day of the Outlaw, One Eyed Jacks, Blood on the Arrow, Welcome to Hard Times/Killer on a Horse, El Condor, The Great Bank Robbery* (comedy), *The Great Northfield Minnesota Raid* (72).

GARY COOPER in 1930 (above, in
The Virginian) and 1958 (below) in
The Hanging Tree

96 COOPER, Gary (1901–1961).
One of the screen's great Westerners,
he made his characters tall, lean,
quiet-spoken, self-conscious, em-
bodying a gentlemanly dignity and
an unswerving integrity. As Marshall
Will Kane in *High Noon* he created
an indelible image of an ageing law-
man who almost loses his self-respect
along with his self-reliance. He was
an extra in many silent films includ-
ing Ws: *The Thundering Herd* (25),
*Wild Horse Mesa, The Lucky Horse-
shoe, The Vanishing American,
Tricks* (comedy) and *The Enchanted
Hill.*

The Winning of Barbara Worth
(26), *Arizona Bound, Nevada, The
Last Outlaw, Wolf Song* (mountain
life—W elements), *The Virginian,
Only the Brave* (Civil War), *The
Texan, The Spoilers* (N–W), *Fight-
ing Caravans, I Take This Woman*
(modern), *Operator 13/Spy 13*
(Civil War), *The Plainsman* (as
Wild Bill Hickok), *The Cowboy and
the Lady* (modern comedy), *The
Westerner, North West Mounted
Police* (Mounties), *Along Came
Jones* (comedy) (also prod.), *Sara-
toga Trunk* (non–W—as a cowboy),
Unconquered (Colonial period), *Dal-
las, Starlift* (musical—guest in W
parody), *It's a Great Country* (non–
W—as a cowboy), *Distant Drums*
(Florida), *High Noon, Springfield
Rifle, Garden of Evil* (Mexico), *Vera
Cruz* (Mexico), *Friendly Persuasion*
(Civil War—W elements), *Man of
the West, The Hanging Tree, Alias
Jesse James* (comedy—guest star)
(59).

97 COOPER, James Fenimore
(1789–1851). Remembered as the
author of the Leatherstocking Tales,
five novels of Eighteenth century
frontier life filmed as follows (title
changes noted in brackets).
"The Last of the Mohicans": 1909
(*Leatherstocking*), 1911 (twice),
1920, 1932(s), 1936, 1947 (*The
Last of the Redmen*), 1965 (*The
Last Tomahawk* [*Der Letzte Mo-
hikaner*]). "The Deerslayer": 1913,

JEFF COREY as Wild Bill Hickok
in *Little Big Man*

1924 (s—*Leatherstocking*), 1944 (*Deerslayer*), 1957. "The Pathfinder": 1952. "The Prairie": 1947. *The Iroquois Trail/The Tomahawk Trail* (1950) was loosely derived from the series as a whole.

98 COREY, Jeff (1914–). Achieved W prominence with key roles as the small-time killer who set

the story of *True Grit* in motion and as an offbeat Wild Bill Hickok in *Little Big Man* after many years of supporting work interrupted by a spell from 1951 to 1963 when the pressures of blacklisting drove him into teaching acting and establishing a well-known school.

North to the Klondike (42), *Ramrod, Hoppy's Holiday, Roughshod, The Nevadan/The Man from Nevada, Singing Guns, The Outriders, Rock Island Trail/Transcontinent Express, Only the Valiant, Rawhide* (TV: *Desperate Siege*), *New Mexico, Red Mountain, True Grit, Butch Cassidy and the Sundance Kid, Little Big Man* (as Wild Bill Hickok), *Shoot Out, Catlow* (72).

99 COTTEN, Joseph (1905–). Highly capable actor, now too rarely exercising his abilities, whose W work, though substantial, hardly compares to his roles for Orson Welles and Hitchcock.

Duel in the Sun (48), *Two Flags West, Untamed Frontier, The Halliday Brand, The Last Sunset, The Great Sioux Massacre, The Tramplers* (*Gli uomini dal passo pesante*), *White Comanche* (*Comancho Blanco*), *The Hellbenders* (*I crudeli*), *Brighty of the Grand Canyon* (W elements) (67).

BRODERICK CRAWFORD (right) with Scott Brady
and Howard Keel in *Red Tomahawk*

100 CRAIN, Jeanne (1925–). A highly attractive adornment to the plains on occasion.

City of Bad Men (53), *Man without a Star, The Second Greatest Sex* (musical comedy), *The Fastest Gun Alive, Guns of the Timberland* (60).

101 CRAWFORD, Broderick (1911–). Thick set actor with tough guy image and a long but routine association with Ws.

When the Daltons Rode (as Bob Dalton) (40), *Trail of the Vigilantes, Texas Rangers Ride Again, Badlands of Dakota, North to the Klondike* (N–W), *Men of Texas/Men of Destiny, Sin Town, Bad Men of Tombstone, Lone Star, Last of the Comanches/The Sabre and the Arrow, The Last Posse, The Fastest Gun Alive, Kid Rodelo, The Texican, Red Tomahawk* (67).

102 CRAWFORD, Joan (1908–). Actress who took her special brand of screen suffering out West rather memorably in *Johnny Guitar;* she seemingly scorned the wide open spaces for most of her starring years, her only other Ws dating very early in her career: *Winners of the Wilderness* (Colonial period) (27), *Law of the Range, Montana Moon* (musical comedy).

103 CRAZY HORSE. The chief of the Ogalalla branch of the Sioux Indian tribe, he was the leader along with Sitting Bull of the uprising against the white man that led to the massacre of the Seventh Cavalry at Little Big Horn on June 25, 1876. Shortly after, Crazy Horse was taken prisoner by the military and bayoneted to death during an alleged attempt to escape. Kieron Moore played the equivalent role as the Comanche called Dull Knife in *Custer of the West*. An unidentified actor portrayed Crazy Horse in *Buffalo Bill* (44).

High Eagle *Custer's Last Stand* (s) (36), Anthony Quinn *They Died with Their Boots On*, Iron Eyes Cody *Sitting Bull*, Victor Mature *Chief Crazy Horse/Valley of Fury*, Murray Alper *The Outlaws Is Coming* (comedy), Iron Eyes Cody *The Great Sioux Massacre* (65).

104 CROCKETT, Davy (1786–1836). Trapper and Indian scout who became a famed hero of Texas when he died defending the Alamo from Mexican forces.

Dustin Farnum *Davy Crockett* (16), Cullen Landis (*With*) *Davy Crockett at the Fall of the Alamo*, Lane Chandler *Heroes of the Alamo*, Jack Perrin *The Painted Stallion* (s), Robert Barrat *Man of Conquest*, Trevor Bardette *The Man from the Alamo*, Arthur Hunnicutt *The Last Command*, Fess Parker *Davy Crockett King of the Wild Frontier*, Fess Parker *Davy Crockett and the River Pirates*, John Wayne *The Alamo* (60).

105 CRONJAGER, Edward (1904–1960). A distinguished cinematographer (one of a family active behind the camera), he received several Oscar nominations, including one for *Cimarron*. His colour photography was perhaps even more breathtaking than his monochrome. He was a favourite cameraman of Richard Dix.

The Gay Defender (W elements) (27), *Redskin* (parts in early colour), *Cimarron, Secret Service* (Civil War), *The Conquerors* (W elements), *Yellow Dust, The Gay Caballero* (Mexico), *The Texas Rangers, *Western Union* (co-ph.), *Canyon Passage, Relentless* (co-ph.), *The Capture* (modern Mexico), *Best of the Badmen, *Powder River, *The Siege at Red River* (54).

106 CRUZE, James (1884–1942). Though he is best remembered as the director of the still impressive *The Covered Wagon,* the first real W epic in which he displayed a genuine eye for telling composition and firm control of actors and story, he only directed one other W, *The Pony Express*. Before directing he

had played one or two character roles in Ws: *Nan of Music Mountain*, etc. As director, also did *The Valley of the Giants* (timber), *Helldorado* (W elements), *Sutter's Gold* (W elements).

107 CUNNINGHAM, John W. (or M.) The W writer whose short story "The Tin Star" was the basis of Carl Foreman's script for *High Noon;* another very similar short story ("Raiders Die Hard") was the basis of *Day of the Badman.* Also novel basis ("Yankee Gold") *The Stranger Wore a Gun,* story basis ("Outlaw's Partner") *Saddle the Wind.*

108 CURTIS, Tony (1925–). For a star groomed at an action studio like Universal, he has done extraordinarily little W work since his bits in *Sierra, Winchester '73* and *Kansas Raiders.* He has only played a Westerner in *The Rawhide Years* and a modern Indian in *The Outsider.*

109 CURTIZ, Michael (1888–1962). Ws were only a minor part of this talented director's huge output which covered all the major *genres.* Curtiz's flair for pace and incisive performances ensures that his action films stand the test of time.

 Under a Texas Moon (30), *River's End* (Mounties), *Gold Is Where You Find It* (W elements), *Dodge City, Virginia City, Santa Fe Trail* (Civil War), *Jim Thorpe All American/ Man of Bronze* (modern Indian), *The Boy from Oklahoma, The Proud Rebel, The Hangman, The Comancheros* (61).

110 CUSTER, George Armstrong (1839–1876). A Civil War hero and general at twenty-six, this glory-seeking soldier found lasting fame when he perished with his entire command of 264 men in a hopeless battle against the Sioux and Cheyenne between the Little Big Horn and Rosebud rivers on June 25, 1876. Hollywood has viewed him both

Robert Shaw as CUSTER
in *Custer of the West*

sympathetically (the best whitewash version being *They Died with Their Boots On*) and unsympathetically with two portraits in the latter vein occurring in *Fort Apache* (Henry Fonda) and *The Glory Guys* (Andrew Duggan) but with a change of name. *7th Cavalry* and *Little Big Horn/The Fighting 7th* are two examples of films drawing on but not actually depicting Custer's last stand. The actor playing Custer in *Custer's Last Stand* or *On the Little Big Horn* (09) has resisted identification.

 Francis Ford *Custer's Last Fight* (year?), Dwight Crittenden *Bob Hampton of Placer* (or *Custer's Last Stand*), Dustin Farnum *The Flaming Frontier,* John Beck (*With*) *General Custer at Little Big Horn,* William Desmond *The Last Frontier* (s), Clay Clement *The World Changes* (non–W), Frank McGlynn Jr. *Custer's Last Stand* (s), John Miljan *The Plainsman,* Roy Barcroft *The Oregon Trail* (s), Paul Kelly *Wyoming* (or *Bad Man of Wyoming*), Addison Richards *Badlands of Dakota,* Ronald Reagan *Santa Fe Trail,* Errol Flynn *They Died with Their Boots On,* James

Millican *Warpath,* Sheb Wooley *Bugles in the Afternoon,* Douglas Kennedy *Sitting Bull,* Britt Lomond *Tonka,* Philip Carey *The Great Sioux Massacre,* Leslie Nielsen *The Plainsman,* Robert Shaw *Custer of the West,* Richard Mulligan *Little Big Man,* Marcello Mastroianni *Touche Pas La Femme Blanche* (satire) (74).

111 THE DALTONS. Cousins of the notorious Youngers, they were a trio of death-dealing desperadoes whose speciality was train robbing and they made their reputation in and around Oklahoma in 1891/92, led by Bob, with Emmett the youngster and Grat the elder brother. Their careers came to a bloody end in a bank raid on Coffeyville, Kansas: Bob and Grat died, Emmett survived severe wounds, went to jail, and died many years after release in 1937. Films concerning the Daltons usually throw in a fourth Dalton brother, Bill, (sometimes called Ben), though he turned to crime later and separately. Emmett Dalton starred as himself in *Beyond the Law* (1918).

Broderick Crawford (Bob), Frank Albertson (Emmett), Brian Donlevy (Grat), Stuart Erwin (Ben): *When the Daltons Rode* (40), Kent Taylor (Bob), Alan Curtis (Emmett), Lon Chaney Jr. (Grat), Noah Beery Jr. (Ben): *The Daltons Ride Again,* Steve Brodie (Bob), Phil Warren (Grat), William Moss (Bill): *Badman's Territory,* Noah Beery Jr. (Bob), Rand Brooks (Emmett), Palmer Lee (Grat), William Reynolds (Will): *The Cimarron Kid,* Scott Brady (Bob), Ray Teal (Emmett): *Montana Belle,* James Griffith (Bob), William Tannen (Emmett), John Cliff (Grat), Bill Phipps (Bill): *Jesse James vs. The Daltons.* The names of the actors playing the roles in *The Dalton Gang* (50) have proved elusive; the Daltons were also portrayed in the cartoon W, *Lucky Luke* (71).

112 DANIELS, William (1895–1970). "Garbo's cameraman" also knew his way out West as he demonstrated when he took up the *genre* in earnest at Universal: in particular, there is his brilliant work on the first film in the now discarded Technirama process, *Night Passage* (2nd Unit: Clifford Stine), with its breathtaking depth and clarity of image.

Montana Moon (musical comedy) (30), *The Great Meadow* (Colonial period), **The Gal Who Took the West, Winchester '73, *War Arrow, *The Far Country, *†Night Passage, *How the West Was Won* (part) (Cinerama) (62).

113 DAVES, Delmer (1904–). A major W talent sadly inactive of recent years. Spent part of his youth living among Hopi and Navajo Indians, broke into films as assistant property boy on *The Covered Wagon,* became a screenwriter (mainly comedies and musicals), then director (1943). Took up the W in 1950 with the acclaimed *Broken Arrow,* notably sympathetic towards the Indian, and largely concentrated on the genre with often memorable results until being sidetracked into youth market pictures like *Susan Slade.* Films as director:

Broken Arrow (50), *Return of the Texan* (modern), *Drum Beat* (also st. sc.), *Jubal* (also co-sc.), *The Last Wagon* (also part sc.), *3:10 to Yuma, Cowboy, The Badlanders, The Hanging Tree* (59). Also co-sc. *White Feather.*

114 DAVIS, Jim (1915–). A Republic regular usually on the side of villainy, this Missouri-born actor also starred in some minor Ws after Republic folded and has made an unusual transition to become a familiar face in the supporting casts of recent big Ws.

Frontier Fury (43), *Cyclone Prairie Rangers, The Romance of Rosy Ridge* (W elements), *The Fabulous Texan, Red Stallion in the Rockies, Hellfire, Brimstone, The Savage Horde, The Cariboo Trail, The Showdown, California Passage,*

JIM DAVIS in *Bad Company*

of the Desperadoes, The Maverick Queen, Frontier Gambler, Duel at Apache Wells, The Quiet Gun, The Restless Breed, The Badge of Marshal Brennan, Last Stagecoach West, Apache Warrior, A Lust to Kill, Raiders of Old California, Toughest Gun in Tombstone, Alias Jesse James (as Frank James) (comedy), *Noose for a Gunman, The Gambler Wore a Gun, Frontier Uprising, Jesse James Meets Frankenstein's Daughter, Fort Utah, El Dorado, Hondo and the Apaches, Five Bloody Graves, Monte Walsh, Rio Lobo, Big Jake, The Honkers* (modern rodeo), *Bad Company* (72).

115　DE CARLO, Yvonne (1924–). This Canadian born actress was a glamorous addition to many a W, usually found hanging around the saloon and possessing a fiery temper.

The Deerslayer (Colonial period) (43), *Salome Where She Danced, Frontier Gal/The Bride Wasn't Willing* (comedy), *Black Bart/Black Bart Highwayman, River Lady* (W elements), *Calamity Jane and Sam Bass* (as Jane), *The Gal Who Took the West, Tomahawk/Battle of Powder River, Silver City/High Vermilion, The San Francisco Story* (W elements), *Border River, Passion* (Mexico), *Shotgun, Raw Edge, Mc-*

Three Desperate Men, Cavalry Scout, Silver Canyon, Little Big Horn/The Fighting 7th, Rose of Cimarron, The Big Sky (Colonial period), *Ride the Man Down, The Woman They Almost Lynched* (as Cole Younger), *Jubilee Trail, The Outcast/The Fortune Hunter, The Outlaw's Daughter, Timberjack* (timber), *The Last Command, The Vanishing American, Last*

YVONNE DE CARLO (right) with Maureen O'Hara and John Wayne in *McLintock!*

Lintock! (comedy), *Law of the Law-
less, Hostile Guns, Arizona Bush-
whackers* (67).

116 DE CORSIA, Ted (1906–
). Though he has probably made
his strongest impression in gangster
films, this tough, usually unsympa-
thetic character actor has also
notched up quite a few W appear-
ances.

The Outriders (50), *Vengeance
Valley, New Mexico, The Savage,
Ride Vaquero, Man with the Gun/
The Trouble Shooter, Mohawk,
Showdown at Abilene, Gunfight at
the O.K. Corral, The Lawless Eigh-
ties, Gun Battle at Monterey, Okla-
homa Territory, Noose for a Gun-
man, The Quick Gun, Blood on the
Arrow, Nevada Smith, 5 Card Stud*
(68).

117 DEHNER, John (1915–).
Character actor who first followed
his father, an artist and illustrator,
by becoming an animator for Walt
Disney; then, after being a disc jock-
ey, pianist and music arranger, he

TED DE CORSIA in
Gun Battle at Monterey

JOHN DEHNER (right) with
Sterling Hayden in *The Iron Sheriff*

turned to screen acting *c*1945. Has
given many of his parts a good deal
more shading than many other actors
have; his best W opportunity, as Pat
Garrett in *The Left Handed Gun,*
unfortunately didn't take him out of
the rut. Early roles in Bs with Tim
Holt, Charles Starrett, etc.

Out California Way (46), *Vigi-
lantes of Boom Town, Horsemen of
the Sierras/Suspected, Bandits of El
Dorado/Tricked, Texas Dynamo,
Dynamite Pass, Fort Savage Raiders,
Al Jennings of Oklahoma, When the
Redskins Rode* (Colonial period),
*The Texas Rangers, Hot Lead, Desert
Passage, Junction City, California
Conquest* (early California), *Crip-
ple Creek, Powder River, Gun Belt,
Southwest Passage/Camels West,
The Cowboy* (documentary—part
narration), *Apache, Bad Men of
Marysville* (TV), *The Man from Bit-
ter Ridge, Tall Man Riding, The
Scarlet Coat* (Civil War), *Top Gun,
A Day of Fury, The Fastest Gun
Alive, Tension at Table Rock, Re-
volt at Fort Laramie, The Iron*

Sheriff, Trooper Hook, The Left Handed Gun (as Pat Garrett), *Apache Territory, Man of the West, Cast a Long Shadow, The Canadians* (Mounties), *The Hallelujah Trail* (comedy—narrator), *The Cheyenne Social Club, Dirty Dingus Magee* (comedy), *Support Your Local Gunfighter* (comedy) (71).

118 DE KOVA, Frank. Former Broadway actor who went to Hollywood in 1951; in his Ws, a specialist in Indians and Spanish/Mexicans, satirised himself as an Indian on TV's *F Troop*.

Viva Zapata! (Mexico) (52), *The Big Sky* (Colonial period), *Pony Soldier/MacDonald of the Canadian Mounties* (Canada), *Arrowhead, Passion* (Mexico), *Drum Beat, They Rode West, Strange Lady in Town, The Man from Laramie, The Lone Ranger, Pillars of the Sky/The Tomahawk and the Cross, Reprisal!, The White Squaw, Run of the Arrow, Ride Out for Revenge, Cowboy, Apache Territory, Day of the Outlaw, The Jayhawkers, The Legend of the Boy and the Eagle* (narrator), *The Wild Country* (71).

119 DeMILLE, Cecil B. (1881–1959). First and foremost a showman whose later spectacles tended to fill the eye and deaden the mind; the gap was less evident in his Ws where lavish spectacle, period reconstruction and dramatic *clichés* generally combined to excellent effect. The producer of all his films.

The Squaw Man (co-dir, also co-sc.) (14), *The Virginian* (also sc., co-ed.), *The Call of the North* (N–W) (also sc.), *The Rose of the Rancho* (also sc., ed.), *The Girl of the Golden West* (also sc., ed.), *The Warrens of Virginia* (Civil War) (also ed.), *Chimmie Fadden Out West* (comedy) (also co-sc., ed.), *Romance of the Redwoods* (also co-sc., ed.), *The Squaw Man/The White Man* (18), *The Squaw Man/ The White Man* (31), *The Plainsman, Union Pacific, North West Mounted Police* (Mounties), *Unconquered* (Colonial period) (48).

120 DE TOTH, Andre (1910–). Director of Hungarian background whose Ws have a cold precision and lack of warmth. Many star Randolph Scott. Was also co-author of the story of *The Gunfighter*, and producer of *El Condor*.

Ramrod (47), *Man in the Saddle/ The Outcast, Carson City, Springfield Rifle, Last of the Comanches/ The Sabre and the Arrow, The Stranger Wore a Gun, Thunder Over the Plains, Riding Shotgun, The Bounty Hunter, The Indian Fighter, Day of the Outlaw* (59).

121 DEVINE, Andy (1905–). Corpulent actor, born in Arizona, with a hoarse, protesting voice: memorable as the stagedriver in *Stagecoach* and the cowardly lawman in *The Man Who Shot Liberty Valance*, both for John Ford. An extra in films from 1926 with obvious usefulness for comic relief. Sidekick to Roy Rogers in 9 films and also to Guy Madison's Wild Bill Hickok in TV series of which many episodes were released to British cinemas as supporting features.

Law and Order (32), *Destry Rides Again, Stagecoach, Geronimo, Buck Benny Rides Again* (comedy), *When the Daltons Rode, Trail of the Vigilantes, Men of the Timberland* (timber), *Badlands of Dakota, Road Agent, North to the Klondike* (N–W), *Sin Town, Frontier Badmen, Frontier Gal/The Bride Wasn't Willing* (comedy), *Canyon Passage, The Michigan Kid, Bells of San Angelo, Springtime in the Sierras, The Marauders, The Vigilantes Return, On the Old Spanish Trail, The Fabulous Texan, The Gay Ranchero, Old Los Angeles, Under California Stars, Eyes of Texas, The Gallant Legion, Night Time in Nevada, Grand Canyon Trail, The Far Frontier, The Last Bandit, Traveling Saleswoman* (comedy), *Never a Dull Moment* (modern W comedy), *New Mexico, Slaughter*

ANDY DEVINE (left) with Claire Trevor, John Carradine
and John Wayne in *Stagecoach*

Trail, *The Red Badge of Courage* (Civil War), *Montana Belle, Arrow in the Dust* (TV), *Behind Southern Lines* (TV), *The Ghost of Crossbone Canyon* (TV), *The Yellow Haired Kid* (TV), *Border City Rustlers* (TV), *Secret of Outlaw Flats* (TV), *Six Gun Decision* (TV). *Two Gun*

ANGIE DICKINSON with
Robert Wilke in *Gun the Man Down*

Marshal (TV), *Thunder Pass, Two Rode Together, The Man Who Shot Liberty Valance, How the West Was Won* (ep. "Civil War"), *The Ballad of Josie, Ride a Northbound Horse* (TV), *Smoke* (modern) (TV) (70).

122 DE WILDE, Brandon (1942–1972). One of the most effective of child actors, unforgettable as Joey Starrett in *Shane,* he never gained a solid image of maturity in later years before his tragic death as the result of a car accident.

Shane (53), *Night Passage, The Tenderfoot* (TV), *The Deserter* (*La spina dorsale del diavolo*) (72).

123 DICKINSON, Angie (1931–). Sexy actress whose screen image really took shape, after numerous minor Ws, in the hands of Howard Hawks for whom she played "Feathers" in *Rio Bravo*; just hasn't had the parts to follow up this magnetic appearance but never stops trying. Dubbed Sarita Montiel in *Run of the Arrow*.

Tennessee's Partner (bit) (55), *Man with the Gun/The Trouble Shooter* (bit), *The Return of Jack Slade/Texas Rose, Hidden Guns, Tension at Table Rock, Gun the Man Down, The Black Whip, Shootout at Medicine Bend, Rio Bravo, The Last Challenge/The Pistolero of Red River, Sam Whiskey, Young Billy Young* (70).

124 DIERKES, John. Tall, gaunt, solemn actor (a former economist) who is best suited for stern, upright figures; probably best known to general audiences as the man with the blind wife in *The Alamo*. Recently to be glimpsed in credit backgrounds of *Buck and the Preacher* though not in film itself.

The Red Badge of Courage (Civil War) (51), *Silver City/High Vermilion, A Perilous Journey, The Vanquished, Shane, The Moonlighter, Gun Fury, Silver Lode, The Desperado, The Raid* (Civil War), *Passion* (Mexico), *Timberjack* (timber), *The Road to Denver, The Vanishing American, Jubal, The Fastest Gun Alive, The Halliday Brand, Duel at Apache Wells, The Guns of Fort Petticoat, The Buckskin Lady, Valerie, The Rawhide Trail, Blood Arrow, The Left Handed Gun, The Hanging Tree, The Oregon Trail, The Alamo, One Eyed Jacks, The Comancheros* (61).

125 DIETRICH, Marlene (c1904–). A bold venture into the W field with the now classic *Destry Rides Again* (39) revived her flagging career; she followed this with a similar role in the 1942 version of *The Spoilers* and later made one further W, *Rancho Notorious* (52).

126 DIX, Richard (1894–1949). Strong-jawed, massive actor who played the colourful idealist Yancey Cravat in the classic *Cimarron;* also essayed the Indian hero of *The Vanishing American* (26) and made a firm impression as Sam Houston,

RICHARD DIX in
The Vanishing American

Wild Bill Hickok and Wyatt Earp in later W work.

To the Last Man (23), *Call of the Canyon, The Vanishing American /The Vanishing Race, The Gay Defender* (W elements; as Joaquin Murrieta), *Redskin, Cimarron, Secret Service* (Civil War), *The Conquerors* (TV: *Pioneer Builders*) (W elements), *West of the Pecos, The Arizonian, Yellow Dust, It Happened in Hollywood* (as a cowboy star), *Man of Conquest* (as Sam Houston), *Cherokee Strip/The Fighting Marshal, The Roundup, Badlands of Dakota* (as Wild Bill Hickok), *Tombstone the Town Too Tough to Die* (as Wyatt Earp), *American Empire/ My Son Alone, Buckskin Frontier, The Kansan* (43).

127 DMYTRYK, Edward (1908–). Director, born in Canada, who rose from messenger boy to studio projectionist to editor before becoming director. Currently based in Europe.

The Hawk (35), *Broken Lance, Warlock* (also prod.), *Alvarez Kelly, Shalako* (68).

128 DONLEVY, Brian (c1901–1972). Colourful character actor, usually a devious villain, whose adventurous early life reportedly included joining forces in pursuit of Pancho Villa and signing up with Lafayette Escadrille.

Jesse James (39), *Union Pacific, Destry Rides Again, Allegheny Uprising/The First Rebel* (Colonial period), *When the Daltons Rode* (as Grat Dalton), *Brigham Young— Frontiersman, Billy the Kid, The Great Man's Lady, The Virginian, Canyon Passage, A Southern Yankee /My Hero* (Civil War comedy), *Heaven Only Knows* (or *Montana Mike*) (fantasy), *Kansas Raiders* (as Quantrill), *Slaughter Trail, Ride the Man Down, Woman They Almost Lynched* (as Quantrill), *Escape from Red Rock, Cowboy, Waco, Hostile Guns, Arizona Bushwhackers* (68).

129 DOUCETTE, John. Actor with a light, agreeable personality more suited to store-keeping than gunslinging in Ws.

Station West (48), *Bandits of El Dorado/Tricked, The Iroquois Trail/ The Tomahawk Trail* (backwoods), *Sierra, Return of the Frontiersman, Winchester '73, Broken Arrow, Border Treasure, Thunder in God's Country, Only the Valiant, Cavalry Scout, The Texas Rangers, Bugles in the Afternoon, The Treasure of Lost Canyon, Rancho Notorious, Rose of Cimarron, Desert Pursuit, The San Francisco Story* (W elements), *High Noon, Goldtown Ghost Riders, Ambush at Tomahawk Gap, War Paint, City of Bad Men, The Fortyniners, River of No Return, Destry, The Far Country, Red Sundown, Ghost Town, The Maverick Queen, Quincannon Frontier Scout/Frontier Scout, The Fastest Gun Alive, Dakota Incident,*

BRIAN DONLEVY in *Waco*

JOHN DOUCETTE in
The Sons of Katie Elder

*Thunder Over Arizona, The Burning
Hills, Mountain Fortress* (TV), *The
True Story of Jesse James/The
James Brothers, Last of the Badmen,
The Big Land/Stampeded, The
Phantom Stagecoach, The Lonely
Man, Gunfire at Indian Gap, The
Lawless Eighties, The Sons of Katie
Elder, Nevada Smith, The Fastest
Guitar Alive* (Civil War musical
comedy), *Journey to Shiloh* (Civil
War), *True Grit, Big Jake, One*

*More Train to Rob, One Little
Indian* (73).

130 DOUGLAS, Gordon (1909–
). Years of training, first as a child
actor, later editor, then director of
comedy shorts, are the foundation of
this director's vigorous handling of
films of all *genres*.

The Little Ranger (comedy short–
W elements) (38), *The Girl Rush*
(W musical comedy), *The Doolins
of Oklahoma/The Great Manhunt,
The Nevadan/The Man from Nevada,
The Great Missouri Raid, Only the
Valiant, The Iron Mistress* (life of
Jim Bowie), *The Charge at Feather
River, The Big Land/Stampeded,
Fort Dobbs, The Fiend Who Walked
the West, Yellowstone Kelly, Gold
of the Seven Saints, Rio Conchos,
Stagecoach, Chuka, Barquero* (70).

131 DOUGLAS, Kirk (1916–).
Intense screen actor who enjoys parts
of men bent on self-destruction. His
own performance often triumphs over
a bad script. His production com-
pany, Bryna, involved in many of
his films, also made *Ride Out for
Revenge.*

Along the Great Divide (51), *The
Big Trees, The Big Sky* (Colonial
period), *Man without a Star, The
Indian Fighter, Gunfight at the O.K.
Corral* (as Doc Holliday), *Last Train*

KIRK DOUGLAS in *The Indian Fighter*

JOANNE DRU
with John Ireland in *Red River*

from Gun Hill, The Last Sunset, Lonely Are the Brave (modern), *The Way West, The War Wagon, There Was a Crooked Man, A Gunfight* (71).

132 DREW, Ellen (1915–). Attractive brunette with quiet charm and strength of personality, badly misused by Hollywood but often an above average W heroine.

Rhythm on the Range (as Terry Ray) (modern musical comedy) (36), *Geronimo, Buck Benny Rides Again* (comedy), *The Parson of Panamint, The Texas Rangers Ride Again, The Man from Colorado, The Baron of Arizona* (W elements), *Indian Scout* or *Davy Crockett Indian Scout, The Great Missouri Raid, The Man in the Saddle/The Outcast, Outlaw's Son* (57).

133 DRU, Joanne (1923–). Shapely actress with provocative looks who did spirited W work for Hawks and Ford; a former model.

Red River (48), *She Wore a Yellow Ribbon, Wagon Master, Vengeance Valley, Return of the Texan,* (modern), *Outlaw Territory, South-*

west *Passage/Camels West, The Siege at Red River, Drango, The Light in the Forest* (Colonial period), *The Wild and the Innocent* (comedy) (59).

134 DUNING, George (1908–). An arranger of film scores for RKO from 1939, an orchestrator from 1944, he has been composing scores since 1947, mostly for Columbia (including all his W work), and the results have greatly enhanced many of the Ws with which he has been associated, especially the later ones.

The Untamed Breed (48), *The Man from Colorado, Lust for Gold, The Doolins of Oklahoma/The Great Manhunt* (collab.), *The Man in the Saddle/The Outcast, Last of the Comanches/The Sabre and the Arrow, The Man from Laramie, Count Three and Pray* (W elements), *3.10 to Yuma, Cowboy, Gunman's Walk, Two Rode Together* (61).

135 DURYEA, Dan (1907–1968). Former stage actor who excelled at corrupt characters and made a formidable villain in many Ws usually giving his roles an extra facet of vivid plausibility. Son Peter has also done some W work.

Along Came Jones (comedy) (45), *River Lady* (W elements), *Black Bart/Black Bart Highwayman, Winchester '73, Al Jennings of Oklahoma, Ride Clear of Diablo, Rails into Laramie, Silver Lode, The Marauders, Night Passage, Gunfight at Sandoval* (TV), *Six Black Horses, He Rides Tall, Taggart, The Bounty Killer, Incident at Phantom Hill, A River of Dollars/The Hills Run Red* (*Un fiume di dollari*) (67).

136 DUVALL, Robert (1931–). Useful addition to the W ranks with some colourful villainy as John Wayne's opponent, Ned Pepper, in *True Grit* and a recent study of Jesse James.

True Grit (69), *Lawman, Joe Kidd, The Great Northfield Minnesota Raid* (as Jesse James) (72).

137 DWAN, Allan (1885–).
Canadian born director who made
scores of shorts 1911–13 including
many with W theme or setting; best
remembered for his Douglas Fair-
banks adventures of the later silent
period; had lesser assignments from
then on but they include several Ws
held in high regard by some critics,
though seeming glossily lethargic to
others. W features listed only.

The Good Bad Man (16), *The
Half-Breed, Manhattan Madness* (W
elements), *Tide of Empire, Frontier
Marshal, Trail of the Vigilantes,
Northwest Outpost/End of the Rain-
bow* (W elements), *Montana Belle,
Woman They Almost Lynched, Sil-
ver Lode, Passion* (Mexico), *Cattle
Queen of Montana, Tennessee's Part-
ner, The Restless Breed* (57).

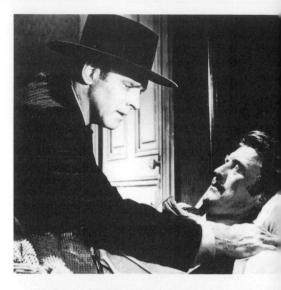

138 EARP, Wyatt (1848–1929).
The celebrated lawman who tamed
Wichita and Dodge City and backed
by his brothers Virgil and Morgan
and friend Doc Holliday shot it out
with the Clantons at Tombstone's
O.K. Corral on October 26, 1881.
Though usually conveyed as an up-
right and courageous man by film
portraits, Earp was certainly an ex-
hibitionist and card cheat and very
dubiously worthy of his place in
Western legend. W. R. Burnett's
book "Saint Johnson" was a dis-
guised account of events in Earp's
life and Walter Huston, Johnny Mack
Brown and Ronald Reagan played
the equivalent of Earp in the three
film versions titled *Law and Order*
while Johnny Mack Brown played
the role, much transformed, in *Wild
West Days* (s). Stuart N. Lake's
biography "Wyatt Earp: Frontier
Marshal" has formed basis of both
films called *Frontier Marshal,* also
of Ford's *My Darling Clementine.*
Hugh O'Brian has played Earp in a
TV series.

George O'Brien *Frontier Marshal*
(34), Randolph Scott *Frontier Mar-
shal* (39), Richard Dix *Tombstone
the Town Too Tough to Die,* Henry
Fonda *My Darling Clementine,* Will

Top, Burt Lancaster as WYATT EARP
with Kirk Douglas as Doc Holliday in
Gunfight at the O.K. Corral. Below,
James Garner as WYATT EARP and
Jason Robards Jr. as Doc Holliday in
Hour of the Gun

Geer *Winchester '73,* James Millican
Gun Belt, Bruce Cowling *Masterson
of Kansas,* Joel McCrea *Wichita,*
Burt Lancaster *Gunfight at the O.K.*

Corral, Buster Crabbe *Badman's Country,* James Stewart *Cheyenne Autumn* (comedy episode), Bill Camfield *The Outlaws Is Coming* (comedy), Guy Madison *Duel at Rio Bravo* (*Jennie Lees ha una nuova pistola*), James Garner *Hour of the Gun,* Harris Yulin *Doc* (71).

139 EASON, B. Reeves (Breezy) (1891–1956). Most famous of the second unit specialists for his chariot race in the original *Ben Hur,* he was the director of many Hoot Gibson Ws of the Twenties and of minor Ws and serials in the Thirties with his major work reserved for action sequences in big budget films like the landrush in the original *Cimarron* and the train wreck of *Duel in the Sun.* Entered films in 1913 as writer, actor, stunt man, property man, etc. for W film outfit; was working in last years on TV's *Lone Ranger* series.

As director: *Blue Streak McCoy* (20), *The Moon Riders* (co-dir) (s), *Colorado* (W elements), *Red Courage, The Fire Eater, Pardon My Nerve!, When East Comes West, Rough Shod, The Lone Hand, Tiger Thompson, Trigger Finger, Flashing Spurs, The Texas Bearcat, Border Justice, Lone Hand Saunders, The Denver Dude, The Prairie King, Painted Ponies* (W elements), *Galloping Fury, A Trick of Hearts, The Flyin' Cowboy* (modern), *Riding for Fame* (also part st. part sc.), *Clearing the Trail, The Lariat Kid, The Winged Horseman* (co-dir?), *Roaring Ranch, Trigger Tricks* (also st. sc.), *Spurs* (also st. and sc.), *The Vanishing Legion* (s), *Sunset Trail, Cornered, Mystery Mountain* (modern; co-dir., also st.) (s), *The Miracle Rider* (co-dir.) (s), *Phantom Empire* (modern; co-dir.) (s), *Land Beyond the Law, Red River Valley, Empty Holsters, Prairie Thunder, Call of the Yukon* (N–W), *Blue Montana Skies, Mountain Rhythm, Black Arrow* (s), *'Neath Canadian Skies* (Mounties), *North of the Border* (Mounties), *Rimfire* (49).

As actor: *The Danger Rider* (28).

As 2nd Unit director: *Cimarron* (31) (landrush), *Man of Conquest, Salome Where She Danced* (chase), *Duel in the Sun* (48).

140 EASTWOOD, Clint (1930–). Despite a quiet, self-effacing voice and manner, he has become one of the few big stars, his work keyed to action pictures of the W and detective variety. Success came via three Ws for Italian director Sergio Leone after a long-running W TV series, *Rawhide,* but East-

CLINT EASTWOOD in *High Plains Drifter*

wood has capitalised on his box-office standing to make some interesting ventures that suggest his career could become artistically varied and rewarding.

The First Traveling Saleslady (comedy) (56), *Star in the Dust* (bit), *Ambush at Cimarron Pass, A Fistful of Dollars* (*Per un pugno di dollari*), *For a Few Dollars More* (*Per qualche dollaro in piu*), *The Good the Bad and the Ugly* (*Il buono, il brutto, il cattivo*), *Hang 'Em High, Coogan's Bluff* (modern—W elements), *Paint Your Wagon* (musical), *Two Mules for Sister Sara* (Mexico), *Joe Kidd, High Plains Drifter* (also dir.) (73).

141 ELAM, Jack (1917–). Supporting actor who hails from Arizona and with his villainous looks and unseeing left eye made a splendid bad guy in numerous Ws and gangster films; has now largely moved into comic studies and invariably steals the scenes in which he appears. A great asset to any picture.

The Sundowners/Thunder in the Dust (50), *A Ticket to Tomahawk* (musical comedy), *High Lonesome, Rawhide* (TV: *Desperate Siege*), *The Bushwackers/The Rebel, Rancho Notorious, The Battle at Apache Pass, Montana Territory, High Noon, Ride*

Vaquero, Gun Belt, The Moonlighter, Ride Clear of Diablo, Jubilee Trail, Cattle Queen of Montana, Vera Cruz (Mexico), *The Far Country, Man without a Star, Wichita, The Man from Laramie, Jubal, Pardners* (comedy), *Thunder over Arizona, Dragoon Wells Massacre, Gunfight at the O.K. Corral, Night Passage, The Last Sunset, Four for Texas* (comedy), *The Comancheros, The Rare Breed, Night of the Grizzly, The Way West, Firecreek, The Last Challenge/The Pistolero of Red River, Ride a Northbound Horse* (TV), *Once upon a Time in the West* (*C'era una volta il West*), *Support Your Local Sheriff* (comedy), *Dirty Dingus Magee* (as John Wesley Hardin), *Rio Lobo, The Wild Country, The Cockeyed Cowboys of Calico County* (comedy), *The Last Rebel, Support Your Local Gunfighter* (comedy), *Hannie Caulder, Pat Garrett and Billy the Kid, A Knife for the Ladies* (73).

142 ELLIOTT, Gordon/Wild Bill (1904–1965). One of the most popular W series stars of the Forties, Elliott (like Johnny Mack Brown) turned to Ws after generally being associated with more sophisticated movie roles. Born on a ranch in Missouri, he learned to ride, rope

JACK ELAM in *Once Upon a Time in the West*

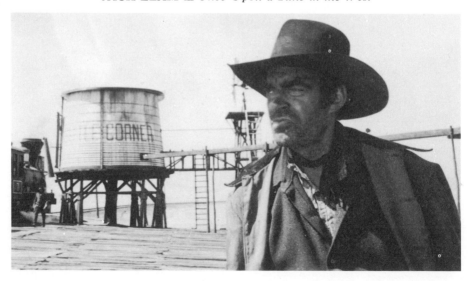

WILD BILL ELLIOTT with Marie Windsor in *The Showdown*

and shoot at an early age; and later broke horses in the stockyard his father ran in Kansas City. He also rode in rodeos but trained for an acting career, his first films dating from the mid-Twenties. His success in the serial *The Great Adventures of Wild Bill Hickok* led him to change his first name from Gordon to Wild Bill; he played Hickok in some later films; was teamed with Tex Ritter in several more; and also made a Red Ryder series with young Bobby (now Robert) Blake. With the collapse of series W production in the early Fifties, his last few films were crime dramas.

The Arizona Wildcat (27), *The Valley of Hunted Men* (bit), *The Great Divide* (bit), *Trailin' West/ On Secret Service*, *Guns of the Pecos*, *Boots and Saddles*, *Roll Along Cowboy*, *The Great Adventures of Wild Bill Hickok* (s) (as Hickok—first starring role), *In Early Arizona/Unwelcome Visitors*, *Frontiers of '49*, *Lone Star Pioneers*, *The Law Comes to Texas*, *Taming of the West*, *Overland with Kit Carson* (s), *Pioneers of the Frontier/The Anchor*, *The Man from Tumbleweeds/False Evidence*, *The Return of Wild Bill*, *Prairie Schooners/Through the Storm* (as Wild Bill Hickok in this and several of following titles—see entry 199), *Beyond the Sacramento/ Power of Justice*, *The Wildcat of Tucson/Promise Fulfilled*, *Across the Sierras/Welcome Stranger*, *North from the Lone Star*, *The Return of Daniel Boone/The Mayor's Nest*, *The Son of Davy Crockett/Blue Clay*, *King of Dodge City*, *Hands Across the Rockies*, *Roaring Frontiers*, *Lone Star Vigilantes/The Devil's Price*, *Bullets for Bandits*, *North of the Rockies/False Clues*, *Devil's Trail*, *Valley of Vanishing Men* (s), *Prairie Gunsmoke*, *Vengeance of the West*, *Calling Wild Bill Elliott*, *The Man from Thunder River*, *Bordertown Gun Fighters*,

Wagon Tracks West, Death Valley Manhunt, Overland Mail Robbery, Mojave Firebrand, Hidden Valley Outlaws, Tucson Raiders, Marshal of Reno, The San Antonio Kid, Cheyenne Wildcat, Vigilantes of Dodge City, Sheriff of Las Vegas, The Great Stagecoach Robbery, Bells of Rosarita (guest), *Phantom of the Plains, Marshal of Laredo, Colorado Pioneers, Lone Texas Ranger, Wagon Wheels Westward, California Gold Rush, Sheriff of Redwood Valley, Sun Valley Cyclone, In Old Sacramento, Plainsman and the Lady, Conquest of Cheyenne, Wyoming, The Fabulous Texan, Old Los Angeles, The Gallant Legion, The Last Bandit, Hellfire* (also prod.), *The Savage Horde, The Showdown* (also prod.), *The Longhorn, Waco/ The Outlaw and the Lady, Kansas Territory, Fargo, The Maverick, The Homesteaders, Rebel City, Topeka, Vigilante Terror, Bitter Creek, The Forty-Niners* (54).

143 ENRIGHT, Ray (1896–1965). Former editor and gagman who became a director in 1927 with Rin Tin Tin movies; his Ws proper come much later on, many star Randolph Scott and are lavishly enough done but otherwise generally uninspired.

Jaws of Steel (dog—W elements) (27), *Land of the Silver Fox* (N–W—dog), *Song of the West* (musical), *River's End* (Mounties) (TV: *Double Identity*), *Bad Men of Missouri, Will Bill Hickok Rides, The Spoilers* (N–W), *Men of Texas/ Men of Destiny, Sin Town, Trail Street, Albuquerque/Silver City, Coroner Creek, Return of the Bad Men, South of St. Louis, Montana, Kansas Raiders, Flaming Feather* (52).

144 FARR, Felicia (1932–). Excellent actress who has largely given up acting in favour of home life with husband Jack Lemmon; but her striking work in three of Delmer Daves's Ws makes it a pity she hasn't gone West more often.

Jubal (56), *The First Texan, The Last Wagon, Reprisal!, 3.10 to Yuma, Hell Bent for Leather* (60).

145 FARROW, John (1904–1963). Australian-born director, father of Mia Farrow, whose early interest in a maritime career was reflected in several sea pictures. A cold, technically thoughtful director, he made one outstanding W in *Hondo*. Earlier as a writer co-wrote titles for *White*

FELICIA FARR with Glenn Ford in *3.10 to Yuma*

FRANK FERGUSON (right) with Fred MacMurray in *At Gunpoint*

Gold (W elements) and co-scripted *Wolf Song*.

California (47), *Copper Canyon*, *Ride Vaquero!*, *Hondo* (54).

146 FENTON, Frank (1906?–1971). Liverpool-born screenwriter and novelist (but not the character actor of the same name), he wrote some rather undistinguished major Ws after numerous B film assignments in crime and comedy.

Co-sc. *Station West* (48), st. sc. *The Wild North* (Mounties), st. sc. *Ride Vaquero!*, sc. *Escape from Fort Bravo*, sc. *River of No Return*, st. sc. *Garden of Evil*, co-sc. *The Dangerous Days of Kiowa Jones* (67).

147 FERGUSON, Frank (c1900–). Actor with a distinguished manner and voice; a former college professor who maintains an educated manner on screen. His roles include honest lawman, crooked gambler, mayor, prison governor, newspaper reporter, etc.—all portrayed with unshakable efficiency.

They Died with Their Boots On (42), *Canyon Passage, California, Road to Rio* (member of posse in W opening), *Fort Apache, Rachel and the Stranger* (comedy—Colonial period), *The Furies, Under Mexicali Stars, Frenchie, The Great Missouri Raid, Thunder in God's Country, Santa Fe* (as Bat Masterson), *Warpath, The Cimarron Kid, Bend of the River/Where the River Bends, Rodeo* (modern), *Rancho Notorious, Oklahoma Annie* (comedy), *Wagons West, Star of Texas, Woman They Almost Lynched, The Marksman, Powder River, Outlaw Territory, City of Bad Men, Texas Badman, The Outcast/The Fortune Hunter, Johnny Guitar, Drum Beat, The Violent Men/Rough Company, A Lawless Street, At Gunpoint/Gunpoint!, The Phantom Stagecoach, The Iron Sheriff, Gun Duel in Durango, The Lawless Eighties, Terror in a Texas Town, Man of the West, The Light in the Forest* (Colonial period), *Cole Younger Gunfighter, The Quick Gun, The Great Sioux Massacre* (65).

148 FIX, Paul (1901–). Small, somewhat mean looking character actor who came to films from stock; became a familiar face as usually one of the villains in Ws and crime/gangster films, has in recent years mellowed into friendly doctors, marshals, army generals, etc. and also played Indians. Has written some scripts.

The Avenger (31), *Fighting Sheriff, South of the Rio Grande, Fargo Express, Somewhere in Sonora, Gun Law, Rocky Rhodes, The Crimson Trail, His Fighting Blood, Valley of Wanted Men, Bulldog Courage, The Eagle's Brood, Bar 20 Rides Again, The Desert Trail, Heritage of the Desert, The Fargo Kid, Virginia City, Triple Justice, Trail of the Vigilantes, Down Mexico Way, A Missouri Outlaw, South of Santa Fe, In Old Oklahoma* or *War of the Wildcats, Tall in the Saddle* (also co-sc.), *Flame of the Barbary*

PAUL FIX in *Red River*

RHONDA FLEMING in
Gunfight at the O.K. Corral

Coast (W elements), *Dakota, The Plunderers, Red River, Hellfire, The Fighting Kentuckian, She Wore a Yellow Ribbon* (bit), *California Passage, The Great Missouri Raid, Fighting Man of the Plains, Warpath, Denver and Rio Grande, Star of Texas, Ride the Man Down, Hondo, Johnny Guitar, Stagecoach to Fury, Giant* (modern), *Night Passage, Man in the Shadow/Pay the Devil* (modern), *Mail Order Bride/West of Montana* (comedy), *The Outrage* (W elements; as an Indian), *Shenandoah* (Civil War), *The Sons of Katie Elder, Ride Beyond Vengeance, Nevada Smith, An Eye for an Eye, Incident at Phantom Hill, El Dorado, Welcome to Hard Times/Killer on a Horse, The Ballad of Josie, Young Billy Young, The Undefeated, Dirty Dingus Magee* (comedy), *Something Big, Shoot Out, Pat Garrett and Billy the Kid, Cahill: United States Marshal/Cahill* (73).

149 FLEMING, Rhonda (1923–). Curvaceous redhead with well-bred air; no great shakes as an actress but a strong contender in any competition for Queen of the Technicolored W in the Fifties. Supposed to have made *début* with bit in *In Old Okla-homa* (or *War of the Wildcats*) (43) but not identifiably present.

Abilene Town (46), *The Eagle and the Hawk, The Redhead and the Cowboy, The Last Outpost, Pony Express, Those Redheads from Seattle* (musical N–W), *Tennessee's Partner, Gunfight at the O.K. Corral, Gun Glory, Bullwhip, Alias Jesse James* (comedy), *Backtrack* (TV material) (69).

150 FLEMING, Victor (1883–1949). Important in the history of the W as the director of the classic version of *The Virginian,* but this is otherwise eclipsed by his primary responsibility for directing *Gone with the Wind.* A former cameraman, he made a few other Ws before *The Virginian,* none after.

The Mollycoddle (modern; W elements) (20), *To the Last Man, Call of the Canyon, A Son of His Father, Rough Riders, Wolf Song, The Virginian* (29).

151 FLIPPEN, Jay C. (1899–1971). Arkansas born, a former vaudeville, stage and radio performer who became a leading W character actor. His rugged build and leathery features gave him a tough, experi-

enced aura while a certain innate friendliness made him usually a virtuous screen character rather than a villain. Suffered a leg amputation in Sixties but continued acting.

Winchester '73 (50), *Two Flags West, The Lady from Texas, Bend of the River/Where the River Bends, Woman of the North Country, Devil's Canyon, The Far Country, Man without a Star, Oklahoma!* (musical; some W elements), *The King and Four Queens, 7th Cavalry, The Halliday Brand, The Restless Breed, Night Passage, Run of the Arrow, The Deerslayer* (backwoods), *Escape from Red Rock, From Hell to Texas/Manhunt, The Plunderers, Six Gun Law* (TV), *How the West Was Won, Cat Ballou* (comedy), *Firecreek* (68).

152 FLYNN, Errol (1909–1959). This Australian born actor who made his name in *Captain Blood* and the swashbuckling field did some Ws with the same dashing style of adventure and engaging good humour, and made a gallant but impulsive George Armstrong Custer in *They Died with Their Boots On.*

Dodge City (39), *Virginia City, Santa Fe Trail* (Civil War), *They Died with Their Boots On* (as Custer), *San Antonio, Silver River, Montana, Rocky Mountain* (50).

153 FONDA, Henry (1905–). Actor from Broadway who seems ideally suited to characters of unquestionable integrity and honesty—thus his Frank James is a victim of injustice, and even his arrogant officer of *Fort Apache* is not unsympathetic, while trick casting in the villain's role in *Firecreek* didn't work at all well. Though worthwhile parts now seem less frequent, he remains one of the screen's finest and most subtle performers.

Jesse James (39) (as Frank James), *Drums along the Mohawk* (Colonial period), *The Return of Frank James* (as Frank James), *The Ox Bow Incident/Strange Incident, My Darling Clementine* (as Wyatt

ERROL FLYNN in *Dodge City*. **HENRY FONDA** in *Once Upon a Time in the West.*

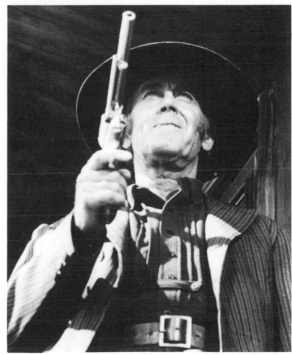

Earp), *Fort Apache, The Tin Star, Warlock, How the West Was Won* (ep. "Railroad"), *The Rounders* (modern), *A Big Hand for the Little Lady/Big Deal at Dodge City* (W setting only), *Welcome to Hard Times/Killer on a Horse, Firecreek, Once upon a Time in the West* (*C'era una volta il West*), *The Cheyenne Social Club* (comedy), *There Was a Crooked Man, My Name Is Nobody* (*Il mio nome è nessuno*) (73).

154 FORAN, Dick (1910–). Cheerful leading man, rather too bland for heroic action parts; starred in series of Ws for Warners in Thirties as Ken Maynard and John Wayne had before him, often repeating their stories, and kidded his W image playing a cowboy film star in *Boy Meets Girl* (38).

Moonlight on the Prairie (36), *Song of the Saddle, Treachery Rides the Range, Guns of the Pecos, Trailin' West/On Secret Service, Land beyond the Law, California Mail, Cherokee Strip/Strange Laws, Blazing Sixes, Empty Holsters, The Devil's Saddle Legion, Prairie Thunder, The Cowboy from Brooklyn* (modern musical comedy), *Heart of the North* (Mounties), *My Little Chickadee* (comedy), *Winners of the West* (s), *Rangers of Fortune, Riders of Death Valley* (s), *Ride 'Em Cowboy* (comedy), *Road Agent, Fort Apache, El Paso, Deputy Marshal, Al Jennings of Oklahoma, Sierra Stranger, Taggart* (65).

155 FORD, Glenn (1916–). Born in Canada, this actor's best W work has been with director Delmer Daves. Frequently plays with an amiable, easy-going manner that proves dangerously deceptive for the villains when he's pushed too far. Recently turned to TV and modern W series, *Cade's County*.

Texas (41), *The Desperadoes, The Man from Colorado, Lust for Gold, The Redhead and the Cowboy, The Secret of Convict Lake* (W

DICK FORAN

GLENN FORD (right) with Henry Fonda in *The Rounders*

elements), *The Man from the Alamo, The Americano* (Brazilian W), *The Violent Men/Rough Company, Jubal, The Fastest Gun Alive, 3:10 to Yuma, Cowboy, The Sheepman* (comedy), *Cimarron, Advance to the Rear/Company of Cowards?* (Civil War comedy), *The Rounders* (modern), *The Last Challenge/The Pistolero of Red River, A Time for*

JOHN FORD with John Wayne (left) working on the Civil War episode of
How the West Was Won

Killing/The Long Ride Home, Day of the Evil Gun, Heaven with a Gun, Smith!, Santee (73).

156 FORD, John (1895–1973). By universal acclaim, the W's greatest director. His unerring eye for good composition is evident as early as *Straight Shooting* while his compassionate outlook and other attitudes make his Ws stand apart from anyone else's and in fact closer to his own work in other *genres*—but nonetheless his portraits of the old West cumulatively present an artistically rich, stirring impression of the West as it should have been and in part was. In early life Ford tried cowpunching in Arizona and met Wyatt Earp who told him about the gunfight at the O.K. Corral (which

he staged much later in *My Darling Clementine*). As a film-maker, he made many short Ws in his first years of directing including a series with Harry Carey as Cheyenne Harry. After making the epic *The Iron Horse*, he virtually abandoned the *genre* to return triumphantly with *Stagecoach* twelve years later and since then has come back to it repeatedly—and most memorably for his loose trilogy about the cavalry: *Fort Apache, She Wore a Yellow Ribbon, Rio Grande*. Credited on his early work as Jack Ford.

The Tornado (also sc. and starred) (2r) (17), *The Trail of Hate* (also sc. and starred) (2r), *The Scrapper* (also sc. and starred) (2r), *The Soul Herder* (3r), *Cactus My Pal* or *Cheyenne's Pal* (also sc.) (2r),

Straight Shooting, The Secret Man, A Marked Man, Bucking Broadway (modern), *Phantom Riders, Wild Women* (comedy), *Thieves' Gold* (modern?), *The Scarlet Drop* or *Hillbilly* (also st.), *Hell Bent* (also co-sc.), *A Woman's Fool, Three Mounted Men, Roped* (W elements), *A Fight for Love* (Mounties), *Fighting Brothers* (2r), *By Indian Post* or *The Love Letter* (2r), *Bare Fists, The Gun Packers* (2r), *Riders of Vengeance* (also part sc.), *The Last Outlaw* (2r), *The Outcasts of Poker Flat, Ace of the Saddle, Rider of the Law, A Gun Fightin' Gentleman, Marked Men, Hitchin' Posts, The Freeze-Out, The Wallop, Desperate Trails, Action, Sure Fire, Three Jumps Ahead, North of Hudson Bay* (Canada), *The Iron Horse, Three Bad Men, Stagecoach, Drums along the Mohawk, My Darling Clementine, Fort Apache, Three Godfathers, She Wore a Yellow Ribbon, Wagonmaster, Rio Grande, The Searchers, The Horse Soldiers, Sergeant Rutledge, Two Rode Together, Hondo* (uncredited 2nd unit), *The Man Who Shot Liberty Valance, How the West Was Won* (ep. "Civil War"), *Cheyenne Autumn* (64).

WALLACE FORD in *Johnny Concho*

157 FORD, Wallace (1899–1966). Capable supporting actor, born in Lancashire, England, who generally undertook sympathetic parts as hero's sidekick or prominent citizen.

Man from Texas (47), *Coroner Creek, Belle Starr's Daughter, Red Stallion in the Rockies, The Furies, Dakota Lil, Warpath, Rodeo* (modern), *The Great Jesse James Raid, The Nebraskan, The Boy from Oklahoma, Destry, Wichita, The Man from Laramie, A Lawless Street, The Spoilers* (N–W), *The Maverick Queen, The First Texan, Johnny Concho, Thunder over Arizona, Stagecoach to Fury, Warlock* (59).

158 FOREMAN, Carl (1914–). The writer who scripted *High Noon* from the short story by John W. Cunningham. Now based on England.

St. *Dakota* (45), sc. *High Noon* sc. *MacKenna's Gold* (also prod.) (68).

159 FOSTER, Lewis R. (1900–). Began directing with Laurel and Hardy comedies; as writer and/or director, worked on several glossy and forgettable Ws.

Sc. dir. *El Paso* (49), co-sc. dir. *The Eagle and the Hawk,* dir. *The Last Outpost,* sc. dir. *Passage West/ High Venture,* part sc. *The Vanquished,* part st. part sc. dir. *Those Redheads from Seattle* (musical N–W), dir. *Dakota Incident,* co-sc. dir. *Tonka* (58).

160 FOSTER, Norman (1900–). Actor who turned to writing and directing, worked with Orson Welles, let his talent fade away in later years to a dull competence.

Dir. *Viva Cisco Kid* (40), dir. *Ride Kelly Ride* (modern; W elements), dir. *Rachel and the Stranger* (Colonial period comedy), dir. narration *Navajo* (documentary), st. sc. dir. *Sky Full of Moon* (modern), dir. *Davy Crockett King of the Wild Frontier,* co-st. co-sc. dir. *Davy Crockett and the River Pirates,* sc.

dir. *The Nine Lives of Elfego Baca,* st. sc. dir. *Indian Paint,* sc. dir. *Brighty of the Grand Canyon* (W elements) (67).

161 FOSTER, Preston (1902–72). Adequate but unexciting actor who lapsed from leads to supporting roles but kept busy.

The Arizonian (35), *Annie Oakley* (Wild West show), *The Outcasts of Poker Flat, Geronimo, Northwest Mounted Police, The Round-Up, American Empire/My Son Alone, The Harvey Girls* (musical), *King of the Wild Horses, Ramrod, Thunderhoof/Fury* (horse), *I Shot Jesse James, The Tougher They Come* (timber), *Three Desperate Men, Tomahawk/Battle of Powder River, Montana Territory, Law and Order, The Marshal's Daughter* (guest), *The Man from Galveston, Advance to the Rear/Company of Cowards?* (Civil War comedy) (64).

FRANK, Harriet, Jr.—see Irving RAVETCH

162 FREGONESE, Hugo (1908–). Argentina-born, this director was such a success in his home industry that Hollywood beckoned and the result has been several underappreciated gems; latest work in Europe, however, has been undistinguished.

Saddle Tramp (50), *Apache Drums, Untamed Frontier, The Raid, Apaches Last Battle* (*Old Shatterhand*), *Savage Pampas* (*Pampa Salvaje*) (also co-sc.) (South American W) (67).

163 FULLER, Samuel (1911–). Controversial writer-director-producer who favours a headline style of coarse impact on an audience's sensibilities—which makes his best W, *Run of the Arrow,* all the more surprising for its beauty and cohesiveness. Played W director in *The Last Movie;* recently started W, *Riata,* but production was halted, then resumed under different director as *The Deadly Trackers.*

Sc. dir. *I Shot Jesse James* (49), sc. dir. *The Baron of Arizona* (W elements), adap. *The Command,* st. sc. dir. prod. *Run of the Arrow,* st. sc. dir. prod. *Forty Guns* (57).

164 FURTHMAN, Jules (1888–1960). Celebrated scriptwriter (insofar as scriptwriters have achieved recognition) with a fascinating but not too clear influence on the work of Sternberg and Hawks.

St. sc. *When a Man Rides Alone* (as Stephen Fox) (19), st. sc. *Where*

CLARK GABLE in *Across the Wide Missouri*

the West Begins (as Stephen Fox),
co-sc. *The Texan*, sc. *Iron Rider*, sc.
Singing River, co-sc. *The Last Trail*,
st. *A California Romance* (W ele-
ments), st. sc. *North of Hudson Bay*,
st. sc. *The Outlaw*, co-sc. *Rio Bravo*
(59).

165 GABLE, Clark (1901–60).
Assertive leading man long associ-
ated with M-G-M; partly because
of that studio's relative disinterest in
Ws, he made comparatively few
contributions to the *genre,* none of
them truly outstanding.

North Star (25) (bit) (N–W),
*The Painted Desert, Honky Tonk,
Across the Wide Missouri, Lone Star,
The Tall Men, The King and Four
Queens, The Misfits* (modern) (61).

166 GAMET, Kenneth (–1971).
Prolific screenwriter with credits on
several Randolph Scott Ws.

Part sc. *Adventures in Silverado/
Above All Laws* (48), add. dia-
logue (uncredited) *Thunderhoof/Fury*
(horse), sc. *Coroner Creek,* co-sc.
Canadian Pacific, sc. *The Doolins of
Oklahoma/The Great Manhunt,* sc.
The Savage Horde, sc. *Santa Fe,* sc.
Man in the Saddle/The Outcast, sc.
Indian Uprising, co-sc. *Last of the
Comanches/The Sabre and the
Arrow,* part sc. *The Last Posse,* sc.
The Stranger Wore a Gun, sc. *Ten
Wanted Men,* sc. *A Lawless Street,*
co-sc. *The Maverick Queen,* co-st.
co-sc. *The Domino Kid,* sc. *The Law-
less Eighties,* co-st. (sc. *Indian Up-
rising*) *Apache Rifles* (64).

167 GARNER, James (1928–).
Excellent light performer who made
his name and found his relaxed style
in TV's *Maverick,* though was more
intense in *Duel at Diablo.*

Shoot-Out at Medicine Bend (57),
Duel at Diablo, Hour of the Gun
(as Wyatt Earp), *Support Your Local
Sheriff* (comedy), *Sledge/A Man
Called Sledge, Support Your Local
Gunfighter* (comedy), *Skin Game*
(comedy), *One Little Indian, The
Castaway Cowboy* (Hawaiian W)
(74).

JAMES GARNER in *The Skin Game*

168 GARRETT, Pat (Patrick
Floyd Garrett) (1850–1908). The
man who shot William Bonney, alias
Billy the Kid, was born in Alabama
and as a young man worked on
Texas ranches and hunted buffalo.
As a friend of young Bill Bonney, he
was considered the ideal man to stop
his troublesome activities and, after
being appointed a peace officer and
trying to get Bonney to leave the
area, he eventually came to shoot
him down on a night visit to his girl
friend on July 13, 1881. By most
accounts a likable and fair-minded
figure, he continued intermittently as
a lawman and rancher and was even-
tually shot in the back by the tenant
of one of his properties in a business
dispute.

Wallace Beery *Billy the Kid* (TV:
The Highwayman Rides) (30),
Wade Boteler *Billy the Kid Returns,*
Thomas Mitchell *The Outlaw,*
Charles Bickford *Four Faces West/
They Passed This Way,* Frank Wil-
cox *The Kid from Texas/Texas Kid
Outlaw,* Robert Lowery *I Shot Billy
the Kid,* James Griffith *The Law
Versus Billy the Kid,* James Craig
Last of the Desperados, John Deh-

ner *The Left Handed Gun,* George Montgomery *Badman's Country,* Rod Cameron *Die Letzten Zwei vom Rio Bravo,* Glenn Corbett *Chisum,* Rod Cameron (as actor in film) *The Last Movie,* James Coburn *Pat Garrett and Billy the Kid* (73).

169 GERONIMO (1829 1909). The notorious leader of the Chiri-

GERONIMO. Above, played by Jay Silverheels with James Stewart in *Broken Arrow.* Below, by Chuck Connors in *Geronimo*

cahua branch of the Apache tribe who, when Cochise made his peace with the white man, took off to the mountains of Mexico with a small band of men and conducted terror raids on both sides of the border for fourteen years until scouts from his own tribe helped in his capture. His real name was Gogathlay (The Yawner) but he was nicknamed Geronimo by the Mexicans. The actors playing him in *Fort Apache* and (as a boy) in *Lone Star* have not been identified. Chief Thundercloud (1899–1955), a real life Cherokee Indian, and Chief Yowlachie (1890–1966), along with Jay Silverheels (entry 354), are among the actual Indians who have played the role.

Chief White Horse *Stagecoach* (39), Chief Thundercloud *Geronimo!,* Tom Tyler *Valley of the Sun,* Chief Thundercloud *I Killed Geronimo,* Jay Silverheels *Broken Arrow,* War Eagle *The Last Outpost,* Miguel Inclan *Indian Uprising,* Jay Silverheels *The Battle at Apache Pass,* Chief Yowlachie *Son of Geronimo* (s), Ian MacDonald *Taza Son of Cochise,* Monte Blue *Apache,* Jay Silverheels *Walk the Proud Land,* Chuck Connors *Geronimo,* Pat Hogan *Geronimo's Revenge* (TV) (64).

170 GIBSON, Hoot (1892–1962). Born in Nebraska, he rode the range as a youth and became a rodeo champion for several years running; entered movies as a stuntman and double for Harry Carey, with whom he appeared in many early John Ford Ws; became known as "The Smiling Whirlwind" as star of two-reeler series, then became major star of the Twenties, lesser star of Thirties, and co-star with Bob Steele of a "Trail Blazers" series in Forties.

A Knight of the Range (16), *The Soul Herder* (3r), *Cheyenne's Pal* (W elements) (2r), *Straight Shooting, The Secret Man, A Marked Man, The Fighting Brothers* (2r), *By Indian Post* (romantic comedy) (2r),

The Rustlers (2r), *Gun Law* (2r), *The Trail of the Holdup Man* (2r), *The Lone Hand* (2r), *The Double Hold-Up* (2r), *West Is Best* (2r), *Roarin' Dan* (2r), *The Sheriff's Oath* (2r), *The Smilin' Kid* (also dir.) (2r), *The Saddle King* (2r), *The Fighting Fury* (also dir.) (2r), *The Cactus Kid* (also dir.) (2r), *Bandits Beware* (2r), *The Man With a Punch* (2r), *Action, Sure Fire, Red Courage, The Fire Eater, Headin' West, The Bearcat, Step on It!, Trimmed* (comedy), *The Loaded Door, The Galloping Kid* (comedy), *The Lone Hand* (comedy), *Ridin' Wild, Kindled Courage, Dead Game, Shootin' for Love, The Ramblin' Kid, Hook and Ladder* (W elements), *Ride for Your Life, The Sawdust Trail* (comedy—W elements), *The Ridin' Kid from Powder River, The Hurricane Kid, The Taming of the West, The Saddle Hawk, Let 'Er Buck, Spook Ranch, The Calgary Stampede* (Canada), *The Arizona Sweepstakes, Chip of the Flying U* (comedy), *The Phantom Bullet, The Man in the Saddle, The Flaming Frontier, The Texas Streak, The Buckaroo Kid, The Silent Rider, The Denver Dude, Hey! Hey! Cowboy* (comedy), *The Prairie King, A Hero on Horseback, Painted Ponies, Galloping Fury* (comedy), *The Rawhide Kid, A Trick of Hearts, The Flyin' Cowboy* (modern), *The Wild West Show, Riding for Fame, Clearing the Trail, The Danger Rider, King of the Rodeo* (rodeo) (also prod.), *Burning the Wind* (modern), *Smilin' Guns* (modern), *The Lariat Kid, The Winged Horseman* (modern), *Points West, The Long Long Trail, Courtin' Wildcats* (modern—part rodeo), *The Mounted Stranger, Trailin' Trouble* (modern comedy), *Roaring Ranch, Trigger Tricks, Spurs, The Concentratin' Kid* (modern), *Clearing the Range, Wild Horse/Silver Devil, The Hard Hombre, The Gay Buckaroo, The Local Bad Man* (comedy), *Spirit of the West, The Boiling Point, A Man's Land, The Cowboy Counsel-*

HOOT GIBSON (left) with John Ford making *The Horse Soldiers*

lor, The Dude Bandit, Fighting Parson, Sunset Range, Rainbow's End, Powdersmoke Range, Frontier Justice, Swifty, The Painted Stallion (s), *Lucky Terror, Feud of the West/ The Vengeance of Gregory Walters, The Last Outlaw, The Riding Avenger, Cavalcade of the West, Wild Horse Stampede, The Law Rides Again, Blazing Guns, Death Valley Rangers, Westward Bound, Arizona Whirlwind, Outlaw Trail, Sonora Stagecoach, The Utah Kid, Marked Trails, Trigger Law, The Marshal's Daughter, The Horse Soldiers* (59).

171 GLENNON, Bert (1895– 1967). The cinematographer of Ford's *Stagecoach* and some of that director's other outstanding pictures including his first colour venture, *Drums along the Mohawk.* Active for fifty years as a cameraman, his last film was a W.

Wild Horse Mesa (25), *Stagecoach, *Drums along the Mohawk* (in collab.) (Colonial period), *They Died with Their Boots On, *San Antonio, Wagonmaster, Rio Grande, *The Big Trees, *The Man behind the Gun, The Moonlighter, *Thunder*

over the Plains, *Riding Shotgun, *Davy Crockett and the River Pirates, *Sergeant Rutledge, The Man from Galveston (63).

172 GOLDSMITH, Jerry (1930–). Prolific composer who has contributed lively and sometimes memorably inventive scores to many Ws.

Black Patch (57), Face of a Fugitive, Lonely Are the Brave (modern), Rio Conchos, Stagecoach, Hour of the Gun, Bandolero!, 100 Rifles (Mexico), Ballad of Cable Hogue (comedy), Rio Lobo, Joaquin Murieta (W elements) (mus. dir. only) (TV), Wild Rovers, The Culpepper Cattle Company (in collab.), One Little Indian (73).

173 GORDON, Leo (1922–). Supporting player, often spectacularly nasty and sadistic in villainous roles with ready hints of mental imbalance, he has developed a career as a screenwriter which seems to have taken over from his acting one. (He is mistakenly included in the cast of The Lonely Man for a part he didn't play).

City of Bad Men (53), Gun Fury, Hondo, The Yellow Mountain, Ten Wanted Men, Seven Angry Men, Robbers' Roost, Santa Fe Passage, Tennessee's Partner, Man with the Gun/The Trouble Shooter, Red Sundown, Great Day in the Morning, Johnny Concho, 7th Cavalry, The Restless Breed, The Tall Stranger, Man in the Shadow/Pay the Devil (modern), Black Patch (also st. sc. as Leo Vincent Gordon), Quantrill's Raiders (as Quantrill), Ride a Crooked Trail, Apache Territory, Escort West (also co-sc.), The Jayhawkers, Noose for a Gunman, Texas John Slaughter (TV), McLintock! (comedy), The Bounty Killer (co-sc. only), Night of the Grizzly, Hostile Guns, Buckskin (68).

174 GRANGER, Stewart (1913–). Probably the most convincing Englishman to have ventured into the wide open spaces; recently on TV's "Men of Shiloh" development of "The Virginian" series.

The Wild North (Mounties) (52), The Last Hunt, Gun Glory, North to Alaska (N–W), Among Vultures (Unter Geiern) (dubbed), Flaming Frontier (Old Surehand 1. Teil), Rampage at Apache Wells (Der Olprinz) (65).

LEO GORDON (left) as Quantrill with Steve Cochran in *Quantrill's Raiders*

175 GRANT, James Edward (1902–1966). Screenwriter since 1935 and close associate of John Wayne with some expert contributions to the *genre*.

St. sc. *Angel and the Badman* (also dir.) (47), st. *The Plunderers,* sc. *California Passage,* sc. *Rock Island Trail/Transcontinent Express,* sc. *Hondo* (later st. basis *Hondo and the Apaches*), co-sc. *The Last Wagon,* sc. *Three Violent People,* st. co-sc. *The Sheepman,* st. *The Proud Rebel,* st. sc. *The Alamo* (also assoc. prod.), co-sc. *The Comancheros,* st. sc. *McLintock!* (comedy), co-st. *Hostile Guns,* st. sc. *Support Your Local Gunfighter* (72).

176 GRAY, Coleen (1922–). Lively W gal who started her W career with a powerful little cameo for Howard Hawks's *Red River,* playing the girl who implored John Wayne not to leave her behind.

Red River (48), *Fury at Furnace Creek, Sand* (modern horse), *Apache Drums, The Vanquished, Arrow in the Dust, Twinkle in God's Eye, Tennessee's Partner, The Wild Dakotas, Star in the Dust, Frontier Gambler, The Black Whip, Copper Sky, Town Tamer* (65).

177 GREY, Zane (1875–1939). Though his work has fallen out of favour with contemporary filmmakers, this novelist's output of over one hundred books has been by far the most heavily used of any W writer, a reflection of his massive popularity with the reading public of his time. He is not regarded as a great novelist nor an authority on the West, but many major Ws were made from his books as well as scores of lesser pictures with popular series stars. These are the works filmed (including short stories) in the order that Hollywood seized on them with dates of all versions and changes from the original title noted in brackets; beginning with *Riders of the Purple Sage,* regarded by some as his best story:

"Riders of the Purple Sage" (18) (25) (31) (41), "The Rainbow Trail" (18) (25) (32), "The Border Legion" (19) (24) (30) (34, *The Last Round-Up*) (40, TV: *West of the Badlands*), "The Lone Star Ranger" (19) (23) (30) (41), "The Last of the Duanes" (19) (24) (30) (41), "Desert Gold" (19) (26) (36), "The Desert of Wheat" (20, *Riders of the Dawn*), "The Man of the Forest" (21) (26) (33), "The Mysterious Rider" (21) (27) (33, TV: *Fighting Phantom*) (38, TV: *Mark of the Avenger*), "The Last Trail" (21) (27) (33), "Wildfire" (22, *When Romance Rides*), (49, *Red Canyon*), "To the Last Man" (23) (33, TV: *Law of Vengeance*), "The Call of the Canyon" (23), "The Heritage of the Desert" (24) (32) (39), "Wanderer of the Wasteland" (24) (35) (45), "The Thundering Herd" (25) (33, TV: *Buffalo Stampede*), "Code of the West" (25) (34, *Home on the Range*) (47), "The Light of Western Stars" (25) (30, TV: *Winning the West*) (40, TV: *Border Renegade*), "Wild Horse Mesa" (25) (32) (47), "The Vanishing American" (25) (55), "Born to the West" (26) (38), "Forlorn River" (26) (37, TV: *River of Destiny*), "Desert Bound" (27, *Drums of the Desert*), "Lightning" (27), "Nevada" (27) (36) (44), "Open Range" (27), "Under the Tonto Rim" (28) (33) (47), story basis (for film) *The Vanishing Pioneer* (28), "The Water Hole" (28), "Avalanche" (28), "Sunset Pass" (29) (33) (46), "Stairs of Sand" (29) (37, *Arizona Mahoney* [TV: *Arizona Thunderbolt*]), "Fighting Caravans" (31) (34, *Wagon Wheels* [TV: *Caravans West*]), "The Golden West" (32), "Robbers' Roost" (33) (55), "Canon Walls" (33, *Smoke Lightning*), "West of the Pecos" (34) (45), "The Dude Ranger" (34) (38, *Roll Along Cowboy*), "Golden Dreams" (non-W story into W: 35, *Rocky Mountain Mystery* [TV: *Fighting Westerner*]), "Thunder Mountain" (35) (47), "Drift

Fence" (36, TV: *Texas Desperadoes*), "Raiders of Spanish Peaks" (36, *Arizona Raiders* [TV: *Bad Men of Arizona*]), "King of the Royal Mounted" (36) (40 [s], released in feature form as *Yukon Patrol*, 42) (42 [s], *King of the Mounties*), "Outlaws of Palouse" (36, *End of the Trail*), "Rangle River" (37, Australian W, TV: *Men with Whips*), "Arizona Ames" (37, *Thunder Trail*), "Knights of the Range" (40), "Western Union" (41, reputedly use of title only), "Twin Sombreros" (47, *Gunfighters/The Assassin*), "The Maverick Queen" (56).

178 GRIES, Tom (1922–). Director whose *Will Penny* was one of the most authentic-looking and impressive Ws of the Sixties. Former film reporter, agent, production assistant and writer who has done most of his work in TV.

Co-st. co-sc. *The Bushwhackers/ The Rebel* (52), assoc. prod. *The Lusty Men* (modern rodeo), st. sc. *Mustang*, st. sc. dir. *Will Penny*, dir. *100 Rifles*, dir. *Journey through Rosebud* (modern Indian) (72).

179 GRIFFITH, D. W. [David Wark] (1875–1948). The early years of this celebrated director's career were considerably involved with W subjects, many centring on Indian life, as well as Civil War dramas; his only W of feature length, however, was *Scarlet Days* (19). Shorts follow (excluding Civil War subjects).

Rescued from an Eagle's Nest (actor only) (07), *The Stage Rustler* (actor only) (08), *The Redman and the Child, The Girl and the Outlaw* (both 08), *The Renunciation* (comedy), *The Mended Lute, The Indian Runner's Romance, Comata the Sioux, Leather Stocking, The Mountaineer's Honor, The Redman's View* (all 09), *A Romance of the Western Hills, The Tenderfoot's Triumph, The Gold Seekers, Ramona, A Mohawk's Way, The Song of the Wildwood Flute* (all 10), *Crossing the American Prairies in the Early Fifties, The Heart of a Savage, The Chief's Daughter, In the Days of '49, Fighting Blood, The Indian Brothers, The Last Drop of Water, The Squaw's Love* (all 11), *A Tale of the Wilderness, The Goddess of Sagebrush Gulch, The Female of the Species, Man's Lust for Gold, A Pueblo Legend, In the Aisles of the Wild, The Massacre, Heredity, My Hero* (all 12), *A Chance Deception, Broken Ways, The Sheriff's Baby, The Wanderer, The Yaqui Cur, The Ranchero's Revenge, The Mistake, During the Round-Up, An Indian's Loyalty, Two Men of the Desert, The Battle at Elderbush Gulch* (all 13).

180 GRUBER, Frank (1904–). Novelist and screenwriter, more impressive for volume than quality, also the often-quoted author of an outline of the seven basic W plots to which, he maintains, all Ws can be fitted: the revenge plot, the empire plot, the ranch plot, the cavalry and Indians plot, the marshal plot, the outlaw plot, and the "Union Pacific" plot. Has done much work in TV.

Novel basis ("Peace Marshal") *The Kansan* (43), novel basis *Oregon Trail*, adap. *In Old Sacramento*, st. sc. *Fighting Man of the Plains*, st. *Dakota Lil*, sc. *The Cariboo Trail*, st. sc. *The Great Missouri Raid*, st. *The Texas Rangers*, sc. *Silver City/High Vermilion*, add. dia. *Flaming Feather*, st. sc. *Warpath*, st. sc. *Denver and Rio Grande*, st. *Pony Express*, st. *Rage at Dawn*, novel basis *Backlash*, novel basis ("Bitter Sage") *Tension at Table Rock*, novel basis ("Buffalo Grass") *The Big Land/Stampeded*, novel basis and sc. (also appeared as hotel clerk) *Town Tamer*, co-st. *Arizona Raiders*, co-st. *White Comanche (Comancho blanco)* (69).

181 GUTHRIE, A. B., Jr. A major W novelist in his own right, he handled the screenplay of *Shane*, effecting subtle improvements on an already fine original work.

Novel basis *The Big Sky* (52), sc. *Shane,* sc. *The Kentuckian,* novel basis *These Thousand Hills,* novel basis *The Way West* (67).

182 HAGEMAN, Richard (c1882–1966). He scored some of John Ford's greatest Ws, making vivid use of traditional melodies.

Stagecoach (39) (in collab.), *Angel and the Badman, Fort Apache, Three Godfathers* (also appeared uncredited as saloon pianist), *She Wore a Yellow Ribbon, Wagonmaster* (50).

183 HALE, Alan (1892–1950). Character actor, most suited to hearty, back-slapping roles with villainous or humorous edge.

The Covered Wagon (23), *Code of the Wilderness, Braveheart* (dir. only), *God's Country and the Woman* (timber), *Valley of the Giants* (timber), *Dodge City, Virginia City, Santa Fe Trail, The Adventures of Mark Twain* (W scenes), *Pursued, Cheyenne* (TV: *The Wyoming Kid*), *South of St. Louis, The Younger Brothers, Colt .45* (TV: *Thunder Cloud*) (50).

184 HALL, Jon (1913–). Dashing leading man, as much at home in the Tropics (Hollywood style) as out West.

Kit Carson (40) (as Kit Carson), *The Michigan Kid, Last of the Redmen* (Colonial period), *The Vigilantes Return, Deputy Marshal, When the Redskins Rode* (Colonial period), *Brave Warrior* (Colonial period) (52).

185 HALL, Porter (1888–1953). Well-known character actor, rather mean and shifty-looking, good at corrupt officials. Played Wild Bill Hickok's assassin, Jack McCall, in *The Plainsman.*

The Plainsman (37), *Wells Fargo, The Dark Command, Trail of the Vigilantes, Arizona, The Parson of Panamint, The Desperadoes, The Woman of the Town, Unconquered* (Colonial period), *The Beautiful*

Blonde from Bashful Bend (comedy), *The Half-Breed, Pony Express* (53).

186 HARDIN, John Wesley (?–1895). A notorious killer of the Old West, a preacher's son whose first victim was a black (one of his pet hates; others were Yankees, Indians and lawmen!). Spent much of his life in jail. Given Hollywood whitewash treatment in *Lawless Breed,* played for laughs by Jack Elam.

John Dehner *The Texas Rangers* (50), Rock Hudson *The Lawless Breed,* Jack Elam *Dirty Dingus Magee* (70).

187 HART, William S. (1870–1946). One of the most famous of all W stars, despite the fact that all his films were made in the silent period, he was raised in the West, became a Broadway actor, often in Shakespeare but also in such stage Ws as "The Squaw Man" and "The Virginian," then after twenty years took up the cinema and became devoted to it, working as writer and director as well as star. He popularised his concept of the "good badman," the outlaw reformed by love, but a combination of advancing age and unwillingness to change with the times cut short his career. His first two screen roles were as villains, then he became the star, working often with writer C. Gardner Sullivan and cameraman Joe August, whose brilliant photography heightened the realism that Hart strove after despite a contradictory penchant for sentimentality. His horse was Fritz. A few of his films were non Ws but they were very much the exception in the career of the man who brought the W to its earliest maturity.

His Hour of Manhood (14) (2r), *Jim Cameron's Wife, The Bargain* (also co-sc.), *On the Night Stage* or *The Bandit and the Preacher, The Passing of Two Gun Hicks* or *Two Gun Hicks* (2r) (also dir.), *Mr. Silent Haskins* (2r) (also dir.), *The Scourge of the Desert* (2r) (also dir.), *The Sheriff's Streak of Yellow*

WILLIAM S. HART

(2r) (also dir.), *The Grudge* (2r), *In the Sage Brush Country* (2r), *The Gentleman from Blue Gulch* or *The Rough Neck* (2r) (also dir.), *The Taking of Luke McVane* or *The Fugitive* (2r) (also co-dir.), *The Man from Nowhere* or *The Silent Stranger, Bad Luck of Santa Ynez* (also dir.), *The Darkening Trail* (also dir.), *The Ruse* (also dir.), *Cash Parrish's Pal* (2r) (also dir.). *The Conversion of Frosty Blake* (also dir.). (feature-length version of *The Gentleman from Blue Gulch*?), *Knight of the Trail* (2r), *The Tool of Providence, Grit* (2r) (also dir.), *Keno Bates Liar* (2r) (also dir.), *Pinto Ben* (also dir. and st.), *The Disciple* (modern) (also dir.), *Between Men* (also dir.), *The Aryan* (also dir.), *Hell's Hinges* (also dir.), *The Primal Lure* (also dir.), *The Captive God, The Apostle of Ven-* *geance, The Dawn Maker* (also dir.), *The Return of Draw Egan* (also dir.), *The Devil's Double* (also dir.), *Truthful Tulliver* (also dir.), *The Gunfighter* (also dir.), *The Square Deal Man* (also dir.), *The Desert Man* (also dir.), *Wolf Lowry* (also dir.), *The Cold Deck* (also dir.), *The Silent Man* (also dir.), *The Narrow Trail* (also co-sc.), *Wolves of the Rail, Blue Blazes Rawden, The Tiger Man, Selfish Yates, Shark Monroe, Riddle Gawne, Border Wireless, Branding Broadway* (modern), *Breed of Men, The Money Corral* (also co-sc.), *Square Deal Sanderson, Wagon Tracks, John Petticoats, Sand, The Toll Gate* (also co-sc.), *The Testing Block* (also st.), *O'Malley of the Mounted* (Mounties) (also co-sc. and prod.), *Three Word Brand,* (also prod.), *White Oak* (also co-sc. and prod.), *Travelin' On* (also co-sc. and

prod.), *Wild Bill Hickok* (also co-sc.), *Singer Jim McKee* (also co-sc. and prod.), *Tumbleweeds* (also prod.) (25) (later reissued with sound prologue by Hart plus sound effects and music).

188 HATHAWAY, Henry (1898–). Indefatigable director of films good, bad and o.k. His Ws are as variable as the rest of his work but *Rawhide* and *North to Alaska* have much to commend them. He was an assistant director, working on *The Virginian* (29) and some of the Zane Grey films of the Twenties that he himself eventually re-made in the Thirties as a full-fledged director.

Heritage of the Desert (32), *Wild Horse Mesa, Under the Tonto Rim, Sunset Pass, Man of the Forest* (re-issued as *Challenge of the Frontier*), *To the Last Man* (TV: *Law of Vengeance*), *The Thundering Herd* (TV: *Buffalo Stampede*), *The Last Round-Up, Brigham Young—Frontiersman, Rawhide* (TV: *Desperate Siege*), *Garden of Evil, From Hell to Texas/ Manhunt, North to Alaska* (North-W) (comedy), *How the West Was Won* (episodes "The Rivers," "The Plains," "The Outlaws"), *Circus World/The Magnificent Showman* (modern Wild West show), *The Sons of Katie Elder, Nevada Smith* (also prod.), *5 Card Stud, True Grit, Shoot Out* (71).

189 HAWKS, Howard (1896–). Veteran director-producer whose skilful entertainments cover all the Hollywood *genres*; in the W he has done his most notable work with star John Wayne, the epic *Red River,* the leisurely but thoughtful *Rio Bravo* and two variations on the latter. Takes a major role in shaping his scripts without credit.

Viva Villa! (34) (uncredited co-dir.), *The Outlaw* (uncredited part dir.), *Red River* (also prod.), *The Big Sky* (Colonial period) (also prod.), *Rio Bravo* (also prod.), *El Dorado* (also prod.), *Rio Lobo* (also prod.) (70).

HENRY HATHAWAY (right) with John Wayne, making *True Grit*

190 HAYCOX, Ernest (1899?–1950). W author respected by his contemporary rivals for good character observation and authentic detailing; wrote some 24 novels and 250 short stories, including the story basis of *Stagecoach*; wrote one original screen story, a sheep v. cattle tale called *Montana*.

Story basis ("Stage to Lordsburg") *Stagecoach* (39), novel basis ("Trouble Shooter") *Union Pacific,* novel basis *Sundown Jim,* story ("Stage Station") *Apache Trail,* novel ("Trail Town") *Abilene Town,* novel basis *Canyon Passage,* adap. *Heaven Only Knows* or *Montana Mike* (W fantasy), st. *Montana,* novel basis *Bugles in the Afternoon,* story basis ("Stage Station") *Apache War Smoke,* novel basis ("The Outcast") *Man in the Saddle/The Outcast,* story basis ("Stage to Lordsburg") *Stagecoach* (66).

191 HAYDEN, Sterling (1916–). Rugged, taciturn figure whose most notable appearances have been outside the W (*The Asphalt Jungle, The Killing, Dr. Strangelove*); but a great deal of his more routine work has been in the *genre* where he has performed forcefully.

El Paso (49), *Flaming Feather,*

STERLING HAYDEN in
Terror in a Texas Town

Denver and Rio Grande, Hellgate, Kansas Pacific, Arrow in the Dust, Johnny Guitar, Timberjack (timber), *Shotgun, The Last Command* (as Jim Bowie), *Top Gun, The Iron Sheriff, Valerie, Gun Battle at Monterey, Terror in a Texas Town* (58).

192 HAYES, George "Gabby" (1885–1969). Well-remembered as a grumpy but lovable bewhiskered sidekick of such W stars as William Boyd (Hopalong Cassidy), Roy Rogers, Wild Bill Elliott in their series pictures. Hayes was born in New York City and had a stage career before entering movies. At first, he was most often a lean meany (as in many of John Wayne's early Ws) but increasing age brought an increase in fortune as his toothless grizzledness and white beard made him into a memorable "character." In the Fifties, he ran a talk show on TV with W film clips. He claimed to have appeared in 174 Ws.

Rose of the Rio Grande (31), *God's Country and the Man, Cavalier of the West, Nevada Buckaroo, Border Devils, Riders of the Desert, From Broadway to Cheyenne* (W elements), *Klondike* (North-W), *Night Rider, Man From Hell's Edges, Hidden Valley, Texas Buddies, The Fighting Champ, Wild Horse Mesa, Trailing North, Breed of the Border, Fighting Texans, Gallant Fool, Devil's Mate, Ranger's Code, The Fugitive, Galloping Romeo, Riders of Destiny, Lucky Texan, West of the Divide, Blue Steel, The Man from Utah, Randy Rides Alone, The Star Packer, Brand of Hate, In Old Santa Fe, 'Neath Arizona Skies, Lawless Frontier, Rainbow Valley, Justice of the Range, Hop-a-long Cassidy, Smoky Smith, Thunder Mountain, Tumbling Tumbleweeds, The Eagle's Brood, Bar 20 Rides Again, The Throwback, Swifty, Valley of the Lawless, The Outlaw Tamer, Call of the Prairie, The Lawless Nineties, Three on the Trail, The Texas Rangers, Heart of the West, Hopalong Cassidy Returns, Trail Dust, The Plainsman, Borderland, Hills of Old Wyoming, North of the Rio Grande, Hopalong Rides Again, Rustler's Valley, Texas Trail, Heart of Arizona, Gold Is Where You Find It* (W elements), *Bar 20 Justice, In Old Mexico, Sunset Trail, The Frontiersman, Silver on the Sage, Let Freedom Ring* (musical), *Man of Conquest, In Old Caliente, Saga of Death Valley, In Old Monterey, Renegade Trail, Wall Street Cowboy* (W elements), *The Arizona Kid, Days of Jesse James, Young Buffalo Bill, The Dark Command, Wagons Westward, Carson City Kid, The Ranger and the Lady, Colorado, Young Bill Hickok, Melody Ranch, The Border Legion* (TV: *West of the Badlands*), *Robin Hood of the Pecos, In Old Cheyenne, Sheriff of Tombstone, Nevada City, Jesse James at Bay, Bad Man of Deadwood, Red River Valley, South of Santa Fe, Sunset on the Desert, Man of Cheyenne, Romance on the Range, Sons of the Pioneers, Sunset Serenade, Heart of the Golden West, Ridin' down the Canyon, Calling Wild Bill Elliott, Man from Thunder River, Bordertown Gunfighters, Wagon Tracks West, Death Valley Manhunt, Over-*

GEORGE "GABBY" HAYES (right) with Dale Robertson and Randolph Scott in *The Cariboo Trail*

land Mail Robbery, In Old Oklahoma or *War of the Wildcats, Tucson Raiders, Hidden Valley Outlaws, Marshal of Reno, Mojave Firebrand, Tall in the Saddle, Lights of Old Santa Fe, Utah, The Big Bonanza, Bells of Rosarita, The Man from Oklahoma, Sunset in El Dorado, Don't Fence Me In, Along the Navajo Trail, Song of Arizona, Badman's Territory, Rainbow over Texas, My Pal Trigger, Roll on Texas Moon, Home in Oklahoma, Under Nevada Skies, Helldorado, Trail Street, Wyoming, Albuquerque/Silver City, Return of the Bad Men, The Untamed Breed, El Paso, The Cariboo Trail* (50).

193 HAYWARD, Lillie (1896–). Screenwriter who worked in many *genres* but probably did her best work in the W where she began writing for Tom Mix in 1925. An antiques expert in her spare time. Has worked in TV.

Sc. *The Best Bad Man* (25), sc. *My Own Pal*, co-sc. *The Heart of the Rio Grande*, part sc. *Smoky* (horse), co-sc. *Northwest Stampede*, sc. Blood *on the Moon*, co-st. co-sc. *Cattle Drive*, co-sc. *Bronco Buster* (modern rodeo), co-sc. *The Raiders* (TV: *Riders of Vengeance*), sc. *Santa Fe Passage*, co-sc. *The Proud Rebel*, co-sc. *Tonka* (58).

194 HAYWARD, Susan (1918– 75). Powerful actress who gives as good as she gets in much of her screen work with rich displays of temper and stubbornness.

Canyon Passage (46), *Rawhide* (TV: *Desperate Siege*), *The Lusty Men* (modern rodeo), *Garden of Evil, Thunder in the Sun, The Revengers* (72).

195 HEFLIN, Van (1910–1971). An outstanding actor rather than star, Heflin was always a conscientiously hard-working performer, and his two W roles of the ordinary family man in *Shane* and *3:10 to Yuma* are among his most distinguished work.

The Outcasts of Poker Flat (37), *Santa Fe Trail, Tomahawk/Battle of Powder River, Wings of the Hawk* (Mexico), *Shane, The Raid* (Civil War), *Count Three and Pray* (W elements), *3:10 to Yuma, Gunman's Walk, Stagecoach, Each Man for Himself* (*Ognuno per se*) (68).

196 HENDRIX, Wanda (1928–). Her beauty fully matched the scenic splendours of any of her Ws; she was at one time married to Audie Murphy and made *Sierra* with him.

Sierra (50), *Saddle Tramp, My Outlaw Brother, Montana Territory, The Last Posse, The Black Dakotas,*

WANDA HENDRIX

Stage to Thunder Rock, Mystic Mountain Massacre (made 71, unreleased).

197 HESTON, Charlton (1924–). Athletic actor who has forged his main association with epics of ancient times; but has also on oc-

casion, and most memorably in the title role of *Will Penny,* ventured out West to convincing effect.

The Savage (52), *The President's Lady* (W scenes), *Pony Express* (as Buffalo Bill Cody), *Arrowhead, The Far Horizons* (early exploration), *Three Violent People, The Big Country, Major Dundee, Will Penny* (67).

198 HIBBS, Jesse (1906–). Workmanlike director who handled many of Universal's glossy Ws.

Ride Clear of Diablo (54), *Rails into Laramie, Black Horse Canyon, The Yellow Mountain, The Spoilers* (N-W), *Walk the Proud Land, Ride a Crooked Trail* (58).

199 HICKOK, "Wild Bill" (James Butler) (1837–1876). One of the West's legendary heroes, the man who tamed the towns of Kansas and Deadwood, romanced Calamity Jane, and was shot in the back by the cowardly Jack McCall. Truth contradicts legend, revealing Hickok as a gun-happy killer who quickly deserted Calamity Jane, but the legend re-

CHARLTON HESTON in *Will Penny*

mains more colourful and enticing.

William S. Hart *Wild Bill Hickok* (23), John Padjan *The Iron Horse*, J. Farrell MacDonald *The Last Frontier*, Yakima Canutt *The Last Frontier* (s), Gary Cooper *The Plainsman*, Gordon (Wild Bill) Elliott *The Great Adventures of Wild Bill Hickok* (s), George Houston *Frontier Scout*, Roy Rogers *Young Bill Hickok*, Lane Chandler *Deadwood Dick* (s), Richard Dix *Badlands of Dakota*, Bruce Cabot *Wild Bill Hickok Rides*, Reed Hadley *Dallas*, Robert "Bob" Anderson *The Lawless Breed*, Ewing Brown *Son of the Renegade*, Douglas Kennedy *Jack McCall Desperado*, Forrest Tucker *Pony Express*, Howard Keel *Calamity Jane* (musical), Tom Brown *I Killed Wild Bill Hickok*, Robert Culp *The Raiders*, Adrian Hoven *Seven Hours of Gunfire* (*Sette ore di fuoco* or *Aventuras del oeste*), Paul Shannon *The Outlaws Is Coming* (comedy), Don Murray *The Plainsman*, Robert Dix *Deadwood '76*. Jeff Corey *Little Big Man* (71).

Series use of character: Wild Bill Elliott (note also serial above): *Prairie Schooners/Through the Storm* (40), *Beyond the Sacramento/Power of Justice, The Wildcat of Tucson/Promise Fulfilled, Across the Sierras/Welcome Stranger, North from the Lone Star, King of Dodge City, Hands across the Rockies, Roaring Frontiers, Lone Star Vigilantes/The Devil's Price, Bullets for Bandits* (42).

Guy Madison (TV series): see entry 265.

200 HILLYER, Lambert (1893–) Director who worked extensively with many of the great W stars, beginning with William S. Hart, then Tom Mix and Buck Jones, Wild Bill Elliott, later Johnny Mack Brown. His most ambitious work was undoubtedly that of the silent period though the later Johnny Mack Brown films were a superior series of their type. After slipping to very minor work on a Jimmy Wakeley

series and a couple of Whip Wilson Ws, he moved to TV where he worked on the *Cisco Kid* series among others.

The Desert Man (sc. only) (17), *The Narrow Trail, Wolves of the Rail, Blue Blazes Rawden, The Tiger Man, Selfish Yates, Shark Monroe, Riddle Gawne, Border Wireless, Branding Broadway* (modern), *Breed of Men, The Money Corral* (also co-sc.), *Square Deal Sanderson, Wagon Tracks, John Petticoats, Sand* (also co-sc.), *The Toll Gate* (also co-sc.), *The Testing Block, O'Malley of the Mounted* (also co-sc.), *Three Word Brand* (also co-sc.), *White Oak, Travelin' On* (also co-sc.), *The Spoilers* (N-W), *The Lone Star Ranger* (also sc.), *Mile-a-Minute Romeo, Eyes of the Forest* (modern), *30 below Zero* (co-dir; N-W), *Hills of Peril, Chain Lightning* (also co-sc.), *The Branded Sombrero, Beau Bandit, Fighting Fool, One Man Law, South of the Rio Grande, Born to Trouble, Hello Trouble, The Deadline, White Eagle, The Forbidden Trail, The Sundown Rider, The California Trail, Unknown Valley, The Fighting Code, The Man Trailer* (also sc.), *The Durango Kid/The Masked Stranger, The Pinto Kid, Beyond the Sacramento/Power of Justice, The Wildcat of Tucson/Promise Fulfilled, North from the Lone Star, The Return of Daniel Boone/The Mayor's Nest, The Son of Davy Crockett/Blue Clay* (also st. and sc.), *King of Dodge City, Hands across the Rockies, The Medico of Painted Springs/The Doctor's Alibi, Thunder over the Prairie, Roaring Frontiers, Prairie Stranger/The Marked Bullet, The Royal Mounted Patrol/Giants A'fire, North of the Rockies/False Clues, Devil's Trail, Prairie Gunsmoke, Vengeance of the West, Fighting Frontier, The Stranger from Pecos, Six Gun Gospel, The Texas Kid, Partners of the Trail, Law Men, Range Law, West of the Rio Grande, Land of the Outlaws, Ghost Guns, Flame of the West, Stranger from Santa Fe, South of the Rio*

Grande, The Lost Trail, Frontier Feud, Border Bandits, Under Arizona Skies, Gentleman from Texas, Shadows on the Range, Trigger Fingers, Silver Range, Raiders of the South (TV: *South Raiders*), *Valley of Fear, Trailing Danger, Land of the Lawless, The Law Comes to Gunsight, Flashing Guns, Prairie Express, Gun Talk, Song of the Drifter, Overland Trails, Oklahoma Blues, Crossed Trails, Partners of the Sunset, Frontier Agent, Range Renegades, The Fighting Ranger, Outlaw Brand, The Sheriff of Medicine Bow, Gun Runner, Gun Law Justice, Trails End, Haunted Trails, Riders of the Dusk* (49).

WILLIAM HOLDEN in
Escape from Fort Bravo

201 HOCH, Winton C. Iowa-born cinematographer initially concerned with special effects work, he contributed some of the most memorable colour images ever seen to some of John Ford's finest Ws.

Three Godfathers (49), *She Wore a Yellow Ribbon, *The Sundowners/Thunder in the Dust, *The Redhead from Wyoming, *The Searchers, *The Young Land* (in collab.) (59).

202 HOLDEN, William (1918–). Actor with a sincere, open and likable style who made several Ws early in his career and has been returning to the *genre* in recent years after only occasional ventures out West.

Arizona (40), *Texas, Rachel and the Stranger* (W elements), *The Man from Colorado, Streets of Laredo, Escape from Fort Bravo, The Horse Soldiers* (Civil War), *Alvarez Kelly, The Wild Bunch, Wild Rovers, The Revengers* (72).

203 HOLLIDAY, Doc (John Henry) (1849–1885). The poker-playing dentist who reached Tomb-

Stacy Keach as DOC HOLLIDAY
in *Doc*

stone a wanted man but became a staunch friend of the marshal, Wyatt Earp, and backed him up at the gunfight at the O.K. Corral. His coughing fits and relationship with "Big Nose Kate" Fisher (also known as Kate Elder) were most colourfully explored by Kirk Douglas.

Cesar Romero *Frontier Marshal* (39), Kent Taylor *Tombstone the Town Too Tough to Die*, Walter Huston *The Outlaw*, Victor Mature *My Darling Clementine*, James Griffith *Masterson of Kansas*, Kirk Douglas *Gunfight at the O.K. Corral*, Arthur Kennedy *Cheyenne Autumn* (comedy episode), Jason Robards Jr. *Hour of the Gun*, Stacy Keach *Doc* (71).

204 HOLT, Jack (1888–1951). A top W star of the Twenties, a character actor in later years, he was raised in Virginia riding country and took to the saddle at the age of six. He tried railroad building, prospecting and trapping in Alaska, then worked as a cowboy in Oregon. Entered movies as a stuntman, quickly progressed to leads (especially in Zane Grey stories). Horse: Grey Ghost. Served as army horse buyer for cavalry in the Second World War. Son Tim and daughter Jennifer both achieved prominence in Ws.

Salomy Jane (stunt double) (14), *Liberty a Daughter of the U.S.A.* (s), *A Desert Wooing, White Man's Law, The Squaw Man, The Call of the North* (N-W), *North of the Rio Grande, While Satan Sleeps, North of 36, The Wanderer of the Wasteland, The Light of Western Stars, The Thundering Herd, The Ancient Highway* (timber), *Wild Horse Mesa, The Enchanted Hill* (modern), *Born to the West, Forlorn River, Man of the Forest, The Mysterious Rider, Avalanche, Court-Martial* (Civil War), *The Vanishing Pioneer, The Water Hole, Sunset Pass, The Border Legion, North of Nome* (N-W), *End of the Trail, Roaring Timber* (timber), *Northwest Rangers* (Mounties),

My Pal Trigger, Renegade Girl, The Wild Frontier, The Treasure of the Sierra Madre (W elements—bit part), *The Arizona Ranger, The Gallant Legion, The Strawberry Roan, Loaded Pistols, The Last Bandit, Brimstone, Red Desert, Return of the Frontiersman, Across the Wide Missouri, Trail of Robin Hood, The Daltons' Women, King of the Bullwhip* (51).

NAT HOLT

205 HOLT, Nat (1894–1971). Showman and cinema circuit executive who became a producer, almost exclusively of Ws, usually well mounted if not particularly memorable. Many starred Randolph Scott, most featured railroads.

Badman's Territory (46), *Return of the Badmen, Canadian Pacific, Fighting Man of the Plains, The Cariboo Trail, The Great Missouri Raid, Warpath, Silver City/High Vermilion, Flaming Feather, Denver and Rio Grande, Pony Express, Arrowhead, Rage at Dawn, Texas Lady, Cattle King/Guns of Wyoming* (63).

TIM HOLT in *The Bandit Trail*

206 HOLT, Tim (1918–1973).
Son of actor Jack Holt (whose
daughter Jennifer also made many
Ws). His brilliant performances in
The Magnificent Ambersons and
The Treasure of the Sierra Madre
make one wonder why he spent the
rest of his career almost entirely on
undemanding starring roles in com-
petent B Ws. Horse was Duke.

The Vanishing Pioneer (28), *Gold
Is Where You Find It* (W elements),
*The Law West of Tombstone, The
Renegade Ranger, Stagecoach, Wag-
on Train, The Fargo Kid, Along the
Rio Grande, Robbers of the Range,
Cyclone on Horseback, The Bandit
Trail, Dude Cowboy, Six Gun Gold,
Thundering Hoofs, Riding the Wind,
Land of the Open Range, Come on
Danger, Bandit Ranger, Red River
Robin Hood, Pirates of the Prairie,
Fighting Frontier, The Avenging
Rider, Sagebrush Law, My Darling
Clementine, Under the Tonto Rim,*

*Thunder Mountain, Wild Horse
Mesa, The Treasure of the Sierra
Madre* (Mexico—W elements),
*Western Heritage, The Arizona Ran-
ger, Guns of Hate, Indian Agent,
Gun Smugglers, Brothers in the Sad-
dle, Rustlers, The Stagecoach Kid,
The Mysterious Desperado, Masked
Raiders, Riders of the Range, Storm
over Wyoming, Rider from Tucson,
Dynamite Pass, Border Treasure, Rio
Grande Patrol, Law of the Badlands,
Saddle Legion, Gunplay, Pistol Har-
vest, Hot Lead, Overland Telegraph,
Trail Guide, Road Agent, Target,
Desert Passage* (53).

207 HOMEIER, Skip (1930–).
Had a good run as an excellent loud-
mouth and braggart of the old West;
the kid who shot Gregory Peck in
the back in *The Gunfighter,* before
which he had been sent for reform
to a modern Texas ranch in *Boy's
Ranch* (46) and appeared in *The
Big Cat* (modern outdoors).
 The Gunfighter (50), *The Last
Posse, The Lone Gun, Dawn at
Socorro, Ten Wanted Men, Road to
Denver, At Gunpoint/Gunpoint!,*

SKIP HOMEIER in *The Gunfighter*

Stranger at My Door, Dakota Incident, Thunder over Arizona, The Burning Hills, The Tall T, Day of the Badman, Plunderers of Painted Flats, Comanche Station, Showdown, Bullet for a Badman (64).

208 HOUSTON, Sam (1793–1863). Tall, lean soldier, politician and hero of Texas, leader of the fight for freedom from Mexican oppression; seen in the various stories of the Alamo as the commander of Texan forces who used the time the fort's defenders won to rally his forces for ultimate victory.

William Farnum *The Conqueror* (17), Richard Dix *Man of Conquest*, Moroni Olsen *Lone Star*, Howard J. Negley *The Man from the Alamo*, Hugh Sanders *The Last Command*, Joel McCrea *The First Texan*, Richard Boone *The Alamo* (60).

209 HOWARD, William K. (1899–1954). Writer, later director, who worked on Buck Jones pictures and then a series of Zane Grey adaptations in the Twenties before making his classic *White Gold* with its harshly realistic W setting.

As writer: sc. *The One-Man Trail* (21), sc. *Trooper O'Neil,* co-st. co-sc. *Sin Town* (29).

As director: *Get Your Man* (in collab.) (Canada) (21), *Lucky Dan* (W elements), *Captain Fly-By-Night* (Mexico), *The Border Legion, The Thundering Herd, Code of the West, The Light of Western Stars, White Gold* (W setting) (27).

210 HUDSON, Rock (1925–). Lightweight but likable leading man who spent much of his early career in the W, then moved into modern dress and light comedy for most of his work.

Winchester '73 (bit) (50), *Tomahawk/Battle of Powder River* (bit), *Bend of the River/Where the River Bends, Horizons West, The Lawless Breed, Seminole, Back to God's Country* (Canada), *Gun Fury, Taza Son of Cochise, Giant* (modern), *The*

Last Sunset, The Undefeated, Showdown (73).

211 HUFFAKER, Clair. An able novelist who turned in some interesting W scripts before losing his early promise with the more routine work of late.

Novel basis and sc. *Seven Ways from Sundown,* novel basis ("Flaming Lance") and co-sc. *Flaming Star,* novel basis and sc. *Posse from Hell,* co-sc. *The Comancheros,* part sc. (refused credit) *The Second Time Around* (comedy), novel basis ("Guns of Rio Conchos") and co-sc. *Rio Conchos,* novel basis ("Badman") and sc. *The War Wagon,* co-sc. *100 Rifles,* novel basis ("Nobody Loves a Drunken Indian") and sc. *Flap/The Last Warrior* (comedy), sc. *The Deserter,* sc. *Valdez the Halfbreed* (74).

212 HUGHES, Russell. Proficient screenwriter, now deceased.

Sc. *Sugarfoot* (TV: *A Swirl of Glory*) (51), st. sc. *Thunder over the Plains,* sc. *The Command,* co-sc. *The Yellow Mountain,* co-sc. *The Last Frontier* (TV: *Savage Wilderness*), co-sc. *Jubal* (56).

HENRY HULL (left) with Robert Mitchum in *Man with the Gun*

ARTHUR HUNNICUTT in *Broken Arrow*. JEFFREY HUNTER in *White Feather*

213 HULL, Henry (1890–). Veteran character actor, at work in films as far back as 1917, who has contributed a good many tiresomely garrulous, bearded oldtimers to the W, often in the company of legendary figures.

Jesse James (39), *Return of the Cisco Kid, The Return of Frank James, Rimfire, El Paso, Colorado Territory, Return of Jesse James, The Last Posse, Inferno* (desert setting; as old prospector), *Thunder over the Plains, Man with the Gun/The Trouble Shooter, Kentucky Rifle, Buckskin Lady, The Proud Rebel, The Sheriff of Fractured Jaw* (comedy), *The Oregon Trail* (59).

214 HUNNICUTT, Arthur (1911–). Tall, lean, grizzled character actor with slow-speaking manner, good at beaver-hatted, buckskinned types.

The Fighting Buckaroo (42), *Riding through Nevada, Pardon My Gun, Law of the Northwest, Frontier Fury, Robin Hood of the Range, Hail to the Rangers!/Illegal Rights, Riding*

West/Fugitive from Time, Lust for Gold, A Ticket to Tomahawk (comedy), *The Furies, Broken Arrow, Two Flags West, Passage West/High Venture, The Red Badge of Courage* (Civil War), *Sugarfoot* (TV: *A Swirl of Glory*), *Distant Drums, The Big Sky* (Colonial period), *The Lusty Men* (modern rodeo), *Devil's Canyon, The Last Command* (as Davy Crockett), *The Tall T, Cat Ballou* (comedy), *The Adventures of Bullwhip Griffin* (comedy), *Apache Uprising, El Dorado, Shoot Out, The Revengers* (72).

215 HUNTER, Jeffrey (1927– 1969). Blue-eyed, handsome actor with honest style; best work for John Ford, career slipping badly at time of his premature death.

Three Young Texans (54), *White Feather, Seven Angry Men, The Proud Ones, The Searchers, The Great Locomotive Chase, The True Story of Jesse James/The James Brothers* (as Frank James), *Gun for a Coward, Sergeant Rutledge, The Man from Galveston, Murieta/Ven-*

WALTER HUSTON in *The Furies*. JOHN HUSTON in *The Deserter*

detta (*Joaquin Murrieta*) (Mexico), *Custer of the West, Find a Place to Die* (*Joe, cercati un posto per morire*) (68).

216 HUSTON, John (1906–). Restlessly adventurous director with a colourful past including service with the Mexican cavalry before he turned to writing and then directing, the latter supplemented by increasingly frequent ventures into acting.

Co-sc. *Law and Order* (32), sc. dir. *Treasure of the Sierra Madre* (W elements), sc. dir. *The Red Badge of Courage* (Civil War), dir. *The Unforgiven,* dir. *The Misfits* (modern), actor *The Deserter,* dir. *The Life and Times of Judge Roy Bean* (also actor) (72).

217 HUSTON, Walter (1884–1950). Canadian-born actor, father of John Huston, with an enviable record of achievement, including a portrayal of the classic villain Trampas in his third picture, the third

version of *The Virginian* (29), and the most sane of the three prospectors in his son's film *The Treasure of the Sierra Madre*.

The Virginian (29), *The Bad Man, Law and Order, The Outlaw* (as Doc Holliday), *Duel in the Sun, The Furies* (50).

218 HYER, Martha (1924–). Actress wife (from 66) of producer Hal Wallis with a cool manner and long acquaintance with the W.

Thunder Mountain (47), *Gun Smugglers, Rustlers, Roughshod, Outcast of Black Mesa, Salt Lake Raiders, Frisco Tornado, Wild Stallion, Yukon Gold* (North-W), *Battle of Rogue River, Wyoming Renegades, Red Sundown, Showdown at Abilene, Once upon a Horse* (comedy), *Blood on the Arrow, The Sons of Katie Elder, The Night of the Grizzly* (66).

219 INCE, Thomas H. (1882–1924). A notable early director of

Ws and Civil War subjects who later turned producer and was associated with William S. Hart. Before that, as director, he hired real cowboys and Indians from a touring show to add realism to some of his W work.

As director (all shorts): *Across the Plains* or *War on the Plains, The Hidden Trail, The Prospector's Daughter* (11), *Custer's Last Raid, The Law of the West, Blazing the Trail, The Indian Massacre, Battle of the Red Men, The Invaders, Custer's Last Fight* or *The Lieutenant's Last Fight, The Raiders, The Renegade, Girl of the Golden West, The Crisis* (12), *The Heart of an Indian, Past Redemption, The Woman, Days of '49* (13).

220 IRELAND, John (1915–). Stage-trained actor from Canada who showed ambition in much of his early work, but is now busy pounding out cheap films in Europe after a steady decline.

My Darling Clementine (46) (as Billy Clanton), *Red River, A Southern Yankee/My Hero* (Civil War comedy), *I Shot Jesse James* (as Bob Ford), *The Walking Hills, The Doolins of Oklahoma/The Great Manhunt, Roughshod, The Return of Jesse James, Vengeance Valley, Little Big Horn/The Fighting 7th, The Bushwhackers/The Rebel, Red Mountain* (as Quantrill), *Outlaw Territory* (also co-dir. and co-prod.), *South West Passage/Camels West, Gunslinger, Gunfight at the O.K. Corral, Fort Utah, Arizona Bushwhackers, Villa Rides* (Mexico), *Tutto per tutto, Corri uomo corri, Hate for Hate* (*Odio per odio*), *Quanto costa morire, Quel caldo maledotto giorno di fuoco* (69).

221 IVES, Burl (1909–). Introduced as a W troubadour in horse picture *Smoky*, his massive figure and booming voice have been used to powerful effect since.

Smoky (46), *Station West, Sierra, Gun Glory* (sings title song), *The Big Country, Wind across the Everglades* (outlaw figure), *Day of the Outlaw, The McMasters* (71).

222 JAECKEL, Richard (1926–). Blond actor best known for his work in war films; but on occasion his pugnacious manner has been effectively used in Ws to cast him as a bully, usually of the shortlived variety.

The Gunfighter (50), *Wyoming*

RICHARD JAECKEL with James Coburn as Pat Garrett in *Pat Garrett and Billy the Kid*

Mail, The Violent Men/Rough Company, Apache Ambush, 3:10 to Yuma, Cowboy, Flaming Star, Four for Texas (comedy), *Town Tamer, Chisum, Ulzana's Raid, Pat Garrett and Billy the Kid* (73).

DEAN JAGGER in *Firecreek*

223 JAGGER, Dean (1903–). Accomplished actor, one of the few to emphasise baldness rather than cover it up.

Home on the Range (35), *Wanderer of the Wasteland, Brigham Young—Frontiersman* (as Young), *Western Union, Valley of the Sun, The Omaha Trail, Alaska* (N-W), *Pursued, Sierra, Rawhide* (TV: *Desperate Siege*), *Warpath, Denver and Rio Grande, Red Sundown, Forty Guns, The Proud Rebel. Firecreek. Day of the Evil Gun, Smith!* (69).

224 JAMES, Frank (1843–1915). Less colourful than brother Jesse, he considered himself intellectually superior for no very good reason. In films, he has often been portrayed as the justified avenger of his brother's assassination; in real life, he surrendered to the law on a train robbery charge, was acquitted through his local popularity, later joined up with a Wild West show and died of natural causes.

James Pierce *Jesse James* (27), Michael Worth *Days of Jesse James,* Henry Fonda *Jesse James,* Henry Fonda *The Return of Frank James,* Tom Tyler *Badman's Territory,* Steve Darrell *The Adventures of Frank and Jesse James* (s), Tom Tyler *I Shot Jesse James,* Robert Bice *The James Brothers of Missouri* (s), Wendell Corey *The Great Missouri Raid,* Don "Red" Barry *Gunfire/ Frank James Rides Again,* Reed Hadley *The Return of Jesse James,* Richard Long *Kansas Raiders,* Tom Tyler *Best of the Badmen,* James Brown *Woman They Almost Lynched,* Jack Buetel *Jesse James' Women,* Jeffrey Hunter *The True Story of Jesse James/The James Brothers,* Douglas Kennedy *Hell's Crossroads,* Jim Davis *Alias Jesse James* (comedy), Robert Dix *Young Jesse James,* John Pearce *The Great Northfield Minnesota Raid* (72).

225 JAMES, Jesse (1847–1882). The most celebrated bad man of them all. As a youth, he was one of Quantrill's best raiders, then embarked on a career as a callous killer and hold-up artist, intimidating the authorities and relying on the support of Southerners resentful at losing the Civil War. He was eventually shot and killed by one of his own gang, Bob Ford, seeking the reward. Legend has it that he was gallant, generous with his illgotten gains, persecuted, and it is legend rather than harsher fact that has largely been perpetuated by the movies.

Jesse James Jr. *Jesse James under the Black Flag* (21), Jesse James Jr. *Jesse James as the Outlaw,* Fred Thomson *Jesse James,* Tyrone Power *Jesse James,* Donald Barry *Days of Jesse James,* Roy Rogers *Jesse James at Bay,* Alan Baxter *Bad Men of Missouri,* Rod Cameron *The Remarkable Andrew* (non-W), Lawrence Tierney *Badman's Territory,*

JESSE JAMES. Left, Wendell Corey in *Alias Jesse James*. Right, Robert Duvall in *The Great Northfield Minnesota Raid*

Clayton Moore *Jesse James Rides Again* (s), Clayton Moore *Adventures of Frank and Jesse James* (s), Reed Hadley *I Shot Jesse James*, Keith Richards *The James Brothers of Missouri* (s), Dale Robertson *Fighting Man of the Plains*, Macdonald Carey *The Great Missouri Raid*, Audie Murphy *Kansas Raiders*, Lawrence Tierney *Best of the Badmen*, Ben Cooper *Woman They Almost Lynched*, Willard Parker *The Great Jesse James Raid*, Don Barry *Jesse James' Women*, Robert Wagner *The True Story of Jesse James/The James Brothers*, Henry Brandon *Hell's Crossroads*, Wendell Corey *Alias Jesse James* (comedy), Ray Stricklyn *Young Jesse James*, Wayne Mack *The Outlaws Is Coming* (comedy), John Lupton *Jesse James Meets Frankenstein's Daughter*, Audie Murphy *A Time for Dying*, Robert Duvall *The Great Northfield Minnesota Raid* (72).

226 JOHNSON, Ben (1918–). One film, *The Last Picture Show*, suddenly thrust fame on him, when he won an Oscar; but W fans have long been familiar with his capable portrayals exuding real W authenticity—as well they might, since his father was a champion steer roper and he himself began his movie career wrangling horses, then acting as a stunt double for stars like Joel McCrea and John Wayne before being selected for acting roles, notably in John Ford's work. Became world champion steer roper in 1953. Handled horses for *The Outlaw* (1940), doubled for Wayne in *Fort Apache*. Then as actor:

Three Godfathers (49), *Mighty Joe Young* (non-W; as a cowboy), *She Wore a Yellow Ribbon, Wagonmaster, Rio Grande, Wild Stallion, Fort Defiance, Shane, Rebel in Town, War Drums, Slim Carter* (W filmmaking comedy), *Fort Bowie, Ten Who Dared, One Eyed Jacks, Major Dundee, The Rare Breed, Will Penny, Ride a Northbound Horse* (TV), *Hang Em High, The Wild Bunch, The Undefeated, Chisum, Something Big, Junior Bonner* (modern rodeo), *The Train Robbers, Kid*

Blue (Comedy), *Bite the Bullet* (W elements) (75).

227 JOHNSON, Chubby. Likable "old timer" with rasping voice in numerous Ws with very little work in other *genres*: his roles encompass such figures as a steamboat captain, prospector and stagecoach driver.

Rocky Mountain (50), *Night Riders of Montana, Wells Fargo Gunmaster, Fort Worth, Fort Dodge Stampede, Westward the Women, Bend of the River/Where the River Bends, The Treasure of Lost Canyon, Last of the Comanches/The Sabre and the Arrow, Gunsmoke, Law and Order, Back to God's Country* (Canada), *Calamity Jane* (musical comedy), *Overland Pacific, Cattle Queen of Montana, The Far Country, Rage at Dawn, Tennessee's Partner, Tribute to a Bad Man, The First Texan, The Fastest Gun Alive, The Rawhide Years, The Young Guns, Drango, The True Story of Jesse James/The James Brothers, Gunfire at Indian Gap, The Firebrand* (TV), *The Seven Faces of Dr. Lao* (non-W; as cowboy), *The Adventures of Bullwhip Griffin* (comedy), *Sam Whiskey, Support Your Local Sheriff* (comedy) (69).

228 JOHNSON, Dorothy M. The most highly regarded of women writers on the West.

Novel basis *The Hanging Tree* (58), story basis *The Man Who Shot Liberty Valance,* story basis *A Man Called Horse* (70).

229 JONES, Buck (1891–1942). One of the great W stars of all time (real name: Charles Gebhart), his style lay between the flamboyance of Mix and the realism of Hart. Brought up in a family that homesteaded in the Oklahoma Territory from when he was in his early teens, he worked on a nearby ranch as a cowboy, enlisted in the U.S. Sixth Cavalry and served in the Philippines, then became a bronc rider and roper in a Wild West show before forming his

BEN JOHNSON in *Chisum*

BUCK JONES

own circus. He then became an extra and stunt double in Hollywood, progressed to supporting Franklyn Farnum in a series of two-reelers, did a few supporting roles at Fox and then became a star there with *The Last Straw*, second only to Tom Mix. Some of his subsequent films were non-Ws. In the sound period, he starred in a vast number of more modest programmers (many of which he also produced), eventually teaming up with Tim McCoy and Raymond Hatton for a "Rough Riders" series. He had just finished these when he died heroically attempting to rescue people trapped in a nightclub fire. His horses were Silver and White Eagle.

True Blue (W elements) (1918), *Riders of the Purple Sage, The Rainbow Trail, Western Blood, The Last Straw, Square Shooter, Firebrand Trevison, Sunset Sprague, The One-Man Trail, Get Your Man* (Mounties), *Straight from the Shoulder* (part comedy), *To a Finish, Bar Nothin', Riding with Death, Pardon My Nerve!, Western Speed, Rough Shod, Trooper O'Neil* (Mounties), *West of Chicago, The Fast Mail* (modern; W elements), *Bells of San Juan, The Footlight Ranger, Snowdrift* (N-W), *Hell's Hole, The Vagabond Trail* (modern), *The Circus Cowboy* (W character), *Western Luck, Against All Odds, The Desert Outlaw, The Man Who Played Square, The Arizona Romeo, The Trail Rider, Gold and the Girl, Hearts and Spurs, Timber Wolf, Durand of the Badlands, The Desert's Price, The Cowboy and the Countess, A Man Four-Square, The Gentle Cyclone* (comedy), *The Flying Horseman, 30 below Zero* (N-W), *Desert Valley, Whispering Sage, Hills of Peril, Good as Gold, Chain Lightning, Black Jack, Blood Will Tell, The Branded Sombrero, The Lone Rider, Shadow Ranch, Men without Law, The Dawn Trail, Desert Vengeance, The Avenger, The Texas Ranger, Fighting Sheriff, Branded, Border Law, Range Feud, One Man Law, Ridin' for Justice, South of the Rio Grande, Born to Trouble, McKenna of the Mounted* (Mounties), *Hello Trouble, The Deadline, White Eagle* (s), *The Forbidden Trail, The Sundown Rider, The California Trail, Unknown Valley, Gordon of Ghost City* (s), *Treason, The Fighting Code, The Thrill Hunter* (W filmmaking comedy), *The Fighting Ranger, The Man Trailer, The Red Rider* (s), *Rocky Rhodes, When a Man Sees Red, The Crimson Trail, Stone of Silver Creek, Border Brigands, The Roaring West* (s), *Outlawed Guns, The Ivory Handled Gun, The Throwback, Sunset of Power, The Phantom Rider* (s), *The Cowboy and the Kid* (also story), *Silver Spurs, Ride 'Em Cowboy* (TV: *Cowboy Round-Up*), *The Boss Rider of Gun Creek, Empty Saddles, Sand Flow, Left Handed Law, For the Service* (also dir.), *Smoke Tree Range, Boss of Lonely Valley, Sudden Bill Dorn, Headin' East* (W elements), *Black Aces* (also dir.), *Law for Tombstone* (also dir.), *Hollywood Round-Up* (W filmmaking), *The Overland Express, Stranger from Arizona, Law of the Texan, California Frontier, Wagons Westward, White Eagle* (s), *Riders of Death Valley* (s), *Arizona Bound, The Gunman from Bodie, Forbidden Trails, Below the Border, Ghost Town Law, Down Texas Way, Riders of the West, West of the Law, Dawn on the Great Divide* (42).

230 JORY, Victor (1902–). Actor, born in Alaska, with a long career in minor Ws, usually playing villains, who broke out into bigger pictures in the Sixties including *Cheyenne Autumn.* Many appearances in Hopalong Cassidy series; was Injun Joe in *The Adventures of Tom Sawyer* (38).

Smoky (horse) (33), *Rangle River* (TV: *Men with Whips*) (Australian W), *Dodge City, Man of Conquest, Susannah of the Mounties* (Shirley Temple), *Knights of the Range, The Light of Western*

Stars (TV: *Border Renegade*),
River's End (Mounties) (TV:
Double Identity), *Cherokee Strip,
Border Vigilantes, Bad Men of Mis-
souri, Wide Open Town, Riders of
the Timberline, Shut My Big Mouth*
(comedy), *Tombstone the Town Too
Tough to Die, Hoppy Serves a Writ,
Buckskin Frontier/The Iron Road,
Colt Comrades, Bar 20, The Kan-
san, The Leather Burners, South of
St. Louis, Canadian Pacific, Fighting
Man of the Plains, The Capture*
(modern Mexico), *The Cariboo
Trail, Cave of Outlaws, Flaming
Feather, Toughest Man in Arizona,
The Man from the Alamo, Black-
jack Ketchum Desperado, Last Stage-
coach West, Cheyenne Autumn, Ride
the Wind* (TV), *Mackenna's Gold*
(narration), *A Time for Dying* (as
Judge Roy Bean). *Flap/The Last
Warrior* (comedy) (70).

231 JURADO, Katy (1927–).
Mexican actress who worked in
Mexican pictures before bringing her
sultry, temperamental style to Holly-
wood pictures.

High Noon (52) *San Antone,
Arrowhead, Broken Lance, The Man
from Del Rio, Dragoon Wells Mas-
sacre, The Badlanders, One Eyed
Jacks, Smoky* (horse), *Stay Away
Joe* (modern), *Pat Garrett and
Billy the Kid* (73).

232 KANE, Joseph (1904–).
Prolific director from the mid-Thirties
making early Autrys, several Waynes
and a great many Roy Rogers, all
for Republic who promoted him to
be their leading house director en-
trusted with many of their biggest
films (on which he was also usually
the associate producer).

Tumbling Tumbleweeds (35),
*Melody Trail, The Sagebrush Trouba-
dour, The Lawless Nineties, King of
the Pecos, The Lonely Trail, Guns
and Guitars, Oh Susannah, Ride
Ranger Ride, Ghost Town Gold, The
Old Corral/Texas Serenade, Round-
Up Time in Texas, Git Along Little
Dogies/Serenade of the West, Gun-*

KATY JURADO in *Arrowhead*

*smoke Ranch, Come on Cowboys!,
Yodelin' Kid from Pine Ridge/Hero
of Pine Ridge, Boots and Saddles,
Public Cowboy No. 1, Heart of the
Rockies, Springtime in the Rockies,
Under Western Stars, The Old Barn
Dance, Gold Mine in the Sky, Man
from Music Mountain, Billy the Kid
Returns, Come on Rangers, Shine on
Harvest Moon, Rough Riders'
Roundup, Frontier Pony Express,
Southward Ho!, In Old Caliente,
Wall St. Cowboy, The Arizona Kid,
In Old Monterey, Saga of Death
Valley, Days of Jesse James, Young
Buffalo Bill, Carson City Kid, The
Ranger and the Lady, Colorado,
Young Bill Hickok, The Border
Legion* (TV: *West of the Badlands*),
*Robin Hood of the Pecos, In Old
Cheyenne, Nevada City, Sheriff of
Tombstone, Bad Man of Deadwood,
Jesse James at Bay, Red River Val-
ley, Man from Cheyenne, Sunset on
the Desert, Romance on the Range,
Sons of the Pioneers, Sunset Seren-
ade, Heart of the Golden West,
Ridin' down the Canyon, Idaho, King
of the Cowboys, Song of Texas,
Silver Spurs, Man from Music*

Mountain, Hands across the Border, The Cowboy and the Senorita, Yellow Rose of Texas, Song of Nevada, Flame of the Barbary Coast (W elements), *Dakota, In Old Sacramento, The Plainsman and the Lady, Wyoming, Old Los Angeles, The Gallant Legion, The Plunderers, The Last Bandit, Brimstone, Rock Island Trail/Transcontinent Express, The Savage Horde, California Passage, Oh! Susanna, Woman of the North Country, Ride the Man Down, San Antone, Jubilee Trail, Timberjack, Road to Denver, The Vanishing American, The Maverick Queen, Thunder over Arizona, Duel at Apache Wells, Spoilers of the Forest, The Last Stagecoach West, The Lawless Eighties, Gunfire at Indian Gap* (58).

233 KARLSON, Phil (1908–). Director of commendable Hollywood efficiency with a stark way of dramatising violence as seen in *Gunman's Walk* and in his numerous crime thrillers.

Black Gold (W elements) (47). *Adventures in Silverado/Above All Laws, Thunderhoof/Fury* (horse).

The Iroquois Trail/The Tomahawk Trail (Colonial period), *The Texas Rangers, They Rode West, Gunman's Walk, A Time for Killing/The Long Ride Home* (taking over from Roger Corman) (67).

234 KEEL, Howard (1917–). Hearty-voiced singer whose powerful figure has often been placed against a W backcloth; has turned increasingly to the *genre* in recent years for straight dramatic roles.

Annie Get Your Gun (musical) (50), *Callaway Went Thataway/The Star Said No* (modern comedy; as W film star and look-alike cowboy), *Ride Vaquero, Calamity Jane* (musical; as Wild Bill Hickok), *The Man from Button Willow* (cartoon; voice only), *Waco, Red Tomahawk, The War Wagon, Arizona Bushwhackers* (67).

235 KEITH, Brian (1921–). Son of late actor Robert Keith, and brought up in the East, he has become a performer of generally underappreciated skill, not least in his knack of looking completely at home in the saddle.

PHIL KARLSON directs Glenn Ford in *A Time for Killing*

Arrowhead (53), *The Violent Men/Rough Company, Hell Canyon Outlaws/The Tall Trouble, Run of the Arrow, Fort Dobbs, Sierra Baron, Villa!* (Mexico), *Ten Who Dared, The Deadly Companions, Savage Sam, The Raiders, The Tenderfoot* (TV), *The Hallelujah Trail* (comedy), *The Rare Breed, Nevada Smith, Something Big* (71).

236 KENNEDY, Arthur (1914–). Frequently Oscar-nominated actor whose name on a picture has always indicated a sensitive, thoughtful performance, usually in his Ws of a man with a fatal flaw that ensures his ultimate demise.

Bad Men of Missouri (as Jim Younger) (41), *They Died with Their Boots On, Cheyenne, The Walking Hills, Red Mountain, Bend of the River/Where the River Bends, Rancho Notorious, The Lusty Men* (modern rodeo), *The Man from Laramie, The Naked Dawn, The Rawhide Years, Cheyenne Autumn* (comedy episode; as Doc Holliday), *Murieta/Vendetta* (*Joaquin Murrieta*), *Nevada Smith, Day of the Evil Gun, A Minute to Pray a Second to Die/Dead or Alive* (*Escondido*) (68).

ARTHUR KENNEDY in
Nevada Smith

st. sc. *Comanche Station,* sc. *Yellowstone Kelly,* st. sc. dir. *The Canadians* (Mounties), st. sc. *Six Black Horses,* sc. dir. *Mail Order Bride/West of Montana,* sc. dir. *The Rounders* (modern), dir. *Return of the Seven,* co-st. *Return of the Gunfighter,* sc. dir. *Welcome to Hard Times/Killer on a Horse,* dir. *The War Wagon,*

GEORGE KENNEDY in
Cahill: United States Marshal

237 KENNEDY, Burt (1923–). Michigan born, this writer and director has been associated with Ws since his days in the late Forties as the scriptwriter of a radio comedy W programme; moved to TV and thence to writing some excellent film scripts for director Budd Boetticher; has since taken to directing himself, with variable results but a general diminishing of the promise shown by the pleasantly good-humoured *Mail Order Bride, The Rounders* and *Support Your Local Sheriff.* Probably too old-fashioned and too leisurely for today's tastes and techniques.

Actor (minor appearance) *The Man from the Alamo* (53), st. sc. *Seven Men from Now,* sc. *Gun the Man Down,* sc. *The Tall T,* co-sc. *Fort Dobbs,* st. sc. *Ride Lonesome,*

dir. *Support Your Local Sheriff* (comedy), sc. dir. *Young Billy Young,* dir. *The Good Guys and the Bad Guys,* dir. *Dirty Dingus Magee* (comedy), dir. *The Deserter,* dir. *Support Your Local Gunfighter,* dir. co-sc. (latter under pseudonym) *Hannie Caulder,* st. sc. dir. *The Train Robbers* (73).

238 KENNEDY, George (1925–). Heftily-built character actor, earlier cast in heavy roles, now more often in sympathetic parts.

Lonely Are the Brave (modern) (62), *Shenandoah* (Civil War), *The Sons of Katie Elder, The Ballad of Josie* (comedy), *Bandolero!, Guns of the Magnificent Seven, The Good Guys and the Bad Guys, Dirty Dingus Magee* (comedy). *Cahill: United States Marshal/Cahill* (73).

239 KING, Henry (1888?/92?/ 96?–). A revered name in film history, King has rarely directed Ws but one of them—*The Gunfighter*—fully matches up to the highest achivements of the *genre,* and early in his career (c.1912) he was an actor in Ince's Ws, then later directed several with William Russell

ALAN LADD in *One Foot in Hell*

as star, including some untraced shorts.

When a Man Rides Alone (18), *Where the West Begins* (modern W comedy), *Six Feet Four, The Winning of Barbara Worth, Ramona* (Indian love story), *Jesse James, The Gunfighter, The Bravados* (58).

240 KING, Louis (1898–1962). Director (brother of Henry) whose associations with the filmic West can be broken down into three phases: a series with child W star Buzz Barton in Twenties; several films with Buck Jones in the early sound period; and many later pictures built around horses (some with W setting included here). May well have been the Lewis King who directed Ws with William Fairbanks before films listed here.

The Boy Rider (27), *The Slingshot Kid, The Pinto Kid, The Little Buckaroo, Bantam Cowboy, Young Whirlwind, Terror, The Fightin' Redhead, Rough Ridin' Red, Orphan of the Sage, The Vagabond Cub, The Freckled Rascal, The Little Savage, Pals of the Prairie, The Lone Rider, Shadow Ranch, Men without Law, Desert Vengeance, Fighting Sheriff, Border Law, Robbers' Roost, Life in the Raw, Song of the Saddle, Smoky* (modern horse), *Sand* (modern horse), *Mrs. Mike* (Mounties), *Frenchie, The Lion and the Horse, Powder River, Massacre* (56).

241 LADD, Alan (1913–1964). Short, blond star of action films ably used by Paramount once he became a star there, not least as the soft-spoken, wistful gunfighter called Shane. An extra and bit player during the Thirties, he can reputedly be found in the Ws *Born to the West, The Light of Western Stars* and *In Old Missouri;* as a star, it was six years before he went West for the first time; in Fifties he formed his own company, Jaguar, made unambitious pictures; in Sixties made something of a comeback as Nevada Smith in *The Carpetbaggers* before his premature death.

Whispering Smith (49), *Branded, Red Mountain, The Iron Mistress* (largely non-W; as Jim Bowie), *Shane, Saskatchewan/O'Rourke of the Royal Mounted, Drum Beat, The Big Land/Stampeded, The Proud Rebel, The Badlanders, Guns of the Timberland, One Foot in Hell, The Carpetbaggers* (as a W cowboy star) (64).

242 LAKE, Stuart N. (1889–). Novelist whose "Wyatt Earp: Frontier Marshal," written from direct contact with the ageing lawman, has formed the basis of three films: *Frontier Marshal* (34 and 39) and Ford's *My Darling Clementine*.

Other work: st. *Wells Fargo* (39), st. *The Westerner*, story basis *Winchester '73*, story basis *Powder River* (53).

243 LAMBERT, Jack. Character actor of menacing appearance, equally at home being nasty in gangsters and Ws, a far cry from his earlier ambitions of being an English professor.

Abilene Town (46), *The Harvey Girls* (musical), *The Plainsman and the Lady, The Vigilantes Return, River Lady* (W elements), *Belle Starr's Daughter, Big Jack, Brimstone, Dakota Lil, North of the Great Divide, The Secret of Convict Lake* (W elements), *Bend of the River/Where the River Bends, Montana Belle, Vera Cruz* (Mexico), *Run for Cover, At Gunpoint/Gunpoint!, Backlash, Canyon River, Alias Jesse James* (comedy), *Day of the Outlaw, How the West Was Won* (ep. "Outlaws"), *Four for Texas* (comedy) (63).

244 L'AMOUR, Louis. An author whose work has been greedily seized for big screen treatment.

Story basis ("Gift of Cochise") *Hondo* (54), story basis *Four Guns to the Border*, story basis *The Treasure of Ruby Hills*, story basis *Stranger on Horseback*, novel basis ("Kilkenny") *Blackjack Ketchum*

JACK LAMBERT (left) with Burl Ives in *Day of the Outlaw*

Desperado, novel basis *The Burning Hills*, novel basis *Utah Blaine*, story basis ("Plunder") *The Tall Stranger*, story basis ("Last Stand at Papago Wells") *Apache Territory*, novel basis *Guns of the Timberland*, novel basis ("Heller with a Gun") *Heller in Pink Tights*, novel basis *Taggart*, story basis *Kid Rodelo*, story basis ("The Gift of Cochise") *Hondo and the Apaches*, novel basis *Shalako*, novel basis *Catlow*, novel basis *A Man Called Noon* (73).

245 LANCASTER, Burt (1913–). Cinema's most athletic star has often brought a sense of zest and vitality or quiet determination to the W.

Vengeance Valley (51), *Jim Thorpe—All American/Man of Bronze* (non-W; as famous modern Indian), *Apache, Vera Cruz* (Mexico), *The Kentuckian* (pioneering) (also dir.), *Gunfight at the O.K. Corral* (as Wyatt Earp), *The Unforgiven, The Hallelujah Trail* (comedy), *The Professionals* (W ele-

BURT LANCASTER in *The Kentuckian*

ments), *The Scalphunters, Lawman, Valdez Is Coming, Ulzana's Raid* (72).

246 LANG, Charles, Jr. (1902–). Would be on anyone's list of outstanding cameramen; contracted to Paramount 1929–52 where he did some stunning colour cinematography on Ws after having belatedly taken up the *genre* in earnest, then continued to enhance many further W subjects as a freelance.

The Light of Western Stars (30), *Buck Benny Rides Again* (comedy), **Copper Canyon, *Fancy Pants* (W elements) (comedy) **Branded, *Red Mountain, *†The Man from Laramie, *Gunfight at the O.K. Corral, *The Last Train from Gun Hill, *†The Magnificent Seven, *One Eyed Jacks, *How the West Was Won* (ep. "Plains") (Cinerama), **†The Stalking Moon* (69).

247 LANG, Fritz (1890–). Austrian-born director whose Ws may

not be the most remarkable works of his long career but are stamped with his characteristic sense of discipline, tautness, and pictorial effectiveness, not least in their strong use of colour: *The Return of Frank James* (40), *Western Union, Rancho Notorious* (52).

LANGTRY, Lily—*see* Judge Roy BEAN.

248 LAWTON, Charles, Jr. (– 1965). A cameraman who provided some superb visuals for the Ws of Delmer Daves and Budd Boetticher. His early W association was with the films of producer Harry Joe Brown and he did much to establish the high pictorial standards one came to associate with Columbia Studios' colour Ws.

**The Untamed Breed* (48), *The Walking Hills, The Doolins of Oklahoma/The Great Manhunt, *The Nevadan/The Man from Nevada, *Stage to Tucson/Lost Stage Valley, *Santa Fe, *Man in the Saddle/The Outcast, *Hangman's Knot, Last of the Comanches/The Sabre and the Arrow, *Three Hours to Kill, *They Rode West, *†Jubal, *The Tall T, 3:10 to Yuma, *Cowboy, *†Gunman's Walk, *†Ride Lonesome, *†Comanche Station, *Two Rode Together* (61).

249 LeMAY, Alan (1899–1964). Able W novelist whose work has provided the basis of some major Ws; he also turned to screenwriting himself and even formed a shortlived company with George Templeton that made two pleasing all-location pictures.

Part st. part sc. *North West Mounted Police* (40), novel basis ("The Useless Cowboy") *Along Came Jones*, co-st. co-sc. *San Antonio*, co-sc. *Cheyenne* (TV: *Wyoming Kid*), sc. *Gunfighters/The Assassin*, st. sc. *The Walking Hills* (modern), st. sc. dir. co-prod. *High Lonesome*, st. co-sc. *Rocky Mountain*, st. sc. co-prod. *The Sundowners*

/Thunder in the Dust, sc. *The Vanishing American*, novel basis *The Searchers*, novel basis *The Unforgiven* (60).

250 LEONARD, Elmore. Novelist whose work is finding increasing favour with Hollywood.

Story basis *3:10 to Yuma* (57), story basis ("The Captives") *The Tall T*, novel basis *Hombre*, novel basis *Valdez Is Coming*, st. sc. *Joe Kidd* (72).

251 LEONE, Sergio (1926–). Italian director whose vulgar and violent *Dollars* films were a breakthrough for European Ws in the English-speaking market; showed some signs of respect for the *genre* when he filmed *Once upon a Time in the West* but dissipated the effect by excessive length and feeble plot thread. First worked under pseudonyms of Bob Robertson and Bob Anderson.

A Fistful of Dollars (*Per un pugno di dollari*) (also co-sc.) (64), *For a Few Dollars More* (*Per qualche dollaro in piu*) (also co-st. co-sc.), *The Good the Bad and the Ugly* (*Il buono, il brutto, il cattivo*) (also part st. co-sc.), *Once upon a Time in the West* (*C'era una volta il West*) (part st. co-sc.), *Duck You Sucker!/ A Fistful of Dynamite* (Mexico), *My Name Is Nobody* (*Il mio nome è nessuno*) (prod. only) (73).

252 LESLIE, Joan (1925–). Generally graceful heroine of many Ws who did, however, have to strap on a six-shooter and prepare to shoot it out on main street with Audrey Totter's Kate Quantrill in *Woman They Almost Lynched*.

Northwest Stampede (48), *Man in the Saddle/The Outcast, Hellgate, Toughest Man in Arizona, Woman They Almost Lynched, Jubilee Trail* (54).

253 LEWIS, Joseph H. (1900–). Former editor—he worked on the Tom Mix serial *The Miracle Rider* (35) and *King of the Pecos* (36)

—who turned director, brought thought and style to numerous B assignments and won better pictures that turned out generally a cut above their rivals through his handling. More recent work for U.S. TV.

Courage of the West (37), *Singing Outlaw, Border Wolves, The Last Stand, Two Fisted Rangers/ Forestalled, Blazing Six Shooters, Texas Stagecoach, The Man from Tumbleweeds/False Evidence, The Return of Wild Bill, Arizona Cyclone, The Silver Bullet, The Boss of Hangtown Mesa, A Lawless Street, 7th Cavalry, The Halliday Brand, Terror in a Texas Town* (58).

254 LLOYD, Frank (1888–1960). Scotsman who went to U.S. as a young man, took up film acting, turned director in 1917. Most noted now for *Mutiny on the Bounty*. Though he made many historical films, there are few Ws. Work tends toward heaviness.

True Blue (18), *Riders of the Purple Sage* (also co-sc.), *Rainbow Trail* (also adap.), *Winds of Chance* (N-W), *The Splendid Road, The Lash/Adios* (W elements), *Wells Fargo* (also prod.), *The Lady from Cheyenne, The Spoilers* (N-W; **prod.** only), *The Last Command* (also assoc. prod.) (55).

255 LOCKHART, Gene (1891–1957). Fat, Canadian-born character actor who specialised in unctuous figures of deceit and treachery.

Geronimo! (39), *Billy the Kid, They Died with Their Boots On, The Lady from Texas, Apache War Smoke, The Vanishing American* (55).

256 LONDON, Julie (1926–). Better known as a singer; as an actress, seemed to specialise in Ws where she made a more forceful impression than most heroines.

Return of the Frontiersman (50), *Drango, Saddle the Wind, Man of the West, The Wonderful Country* (59).

JULIE LONDON with Gary Cooper in *Man of the West*

LONGBAUGH, Harry—*see* The SUNDANCE KID.

257 LYLES, A. C. A former messenger boy at Paramount, he rose to become a producer and delighted W fans with a series of modest films for Paramount in which he assembled a formidable array of ageing W faces to compensate for dreary plots, stock footage, and lacklustre direction. Wrote some of the stories under pseudonym of Andrew Craddock, all in collaboration with Steve Fisher.

Law of the Lawless, Stage to Thunder Rock, Young Fury, Black Spurs, Town Tamer, Apache Uprising, Johnny Reno (also co-st.), *Waco, Red Tomahawk* (also co-st.), *Hostile Guns, Fort Utah* (also co-st.), *Arizona Bushwhackers* (also co-st.), *Buckskin* (68).

258 LYONS, Cliff. Actor in late Twenties, working mostly with director J. P. McGowan and very often appearing in Bob Custer Ws, he also made one or two appearances in films with Yakima Canutt—and, like Canutt, switched to becoming a stuntman and 2nd Unit director, working very often with John Ford.

Where not otherwise indicated, Lyons acted in the following films, although his appearances in later titles probably indicate that he was also working as a stuntman. He died in 1974.

West of the Law (26), *Across the Plains, Manhattan Cowboy, The Old Code* (N-W), *Law of the Mounted* (N-W), *Headin' Westward, The Arizona Kid, Captain Cowboy, The Last Roundup, The Fighting Terror, The Saddle King, The Cowboy and the Outlaw, Code of the West, West of the Rockies, O'Malley Rides Alone* (N-W), *Breezy Bill, Fire-Brand Jordan, Call of the Desert, The Oklahoma Sheriff, The Canyon of Missing Men, Canyon Hawks, Tumbling Tumbleweeds, The Rustlers of Red Dog* (s) (also stunt double), *The Lawless Nineties, Dodge City* (stuntman), *The Dark Command* (co-2nd Unit dir.), *Wagon Tracks West, Dakota, Fort Apache* (2nd Unit dir.), *Three Godfathers, The Fighting Kentuckian* (Colonial period), *She Wore a Yellow Ribbon* (technical adviser and actor), *Wagonmaster* (2nd Unit dir. and actor), *Rio Grande* (2nd Unit dir. and stuntman), *Bend of the River/ Where the River Bends, Hondo* (2nd Unit dir.), *The Searchers, Seven*

Men from Now, The Young Land, Sergeant Rutledge, The Alamo (2nd Unit dir.), *Two Rode Together, The Comancheros* (2nd Unit dir.), *McLintock!* (comedy) (consultant), *Major Dundee* (2nd Unit dir.), *The War Wagon* (2nd Unit dir.), *Big Jake* (2nd Unit dir.), *The Train Robbers* (stunt co-ordinator) (73).

259 MacDONALD, Ian (1914–). Most familiar to general audiences as the Frank Miller who menaced Gary Cooper's Will Kane in *High Noon*, he has been a W stalwart for many years, rarely escaping typecasting as a villain or Indian. Early life as the son of a Methodist minister may have developed an appreciation of evil! Some screenwriting in association with Richard Bartlett.

Secrets of the Wasteland (41), *They Died with Their Boots On, North of the Rockies/False Clues, Pursued, Ramrod, The Man from Colorado, Montana, Comanche Territory, Colt .45* (TV: *Thunder Cloud*), *Thunder in God's Country, The Texas Rangers, New Mexico, Flaming Feather, High Noon, Toughest Man in Arizona, The Savage, Hiawatha* (early Indian), *Silver Whip, A Perilous Journey, Taza Son of Cochise* (as Geronimo), *Apache, Johnny Guitar, Timberjack* (timber), *The Silver Star* (co-st. co-sc. prod. only) *The Lonesome Trail* (also co-sc.), *Stagecoach to Fury, Two-Gun Lady* (also assoc. prod.), *Duel at Apache Wells, Money Women and Guns, Warlock* (59).

260 MacDONALD, Joe (1906–1968). Brilliant cinematographer, principally associated with 20th Century-Fox, and one of the great masters of bold shading in monochrome.

My Darling Clementine (46), *Yellow Sky, Viva Zapata!* (Mexico), **†Broken Lance, *†The True Story of Jesse James/The James Brothers, *†Warlock, †The Fiend Who Walked the West, *†Rio Conchos, *Invita-* tion to a Gunfighter, **†The Reward* (modern), **†Alvarez Kelly, *MacKenna's Gold* (70mm) (69).

261 MacLANE, Barton (1902–1969). Burly supporting actor, rarely up to much good in his screen appearances, and more readily identified with the gangster film although he has made a vast number of Ws.

Man of the Forest (33), *To the Last Man, The Thundering Herd* (TV: *Buffalo Stampede*), *The Lone Cowboy, The Last Round-Up, God's Country and the Woman* (W elements), *Gold Is Where You Find It* (W elements), *Stand Up and Fight, Melody Ranch* (modern), *Western Union, Song of Texas, Gentle Annie, Santa Fe Uprising, Cheyenne, Relentless, Silver River, The Dude Goes West* (comedy), *The Bandit Queen, Best of the Badmen, Drums in the Deep South, Bugles in the Afternoon, The Half Breed, Kansas Pacific, Cow Country, Jack Slade/ Slade, Rails into Laramie, Jubilee*

BARTON MacLANE
in *Law of the Lawless*

Trail, *The Treasure of Ruby Hills,
The Silver Star, Last of the Des-
perados, Backlash, Three Violent
People, Hell's Crossroads, The
Storm Rider, Sierra Stranger, Naked
in the Sun, Frontier Gun, The
Rounders* (modern), *Law of the
Lawless, Town Tamer, Arizona
Bushwhackers, Buckskin* (68).

FRED MacMURRAY
in *The Moonlighter*

262 MacMURRAY, Fred (1908–
). Actor with an easy-going
personality more readily attuned to
comedy; his later Ws represent a low
point in his career before starring
roles for Walt Disney revived his
career fortunes.

The Texas Rangers (36), *Rangers
of Fortune, Smoky* (modern horse),
Never a Dull Moment (modern W
comedy), *The Moonlighter, The Far
Horizons* (early exploration), *At
Gunpoint/Gunpoint!, Gun for a
Coward, Day of the Bad Man,
Quantez, Good Day for a Hanging,
Face of a Fugitive, The Oregon Trail*
(59).

263 MACREADY, George (1909–
1973). Suave, cultivated villain,

often admirably ruthless and treach-
erous! Arrived in Ws six years after
starting his film career.

Coroner Creek (48), *The Doolins
of Oklahoma/The Great Manhunt,
The Nevadan/The Man from Nevada,
The Stranger Wore a Gun, Vera Cruz*
(Mexico), *Thunder over Arizona,
Gunfire at Indian Gap, Plunderers
of Painted Flats* (59).

264 MADDOW, Ben. Able screen-
writer who was blacklisted during the
McCarthy witchhunt era and re-
putedly continued working on scripts
credited to Philip Yordan, including
Ws *Johnny Guitar* and *The Last
Frontier*; regained direct credits in
Sixties.

Official W credits: Co-sc. *The
Man from Colorado* (48), sc. *The
Unforgiven*, co-sc. *The Way West*
(67).

265 MADISON, Guy (1922–).
Lightweight but likably amiable
leading man; star of TV series *Wild
Bill Hickok* in early Fifties with many
eps. released to British cinemas in
pairs: *Arrow in the Dust, Behind
Southern Lines, The Ghost of Cross-
bone Canyon, The Yellow Haired
Kid, Border City Rustlers, Secret of
Outlaw Flats, Six Gun Decision, Two
Gun Marshal;* recently in Europe.

Massacre River (49), *Drums in
the Deep South* (Civil War), *The
Charge at Feather River, The Com-
mand, The Last Frontier* (TV: *Sav-
age Wilderness*), *The Beast of Hol-
low Mountain* (horror W), *Reprisal!,
Bullwhip, The Hard Man, Apaches
Last Battle* (*Old Shatterhand*), *Duel
at Rio Bravo* (*Jennie Lees ha una
nuova pistola*) (as Wyatt Earp),
Five Giants from Texas (*I cinque
della vendetta*), *Son of Django* (*Il
figlio di Django*), *The Bang Bang
Kid, Payment in Blood* (68).

266 MALDEN, Karl (1914–).
Powerful player originally from the
American theatre; occasional unre-
strained performances are more than
compensated for by the vigour and

KARL MALDEN in *Nevada Smith*

thoughtfulness he has brought to most of his work.

The Gunfighter (50), *The Hanging Tree* (also dir. few scenes uncredited), *One Eyed Jacks, How the West Was Won* (ep. "Plains"), *Cheyenne Autumn, Nevada Smith, The Adventures of Bullwhip Griffin* (comedy), *Blue, Wild Rovers* (72).

267 MALONE, Dorothy (1925–
). Strong actress whose W work conveys the stamina necessary in pioneering women.

South of St. Louis (49), *Colorado Territory, The Nevadan/The Man from Nevada, Saddle Legion, The Bushwhackers/The Rebel, Law and Order, Jack Slade/Slade, The Lone Gun, Five Guns West, Tall Man Riding, At Gunpoint/Gunpoint!, Pillars of the Sky/The Tomahawk and the Cross, Tension at Table Rock, Quantez, Warlock, The Last Sunset* (61).

268 MANN, Anthony (1907–67). One of the finest directorial talents ever to work in the W, bringing a sharp intelligence to bear on his films, using a maximum of location work, and creating Ws that remain taut, realistic in detail, and purposeful in development. Particular associations with star James Stewart and writer Borden Chase. All his Ws except the last are notable achievements.

Devil's Doorway (50), *Winchester '73, The Furies, Bend of the River/Where the River Bends, The Naked Spur, The Far Country, The Man from Laramie, The Last Frontier* (TV: *Savage Wilderness*), *The Tin Star, Man of the West, Cimarron* (60).

269 MARIN, Edwin L. (1901–51). Director who turned to Ws late in his career and turned out numerous pleasing but unremarkable examples, mostly starring Randolph Scott.

Tall in the Saddle (44), *Abilene Town, Canadian Pacific, The Younger Brothers, Fighting Man of the Plains, Colt .45* (TV: *Thunder Cloud*), *The Cariboo Trail, Sugarfoot* (TV: *Swirl of Glory*), *Raton Pass/Canyon Pass, Fort Worth* (51).

**DOROTHY MALONE and
George Montgomery in *The Lone Gun***

270 MARSHALL, George (1891–
). Veteran director at home in
most of the *genres* but perhaps seen
at his best in the W where one thinks
immediately of his association with
Tom Mix, his work with Dietrich
on *Destry Rides Again* and with
Glenn Ford in the equally amusing
and pacifistic *The Sheepman* (com-
edy having always been one of
Marshall's strong suits).

Love's Lariat (16) (co-st. co-sc.
co-prod. only), *The Man from
Montana* (also co-sc.), *Border
Wolves* (also part sc.), *Prairie
Trails, Hands Off, A Ridin' Romeo*
(comedy), *After Your Own Heart,
Haunted Valley* (modern) (s), *Don
Quickshot of the Rio Grande, Where
Is This West?* (part comedy), *Men
in the Raw, The Soilers* (2r comedy)
(also sc.), *Olsen's Big Moment* (sc.
only), *Wild Gold, Ten Dollar Raise*
(comedy), *Destry Rides Again*
(part comedy), *When the Daltons
Rode, Texas, Valley of the Sun,
Fancy Pants* (comedy—W elements),
Never a Dull Moment (modern com-
edy), *The Savage, Red Garters* (musi-
cal), *Destry, The Second Greatest Sex*
(musical), *Pillars of the Sky/The
Tomahawk and the Cross, The Guns
of Fort Petticoat, The Sheepman*
(comedy), *How the West Was Won*
(ep. "Railroad"), *Advance to the
Rear/Company of Cowards?* (com-
edy) (64).

271 MARTIN, Dean (1917–).
Formerly the singing and straightman
half of the Martin and Lewis comedy
team, he survived the split-up in
fine style, not least through his per-
formance as the drunk in *Rio Bravo*.

Pardners (comedy) (56), *Rio
Bravo, Sergeants 3* (comedy), *Four
for Texas* (comedy), *The Sons of
Katie Elder, Texas across the River*
(comedy), *Rough Night in Jericho,
Something Big, Showdown* (73).

272 MARTIN, Strother (1920–
). Barely noticed in bit parts in
the Fifties, Martin has come into his
own since then as one of the most

STROTHER MARTIN in *True Grit*

entertaining of character actors,
usually with a sly or devious edge.

Drum Beat (54), *The Black Whip,
Copper Sky, Black Patch, Cowboy,
The Wild and the Innocent, The
Horse Soldiers* (Civil War), *The
Deadly Companions, The Man Who
Shot Liberty Valance, Showdown,
McLintock!* (comedy), *Invitation to
a Gunfighter, The Sons of Katie
Elder, Shenandoah* (Civil War),
*Nevada Smith, An Eye for an Eye,
The Wild Bunch, True Grit, Butch
Cassidy and the Sundance Kid, The
Ballad of Cable Hogue* (comedy),
Hannie Caulder, Pocket Money
(modern) (72).

273 MARVIN, Lee (1924–).
Actor whose Academy Award win-
ning performances as the woebegone
gunfighter Kid Shelleen and his tin-
nosed killer of a brother in *Cat Bal-
lou* shot him to stardom after fifteen
years of fine supporting work, mostly
playing brutal killers in crime dramas
and Ws, including that whip-wielding
villain Liberty Valance.

Duel at Silver Creek (52), *Hang-
man's Knot, Seminole, The Stranger*

Wore a Gun, Gun Fury, The Raid (Civil War), *Seven Men from Now, Pillars of the Sky/The Tomahawk and the Cross, The Comancheros, The Man Who Shot Liberty Valance, Cat Ballou* (comedy), *The Professionals* (W elements), *Paint Your Wagon* (musical), *Monte Walsh, Pocket Money* (modern), *The Spikes Gang* (74).

274 MASSEY, Raymond (1896–). Actor, born in Toronto, Canada, whose W career is most noteworthy for his two portrayals of the fanatical abolitionist John Brown in *Santa Fe Trail* and *Seven Angry Men.*

Santa Fe Trail (40), *Barricade, Dallas, Sugarfoot* (TV: *Swirl of Glory*), *Carson City, Seven Angry Men, How the West Was Won* (as Abraham Lincoln), *Mackenna's Gold* (68).

275 MASTERSON, Bat [William Barclay] (–1921). Born in Illinois, raised in Kansas, he had become a veteran plainsman and hunter before leaving his teens. After scouting for the army, he took up the post of assistant marshal under Wyatt Earp in Dodge City, rose to become sheriff through his fairminded and popular ways, and stayed a lawman for many years, eventually going East and trying journalism. One of the few genuinely heroic real-life Westerners. Played by Gene Barry in TV series with cane and derby.

Jack Gardner *Wild Bill Hickok* (23), Albert Dekker *Woman of the Town,* Randolph Scott *Trail Street,* Steve Darrell *Winchester '73,* Frank Ferguson *Santa Fe,* George Montgomery *Masterson of Kansas,* Kenneth Tobey *Gunfight at the O.K. Corral,* Gregory Walcott *Badman's Country,* Joel McCrea *The Gunfight at Dodge City,* Ed. T. McDonnell *The Outlaws Is Coming* (comedy) (65).

276 MATE, Rudolph (1898– 1964). Born in Poland, he achieved renown as a cameraman in Europe, then Hollywood, before turning to direction with less distinctive results; nevertheless his first Ws show intelligence, style and impact, especially *The Violent Men,* a triumph over the restrictive shape of CinemaScope.

Branded (51), *The Siege at Red River, The Violent Men/Rough Company, The Far Horizons* (early exploration), *The Rawhide Years, Three Violent People* (57).

277 MATURE, Victor (1916–). Husky leading man—a disappointing Doc Holliday in *My Darling Clementine* but a very effective primitive trapper turned army scout in Mann's *The Last Frontier.*

My Darling Clementine (46), *Fury at Furnace Creek, Chief Crazy Horse/Valley of Fury* (as Crazy Horse), *The Last Frontier* (TV: *Savage Wilderness*), *Escort West* (59).

278 MAYES, Wendell (1918–). Pleasingly proficient screenwriter

RAYMOND MASSEY
in *How the West Was Won*

VICTOR MATURE in *Escort West*

whose most ambitious W script, *The Day Custer Fell*, was never filmed due to Hollywood's fear of high budget pictures in the Sixties.

Co-sc. *From Hell to Texas/ Manhunt* (58), co-sc. *The Hanging Tree*, uncredited add. scenes *North to Alaska* (N-W comedy), adap. *The Stalking Moon*, sc. *The Revengers* (72).

KEN MAYNARD with Tarzan

279 MAYNARD, Ken (1895–1973). A tall, Indiana-born figure whose own clearly seen stunting abilities helped make him one of the top W stars of the Twenties, he declined to series work in the Thirties and eventually to combining forces with Hoot Gibson (and later Bob Steele) as "The Trail Blazers"; recently made an isolated comeback appearance in non-W *Bigfoot*. It was his riding and roping skills in Wild West shows that first attracted Hollywood's attention; and it was to the world of rodeos and circuses that he returned after quitting the screen in 1944. Horse: Tarzan.

The Man Who Won (bit) (23), *$50,000 Reward, Fighting Courage, The Demon Rider, North Star* (N-W), *The Haunted Range, The Grey Vulture, The Range Fighter* (serial version of earlier features), *Senor Daredevil, The Unknown Cavalier, The Overland Stage, Somewhere in Sonora, The Land beyond the Law, The Devil's Saddle, The Red Raiders, Gun Gospel, The Wagon Show, The Canyon of Adventure, The Upland Rider, The Code of the Scarlet* (Mounties), *The Glorious Trail, The Phantom City, Cheyenne, The Lawless Legion, The California Mail, The Royal Rider* (W characters—Wild West Show), *The Wagon Master, Senor Americano, Parade of the West, Lucky Larkin, The Fighting Legion, Mountain Justice, Song of the Caballero, Sons of the Saddle, Fighting Thru* or *California in 1878, The Two Gun Man, Alias the Bad Man, Arizona Terror, Range Law, Branded Men, The Pocatello Kid, Sunset Trail, Texas Gunfighter, Whistlin' Dan, Hell-Fire Austin, Dynamite Ranch, Come on Tarzan, Between Fighting Men, Fargo Express, Tombstone Canyon, Drum Taps, Phantom Thunderbolt, The Lone Avenger, King of the Arena* (W elements), *The Fiddlin' Buckaroo* (also dir.), *Trail Drive, The Strawberry Roan, Gun Justice, Wheels of Destiny, Honor of the Range, Smok-*

ing Guns (also st.), *In Old Santa Fe, Mystery Mountain* (s), *Western Frontier* (also st.), *Heir to Trouble* (also st.), *Western Courage, Lawless Riders, The Cattle Thief, Heroes of the Range, Avenging Waters, The Fugitive Sheriff, Boots of Destiny, Trailin' Trouble, The Whirlwind Horseman, Six Shootin' Sheriff, Flaming Lead, Death Rides the Range, The Phantom Rancher, Lightning Strikes West, Wild Horse Stampede, The Law Rides Again, Blazing Guns, Death Valley Rangers, Westward Bound, Arizona Whirlwinds, Harmony Trail* (later *White Stallion*) (44).

280 MAYO, Virginia (1920–). A glamorous blonde W belle.

Colorado Territory (49), *Along the Great Divide, Devil's Canyon, Great Day in the Morning, The Proud Ones, The Big Land/Stampeded, The Tall Stranger, Fort Dobbs, Westbound, Young Fury, Fort Utah* (67).

281 McCOY, Horace (1897–1955). Writer of some notable novels including the celebrated "They Shoot Horses Don't They?," with a strong feeling for the stark circumstances of the desperate and down-and-out— best exemplified in his largely routine W work by *The Lusty Men* dealing with life on a rodeo circuit.

Co-st. co-sc. *The Texas Rangers Ride Again* (40), part sc. *Texas*, sc. *Valley of the Sun*, sc. *The Fabulous Texan*, co-sc. *Bronco Buster* (modern rodeo), co-sc. *The Lusty Men* (modern rodeo), co-sc. *Montana Belle*, sc. *Rage at Dawn*, co-sc. *Road to Denver*, sc. *Texas Lady* (55).

282 McCOY, Colonel Tim (1891–). One of the screen's great Westerners, he was born in Michigan but ran off to work on Wyoming ranches in 1907 after seeing a Wild West Show. He studied the Plains Indians and organised their participation in *The Covered Wagon*, also performing trick riding. He turned to acting with a small role in *The Thundering Herd*, then worked (uncredited) as technical director on *The Vanishing American* before becoming a big W star in a series of lavishly mounted and exciting M-G-M films. With the arrival of sound, he was dropped by a cautious M-G-M, turned to serials and then a long line of B films (including eight non-Ws in 1933–4). With his understated style and calm dignity, he remained an impressive figure even as he worked on Poverty Row in the mid to late Thirties. Last series work was with Buck Jones and Raymond Hatton as the Rough Riders; after wartime service, when he reached the highest rank of any film star, he worked on TV W documentaries and has toured for many years with a show, performing with whip and pistol. Horse was Pal.

The Covered Wagon (adviser, trick rider), *The Thundering Herd, The Vanishing American/The Vanishing Race* (adviser only), *War Paint, Winners of the Wilderness* (Colonial period), *California, The Frontiersman*

TIM McCOY

(Colonial period), *Spoilers of the West, The Law of the Range, Wyoming, Riders of the Dark, Beyond the Sierras, The Bushranger* (Australian W), *Morgan's Last Raid, The Overland Telegraph, Sioux Blood, The Desert Rider, A Night on the Range* (short), *The Indians Are Coming* (s), *The One Way Trail, Shotgun Pass, The Fighting Marshal, The Fighting Fool, Texas Cyclone, Daring Danger, The Riding Tornado, Two Fisted Law, Cornered, The Western Code, Fighting for Justice, The End of the Trail, Man of Action, Silent Men, The Whirlwind, Rusty Rides Alone, The Prescott Kid, The Westerner, Square Shooter, Law beyond the Range, The Revenge Rider, Fighting Shadows* (Mounties), *Justice of the Range, Riding Wild, The Outlaw Deputy, The Man from Guntown, Bulldog Courage, Roarin' Guns, Border Caballero, Lightnin' Bill Carson, Aces and Eights, The Lion's Den/Single Shot Barton* (modern), *Ghost Patrol* (modern), *The Traitor, West of Rainbow's End, Code of the Rangers, Two-Gun Justice, Phantom Ranger, Lightning*

JOEL McCREA

Carson Rides Again, Six-Gun Trail, Code of the Cactus, Texas Wildcats, Outlaw's Paradise, Trigger Fingers, Straight Shooter, The Fighting Renegade, Texas Renegades, Frontier Crusader, Gun Code, Arizona Gang Busters, Riders of Black Mountain, Outlaws of the Rio Grande, Texas Marshal, Arizona Bound, The Gunman from Bodie, Forbidden Trails, Below the Border, Ghost Town Law, Down Texas Way, Riders of the West, West of the Law, Around the World in 80 Days (non-W; as U.S. cavalry officer), *Run of the Arrow* (bit), *Requiem for a Gunfighter* (bit) (65).

283 McCREA, Joel (1905–). A major W star whose mild voice and dignified manner have best suited him for amiable, peace-loving figures, slow to fight but stubborn when aroused; impossible to imagine him villainous such is the sense of integrity he conveys. Born in Los Angeles, he worked on California ranches during his vacations and at fourteen started appearing in films as an extra—most of them Ws and untraced. Progressed to walk-on roles at M-G-M, became star *c*1930, and was more readily associated with comedy and drama than the W until the mid-Forties when, like Randolph Scott, he turned almost exclusively to the *genre* (in fact, his only subsequent venture outside it was the British made *Rough Shoot*); had the good fortune to be tempted out of retirement to make one of the best Ws of all time, *Ride the High Country,* teamed for the first time with Scott. Was announced for a guest appearance in film called *Born Wild* to be made in 1969 on his ranch at Camarillo, California, with his son Jody as star.

Wells Fargo (37), *Union Pacific, The Great Man's Lady* (part W), *Buffalo Bill* (as Buffalo Bill), *The Virginian, Ramrod, Four Faces West/They Passed This Way, South of St. Louis, Colorado Territory, Stars In My Crown* (W opening),

The Outriders, Saddle Tramp, Frenchie, Hollywood Story (non-W; guest appearance as himself, W star), *Cattle Drive, The San Francisco Story* (W elements), *The Lone Hand, Border River, Black Horse Canyon, Stranger on Horseback, Wichita* (as Wyatt Earp), *The First Texan* (as Sam Houston), *The Oklahoman, Trooper Hook, Gunsight Ridge, The Tall Stranger, Cattle Empire, Fort Massacre, The Gunfight at Dodge City* (as Bat Masterson), *Ride the High Country/Guns in the Afternoon, The Great American Cowboy* (narrated only) (74).

284 McINTIRE, John (1907–). First-rate character actor who brings an air of strength and authenticity to his parts which are usually those of educated men, whether doctors, judges or sophisticated villains.

Black Bart/Black Bart Highwayman (48), *River Lady* (W elements), *Red Canyon, Ambush, Winchester '73, Saddle Tramp, Westward the Women, Horizons West, The Lawless Breed, The President's Lady* (W scenes), *War Arrow, Apache, Four Guns to the Border, The Yellow Mountain, The Far Country, Stranger on Horseback, The Kentuckian* (Colonial period), *The Scarlet Coat* (Civil War), *The Spoilers* (N-W), *Backlash, The Tin Star, The Light in the Forest* (Colonial period), *Two Rode Together, The Gunfight at Dodge City, Seven Ways from Sundown, Flaming Star, Rough Night in Jericho, Powderkeg* (TV) (72).

285 McLAGLEN, Andrew V. (1920–). London-born son of a famous father (next entry), he took up a career as an assistant director then became the actual director of low-budget films before becoming a favourite director for James Stewart and John Wayne. After the acclaim that greeted his *Shenandoah*, he has largely disappointed those who hoped to see him emerge as a revitalising force in the W field.

JOHN McINTIRE (left)
with Burt Lancaster in *Apache*

Seven Men from Now (co-prod. only) (56), *Gun the Man Down* (TV: *Arizona Mission*), *McLintock!* (comedy), *Shenandoah* (Civil War), *The Rare Breed, The Way West, The Ballad of Josie* (comedy), *Bandolero!, The Undefeated, Chisum, Something Big, One More Train to Rob, Cahill: United States Marshal /Cahill* (73).

286 McLAGLEN, Victor (1886– 1959). Much-loved character actor, particularly associated with John

ANDREW V. McLAGLEN
directing *Chisum*

STEVE McQUEEN in *Junior Bonner*

Ford. In the W field, he provided boisterous comedy relief as the sergeant-major in Ford's Cavalry pictures, itching for whisky and a good scrap. Born in Tunbridge Wells, England, he spent part of his early life prospecting for gold in California. Entered films 1922.

The Beloved Brute (24), *The Hunted Woman* (N-W), *Winds of Chance* (N-W), *Rough and Ready, The Gay Caballero, Let Freedom Ring, The Michigan Kid, Fort Apache, She Wore a Yellow Ribbon, Rio Grande, Many Rivers to Cross* (Colonial period comedy) (55).

287 McNALLY, Stephen (1916?–). Excellent player—an occasional hero but more often on the other side of the fence. Curiously neglected in Sixties.

The Harvey Girls (musical—as Horace McNally) (46), *Winchester '73, Wyoming Mail, Apache Drums, Duel at Silver Creek, Devil's Canyon, The Stand at Apache River, The Man from Bitter Ridge, Tribute to a Bad Man, Hell's Crossroads, The Fiend Who Walked the West, Hell Bent for Leather, Stampede at Bitter Creek* (TV), *Requiem for a Gunfighter* (65).

288 McQUEEN, Steve (1930–). One of the new breed of super stars with his own production company, Solar, usually involved in his pictures, he had an adventurous early life including work as a lumberjack in Canada and makes an impressively virile leading man with a streak of sleepy humour. Only two real Ws to date.

The Magnificent Seven (60), *Nevada Smith, Junior Bonner* (modern rodeo) (72).

289 METTY, Russell. One of the most reliable names in cinematography, seeming effortlessly to impart a rich professional gloss to all his work, especially rewarding in his colour Ws. Began his career as an operator, then had first break as director of photography on a W.

West of the Pecos (in collab.) (34), **Sierra, *Curtain Call at Cactus Creek/Take the Stage* (comedy), **Wyoming Mail, *The Treasure of Lost Canyon, *Seminole, *The Man from the Alamo, *Tumbleweed, *Taza Son of Cochise, *Four Guns to the Border, *Man without a Star, *The Man from Bitter Ridge, The Misfits* (modern; W elements), **†The Appaloosa/*

*Southwest to Sonora, *†Texas across the River* (comedy), **†Rough Night in Jericho* (67).

290 MEYER, Emile. Balding character actor with cutting, nasal voice and rough appearance; has had a few sympathetic parts but seems more at home making life unpleasant for those around him, as when playing the not-entirely-blackhearted big rancher of *Shane*.

Queen of the West (TV) (51), *Shane, Drums across the River, The Silver Lode, White Feather, Stranger on Horseback, The Tall Men, Man with the Gun/The Trouble Shooter, The Maverick Queen, Raw Edge, Gun the Man Down* (TV: *Arizona Mission*), *Badlands of Montana, The Fiend Who Walked the West, Good Day for a Hanging, King of the Wild Stallions, Young Jesse James, Taggart, Hostile Guns, A Time for Killing/The Long Ride Home, Buckskin, More Dead than Alive* (69).

291 MIDDLETON, Robert (1911–). Hefty, bald, twenty-stone character actor, capable of being

EMILE MEYER
in *Gun the Man Down*

one of the most convincingly nasty villains around. Stage background.

Red Sundown (56), *The Proud Ones, Friendly Persuasion* (Civil War), *Love Me Tender, The Lonely Man, Day of the Badman, The Law and Jake Wade, Hell Bent for Leather, Gold of the Seven Saints, Cattle King/Guns of Wyoming, A*

ROBERT MIDDLETON
in *The Lonely Man*

RAY MILLAND (left)
and Ward Bond in *A Man Alone*

Big Hand for the Little Lady/Big Deal at Dodge City (comedy; W setting), *The Cheyenne Social Club* (comedy) (70).

292 MILLAND, Ray (1905–). A skilled rider and marksman from his British Army days, he was able to cast aside his image as a light player of skilled comedy to make a convincing Westerner late in his career as a leading man.

California (47), *Copper Canyon, Bugles in the Afternoon, A Man Alone* (also dir. and assoc. prod.) (55).

293 MILLER, Winston (1910–). Screenwriter who wrote minor series Ws for Autry, Rogers and Starrett before rising to bigger assignments.

Co-st. *The Vigilantes Are Coming* (s) (36), co-sc. *The Painted Stallion* (s), sc. *Carolina Moon*, sc. *Ride Tenderfoot Ride*, co-sc. *The Medico of Painted Springs/The Doctor's Alibi*, sc. *Prairie Stranger/The Masked Bullet*, st. sc. *The Royal Mounted Patrol/Giants A'Fire*, co-sc. *The Heart of the Rio Grande*, st. sc. *Man from Cheyenne*, st. sc. *Song of Texas*, co-sc. *My Darling Clementine*, sc. *Relentless*, add. dia. *Fury at Furnace Creek*, co-sc. *Station*

West, co-sc. *Rocky Mountain*, part sc. *The Last Outpost*, co-sc. *Carson City*, part sc. *The Vanquished*, co-sc. *The Boy from Oklahoma*, co-st. sc. *The Bounty Hunter*, sc. *Run for Cover*, co-sc. *The Far Horizons* (early exploration), sc. *Tension at Table Rock* (56).

294 MITCHELL, Millard (1903–53). Former stage actor whose screen career included only three Ws but he was memorable in each, playing a kindly marshal, sidekick, and old prospector.

The Gunfighter (50), *Winchester '73, The Naked Spur* (53).

295 MITCHELL, Thomas (1895–1962). Reliable character actor, good at talkative, drink-addicted types like his old-soak doctor of *Stagecoach*, usually with an air of wisdom.

Stagecoach (39), *The Outlaw* (as Pat Garrett), *Buffalo Bill, The Romance of Rosy Ridge* (W elements), *Silver River, High Noon, Destry* (55).

296 MITCHUM, Robert (1917–). Actor with a deceptively lazy style who has contributed some of the best performances seen in Hollywood films; began with bit roles in Hopalong Cassidy pictures.

MILLARD MITCHELL (right) and Gregory Peck in *The Gunfighter*

Border Patrol (43), *Hoppy Serves a Writ, The Leather Burners, Colt Comrades, Beyond the Last Frontier, Bar 20, The Lone Star Trail, False Colors, Riders of the Deadline, The Girl Rush* (musical comedy), *Nevada, West of the Pecos, Pursued, Rachel and the Stranger* (backwoods comedy), *Blood on the Moon, The Red Pony* (modern horse), *The Lusty Men* (modern rodeo), *River of No Return, Track of the Cat* (W elements), *Man with the Gun/The Trouble Shooter, Bandido* (modern Mexico), *The Wonderful Country* (also exec. prod.), *The Way West, El Dorado, Villa Rides* (Mexico), *5 Card Stud, Young Billy Young* (also sings title song), *The Good Guys and the Bad Guys, The Wrath of God* (Mexico) (72).

ROBERT MITCHUM (left) with Kirk Douglas in *The Way West*

297 MIX, Tom (1880–1940). The man who succeeded William S. Hart as the most popular W star from 1920, he was actually born in Pennsylvania and became fascinated with the West when he saw a Wild West show at age ten. He learned to ride, rope and shoot as a boy and after army service moved to Oklahoma in 1902 with his first wife, becoming a cowboy three years later, and rising to become a champion rider and bronco-buster. In the latter capacity he was featured in a documentary in 1910 and subsequently made a vast number of shorts for the Selig company, mostly Ws, many with broad comedy, some about W film-making, and some featuring Victoria Forde whom he later married. He progressed to features for Fox and brought a flamboyant showmanship to his pictures, often performing his own stunts. Horse–Tony. He was never as successful in the sound period and spent much of his time with his own Wild West Show. When that collapsed, he toured making personal appearances and died in a car crash.

Shorts (1-2r, incomplete list, many written, prod. or dir. by Mix): *Ranch Life in the Great South West* (docu.; as himself), *The Range Rider, An Indian Wife's Devotion, Millionaire Cowboy* (all 10), *Back to the Primitive* (11), *The Law and the Outlaw* (reissued 25, expanded to 5r), *The Child of the Prairie, The Escape of Jim Dolan* (all 13), *Chips of the Flying U, In Defiance of the Law* (3r), *The Wilderness Mail, The Way of the Redman, The Moving Picture Cowboy, Why the Sheriff Is a Bachelor, The Ranger's Romance, The Telltale Knife, The Scapegoat, The Sheriff's Reward, Saved by a Watch, The Rival Stage Lines, In the Days of the Thundering Herd, The Man from the East, Cactus Jake Heart-Breaker* (all 14), *Cactus Jim's Shop Girl, Forked Trails, Slim Higgins, Man from Texas, A Child of the Prairie* (second use of title), *The Stagecoach Driver and the Girl, Sagebrush Tom, The Outlaw's Bride, Ma's Girls, An Arizona Wooing, Pals in Blue* (3r), *Saved by Her Horse, The Heart of the Sheriff, Cactus Jim, The Parson Who Fled West, The Foreman of Bar Z Ranch, A Lucky Deal, Never Again, The Range Girl and the Cowboy, The Brave Deserve the Fair, The Stagecoach Guard, Athletic Ambitions, On the Eagle Trail* (all 15), *A Mix-Up in Movies, Making Good, The Pass-*

ing of Pete, Along the Border, The Sheriff's Duty, Crooked Trails, Going West to Make Good, The Cowpuncher's Peril, Taking a Chance, Some Duel, Legal Advice, Shooting Up the Movies, Local Color, A Western Masquerade, A Bear of a Story, Roping a Sweetheart, Tom's Strategy, The Taming of Grouchy Bill, The Pony Express Rider, A Corner in Water, The Raiders, The Canby Hill Outlaws, A Mistake in Rustlers, A Close Call, Tom's Sacrifice, The Sheriff's Blunder, Twisted Trails, The Golden Thought, Hearts and Saddles, A Roman Cowboy, Six Cylinder Love, A Soft Tenderfoot, Tom and Jerry Mix.

Features: The Heart of Texas Ryan (17), Durand of the Badlands, Cupid's Round Up, Six Shooter Andy, Western Blood (also st.), Ace High, Mr. Logan U.S.A., Fame and Fortune, Treat 'Em Rough, Hell Roarin' Reform, Fighting for Gold, The Coming of the Law, The Wilderness Trail, The Speed Maniac, Rough Riding Romance (foreign setting), The Feud (W elements), The Cyclone (W elements), The Daredevil (also st. sc. and dir.), Desert Love (also st.), The Terror (also st.),

TOM MIX

Three Gold Coins (comedy), The Untamed, The Texan, Prairie Trails, The Road Demon (modern; W elements), Hands Off, A Ridin' Romeo, After Your Own Heart, The Night Horsemen, The Rough Diamond (W elements), Trailin' (W elements), Sky High, Up and Going (modern; W elements), The Fighting Streak, For Big Stakes, Just Tony, Arabia or Tom Mix in Arabia (comedy; part W), Catch My Smoke, Romance Land (burlesque W), Three Jumps Ahead, Stepping Fast, Soft Boiled (comedy), North of Hudson Bay (N-W), The Lone Star Ranger, Mile-a-Minute Romeo, Eyes of the Forest (modern timber), The Trouble Shooter, The Last of the Duanes, The Heart Buster (part comedy), Oh You Tony! (part comedy), Teeth, The Deadwood Coach, Riders of the Purple Sage, The Rainbow Trail, The Lucky Horseshoe, The Everlasting Whisper, The Best Bad Man, The Yankee Senor, My Own Pal, Tony Runs Wild, Hard Boiled (modern comedy), No Man's Gold, The Great K & A Train Robbery, The Canyon of Light, The Last Trail, The Bronco Twister, The Circus Ace (modern; W elements), Tumbling River, Outlaws of Red River, The Silver Valley, The Arizona Wildcat, Daredevil's Reward, A Horseman of the Plains, Hello Cheyenne, Painted Post, Son of the Golden West, King Cowboy, Outlawed, The Drifter, The Big Diamond Robbery, Destry Rides Again, Riders of Death Valley, Texas Bad Man, My Pal the King (foreign setting), The Fourth Horseman, Hidden Gold, Flaming Guns, Terror Trail, Rustlers Roundup, The Miracle Rider (s) (35).

298 MONTGOMERY. George (1916–). Clear-voiced, ruggedly handsome leading man who was brought up on a Montana ranch, and went into the movies as a stuntman and double, progressed to acting under real name George Letz until given bigger roles and a new name; spent a busy ten years (1948–58)

GEORGE MONTGOMERY
in *Robbers' Roost*

perado, Fort Ti (Colonial period), *Gun Belt, Battle of Rogue River, The Lone Gun, Masterson of Kansas* (as Bat Masterson), *Robbers' Roost, Seminole Uprising, Canyon River, Last of the Badmen, Gun Duel in Durango, Black Patch* (also prod.), *Pawnee/Pale Arrow, Man from God's Country, Toughest Gun in Tombstone, Badman's Country* (as Pat Garrett), *King of the Wild Stallions, Hostile Guns* (67).

299 MORGAN, Dennis (1910–). Probably best remembered for his work in musicals, this long-time Warner Bros. star also made some trips out West.

River's End (Mounties) (TV: *Double Identity*) (40), *Bad Men of Missouri* (as Cole Younger), *Cheyenne, Raton Pass/Canyon Pass, Cattle Town, The Gun that Won the West* (55).

300 MOROSS, Jerome. After a long career as an orchestral arranger etc. for other composers, he wrote his own film scores including the immensely popular music for *The Big Country*.

The Proud Rebel (58), *The Big Country, The Jayhawkers* (59).

301 MORRIS, Wayne (1914–1959). Workaday Warner player (1936–49), weak-voiced but huskily built; at Monogram in the Fifties, became the last star to be given a regular series.

Valley of the Giants (timber) (38), *Bad Men of Missouri, The Younger Brothers, The Tougher They Come* (timber), *Stage to Tucson/Lost Stage Valley, Sierra Passage, The Bushwhackers/The Rebel, Desert Pursuit, The Fighting Lawman, The Marksman, Star of Texas, Riding Shotgun, The Desperado, Two Guns and a Badge, The Lonesome Trail* (55).

302 MURPHY, Audie (1924–71). Texas born, the most decorated hero of the Second World War, he

appearing almost exclusively in Ws, these generally lavish but undistinguished, the biggest exception being the offbeat *Black Patch* which he also prod.

Springtime in the Rockies (37), *Gold Mine in the Sky, The Lone Ranger* (s), *The Cisco Kid and the Lady, The Cowboy and the Blonde* (as W film star), *Last of the Duanes, Riders of the Purple Sage, Belle Starr's Daughter, Indian Scout* or *Davy Crockett Indian Scout, Dakota Lil, The Iroquois Trail/The Tomahawk Trail* (Colonial period), *The Texas Rangers, Indian Uprising, Cripple Creek, The Pathfinder* (Colonial period), *Jack McCall Des-*

AUDIE MURPHY
in *Cast a Long Shadow*

Shadow, Hell Bent for Leather, Seven Ways from Sundown, The Unforgiven, Posse from Hell, Six Black Horses, Showdown, Gunfight at Comanche Creek, The Quick Gun, Bullet for a Badman, Apache Rifles, Arizona Raiders, Gunpoint, The Texican, Forty Guns to Apache Pass, A Time for Dying (as Jesse James; also prod.) (69).

303 MURRAY, Don (1929–). Earnest leading man put into several W leading roles at Fox where he showed a potential since neglected.

From Hell to Texas/Manhunt (58), *These Thousand Hills, One Foot in Hell, Kid Rodelo, The Plainsman* (as Wild Bill Hickok) (66).

304 NAISH, J. Carrol (1900–73). Expert character actor, usually on the dark side, often playing foreign

J. CARROL NAISH in
the title role of *Sitting Bull*

kept his youthful looks up to his premature death in an air crash. Small and soft-spoken, he radiated quiet determination and virtue; was occasionally cast as a bad man but usually with sympathetic aspects. Little work outside W where he was kept busy turning out above-average supporting pictures until this kind of production was abandoned. He then turned to being an independent producer with one picture resulting.

The Kid from Texas/Texas Kid Outlaw (as Billy the Kid) (50), *Sierra, Kansas Raiders, The Red Badge of Courage* (Civil War), *The Cimarron Kid, Duel at Silver Creek, Gunsmoke, Column South, Tumbleweed, Ride Clear of Diablo, Drums across the River, Destry, Walk the Proud Land, The Guns of Fort Petticoat* (also co-prod.), *Night Passage, Ride a Crooked Trail, No Name on the Bullet, The Wild and the Innocent* (comedy), *Cast a Long*

nationalities; two performances as Sitting Bull, also many other Indians.

Gun Smoke (modern) (31), *The Avenger, The Whirlwind, The Last Trail, Silent Men, Robin Hood of El Dorado, Ramona* (Indian love story), *Thunder Trail, Jackass Mail, Bad Bascomb, The Kissing Bandit* (musical), *Canadian Pacific, Annie Get Your Gun* (musical; as Sitting Bull), *Rio Grande, Across the Wide Missouri, Denver and Rio Grande, Woman of the North Country, Ride the Man Down, Saskatchewan/ O'Rourke of the Royal Mounted* (Mounties), *Sitting Bull* (as Sitting Bull), *Rage at Dawn, The Last Command, Rebel in Town, Yaqui Drums* (56).

305 NEUMANN, Kurt (1906– 58). German who came to Hollywood in 1925, gained job of supervising foreign language versions of early sound films, then became director who made many Ws and several Tarzan films.

My Pal the King (foreign setting) (32), *The Dude Goes West* (comedy), *Bad Men of Tombstone, The Kid from Texas/Texas Kid Outlaw, Cattle Drive, Hiawatha* (Indian life), *Mohawk, The Desperadoes Are in Town* (also co-sc.), *Apache Warrior* (co-st. part sc. only), *The Deerslayer* (Colonial period) (also prod. and co-sc.) (57).

306 NEWMAN, Alfred (1901– 70). One of Hollywood's most disttinguished composers, whose prolific output has included a few Ws; also music director (for 20th Century-Fox) on others not listed.

Drums along the Mohawk (Colonial period) (39), *Brigham Young Frontiersman, Belle Starr, Yellow Sky, The Gunfighter, Pony Soldier/ MacDonald of the Canadian Mounted, How the West Was Won* (in collab.), *Nevada Smith, Firecreek* (68).

307 NEWMAN, Joseph M. (1909–). One of the talented directors to

emerge from the M-G-M shorts school, who made some exceptional low-budget pictures but rarely had the chance to make worthwhile bigger films. Most recently in TV.

Northwest Rangers (N-W) (42), *The Outcasts of Poker Flat, Pony Soldier/MacDonald of the Canadian Mounties, Fort Massacre, The Gunfight at Dodge City, A Thunder of Drums* (61).

308 NEWMAN, Paul (1925–). Powerful actor who portrayed Billy the Kid in the screen's most probing study of the character.

The Left Handed Gun (as Billy the Kid) (58), *Hud* (modern), *The Outrage* (Mexico), *Hombre, Butch Cassidy and the Sundance Kid* (as Cassidy), *Pocket Money* (modern), *The Life and Times of Judge Roy Bean* (72).

309 NICHOLS, Dudley (1895– 1960). A former journalist who turned scriptwriter; particularly associated with John Ford for whom he scripted *Stagecoach*.

Sc. *Robbers' Roost* (33), co-sc. *Wild Gold*, st. sc. *The Arizonian*, sc. *Stagecoach*, st. sc. *Rawhide* (TV: *Desperate Siege*), sc. *Return of the Texan* (modern), sc. *The Big Sky*, sc. *The Tin Star*, sc. *The Hangman*, co-sc. *Heller in Pink Tights*, sc. basis *Stagecoach* (66).

310 NORTH, Edmund H. (1911–). Screenwriter.

Co-st. co-sc. *Colorado Territory* (49), co-sc. *Only the Valiant*, sc. *Outcasts of Poker Flat*, co-sc. *Destry*, co-sc. *The Far Horizons* (early exploration), co-sc. *The Proud Ones*, sc. *Cowboy* (58).

311 NUGENT, Frank S. (1908– 65). Former reporter and film critic who turned scriptwriter and, like Dudley Nichols, forged a particular association with John Ford. As one of the writers of so many of Ford's finest Ws, he is clearly one of the best writers to have worked in the

genre—and with other excellent work besides.

Sc. *Fort Apache* (48), co-sc. *Three Godfathers*, co-sc. *She Wore a Yellow Ribbon*, co-sc. *Wagonmaster*, co-st. *Two Flags West*, co-sc. *They Rode West*, co-sc. *The Tall Men*, sc. *The Searchers*, sc. *Gunman's Walk*, sc. *Two Rode Together*, sc. *This Rugged Land* (TV) (modern), co-sc. *Incident at Phantom Hill* (66).

312 OAKLEY, Annie (1859–1926). A formidable sharpshooter from her teens, she became one of the attractions in Buffalo Bill's Original Wild West Show. Glamorous-looking, she had no exciting real-life W background though journalists invented one for her.

Barbara Stanwyck *Annie Oakley* (35), Betty Hutton *Annie Get Your Gun* (musical), Nancy Kovack *The Outlaws Is Coming* (comedy), Angela Douglas *Carry On Cowboy* (comedy) (66).

313 OATES, Warren (c1928–). Rapidly emerging as one of the screen's best character actors, Oates has played a fair number of dumb, oafish, loud-mouthed characters in a way that audiences could appreciate and often relish. Very expressive features compensate for a Kentucky drawl.

Yellowstone Kelly (59), *Ride the High Country/Guns in the Afternoon*, *Mail Order Bride/West of Montana* (comedy), *The Rounders* (modern comedy), *Major Dundee*, *Return of the Seven*, *Welcome to Hard Times/Killer on a Horse*, *Smith!*, *The Wild Bunch*, *Barquero*, *There Was a Crooked Man*, *The Hired Hand* (modern), *The Shooting*, *Kid Blue* (comedy) (73).

314 O'BRIEN, Edmond (1915–). Expressive actor who had a brief spell as a rather podgy-cheeked W hero before becoming a character actor with a taste, enjoyably communicated, for ham.

The Redhead and the Cowboy (50), *Warpath*, *Silver City/High Vermilion*, *Denver and Rio Grande*, *Cow Country*, *The Big Land/Stampeded*, *The Man Who Shot Liberty*

WARREN OATES in *The Hired Hand.* EDMOND O'BRIEN in *The Wild Bunch*

Valance, Rio Conchos, The Wild Bunch (69).

315 O'BRIEN, George (1900–). An expert rider from childhood, he was the virtual unknown (some work as an extra, minor player and stunt-man) who was cast for the lead in John Ford's W classic, *The Iron Horse;* spent most of the Thirties starring in a well-produced but minor W series featuring many Zane Grey adaptations; then, as a character actor, played an army officer in several later Ford Ws.

The Iron Horse (24), *Rustling for Cupid, Three Bad Men, The Lone Star Ranger, Rough Romance* (tim-ber), *Last of the Duanes, Fair Warn-ing, A Holy Terror, Riders of the Purple Sage, The Rainbow Trail, The Gay Caballero, Mystery Ranch, The Golden West, Robbers' Roost, Smoke Lightning, Life in the Raw* (modern), *The Last Trail* (modern), *Frontier Marshal* (as Wyatt Earp), *The Dude Ranger* (comedy), *When a Man's a Man* (TV: *Saga of the West*), *The Cowboy Millionaire, Thunder Moun-tain, O'Malley of the Mounted* (Mounties), *Daniel Boone* (as Daniel Boone), *Hollywood Cowboy* (TV: *Wings Over Wyoming*) (mod-ern), *Park Avenue Logger* (TV: *Tall Timber*) (modern; timber), *Gun Law, Border G-Man* (modern), *Painted Desert, The Renegade Ran-ger, Lawless Valley, The Arizona Legion, Trouble in Sundown, Racke-teers of the Range* (modern), *Tim-ber Stampede, The Fighting Gringo, The Marshal of Mesa City, Legion of the Lawless, Bullet Code, Prairie Law, Stage to Chino, Triple Justice, Fort Apache, She Wore a Yellow Ribbon, Gold Raiders/Stooges Go West* (comedy), *Cheyenne Autumn* (64).

316 O'HARA, Maureen (1920–). Dublin-born redhead actress who can most effectively portray determined women with fiery temperaments; has often been well-matched with John Wayne.

GEORGE O'BRIEN

MAUREEN O'HARA with Brian Keith in *The Deadly Companions*

JACK PALANCE (left) with Lee Marvin in *Monte Walsh*

Buffalo Bill (44), *Comanche Territory, Rio Grande, Kangaroo* (Australian W), *The Redhead from Wyoming, War Arrow, The Deadly Companions* (also part prod.), *McLintock!* (comedy), *The Rare Breed, Big Jake* (71).

317 PAGET, Debra (1933–). Actress from Denver, Colorado, whose successful portrayal of an Indian girl in *Broken Arrow* led to a certain amount of typecasting.
Broken Arrow (50), *White Feather, Seven Angry Men, The Last Hunt, Love Me Tender* (56).

318 PALANCE, Jack (1920–). His performance as the quiet, black-garbed, sinister gunman of *Shane* elevated him to the front ranks of heavies; has played some heroes too but now back to character work, sometimes performing with excessive enthusiasm.
Shane (53), *Arrowhead, The Lonely Man, The Professionals* (Mexico; W elements), *The Desperados, A Professional Gun* (*Il mercenario*), *The McMasters, Monte Walsh, Chato's Land, The Big and the Bad* (*Si può fare . . . amigo*) (comedy) (72).

319 PARKER, Fess (1927–). Actor from Fort Worth, Texas, who achieved stardom as Walt Disney's choice for the title role in *Davy Crockett*.
Untamed Frontier (52), *Springfield Rifle, Thunder over the Plains, The Bounty Hunter, Davy Crockett*

FESS PARKER in *The Jayhawkers*

King of the Wild Frontier (as Davy
Crockett), *The Great Locomotive
Chase, Davy Crockett and the River
Pirates* (as Davy Crockett), *West-
ward Ho the Wagons!, Old Yeller*
(W elements), *The Light in the
Forest* (Colonial period), *Alias Jesse
James* (comedy; guest), *The Hang-
man, The Jayhawkers, Smoky* (horse),
Daniel Boone—Frontier Trail Rider
(TV) (67).

320 PATE, Michael (1920–).
Actor from Australia who had
prominent roles in two outdoor
action films down under—*The
Rugged O'Riordans* and *Bitter
Springs*—before continuing in similar
vein in Hollywood where he has
very often played Indians. Co-
authored story of *Escape From Fort
Bravo* (53).
 Hondo (54), *A Lawless Street,
Reprisal!, 7th Cavalry, The Okla-
homan, The Tall Stranger, West-
bound, Curse of the Undead* (W
elements), *Walk like a Dragon, The
Canadians* (Mounties), *Sergeants 3*
(comedy), *California* (TV), *Mc-
Lintock!* (comedy), *Advance to the
Rear/Company of Cowards?* (Civil
War comedy), *Major Dundee, The
Great Sioux Massacre* (as Sitting
Bull), *Return of the Gunfighter*
(TV), *Mosby's Marauders* (TV)
(*Willie and the Yank*), *Hondo and
the Apaches* (TV) (67).

321 PAYNE, John (1912–).
Stolid leading man who spent many
years lightly performing in Fox
musicals before taking to adventure,
crime and W films with a furrowed
brow look of intensity and endur-
ance.
 King of the Lumberjacks (tim-
ber) (40), *El Paso, The Eagle and
the Hawk, Passage West/High Ven-
ture, The Vanquished, Rails into
Laramie, Silver Lode, Sante Fe Pas-
sage, Road to Denver, Tennessee's
Partner, Rebel in Town* (56).

322 PECK, Gregory (1916–).
A star with a solid, rather dour

JOHN PAYNE in *Rebel in Town*

personality; was ideal for the tragic,
ageing title figure in *The Gunfighter*
and the stubborn seaman out west
in *The Big Country*.
 Duel in the Sun (46), *Yellow
Sky, The Gunfighter, Only the
Valiant, The Bravados, The Big
Country, How the West Was Won*
(ep. "Plains"), *Mackenna's Gold,
The Stalking Moon, Shoot Out, Billy
Two Hats* (74).

323 PECKINPAH, Sam (1926–
). Director and writer who grew
up in the modern West on land that
his grandfather homesteaded; listened
well and used many of the stories he
heard in his scripts. Made perhaps
the best W of the Sixties, *Ride the
High Country,* and has had his career
keenly followed by critics since with
a muddled attitude to violence per-
meating much of his more recent
work, especially *The Wild Bunch.*
Wrote original draft of *One Eyed
Jacks;* not credited on finished film.
 Dir. *The Deadly Companions* (61),
dir. *Ride the High Country/Guns in
the Afternoon,* dir. part sc. *Major
Dundee,* sc. *The Glory Guys,* co-st.
co-sc. *Villa Rides* (Mexico), co-sc.
dir. *The Wild Bunch,* dir. *The Bal-
lad of Cable Hogue* (comedy), dir.

Junior Bonner (modern rodeo), dir. *Pat Garrett and Billy the Kid* (73).

324 PICKENS, Slim (1919–). Portly, slow-talking, hoarse-voiced character actor who did many early films with Rex Allen, slowly progressed to bigger parts and has proven adept at portraying sadistic and spiteful figures as well as comic characters. Expert rodeo rider from age twelve, he had specialised in clowning in the arena before going into the movies.

Rocky Mountain (50), *Colorado Sundown, Border Saddlemates, The Boy from Oklahoma, Old Oklahoma Plains, South Pacific Trail, Iron Mountain Trail, Down Laredo Way, Old Overland Trail, Shadows of Tombstone, Red River Shore, The Outcast/The Fortune Hunter, Santa Fe Passage, The Last Command, Stranger at My Door, The Great Locomotive Chase, Gun Brothers, Gunsight Ridge, The Sheepman* (comedy), *Tonka, Escort West, Stampede at Bitter Creek* (TV), *One Eyed Jacks, A Thunder of Drums,*

SLIM PICKENS with John Wayne in *The Cowboys*

Savage Sam, Major Dundee, The Glory Guys, Stagecoach, An Eye for an Eye, Rough Night in Jericho, Will Penny, Joaquin Murieta (TV), *The Ballad of Cable Hogue* (comedy), *The Honkers* (modern rodeo), *The Deserter, The Cowboys, Pat Garrett and Billy the Kid, Blazing Saddles* (comedy) (74).

325 PORTER, Edwin S. (1869–1941). The most important American film-maker prior to D. W. Griffith and the man principally remembered for having made the first important W, *The Great Train Robbery* (nine minutes long). Griffith acted in his *Rescued from an Eagle's Nest*. A very busy writer-director until 1911 when he became more of a supervising producer; left films in 1915. No Ws of feature length.

The Great Train Robbery (also ph. and prod.), *The Capture of the Yegg Bank Burglars* (W?) (both 03), *Rounding Up and Branding Cattle, Rounding Up of the Yegg Men* (W?), *The Western Stage Coach Hold-Up, Trapped by Nat Pinkerton, The Hold-Up of the Leadville Stage* (all 04), *The Train Wreckers* (05), *The Life of an American Cowboy* or *Adventures of an American Cowboy* (06), *Daniel Boone* (dir. only) (07), *Rescued from an Eagle's Nest* or *The Eagle's Nest* (dir. only) (08), *On the Western Frontier* (dir. only), *The Pony Express* (dir. only), *The Child of the Forest* (all 09), *The Cowpuncher's Glove, The Bad Man from Riley's Gulch, The Luck of Roaring Camp, Bradford's Claim, A Western Romance, Pardners, Onoko's Vow* (all 10).

326 POWER, Tyrone (1914–58). Played a highly sympathetic Jesse James, few later W roles, but seemed more at home swashbuckling rather than six-shooting.

Jesse James (39), *Brigham Young-Frontiersman, Rawhide* (TV: *Desperate Siege*), *Pony Soldier/MacDonald of the Canadian Mounties* (52).

327 PRESTON, Robert (1917–
). Excellent player who has never
quite matched his stage successes in
the movies. In Forties, was frequent
second lead to star and often played
bluff, generous, irresponsible types
who made a moral contrast with the
hero. Frequently moustached.

Union Pacific (39), *North West
Mounted Police* (Mounties), *The
Lady from Cheyenne, Whispering
Smith, Blood on the Moon, The Sun-
downers/Thunder in the Dust, My
Outlaw Brother, Best of the Badmen.
Face to Face* (W ep. *The Bride
Comes to Yellow Sky*), *The Last
Frontier* (TV: *Savage Wilderness*),
How the West Was Won (ep. "The
Plains "), *Junior Bonner* (modern
rodeo) (72).

ROBERT PRESTON in
How the West Was Won

328 QUANTRILL, Charles or
William Clarke. Schoolteacher who
became the ruthless leader of a
guerilla band that included the
James and Younger Brothers and
ravaged the Missouri area during the
Civil War, supposedly acting for the
Confederacy; most noted for his
destruction of Lawrence, Kansas, on
January 21, 1863, when more than
one hundred townspeople were
killed.

Walter Pidgeon *The Dark Com-
mand* [called Cantrell] (40), Ray
Corrigan *Renegade Girl,* Brian Don-
levy *Kansas Raiders,* John Ireland
Red Mountain, Brian Donlevy
Woman They Almost Lynched, Leo
Gordon *Quantrill's Raiders,* Emile
Meyer *Young Jesse James,* Fred
Graham *Arizona Raiders* (65).

329 QUINN, Anthony (1915–).
Actor of Irish-Mexican descent
(born in Mexico) who was long type-
cast as Indians, Mexicans and gang-
sters before breaking out into leading
roles; a volatile performer.

The Plainsman (37), *Union Pa-
cific, Texas Rangers Ride Again,
They Died with their Boots On* (as
Chief Crazy Horse), *The Ox-Bow
Incident/Strange Incident, Buffalo
Bill, California, Black Gold* (W ele-
ments), *Viva Zapata!* (Mexico),
*Seminole, Ride Vaquero!, The Man
from Del Rio, The Ride Back, Last
Train from Gun Hill, Warlock, Heller
in Pink Tights, Guns of San Sebastian*
(Mexico), *Flap/The Last Warrior*
(comedy), *Deaf Smith and Johnny
Ears* (*Los amigos*) (73).

330 RAVETCH, Irving. Top-brack-
et screenwriter who usually works
in collaboration with his wife, Har-
riet Frank Jr. (though she co-sc.
Silver River without him).

Sc. *The Outriders* (50), sc. *Ven-
geance Valley,* st. *The Lone Hand,*
st. (with wife) *Run for Cover,* st.
(with wife) *Ten Wanted Men,* sc.
(with wife) *Hud* (modern), sc.
(with wife) and co-prod. *Hombre,*
part sc. (with wife) *The Cowboys,*
sc. (with wife) *The Spikes Gang*
(74).

331 RAY, Nicholas (1911–).
Talented director whose few Ws all
reveal distinctive handling. Also dir.
Wind across the Everglades with
Burl Ives's outlaw figure.

The Lusty Men (modern rodeo)
(52), *Johnny Guitar, Run for Cover,*

NICHOLAS RAY (right) with
James Cagney on *Run for Cover*

The True Story of Jesse James/The James Brothers (57).

332 RENNAHAN, Ray (1898–).One of the great names in the evolution of colour cinematography, a specialist in early colour systems from 1921, he handled the first three-colour Technicolor features of the Thirties, went on to visually enhance numerous otherwise undistinguished Ws, has more recently been displaying his talents on TV series, especially *The Virginian*.

Blood Test (23), *Redskin* (Technicolor sequences), **Dodge City* (assoc. ph.), **Drums along the Mohawk* (in collab.), **Belle Starr* (in collab.), **California, *Duel in the Sun* (in collab.), **Unconquered* (Colonial period; in collab.), **The Paleface* (comedy), **Whispering Smith, *Streets of Laredo, *The Great Missouri Raid, *Warpath, *Silver City/High Vermilion, *Flaming Feather, *Denver and Rio Grande, *Pony Express, *Arrowhead, *Stranger on Horseback, *Rage at Dawn, *Texas Lady* (SuperScope), **A Lawless Street, *7th Cavalry, The Halliday Brand, *The Guns of Fort Petticoat, Terror in a Texas Town* (58).

333 ROBERSON, Chuck [Charles]. A valued aide of Wayne/Ford/McLaglen/Kennedy. Came into the movies as a stuntman, often doubling for W stars as an expert horseman, and frequently plays a minor role, occasionally with a few lines stolidly spoken. Doubled Reed Hadley in *I Shot Jesse James*. Was "in charge of horses" and Gable's stuntman for *The Misfits*, 2nd Unit dir. for *100 Rifles*. Earliest suspected appearances in *Renegades* (46) and *Angel and the Badman* (47). To be at least glimpsed in following films where his more important work was almost invariably staging action scenes.

Stampede (49), *Haunted Trails, The Fighting Kentuckian, Western Renegades, Trail of the Rustlers/Lost River, Outcast of Black Mesa/The Clue, Cow Town/Barbed Wire, Winchester '73, Rio Grande, Lightning Guns/Taking Sides, Bandit Queen, Frontier Outpost, Frenchie, Ridin' the Outlaw Trail, Cattle Drive, Fort Dodge Stampede, The Lusty Men* (modern rodeo), *The Far Country, The Tall Men, The Searchers, Seven Men from Now, Night Passage, Run of the Arrow, Forty Guns, The Big Country, Man of the West, Texas John Slaughter* (TV), *The Wonderful Country, Sergeant Rutledge, The Alamo, Two Rode Together, How the West Was Won* (billed but possibly cut out), *McLintock!* (comedy), *Four for Texas* (comedy), *Mail Order Bride/West of Montana* (comedy), *Cheyenne Autumn, Shenandoah* (Civil War), *Black Spurs, Cat Ballou* (comedy), *The Sons of Katie Elder, Daniel Boone—Frontier Trail Rider* (TV), *Welcome to Hard Times/Killer on a Horse, El Dorado, The War Wagon, The Scalphunters, The Undefeated, Rio Lobo, Chisum, Big Jake, Cahill: United States Marshal/Cahill* (73).

334 ROBERTS, William (1913–). Had a hand in the amiable spoof W, *The Sheepman;* final writer on *The Magnificent Seven;* had un-

credited part in writing *Ride the High Country*.

Adap. *The Sheepman*, sc. *The Magnificent Seven*, sc. contrib. *Ride the High Country/Guns in the Afternoon*, st. *One More Train to Rob*, part sc. *Red Sun (Soleil rouge)* (71).

335 ROBERTSON, Dale (1923–). Quiet-spoken Oklahoman who played Jesse James in his first W. TV series *Scalplock* has kept him busy after long running *Tales of Wells Fargo*.

Fighting Man of the Plains (as Jesse James) (49), *The Cariboo Trail, Two Flags West, Golden Girl* (Civil War musical), *Return of the Texan* (modern), *The Outcasts of Poker Flat, The Silver Whip, City of Bad Men, Devil's Canyon, Sitting Bull, A Day of Fury, Dakota Incident, Hell Canyon Outlaws/The Tall Trouble, Law of the Lawless, Blood on the Arrow, The Man from Button Willow* (cartoon—st. prod. and intro.) (65).

336 ROGERS, Roy (1912–). Billed as a "King of the Cowboys" with a faithful friend called Trigger, "The Smartest Horse in the Movies," his reign as a series star came in the Forties when his blend of music and action overtook that supplied by Gene Autry in the popularity stakes. Originally a radio singer and member of the "Sons of the Pioneers" group, he usually featured in Ws with strong plots but found time to perform a song and play the guitar. His wife Dale Evans (whom he married in 1947) was often his co-star while Gabby Hayes and more briefly Andy Devine were among his saddlemates. With the decline in B film production, he moved to TV in the Fifties, now does TV specials, recordings, personal appearances and night-club work in Nevada. First few film appearances under real name, Leonard Slye, and Dick Weston.

The Old Homestead (35), *The Big Show, Gallant Defender, The Mysterious Avenger, Rhythm on the* .

ROY ROGERS (right) with Jack Holt in *Trail of Robin Hood*

Range, The Old Corral/Texas Seren- ade, The Old Wyoming Trail, Wild Horse Rodeo, The Old Barn Dance, Under Western Stars, Billy the Kid Returns, Come on Rangers, Shine' on Harvest Moon, Rough Riders' Round-Up, Frontier Pony Express, Southward Ho!, In Old Caliente, Wall Street Cowboy, The Arizona Kid, Saga of Death Valley, Days of Jesse James, Young Buffalo Bill (as Buf- falo Bill), *The Dark Command, Car- son City Kid, The Ranger and the Lady, Colorado, Young Bill Hickok* (as Hickok), *The Border Legion* (TV: *West of the Badlands*), *Robin Hood of the Pecos, In Old Cheyenne, Nevada City, Sheriff of Tombstone, Bad Man of Deadwood, Jesse James at Bay* (as Jesse James), *Red River Valley, Man from Cheyenne, South of Santa Fe, Sunset on the Desert, Romance on the Range, Sons of the Pioneers, Sunset Serenade, Heart of the Golden West, Ridin' down the Canyon, Idaho, King of the Cowboys, Song of Texas, Silver Spurs, The Man from Music Mountain, Hands across the Border, The Cowboy and the Senorita, The Yellow Rose of Texas, Song of Nevada, San Fernando Val- ley, Lights of Old Santa Fe, Utah, Bells of Rosarita, The Man from Oklahoma, Sunset in El Dorado, Don't Fence Me In, Along the Nava- jo Trail, Song of Arizona, Rainbow over Texas, My Pal Trigger, Under Nevada Skies, Roll on Texas Moon, Home in Oklahoma, Out California Way, Helldorado, Apache Rose, Bells of San Angelo, Springtime in the Sierras, On the Old Spanish Trail, The Gay Ranchero, Under California Stars, Eyes of Texas, Night Time in Nevada, Grand Canyon Trail, The Far Frontier, Susanna Pass, Down Dakota Way, The Golden Stallion, Bells of Coronado, Twilight in the Sierras, Trigger Jr., Sunset in the West, North of the Great Divide, Trail of Robin Hood, Spoilers of the Plains, Heart of the Rockies, In Old Amarillo, South of Caliente, Pals of the Golden West, Son of Paleface*

(guest star) (comedy), *Alias Jesse James* (comedy; guest star) (59).

337 ROLAND, Gilbert (1905–). Born in Mexico of a bull-fighter's family, he became an extra and later a star of silent films; survived the transition to sound, became one of the screen's best Cisco Kids, and has continued as a supporting player, looking far younger than his real age.

Rose of the Golden West (early California) (27), *Men of the North* (N-W), *Thunder Trail, Rangers of Fortune, The Gay Cavalier, South of Monterey, Beauty and the Bandit, Robin Hood of Monterey, Riding the California Trail, King of the Bandits* (last six as the Cisco Kid), *The Dude Goes West* (comedy), *The Furies, The Torch/Bandit General* (W elements), *Apache War Smoke, The Treasure of Pancho Villa* (Mexi- co), *Three Violent People, Bandido* (Mexico; W elements), *The Last of the Fast Guns, The Wild and the Innocent* (comedy), *Guns of the Timberland, Cheyenne Autumn, The Reward* (modern), *For a Few Bullets More* (*Vado . . l'ammazzo e torno*), *Each Man for Himself* (*Ognuno per se*), *Johnny Hamlet* (*Quella sporca storia del West*), *Running Wild* (horse) (73).

GILBERT ROLAND in *The Furies*

AARON ROSENBERG

338 ROSENBERG, Aaron (1912–). A former all-American football guard who became the producer of an excellent batch of Ws at Universal; was lured to M-G-M on the broken promise of handling *How the West Was Won*, and though he soon switched to Fox his career has seemed lacklustre ever since. Production company: Arcola.

Red Canyon (assoc. prod.) (49), *Calamity Jane and Sam Bass* (assoc. prod.), *Cattle Drive, Winchester '73, Bend of the River/Where the River Bends, Gunsmoke, The Man from the Alamo, Wings of the Hawk* (Mexico), *Saskatchewan/O'Rourke of the Royal Mounted* (Mounties), *The Far Country, Man without a Star, Backlash, Walk the Proud Land, Night Passage, The Badlanders, The Reward* (modern), *Smoky* (horse), *Daniel Boone—Frontier Trail Rider* (TV), *Joaquin Murieta* (TV) (70).

339 ROSSON, Arthur H. (?– 1960). An English-born stage director, he entered American films as a stunt man and actor, became writer and assistant director, then director, making several Ws with William Desmond, Tom Mix, before becoming a 2nd Unit Director, working for many years with Cecil B. DeMille and handling the massive outdoors action sequences that DeMille's films are often best remembered for. Listing incomplete:

As writer: sc. *The Picket Guard* (Civil War), st. sc. *Bloodhounds of the North* (Mounties), st. sc. *The Honor of the Mounted* (Mounties) (all shorts, 13).

As director: *Headin' South* (18), *Rough Riding Romance, The Fighting Streak* (also sc.), *Blasted Hopes, Ridin' Pretty* (comedy), *The Taming of the West, Straight Through, The Burning Trail, The Meddler, Set Free, The Last Outlaw, The Winged Horseman* (co-dir.?), *Points West, The Long Long Trail, The Mounted Stranger* (also adap. and dial.), *Trailin' Trouble* (comedy; also st.), *The Concentratin' Kid, Hidden Gold, Flaming Guns, Boots of Destiny* (also sc.), *Trailin' Trouble* (37).

As 2nd Unit director: *The Plainsman* (35), *Union Pacific, Kit Carson, North West Mounted Police* (Canada), *Unconquered* (Colonial period), *Red River* (billed as co-dir.), *The Man from Colorado, The Big Sky* (Colonal period), *The Jayhawkers, Heller in Pink Tights* (60).

340 ROWLAND, Roy (1910–). Interesting director who worked his way up from script clerk to director of shorts to features at M-G-M.

The Romance of Rosy Ridge (W elements) (47), *The Outriders, Bugles in the Afternoon, The Moonlighter, Many Rivers to Cross* (backwoods comedy), *Gun Glory, Gunfighters of Casa Grande, Man Called Gringo* (*Sie Nannten ihn Gringo/La Ley del forestero*) (66).

341 RUSSELL, Jane (1921–). The busty sensation of *The Outlaw*, she continued to be brazenly glamorous in later Ws, playing two of the West's legendary women.

The Outlaw (43), *The Paleface* (comedy; as Calamity Jane), *Son of Paleface, Montana Belle* (as Belle Starr), *The Tall Men, Johnny Reno, Waco* (66).

JANE RUSSELL in *Waco*

ROBERT RYAN as Ike Clanton
in *Hour of the Gun*

342 RYAN, Robert (1909–1973). Skillful actor who did his most important work outside the W, but contributed some subtle portrayals to the *genre* nevertheless.

North West Mounted Police (40), *Trail Street, Return of the Bad Men* (as the Sundance Kid), *Best of the Bad Men, Horizons West, The Naked Spur, The Tall Men, The Proud Ones, Day of the Outlaw, The Canadians* (Mounties), *The Professionals* (Mexico; W elements), *Custer of the West, Hour of the Gun* (as Ike Clanton), *A Minute to Pray A Second to Die/Dead or Alive* (Escondido), *The Wild Bunch, Lawman* (71).

343 SALTER, Hans J. Composer from Austria-Germany who came to Hollywood in 1937, joined Universal where he was music director for a large number of minor Universal Ws in the early Forties before writing his own scores, including many pleasingly unobtrusive and traditional W scores.

Scores: *The Spoilers* (N-W) (42), *Can't Help Singing* (musical), *The Michigan Kid, Frenchie, Tomahawk/Battle of Powder River, Apache Drums, Bend of the River/Where the River Bends, Battle at Apache Pass, Untamed Frontier, The Far Horizons* (early exploration), *Man without a Star, Wichita, Red Sundown, The Rawhide Years, The Oklahoman, The Tall Stranger, Man in the Shadow/Pay the Devil* (modern), *The Wild and the Innocent* (comedy), *The Gunfight at Dodge City, Gunpoint, Incident at Phantom Hill, Return of the Gunfighter* (TV) (67).

344 SCHAEFER, Jack (1907–). The finest of modern W writers, a former newspaperman who became a freelance writer in 1949, the year that his most famous novel, "Shane", appeared. His work has combined an extraordinary command of convincing detail with a broader sense

of the mythical values of the *genre,* lapsing occasionally into sentimentality or patness but unrivalled for its richness of background and atmosphere.

Novel basis *Shane* (53), novel basis ("First Blood") *The Silver Whip,* story basis ("Jeremy Rodock") *Tribute to a Bad Man,* story basis ("Sergeant Houck") *Trooper Hook,* screen st. *Advance to the Rear/ Company of Cowards?* (Civil War comedy) (subsequently novelised as "Company of Cowards"), novel basis *Monte Walsh* (70).

345 SCHNEE, Charles (1916–62). Former lawyer and playwright who worked as a minor production executive in Hollywood, then turned screenwriter and subsequently producer.

Co-sc. *Red River,* sc. *The Furies,* sc. *Westward the Women* (52).

346 SCOTT, Randolph (1903–). A quiet-spoken Virginian with a rather passive screen manner, he starred in a series of Zane Grey adaptations in the early Thirties, and returned exclusively to Ws after 1947, making his most interesting work for director Budd Boetticher before retiring with the splendid *Ride the High Country,* co-starring for the first time in his career with another W stalwart, Joel McCrea. Before becoming a screen actor, he had stage experience and taught Gary Cooper the right accent for playing the title role in *The Virginian* (29). His soft voice and polite manner later served to make him a refined villain on occasion; then he turned to starring in and later co-producing (with Harry Joe Brown) Ws with superior production qualities and occasional distinction, becoming in his later films as much acted upon as forcing the action and one of the most immediately convincing of actors out West.

Heritage of the Desert (32), *Wild Horse Mesa, Sunset Pass, Man of*

RANDOLPH SCOTT in *Ride the High Country*

the Forest, To the Last Man, The Thundering Herd (TV: Buffalo Stampede), The Last Round Up, Wagon Wheels (TV: Caravans West), Home on the Range, Rocky Mountain Mystery, The Last of the Mohicans (Colonial period), The Texans, Jesse James, Susannah of the Mounties (Shirley Temple), Frontier Marshal (as Wyatt Earp), Virginia City, When the Daltons Rode, Western Union, Belle Starr, The Spoilers (N-W), The Desperadoes, Abilene Town, Badman's Territory, Trail Street (as Bat Masterson), Gunfighters/The Assassin, Albuquerque/Silver City, Coroner Creek, Return of the Bad Men, The Walking Hills (modern), Canadian Pacific, The Doolins of Oklahoma/The Great Manhunt, Fighting Man of the Plains, The Nevadan/The Man from Nevada, Colt .45 (TV: Thunder Cloud), The Cariboo Trail, Sugarfoot (TV: A Swirl of Glory), Santa Fe, Fort Worth, Man in the Saddle/The Outcast, Carson City, Hangman's Knot, The Man behind the Gun, The Stranger Wore a Gun, Thunder over the Plains, Riding Shotgun, The Bounty Hunter, Ten Wanted Men, Rage at Dawn, Tall Man Riding, A Lawless Street (also assoc. prod.), Seven Men from Now, 7th Cavalry (also assoc. prod.), The Tall T (also co-prod.), Shoot-Out at Medicine Bend, Decision at Sundown (also co-prod.), Buchanan Rides Alone (also assoc. prod.), Ride Lonesome (also co-prod.), Westbound, Comanche Station (also co-prod.), Ride the High Country/Guns in the Afternoon (62).

347 SEITZ, George B. (1888–1944). A Bostonian who began as a film writer and made his name as the director of Pearl White serials which helped gain him a reputation for speed and efficiency; after largely working on action films, concluded his career with Andy Hardy pictures.

Galloping Hoofs (s) (24), Leatherstocking (s) (Colonial period), Wild Horse Mesa, The Vanishing American, Desert Gold, The Last Frontier, The Ice Flood (modern timber), Pals in Paradise (W elements), Jim the Conquerer (modern), Court-Martial, Treason, The Thrill Hunter (W film-making comedy), The Fighting Rangers, The Last of the Mohicans (Colonial period), Kit Carson, Pierre of the Plains (Canada) (42).

348 SELANDER, Lesley (1900–). An assistant director on a couple of 1925 Buck Jones pictures, Timber Wolf and Durand of the Badlands, he became a full-fledged director for the same star some ten years later, then moved to the Hopalong Cassidy series, directed many Tim Holt Bs, and progressed to slightly bigger films in Fifties. Though finally undistinguished artistically, his work was usually competent and watchable and certainly represents a massive contribution to the genre in which he almost exclusively worked.

Ride 'Em Cowboy (TV: Cowboy Round-Up) (36), The Boss Rider of Gun Creek, Empty Saddles, Sandflow, Left Handed Law, Smoke Tree Range, The Barrier (N-W), Hopalong Rides Again, Partners of the Plains, Cassidy of Bar 20, Heart of Arizona, The Mysterious Rider, Bar 20 Justice, Pride of the West, Sunset Trail, The Frontiersman, Silver on the Sage, Renegade Trail, Heritage of the Desert, Range War, Knights of the Range, The Light of Western Stars, Santa Fe Marshal, Hidden Gold, Stagecoach War, Cherokee Strip, Three Men from Texas, Doomed Caravan, Pirates on Horseback, Wide Open Town, The Round Up, Riders of the Timberline, Stick to Your Guns, Thundering Hoofs, Bandit Ranger, Red River Robin Hood, Undercover Man, Lost Canyon, Border Patrol, Colt Comrades, Buckskin Frontier, Bar 20, Riders of the Deadline, Lumberjack, Forty Thieves, Bordertown Trail, Call of the Rockies, Stagecoach to Monterey, Cheyenne Wildcat, Firebrands

of Arizona, Sheriff of Las Vegas, Sheriff of Sundown, The Great Stagecoach Robbery, Phantom of the Plains, Trail of Kit Carson, Out California Way (film cowboy), *Red Stallion, Saddle Pals, The Last Frontier Uprising, Robin Hood of Texas, Panhandle, Guns of Hate, Indian Agent, Belle Starr's Daughter, Brothers in the Saddle, Stampede, Rustlers, The Mysterious Desperado, Masked Raiders, Riders of the Range, Dakota Lil, Storm over Wyoming, Rider from Tucson, The Kangaroo Kid* (Australian W), *Rio Grande Patrol, Short Grass, Law of the Badlands, Saddle Legion, Gunplay, Cavalry Scout, Pistol Harvest, Overland Telegraph, Trail Guide, Fort Osage, Road Agent, Desert Passage, The Raiders, Cow Country, War Paint, Fort Vengeance* (Mounties), *Arrow in the Dust, The Yellow Tomahawk, Shotgun, Tall Man Riding, Fort Yuma, The Broken Star, Quincannon Frontier Scout/Frontier Scout, Tomahawk Trail/Mark of the Apache, Revolt at Fort Laramie, Outlaw's Son, Taming Sutton's Gal* (modern), *The Lone Ranger and the Lost City of Gold, War Party, Convict Stage, Fort Courageous, Town Tamer, The Texican, Fort Utah, Arizona Bushwhackers* (67).

349 SHERMAN, George (1908–). A prolific director of minor Ws for many years, initially with Gene Autrys and the Three Mesquiteers series (including the eight with John Wayne), later with a group starring Don "Red" Barry, he escaped to glossy colour Ws distinguished by his eye for landscape, and was remembered by John Wayne who made him director of the recent *Big Jake*.

Wild Horse Rodeo (37), *The Purple Vigilantes/Purple Hills, Outlaws of Sonora, Riders of the Black Hills, Heroes of the Hills, Pals of the Saddle, Overland Stage Raiders, Rhythm of the Saddle, Santa Fe Stampede, Red River Range, Mexicali Rose, The Night Riders, Three Texas Steers/Danger Rides the Range, Wyoming Outlaw, Colorado Sunset, New Frontier* (TV: *Frontier Horizon*), *Cowboys from Texas, In Old Monterey* (co-st. only), *The Kansas Terrors, Rovin' Tumbleweeds, South of the Border, Ghost Valley Raiders* (also assoc. prod. of this and next twenty-two titles), *One Man's Law, The Tulsa Kid, Texas Terrors, Covered Wagon Days, Rocky Mountain Rangers, Under Texas Skies, The Trail Blazers, Lone Star Raiders, Frontier Vengeance* (assoc. prod. only), *Wyoming Wildcat, The Phantom Cowboy, Two Gun Sheriff, Desert Bandit, Kansas Cyclone, Death Valley Outlaws, A Missouri Outlaw, The Apache Kid, Arizona Terrors, Stagecoach Express, Jesse James Jr.* (TV: *Sundown Fury*), *The Cyclone Kid, The Sombrero Kid, Renegades, Last of the Redmen, Relentless, Black Bart/Black Bart Highwayman, River Lady* (W elements), *Red Canyon* (horse), *Calamity Jane and Sam Bass* (also st.), *Comanche Territory, Tomahawk/Battle of Powder River, The Battle at Apache Pass, The Lone Hand, War Arrow, Border River, Dawn at Socorro, Chief Crazy Horse/Valley of Fury, Count Three and Pray* (W elements), *The Treasure of Pancho Villa* (Mexico), *Comanche, Reprisal!, The Hard Man, The Last of the Fast Guns, Hell Bent for Leather, The Comancheros* (prod. only), *Murieta/Vendetta* (*Joaquin Murrieta*), *Smoky* (horse), *Daniel Boone—Frontier Trail Rider* (TV), *Big Jake* (71).

350 SHERMAN, Harry (1884– 1952). The producer who put Hopalong Cassidy on the screen. Once an exhibitor and States rights' distributor, he went into producing in the silent days, finally formed his own production company to start the Hopalong Cassidy series, based on books by Clarence E. Mulford, in 1935 and made fifty-four films (all those from start of Hopalong Cassidy list in entry 47 up to and incl. *Forty Thieves*) before star William Boyd

took over production of a last twelve. Sherman also made other films which were almost invariably Ws and often Zane Grey adaptations. Very popular with his fellow workers (who nicknamed him "Pop") he ran into financial problems with his last two big-budget pictures and died when he was about to get back into production. Following list is all non-Cassidy Ws.

The Barrier (37) (N-W), *The Mysterious Rider, Heritage of the Desert, The Llano Kid, Knights of the Range, The Light of Western Stars* (TV: *Border Renegade*), *Cherokee Strip, The Round Up, The Parson of Panamint, Tombstone the Town Too Tough to Die, American Empire, Buckskin Frontier/The Iron Road, The Woman of the Town, The Kansan, Buffalo Bill, Ramrod, Four Faces West/They Passed This Way* (48).

351 SHORT, Luke (Frederick Dilley Glidden). Another W novelist whose work interested Hollywood; the name is a pseudonym derived from the real-life Dodge City gunfighter of the same name. His novels tend towards considerable complexity and are frequently concerned with range feuds.

Novel basis *Ramrod* (47), novel basis ("Dead Freight for Piute") *Albuquerque/Silver City,* novel basis *Coroner Creek,* novel basis *Station West,* novel basis ("Gunman's Choice") and co-adap. *Blood on the Moon,* novel basis *Ambush,* magazine serial/novel basis *Vengeance Valley,* novel basis ("High Vermilion") *Silver City/High Vermilion,* magazine story basis *Ride the Man Down,* story basis *The Hangman* (59).

352 SHUMATE, Harold (1893–). Screenwriter, born in Texas, with thirty years of W work a high proportion of his total output.

Story basis *Hitchin' Posts* (20), st. sc. *The Outlaw's Daughter,* st. sc. *The Call of Courage,* sc. *West of Broadway* (comedy), sc. *Whispering Sage,* sc. *Outlaws of Red River,* st. *The Circus Ace* (modern comedy; W elements), sc. *Black Jack,* st. sc. *Ridin' for Justice,* st. *South of the Rio Grande,* co-sc. *Wild Horse Mesa,* st. sc. *Scarlet River,* st. sc. *Crossfire,* co-sc. *Heritage of the Desert,* co-sc. *Man of the Forest,* sc. *The Westerner,* st. sc. *Square Shooter,* st. sc. *Dodge*

DON SIEGEL (left) with Clint Eastwood on *Two Mules for Sister Sara*

City Trail, sc. *End of the Trail*, co-st. *Man of Conquest*, sc. *When the Daltons Rode*, st. sc. *Trail of the Vigilantes*, sc. *The Round Up*, adap. *Ride 'Em Cowboy* (comedy), co-sc. *The Parson of Panamint*, st. sc. *Men of Texas/Men of Destiny*, st. *Badlands of Dakota*, sc. *The Kansan*, sc. *Abilene Town*, st. *Renegades*, co-adap. *Blood on the Moon*, sc. *Saddle Tramp*, st. *Little Big Horn/The Fighting 7th*, st. *The Lady from Texas*, co-sc. *The Half Breed* (52).

353 SIEGEL, Donald (1912–). Highly regarded director of action subjects, more usually in urban or contemporary melodrama than tales of the plains.
 Duel at Silver Creek (52), *Flaming Star, Coogan's Bluff* (modern; W elements), *Death of a Gunfighter* (completion only; uncredited), *Two Mules for Sister Sara* (70).

354 SILVERHEELS, Jay (1919–). A six-foot tall full-blooded Mohawk born on the Six Nations Indian Reservation in Ontario, Canada, he is best known as the Lone Ranger's friend, Tonto; is also the screen's most frequent portrayer of Geronimo. In 1936 he became a professional lacrosse player. Then, when his family moved to the U.S., he also achieved fame as a boxer. He began in films with bit parts from 1938.
 Unconquered (Colonial period) (48) (unconfirmed listing), *The Prairie, Fury at Furnace Creek, Singing Spurs* (modern), *Yellow Sky, Laramie, Lust for Gold, Sand* (modern horse), *Trail of the Yukon* (Mounties), *The Cowboy and the Indians, Broken Arrow* (as Geronimo), *Red Mountain, Battle at Apache Pass* (as Geronimo), *Brave Warrior* (Colonial period), *The Pathfinder* (Colonial period), *Jack McCall Desperado, The Nebraskan, War Arrow, Saskatchewan/O'Rourke of the Royal Mounted, Drums across the River, The Black Dakotas, Four Guns to the Border, Masterson of Kansas, The Vanishing American,*

JAY SILVERHEELS in *The Lone Ranger and the Lost City of Gold*

The Lone Ranger, Walk the Proud Land (as Geronimo), *Return to Warbow, The Lone Ranger and the Lost City of Gold, Alias Jesse James* (comedy; guest), *Geronimo's Revenge* (TV), *Indian Paint, One Little Indian, The Man Who Loved Cat Dancing, Santee* (73).

355 SINATRA, Frank (1915–). Actor and singer with one dramatic W and four lighter excursions.
 The Kissing Bandit (musical) (49), *Johnny Concho, Sergeants 3* (comedy), *Four for Texas* (comedy), *Dirty Dingus Magee* (comedy) (70).

356 SITTING BULL (c1835–1890). The great leader of the Sioux who laid the trap that destroyed Custer and his command at the Little Big Horn, he was a member of the Hunkpapa tribe and united the other tribes behind him. A skilful organiser and medicine man as much as a fighter, he is usually portrayed on screen with some dignity and respect, giving Crazy Horse the role of the ruthless, eager warrior in Custer's demise; he was murdered when the cult of the Ghost Dance

FRANK SINATRA in *Johnny Concho*

stirred up the Indians and he might have proved a figurehead for a new war against the white man.

Noble Johnson *Hands Up!* (comedy) (26), Noble Johnson *The Flaming Frontier,* Chief Yowlach(i)e (*With*) *Sitting Bull at the Spirit Lake Massacre,* Chief Thunderbird *Annie Oakley* (Wild West Show), Howling Wolf *Custer's Last Stand,* J. Carrol Naish *Annie Get Your Gun* (musical), Michael Granger *Fort Vengeance,* J. Carrol Naish *Sitting Bull,* Michael Pate *The Great Sioux Massacre* (65).

357 SPRINGSTEEN, R. G. (1904–). Director who made many of the Wild Bill Elliott, Allan Rocky Lane and Monte Hale Ws of the late Forties onwards and went on to direct a good number of the few minor Ws made in the Sixties; unfortunately, his only work of recognised distinction, *Come Next Spring,* was outside the W field.

Phantom of the Plains (assoc. prod. only) (45), *Marshal of La-* *redo, Colorado Pioneers, Wagon Wheels Westward, California Gold Rush, Sheriff of Redwood Valley, Home on the Range, Sun Valley Cyclone, Man from Rainbow Valley, Conquest of Cheyenne, Santa Fe Uprising, Vigilantes of Boomtown, Homesteaders of Paradise Valley, Oregon Trail Scouts, Rustlers of Devil's Canyon, Marshal of Cripple Creek, Along the Oregon Trail, Under Colorado Skies, Sundown in Santa Fe, Renegades of Sonora, Sheriff of Wichita, Death Valley Gunfighters, Hellfire, Navajo Trail Raiders, Singing Guns, Arizona Cowboy, Hills of Oklahoma, Covered Wagon Raid, Frisco Tornado, Oklahoma Annie* (comedy), *Toughest Man in Arizona, A Perilous Journey, Cole Younger Gunfighter, King of the Wild Stallions, Showdown, He Rides Tall, Bullet for a Badman, Black Spurs, Taggart, Apache Uprising, Johnny Reno, Waco, Red Tomahawk, Hostile Guns* (67).

358 STALLINGS, Laurence (1894–1968). Though best known as the co-author of the play "What Price Glory?", he was one of the writers of two of John Ford's finest Ws and also some rather offbeat Ws for other directors.

Co-dial. *Billy the Kid* (TV: *The Highwayman Rides*) (30), co-sc. *Northwest Passage* (Colonial period), sc. *The Man from Dakota/Arouse and Beware* (Civil War comedy), sc. *Salome Where She Danced* (W scenes), co-sc. *Three Godfathers,* co-sc. *She Wore a Yellow Ribbon* (49).

359 STANWYCK, Barbara (1907–). Brooklyn-born actress whose W portrayals have memorably been of stubborn, hard-as-nails women not to be taken lightly.

Annie Oakley (in title role) (35), *Union Pacific, The Great Man's Lady* (W scenes), *California, The Furies, The Moonlighter, Cattle Queen of Montana, The Violent Men/Rough Company, The Maverick Queen, Trooper Hook, Forty Guns* (57).

BARBARA STANWYCK in
The Moonlighter

360 STARR, Belle (Myra Belle Shirley) (1848–1889). Born in Missouri in the frontier days, this glamorous and courageous heroine of the Old West was in reality nothing of the sort. Unattractive, she fell in with bad company in her late teens, meeting Cole Younger in Texas and eventually leading a band of rustlers from a base in Oklahoma until she was jailed by "Hanging Judge" Parker and made famous by newspaper accounts. She continued horse-stealing and enjoying her fame until killed by a bushwhacker under mysterious circumstances.

Betty Compson *Court-Martial* (28), Gene Tierney *Belle Starr*, Isabel Jewell *Badman's Territory*, Isabel Jewell *Belle Starr's Daughter*, Jane Russell *Montana Belle*, Sally Starr *The Outlaws Is Coming* (comedy), Pat Quinn *Zachariah* (71).

361 STARRETT, Charles (1903– .) Well-educated figure from a New England background who went to college and trained to be an actor; after several years of mild success, he turned to series Ws for Columbia, becoming one of the most prolific and efficient of such stars, portraying in many films a character called the Durango Kid. In Britain, his films almost invariably suffered title changes to disguise their *genre* (most of these changes are listed here).

Gallant Defender (35), *Mysterious Avenger, Secret Patrol* (Mounties), *Stampede, Code of the Range, The Cowboy Star* (W film-making), *Dodge City Trail, Westbound Mail, Trapped, Two Gun Law, Two Fisted Sheriff, One Man Justice, The Old Wyoming Trail, Law of the Plains, Call of the Rockies, Cattle Raiders, West of Cheyenne, Colorado Trail, South of Arizona, Outlaws of the Prairie, Rio Grande, The Thundering West, West of Santa Fe, Texas Stampede, North of the Yukon, Spoilers of the Range, Western Caravans/Silver Sands, Man from Sundown/A Woman's Vengeance, Riders of Black River, Outpost of the Mounties, Stranger from Texas, Bullets for Rustlers/On Special Duty, Blazing Six-Shooters/Stolen Wealth, Two - Fisted Rangers / Forestalled, Texas Stagecoach/Two Roads, West of Abilene/The Showdown, The Durango Kid/The Masked Stranger, Thundering Frontier, Outlaws of the Panhandle/Faro Jack, The Pinto Kid/All Square, The Medico of Painted Springs/The Doctor's Alibi, Thunder over the Prairie, Prairie Stranger/The Marked Bullet, The Royal Mounted Patrol/Giants A'Fire, Riders of the Badlands, West of Tombstone, Lawless Plainsmen/Roll On, Down Rio Grande Way/The Double Punch, Riders of the Northland/Next in Line* (modern N-W), *Bad Men of the Hills, Overland to Deadwood/Falling Stones, Riding through Nevada, The Fighting Buckaroo, Frontier Fury, Cowboy in the Clouds, Pardon My Gun, Law of the Northwest, Robin Hood of the Range, Hail to the Rangers/Illegal Rights, Cowboy Canteen/Close Harmony* (musical comedy), *Sundown Valley,*

CHARLES STARRETT

Riding West/Fugitive from Time, Cowboy from Lonesome River/ Signed Judgement, Cyclone Prairie Rangers, Saddle Leather Law/The Poisoner, Sagebrush Heroes, Rough Ridin' Justice/The Decoy, Return of the Durango Kid/Stolen Time, Both Barrels Blazing, Rustlers of the Badlands/By Whose Hand?, Outlaws of the Rockies/A Roving Rogue, Blazing the Western Trail/Who Killed Waring?, Lawless Empire/Power of Possession, Texas Panhandle, Frontier Gunlaw/Menacing Shadows, Roaring Rangers/False Hero, Gunning for Vengeance/Jail Break, Galloping Thunder, Two Fisted Stranger /High Stakes, Desert Horseman/ Checkmate, Heading West/The Cheat's Last Throw, Landrush/The Claw Strikes, Terror Trail/Hands of Menace, Fighting Frontiersman/ Golden Lady, South of the Chisholm Trail/Strange Disappearance, Lone Hand Texan/The Cheat, West of Dodge City/The Sea Wall, Law of the Canyon, Prairie Raiders/The Forger, Stranger from Ponca City, *Riders of the Lone Star, Buckaroo from Powder River, Last Days of Boot Hill/On Boot Hill, Six-Gun Law, Phantom Valley, West of Sonora, Whirlwind Raiders/State Police, Blazing across the Pecos/Under Arrest, Desert Vigilante, Trail to Laredo/Sign of the Dagger, El Dorado Pass, Challenge of the Range/Moonlight Raid, Quick on the Trigger/ Condemned in Error, Laramie, The Blazing Trail/The Forged Will, South of Death Valley/River of Poison, Horsemen of the Sierras/Remember Me, Bandits of El Dorado/Tricked, Renegades of the Sage/The Fort, Trail of the Rustlers/Lost River, Outcast of Black Mesa/The Clue, Texas Dynamo/Suspected, Streets of Ghost Town, Across the Badlands/ The Challenge, Riders of Tomahawk Creek/Circle of Fear, Frontier Outpost, Lightning Guns/Taking Sides, Smoky Canyon, Prairie Round-Up, Ridin' the Outlaw Trail, Fort Savage Raiders, Snake River Desperadoes, Bonanza Town/Two Fisted Agent, Cyclone Fury, The Kid from Amarillo/Silver Chains, Pecos River/ Without Risk, The Hawk of Wild River, Laramie Mountains/Mountain Desperadoes, Rough Tough West, Junction City, The Kid from Broken Gun* (52).

362 STEIGER, Rod (1925–). Skilful actor who did not enjoy starring in *Run of the Arrow* and has shown little inclination to head West since achieving real fame.

Jubal (56), *Oklahoma!* (musical; W elements), *Run of the Arrow, Duck You Sucker!/A Fistful of Dynamite* (Mexico) (72).

363 STEINER, Max (1888–1971). Born in Vienna, this extraordinarily prolific composer, so much a part of Warner Bros. history, was frequently called on to give the W excitement and grandeur via his vigorous, stentorian scores.

Cimarron (31), *The Conquerors* (W elements), *Cheyenne Kid, Renegades of the West, Son of the Border,*

*West of the Pecos, God's Country
and the Woman* (W elements), *Gold
Is Where You Find It* (W elements),
Valley of the Giants (timber), *The
Oklahoma Kid, Dodge City, Viriginia
City, Santa Fe Trail, They Died with
Their Boots On, San Antonio, Pur-
sued, Cheyenne, The Treasure of the
Sierra Madre* (W elements), *Silver
River, South of St. Louis, Mrs. Mike*
(Mounties), *Rocky Mountain, Dallas,
Sugarfoot* (TV: *A Swirl of Glory*),
*Raton Pass/Canyon Pass, Distant
Drums, The Lion and the Horse,
Springfield Rifle, The Iron Mistress*
(W scenes), *The Charge at Feather
River, The Boy from Oklahoma, The
Violent Men/Rough Company, The
Last Command, The Searchers, Ban-
dido* (Mexico), *Fort Dobbs, The
Hanging Tree, A Distant Trumpet*
(64).

364 STEVENS, George (1904–75).
Former cameraman turned director
with the classic *Shane* as his one
real W.

As co-photographer: *Black Cy-
clone* (horse) (25), *The Devil
Horse, The Desert's Toll* (or *The
Devil's Toll*), *The Valley of Hell,
No Man's Law* (or *No Man's Land*),
Lightning (modern) (27).

As director: *Annie Oakley* (W
elements) (35), *Shane, Giant* (mod-
ern; W elements) (56).

365 STEWART, James (1908–
). Lanky, soft-spoken star who in
his Ws has built up an image that
usually reflects a quiet integrity and
stubbornness, seen at its most intense
in his Anthony Mann films where
pursuing some private quest of re-
venge. Apart from playing a small
role in musical *Rose Marie* and the
deceptively peaceable deputy of
Destry Rides Again, he only turned
to Ws quite late in his career to re-
vive his fortunes and has never ne-
glected them since.

Rose Marie (musical; Canada)
(36), *Destry Rides Again, Winches-
ter '73, Broken Arrow, Bend of the
River/Where the River Bends, The*

JAMES STEWART with Marlene
Dietrich in *Destry Rides Again*

*Naked Spur, The Far Country, The
Man from Laramie, Night Passage,
Two Rode Together, The Man Who
Shot Liberty Valance, How the West
Was Won* (ep. "Rivers"), *Cheyenne
Autumn* (comedy episode; as Wyatt
Earp), *Shenandoah* (Civil War),
*The Rare Breed, Firecreek, Bando-
lero!, The Cheyenne Social Club*
(comedy) (70).

JOHN STURGES (left) with
Clint Eastwood on *Joe Kidd*

366 STURGES, John (1911).
Director with a cool, detached style,
favouring long shots and pans, that
lets one appreciate the actors in their
environment, whether interiors or ex-
teriors. His work relies for forceful-
ness on the scripts and varies in merit
according to their quality, but he has

allowed much of his recent work to
run to excessive length and slack-
ness, a far cry from the tautness of
such films as *Escape from Fort
Bravo.*

The Walking Hills (modern) (49),
The Capture (modern Mexico), *Es-
cape from Fort Bravo, The Scarlet
Coat* (Civil War), *Backlash, Gun-
fight at the O.K. Corral, Saddle the
Wind* (uncredited completion; song
sequence), *The Law and Jake Wade,
Last Train from Gun Hill, The Mag-
nificent Seven, Sergeants 3* (comedy),
The Hallelujah Trail (comedy),
*Hour of the Gun, Joe Kidd, Valdez
the Halfbreed* (74).

367 SULLIVAN, Barry (1912–
). Slightly inexpressive, reserved
actor, usually playing coolly self-
assured types in Ws; has a good
combination of charm and power
giving strong screen presence.

The Woman of the Town (43),
*Bad Men of Tombstone, The Out-
riders, Texas Lady, The Maverick
Queen, Dragoon Wells Massacre,
Forty Guns, Seven Ways from Sun-
down, Stage to Thunder Rock, Buck-
skin* (68).

368 SULLIVAN, C. Gardner
(1879–1965). The first great W film
writer, responsible for many of the

BARRY SULLIVAN (right) with Audie Murphy in *Seven Ways from Sundown*

ROBERT REDFORD (left) as The Sundance Kid with Paul Newman as Butch Cassidy in *Butch Cassidy and the Sundance Kid*

austerely authentic William S. Hart pictures like the classic *Hell's Hinges.* In the late Thirties, he worked for DeMille with less distinctive results. Supervised *White Gold* (27).

St. sc. *The Heart of an Indian,* st. sc. *Redemption,* st. sc. *The Woman,* st. sc. *Days of 1849* (all 2r, 13), st. co-sc. *The Bargain,* st. sc. *On the Night Stage* or *The Bandit and the Preacher,* st. sc. *The Reckoning* or *Satan McAllister's Heir,* st. sc. *The Aryan,* st. sc. *Hell's Hinges,* st. sc. *The Return of Draw Egan,* st. sc. *Border Wireless,* st. sc. *Branding Broadway* (modern), st. sc. *Selfish Yates,* st. sc. *Shark Monroe,* st. sc. *John Petticoats,* st. sc. *Wagontracks,* sc. *Tumbleweeds,* st. *The Bugle Call,* part sc. *Union Pacific,* part sc. *North West Mounted Police,* st. *Jackass Mail* (42).

369 SUNDANCE KID, The (Harry Longbaugh) (–1908). Shot to screen prominence by Robert Redford's portrayal opposite Paul Newman in *Butch Cassidy and the Sundance Kid,* the Kid was given an essentially accurate portrait in that film except that he was by nature more brutal and less sympathetic than Butch. The Kid was born in the East—at Plainfield, New Jersey —but jailed as a boy at Sundance, Wyoming, for horse-stealing out West. He escaped from a later jail sentence for train-robbing and pursued this sport (and bank hold-ups) as a member of "The Wild Bunch" led by Butch Cassidy. He accompanied Butch and their woman friend, Etta Place, to New York, New Orleans and South America. It was there that he died, *c*1908, along with Butch after a series of hold-ups on the pampas.

Ian MacDonald *The Texas Rangers* (51), William Bishop *Wyoming Renegades,* Scott Brady *The Maverick Queen* (character called Sundance), Alan Hale Jr. *The Three Outlaws,* Russell Johnson *Badman's Country,* John Davis Chandler *Return of the Gunfighter,* Robert Redford *Butch Cassidy and the Sundance Kid* (69).

370 TAYLOR, Robert (1911– 1969). Nebraskan whose handsome looks and cleancut appearance delayed his whole-hearted entry into the rough-and-tumble world of the W; in fact, he remained well-dressed for his W parts and gave neatly effective, seemingly effortless performances of considerable persuasiveness.

ROBERT TAYLOR in *Cattle King*

Stand Up and Fight (39), *Billy the Kid* (in title role), *Ambush, Devil's Doorway, Westward the Women, Ride Vaquero!, Many Rivers to Cross* (backwoods comedy), *The Last Hunt, Saddle the Wind, The Law and Jake Wade, The Hangman, Cattle King/Guns of Wyoming, Johnny Tiger, Savage Pampas* (*Pampa salvaje*), *Return of the Gunfighter, Hondo and the Apaches* (bit) (67).

371 TEAL, Ray (1902–). Former musician with his own show who turned character actor, entering films in 1938; excels at conveying an irritable or sly temperament if not both; apt to be a corrupt official or henchman killed off serving the villains.

Western Jamboree (38), *Adventures of Red Ryder* (s), *Northwest Passage* (Colonial period), *Prairie Schooners/Through the Storm, Cherokee Strip, Pony Post, Honky Tonk, Outlaws of the Panhandle/ Faro Jack, They Died with Their Boots On, Wild Bill Hickok Rides, Northwest Rangers* (Colonial period), *Apache Trail, Barbary Coast Gent, Along Came Jones* (comedy), *The*

Harvey Girls (musical), *Canyon Passage, The Michigan Kid, Ramrod, Road to Rio* (W sequence), *Unconquered* (Colonial period), *The Man from Colorado, Streets of Laredo, Whispering Smith, Indian Scout* or *Davy Crockett Indian Scout, Ambush, The Kid from Texas/ Texas Kid Outlaw, Winchester '73, The Great Missouri Raid, The Redhead and the Cowboy, Along the Great Divide, Fort Worth, Distant Drums, Flaming Feather, The Wild North* (Mounties), *The Lion and the Horse, Montana Belle* (as Emmett Dalton), *Hangman's Knot, Cattle Town, Ambush at Tomahawk Gap, The Command, Rage at Dawn, Run for Cover, The Man from Bitter Ridge, Apache Ambush, The Indian Fighter, The Young Guns, The Burning Hills, Utah Blaine, The Guns of Fort Petticoat, The Phantom Stagecoach, The Oklahoman, Decision at Sundown, The Tall Stranger, Saddle the Wind, Gunman's Walk, One Eyed Jacks, Posse from Hell, Cattle King/Guns of Wyoming, Bullet for a Badman, Taggart, Chisum* (70).

372 THOMSON, Fred (1890– 1928). The least remembered of topflight W stars due to an early death from pneumonia while at the peak of popularity, he had a popular appeal almost level with that of William S. Hart (whom he replaced as Paramount's main W star) and Tom Mix. A highly capable athlete who performed many of his own stunts, he was a former army chaplain whose films eschewed excessive violence and gunplay, instead concentrated on light, enjoyable stories. Horse: Silver King.

The Eagle's Talons (s) (modern?) (23), *The Mask of Lopez, North of Nevada, Galloping Gallagher* (or *The Sheriff of Tombstone*), *The Silent Stranger, The Dangerous Coward, The Fighting Sap, Thundering Hoofs* (Mexico), *That Devil Quemado* (Mexico), *The Bandit's*

*Baby, The Wild Bull's Lair, Ridin'
the Wind, All around Frying Pan,
The Tough Guy, Hands across the
Border* (modern), *The Two-Gun
Man, Lone Hand Saunders, A Reg-
ular Scout, Don Mike* (early Cali-
fornia), *Arizona Nights, Silver Comes
Through* (W elements), *Jesse James*
(as Jesse), *The Pioneer Scout, The
Sunset Legion, Kit Carson* (as Car-
son) (28).

373 TIOMKIN, Dimitri (1899–
). Born in Russia, a composer of
versatility, able to fully match the
visual proportions of the epic (*Duel
in the Sun*) or take a simpler ap-
proach to quietly reinforcing a
smaller dramatic situation (*High
Noon*). His work is insistent, like
that of Steiner, but rewardingly so.
 The Westerner (39), *Duel in the
Sun, The Dude Goes West* (comedy),
*Red River, Canadian Pacific, Dakota
Lil, Drums in the Deep South* (Civil
War), *Bugles in the Afternoon, High
Noon, The Big Sky* (Colonial
period), *The Command, Strange
Lady in Town, Tension at Table
Rock, Friendly Persuasion* (Civil
War), *Gunfight at the O.K. Corral,
Night Passage, The Young Land, Rio
Bravo, Last Train from Gun Hill,
The Unforgiven, The Alamo, The
Last Sunset* (scored song only), *The
War Wagon, Mackenna's Gold* (co-
prod. only) (68).

374 TOURNEUR, Jacques (1904–
). The son of Maurice Tourneur,
he is best known for his horror films
but has brought the same under-
stated style and delicacy to the W.
An actor in *Trail of '98* (N-W)
(29).
 Canyon Passage (46), *Stars in
My Crown* (W opening scene),
Way of a Gaucho (South America),
*Stranger on Horseback, Wichita,
Great Day in the Morning, Fury
River* (ep. "The Vulture") (TV),
Frontier Ranger (all three eps.)
(TV), *Mission of Danger* (ep. "The
Break Out") (TV) (59) (last three

FRED THOMSON

derived from *Northwest Passage*
series).

375 TRACY, Spencer (1900–67).
One of the screen's most reliable
and outstanding actors, rarely in-
volved with the W.
 Northwest Passage (Colonial
period) (40), *Sea of Grass, Broken
Lance, How the West Was Won*
(narration only) (62).

376 TREVOR, Claire (1912–).
Actress whose Dallas, the good
"bad" girl, in *Stagecoach* is outstand-
ing among many contributions to the
W, most of them of blowsy, "com-
mon" types.
 Life in the Raw (modern) (33),
The Last Trail (modern), *Wild
Gold, Valley of the Giants* (timber),
*Stagecoach, Allegheny Uprising/The
First Rebel* (Colonial period), *The
Dark Command, Texas, Honky Tonk,
Desperadoes, The Woman of the
Town, Best of the Badmen, The*

Stranger Wore a Gun, Man without a Star (55).

377 TROTTI, Lamar (1900–52). A prolific and talented writer for 20th Century-Fox who also produced his later work.

Though he wrote many originals, all his W scripts were derived from others' basic material.

Sc. *Ramona* (Indian love story) (36), co-sc. *The Country Beyond* (Mounties), co-sc. *Drums along the Mohawk* (Colonial period), sc. *Brigham Young—Frontiersman*, sc. *Belle Starr*, sc. and prod. *The Ox Bow Incident/Strange Incident*, sc. and prod. *Yellow Sky* (48).

378 TUCKER, Forrest (1919–). Rugged actor, an occasional hero but more often a bully, villain or coward; one of the screen's best fighters from his debut battling Gary Cooper in *The Westerner*.

The Westerner (39), *Shut My Big Mouth* (comedy), *Renegades, Gun fighters/The Assassin, Adventures in Silverado/Above All Laws, Coroner Creek, The Plunderers, The Last*

LAMAR TROTTI

Bandit, Hellfire, Brimstone, The Nevadan/The Man from Nevada, Rock Island Trail/Transcontinental Express, California Passage, Oh! Susanna, Warpath, Flaming Feather, Bugles in the Afternoon, Montana Belle, Ride the Man Down, San Antone, Pony Express (as Wild Bill Hickok), *Jubilee Trail, Rage at Dawn, The Vanishing American, Stagecoach to Fury, The Quiet Gun, Three Violent People, The Deerslayer* (Colonial period), *Fort Massacre, Gunsmoke in Tucson, Barquero, Chisum* (70).

FORREST TUCKER in *Barquero*

379 TWIST, John (1898–). Veteran screenwriter.

Co-st. *The Slingshot Kid* (27), co-st. *The Pinto Kid*, st. *Tracked*, co-sc. *The Yellowback* (Canada), sc. *The Big Diamond Robbery* (modern), co-sc. *West of the Pecos*, co-sc. *Annie Oakley* (Wild West show), part sc. *The Last Outlaw*, co-sc. *Yellow Dust*, co-sc. *The Outcasts of Poker Flat*, co-sc. *The Law West of Tombstone*, co-st. co-sc. *Colorado Territory*, sc. *Dallas*, co-sc. *Best of the Badmen*, st. sc. *Fort Worth*, co-sc. *The Big Trees*, sc. *The Man behind the Gun*, sc. *A Distant Trumpet* (64).

LEE VAN CLEEF

380 VAN CLEEF, Lee (1925–). An actor whose narrow eyes, lean, bony features and voice for long type-cast him as a villain in Ws and crime dramas; has become an anti-hero lead in big Italian Ws.

High Noon (52), *Untamed Frontier, The Lawless Breed, Tumbleweed, Arena* (rodeo), *Jack Slade/ Slade, The Nebraskan, Rails into Laramie, Arrow in the Dust, The Yellow Tomahawk, The Desperado, Dawn at Socorro, Treasure of Ruby Hills, Ten Wanted Men, Road to Denver, A Man Alone, The Vanishing American, Red Sundown* (footage from *Dawn at Socorro*), *Tribute to a Bad Man, Pardners* (comedy), *The Quiet Gun, Gunfight at the O.K. Corral, The Badge of Marshal Brennan, The Last Stagecoach West, The Lonely Man, Joe Dakota, Gun Battle at Monterey, The Tin Star, Raiders of Old California, Day of the Badman, The Bravados, Ride Lonesome, Posse from Hell, The Man Who Shot Liberty Valance, How the West Was Won* (ep. "Outlaws"), *For a Few Dollars More (Per qualche dollaro in più), The Good the Bad and the Ugly (Il buono il brutto il cattivo), The Big Gundown (La resa dei conti), Day of Anger (I giorni dell' ira), Death Rides a Horse (Da uomo a uomo), Beyond the Law (Al di la della legge), A Professional Gun (Il Mercenario), Barquero, El Condor, Sabata (Ehi, amico . . . c'è Sabata, hai chiuso!), Captain Apache, Bad Man's River, The Magnificent Seven Ride!, Return of Sabata* (72).

381 VIDOR, King (1896–). Texas-born director with a long and honourable career; his Ws may not represent his most ambitious or personal work, but they are all first-rate examples of the genre.

The Sky Pilot (N-W) (21), *Billy the Kid* (TV: *The Highwayman Rides), The Texas Rangers, Northwest Passage* (Colonial period), *Duel in the Sun* (co-dir.), *Man without a Star* (55).

382 WALKER, Clint (1927–). Powerfully built actor who once worked as a deputy sheriff and prospected for silver, two "roles" that must have stood him in good stead as a screen cowboy which he first became with the TV series

CLINT WALKER with
Virginia Mayo in *Fort Dobbs*

ELI WALLACH in *Mackenna's Gold*

Cheyenne, some eps. of which were released to British cinemas (first six titles).

Border Showdown (56), *The Storm Riders, Julesburg, Mountain Fortress, The Argonauts, The Outlander, Fort Dobbs, Yellowstone Kelly, Gold of the Seven Saints, The Night of the Grizzly* (also st.), *More Dead than Alive, Sam Whiskey, The Great Bank Robbery* (comedy), *Pancho Villa* (Mexico) (72).

383 WALLACH, Eli (1915–). Actor from the "method" school, the Mexican bandit of *The Magnificent Seven* and the "ugly" third of *The Good, the Bad and the Ugly.*

The Magnificent Seven (60), *The Misfits* (modern), *How the West Was Won* (ep. "Railroad"), *The Good the Bad and the Ugly* (*Il buono il brutto il cattivo*), *Ace High/Revenge in El Paso* (*I quattro dell' Ave Maria*), *Mackenna's Gold* (68).

384 WALSH, Raoul (1887–). A director whose reputation is based on his brisk handling of action films —gangster dramas and Ws especially —he grew up on the family ranch and became a bronc buster before taking up acting and being an assistant to D. W. Griffith who sent him to Mexico to make a film on Pancho Villa; he was also an occasional actor until he lost an eye in 1929. Reputedly took an uncredited hand in the direction of *San Antonio* and *Montana;* recently wrote a W novel, "La Colère des Justes," published in France.

Life of Villa (sc. and co-dir.) (12), *Blue Blood and Red* (also sc.), *Betrayed* (also sc.; W elements), *The Conqueror* (also sc.), *In Old Arizona* (co-dir.), *The Big Trail, The Dark Command, They Died with Their Boots On, Pursued, Cheyenne* (TV: *Wyoming Kid*), *Silver River, Colorado Territory, Along the Great Divide, Distant Drums, The Lawless Breed, Gun Fury, Saskatchewan/O'Rourke of the Royal Mounted, The Tall Men,*

The King and Four Queens, The Sheriff of Fractured Jaw (comedy), *A Distant Trumpet* (64).

385 WARREN, Charles Marquis (1912–). Novelist, screenwriter, director, producer, principally associated with Ws.

Sc. *Streets of Laredo* (49), st. *The Redhead and the Cowboy*, st. sc. *Oh! Susanna*, novel basis *Only the Valiant*, sc. dir. *Little Big Horn/The Fighting 7th*, co-st. *Woman of the North Country*, co-st. sc. dir. *Hellgate*, co-sc. *Springfield Rifle*, sc. *Pony Express*, sc. dir. *Arrowhead*, dir. *Seven Angry Men*, dir. *Tension at Table Rock*, dir. *The Black Whip*, dir. *Trooper Hook*, dir. exec. prod. *Copper Sky*, dir. exec. prod. *Blood Arrow*, st. dir. exec. prod. *Ride a Violent Mile*, dir. *Cattle Empire*, st. co-sc. *Day of the Evil Gun*, sc. dir. prod. *Charro* (69).

386 WAYNE, John (1907–). Even today the leading star of the *genre* (challenged only by Clint Eastwood) after some thirty years of being a W favourite; had big starring opportunity with *The Big Trail* in 1930, lapsed into B features until John Ford rescued him to play the Ringo Kid in *Stagecoach;* has never looked back since, and notched up a splendid W record with such directors as Ford, Hawks and Hathaway. Son Michael now produces most of his pictures for the Batjac company.

Rough Romance (timber) (30), *The Big Trail, Range Feud, Texas Cyclone, Two Fisted Law, Ride Him Cowboy/The Hawk, The Big Stampede, Haunted Gold, The Telegraph Trail, Somewhere in Sonora, The Man from Monterey* (early California), *Riders of Destiny, Sagebrush Trail, The Lucky Texan, West of the Divide, Blue Steel, The Man from Utah, Randy Rides Alone, The Star Packer, The Trail Beyond, The Lawless Frontier, 'Neath Arizona Skies, Texas Terror, Rainbow Valley, The Desert Trail, The Dawn Rider, Paradise Canyon, Westward Ho, The*

JOHN WAYNE with
Claire Trevor in *Stagecoach*

New Frontier, The Lawless Range, The Oregon Trail, The Lawless Nineties, King of the Pecos, The Lonely Trail, Winds of the Wasteland, Born to the West (later *Hell Town*), *Pals of the Saddle, Overland Stage Raiders, Santa Fe Stampede, Red River Range, Stagecoach, The Night Riders, Three Texas Steers /Danger Rides the Range, Wyoming Outlaw, New Frontier* (TV: *Frontier Horizon*), *Allegheny Uprising/The First Rebel* (Colonial period), *The Dark Command, The Spoilers* (N-W), *In Old California, A Lady Takes a Chance* (modern comedy), *In Old Oklahoma* (later *War of the Wildcats*), *Tall in the Saddle, Flame of the Barbary Coast* (W elements), *Dakota, Angel and the Badman, Fort Apache, Red River, Three Godfathers, The Fighting Kentuckian* (Colonial period), *She Wore a Yellow Ribbon, Rio Grande, Hondo, The Searchers, Rio Bravo, The Horse Soldiers* (Civil War), *The Alamo* (also dir. and prod.), *North to*

JOHN WAYNE in *True Grit*

Alaska (N-W), *The Comancheros, The Man Who Shot Liberty Valance, How the West Was Won* (ep. "Civil War"), *McLintock!* (comedy), *The Magnificent Showman* or *Circus World* (Wild West show), *The Sons of Katie Elder, The War Wagon, El Dorado, True Grit, The Undefeated, Chisum, Rio Lobo, Big Jake, The Cowboys, The Train Robbers, Cahill: United States Marshal/Cahill* (73).

387 WEBB, James R. (1909–74). Former writer of magazine fiction who turned to scripting for Roy Rogers then later worked on major pictures including many Ws, winning an Oscar for *How the West Was Won*.

St. sc. *Nevada City* (41), st. *Sheriff of Tombstone*, st. sc. *Bad Man of Deadwood*, sc. *Jesse James at Bay*, sc. *South of Santa Fe*, co-sc. *South of St. Louis*, part sc. *Montana*, co-sc. *Raton Pass/Canyon Pass*, co-sc. *The Big Trees*, sc. *The Iron Mistress* (life of Jim Bowie), st. sc.

The Charge at Feather River, sc. *Apache*, co-sc. *Vera Cruz* (Mexico), part sc. *The Big Country*, st. sc. *How the West Was Won*, sc. *Cheyenne Autumn*, sc. *Guns of San Sebastian* (W elements) (67).

388 WELLES, Halsted. Two good Ws out of the three in this writer's few scripts.

Sc. *3:10 to Yuma* (57), co-sc. *The Hanging Tree*, sc. *A Time for Killing/The Long Ride Home* (67).

389 WELLMAN, Paul I. (1898–1966). Novelist, predominantly a W writer.

St. *Cheyenne* (47), novel basis *The Iron Mistress* (life of Jim Bowie), novel basis ("Broncho Apache") *Apache*, novel basis ("Jubal Troop") *Jubal*, novel basis *The Comancheros* (61).

390 WELLMAN, William A. (1896–). Director whose work covers most of the *genres* but shows a special interest in aviation; his Ws

are a diverse bunch with the stark anti-lynching drama *The Ox Bow Incident* the best known.

The Man Who Won (23), *The Vagabond Trail, The Circus Cowboy* (W character), *The Conquerors* (W elements), *Stingaree* (Australian W), *Robin Hood of El Dorado, The Great Man's Lady* (W scenes), *The Ox Bow Incident/Strange Incident, Buffalo Bill, Yellow Sky, Across the Wide Missouri, Westward the Women, Track of the Cat* (W elements) (54).

391 WERKER, Alfred (1896–). Born in the W town of Deadwood, South Dakota, he worked on a number of Fred Thomson's silent Ws first as asst. dir. then as co-dir; and made three of George O'Brien's Ws in Thirties. Asst. dir. on *That Devil Quemado, The Bandit's Baby, The Wild Bull's Lair* (all 25), *The Tough Guy, Lone Hand Saunders* (both 26); supervised *Jesse James* (27).

Ridin' the Wind (co-dir.) (25), *Pioneer Scout* (co-dir.), *Sunset Legion* (co-dir.), *Kit Carson* (co-dir.), *Last of the Duanes, Fair Warning, The Gay Caballero, The Last Posse, Devil's Canyon, Three Hours to Kill, Canyon Crossroads, At Gunpoint/ Gunpoint!, Rebel in Town* (56).

392 WIDMARK, Richard (1915–). Forceful, always conscientious actor who conveys a wiry toughness and hard determination.

Yellow Sky (48), *Garden of Evil, Broken Lance, Backlash, The Last Wagon, The Law and Jake Wade, Warlock, The Alamo* (as Jim Bowie), *Two Rode Together, How the West Was Won* (ep. "Railroad"), *Cheyenne Autumn, Alvarez Kelly, The Way West, Death of a Gunfighter, A Talent for Loving* (unreleased), *When the Legends Die* (modern rodeo/Indian life) (72).

393 WILKE, Robert J. Tall character actor from Ohio with toothy smile and (usually) evil intent: a former lifeguard who became a

RICHARD WIDMARK in
How the West Was Won

stuntman in mid-Thirties, working on modern W serial *King of the Texas Rangers* (41) among others; progressed to series Ws with Tim Holt and Charles Starrett; made his way to bigger work after playing in *High Noon*.

The San Antonio Kid (44), *Sheriff of Sundown, Vigilantes of Dodge City, Sunset in El Dorado, Trail of Kit Carson, The Topeka Terror, Sheriff of Cimarron, Santa Fe Saddlemates, Rough Riders of Cheyenne, Corpus Christi Bandits, Roaring Rangers/False Hero, Out California Way, The Vigilantes Return, West of Dodge City/The Sea Wall, Law of the Canyon, Last Days of Boot Hill/ On Boot Hill, West of Sonora, Carson City Raiders, A Southern Yankee/ My Hero* (Civil War comedy), *Laramie, The Wyoming Bandit, Mule Train, Outcast of Black Mesa/The Clue, Beyond the Purple Hills, Across the Badlands/The Challenge, Frontier Outpost, Saddle Legion, Gunplay, Best of the Badmen* (as Jim Younger), *Pistol Harvest, Cyclone Fury, Hot Lead, Overland Telegraph, Road*

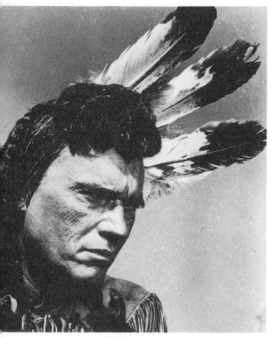

ROBERT WILKE in
The Hallelujah Trail

Agent, Laramie Mountains/Mountain Desperadoes, High Noon, Hellgate, Fargo, Wyoming Roundup, Cattle Town, The Maverick, Cow Country, Powder River, Arrowhead, War Paint, The Lone Gun, Two Guns and a Badge, The Far Country, Smoke Signal, Shotgun, Strange Lady in Town, Wichita, The Lone Ranger, Backlash, The Rawhide Years, Canyon River, Mountain Fortress (TV), *Raw Edge, Gun the Man Down, Night Passage, Return to Warbow, Man of the West, Texas John Slaughter* (TV), *The Magnificent Seven, The Long Rope, The Gun Hawk, The Hallelujah Trail* (comedy), *Smoky* (horse), *Joaquin Murieta* (TV), *The Cheyenne Social Club* (comedy), *A Gunfight, Santee* (73).

394 WILLS, Chill (1903–). Texan who broke into films through being spotted singing in a Hollywood restaurant, made his early appearances as the leader of the Avalon Boys group; later appeared in several George O'Brien Ws and went on to become one of the outstanding W character actors, usually loquacious, often something of a homespun philosopher, more shrewd than comic.

Bar 20 Rides Again (35), *Call of the Prairie, Way Out West* (comedy), *Lawless Valley, Arizona Legion, Trouble in Sundown, Racketeers of the Range* (modern), *Timber Stampede, Allegheny Uprising/The First Rebel* (Colonial period), *The Westerner, Western Union, The Bad Man /Two Gun Cupid, Billy the Kid, Belle Starr, Honky Tonk, The Omaha Trail, Apache Trail, Barbary Coast Gent, The Harvey Girls* (musical), *Northwest Stampede, Loaded Pistols, Red Canyon, The Sundowners/ Thunder in the Dust, Rock Island Trail/Transcontinent Express, High Lonesome, Rio Grande, Oh! Susanna, Cattle Drive, Bronco Buster* (modern rodeo), *Ride the Man Down, The Man from the Alamo, Tumbleweed, Timberjack, Kentucky Rifle, Giant* (W elements), *Gun for a Coward,*

CHILL WILLS (left) with
Don Murray in *From Hell to Texas*

*Gun Glory, From Hell to Texas/
Manhunt, The Sad Horse* (horse),
*The Alamo, Gold of the Seven Saints,
The Deadly Companions, Young
Guns of Texas, McLintock!* (comedy), *The Rounders* (modern), *Pat
Garrett and Billy the Kid* (73).

395 WINDSOR, Marie (1924–).
Tall actress, an expert horsewoman
(holder of several awards) who has
maintained her good looks superbly,
specialising in brazen, vulgar, domineering women.

The Romance of Rosy Ridge (W
elements) (47), *The Kissing Bandit*
(musical), *The Beautiful Blonde
from Bashful Bend* (comedy), *Hellfire, The Fighting Kentuckian* (Colonial period), *Dakota Lil, The Showdown, Frenchie, Little Big Horn/
The Fighting 7th, Outlaw Women,
The Tall Texan, The Bounty Hunter,
The Silver Star, Two-Gun Lady, The
Parson and the Outlaw, Day of the
Badman, Mail Order Bride/West of
Montana* (comedy), *The Good Guys
and the Bad Guys, One More Train
to Rob, Support Your Local Gunfighter* (comedy), *Cahill: United
States Marshal/Cahill* (73).

MARIE WINDSOR in
Cahill: United States Marshal

SHELLEY WINTERS with
Dan Duryea in *Winchester '73*

396 WINTERS, Shelley (1922–
). Boisterous actress, usually
around saloons in her Ws.

Red River (bit) (48), *Winchester
'73, Frenchie, Untamed Frontier,
Saskatchewan/O'Rourke of the Royal
Mounted, The Treasure of Pancho
Villa* (Mexico), *The Scalphunters,
Flap/The Last Warrior* (comedy)
(70).

397 WISE, Robert (1914–). Director of considerable technical
ability and skill with actors. Former
editor (no Ws).

Blood on the Moon (48), *Two
Flags West, Tribute to a Bad Man*
(56).

398 WORDEN, Hank. Usually
appears as an amiable half-wit in a
great many John Ford films; lesser
parts in other pictures, almost all Ws.
Tall, thin and bald-headed.

Stranger from Arizona (38),
Ghost Town Riders, Northwest Passage (Colonial period), *Gaucho
Serenade, Border Vigilantes, Tenting
Tonight on the Old Camp Ground,
Lawless Breed* (TV: *Lawless Clan*),
Angel and the Badman, Prairie Express, Fort Apache, Red River, Yel-

HANK WORDEN in *Red River*

low Sky, Three Godfathers, The
Fighting Kentuckian (Colonial peri-
od), Wagonmaster, Sugarfoot (TV:
Swirl of Glory), The Big Sky (Co-
lonial period), Woman of the North
Country, Apache War Smoke, The
Indian Fighter, The Searchers, Davy
Crockett and the River Pirates, The
Quiet Gun, Spoilers of the Forest,
Dragoon Wells Massacre, Bullwhip,
The Buckskin Lady, Forty Guns,

WILLIAM WYLER
directing *The Big Country*

Toughest Gun in Tombstone, The
Alamo, One Eyed Jacks, McLintock!
(comedy), True Grit, Chisum, Rio
Lobo, Big Jake, Cahill: United States
Marshal/Cahill (73).

399 WRIGHT, Will (1891–1962).
Former newspaper reporter who went
into vaudeville and acting in stock
as well as producing for the stage,
then became a very busy character
actor, expertly breathing life into
such subsidiary figures as bartenders,
storekeepers, bank managers and age-
ing sheriffs in Ws.

Honky Tonk (41), *Shut My Big
Mouth* (comedy), *In Old Oklahoma*
(later *War of the Wildcats*), *Gun
Smoke, Salome Where She Danced*
(W scenes), *Relentless, Whispering
Smith, Black Eagle* (horse), *Big
Jack, Lust for Gold, Brimstone, Mrs.
Mike* (Mounties), *A Ticket to Toma-
hawk* (comedy), *The Savage Horde,
Sunset in the West, Dallas, Vengeance
Valley, The Last Posse, River of No
Return, The Raid* (Civil War),
Johnny Guitar, The Kentuckian
(Colonial period), *The Tall Men,
The Iron Sheriff, Quantrill's Raiders,
Gunman's Walk, Alias Jesse James*
(comedy), *The Deadly Companions*
(61).

400 WYLER, William (1902–).
Director, born in Europe, who was
broken in on Ws in the late silent era,
many of them two-reelers, and has
rarely ventured out West again since
becoming established as a major di-
rector.

Crook Buster (2r) (25), *The Gun-
less Badman* (2r), *Ridin' for Love*
(also st.) (2r), *The Fire Barrier*
(2r), *Don't Shoot* (2r), *Lazy
Lightning, The Stolen Ranch, Martin
of the Mounted* (2r), *The Two Fister*
(2r), (all 26), *Kelcy Gets Her Man*
(2r), *Blazing Days, Tenderfoot
Courage* (2r), *The Silent Partner*
(2r), *Hard Fists, Galloping Justice*
(2r), *The Haunted Homestead* (2r),
The Lone Star (2r), *The Ore Raiders*
(2r), *The Home Trail* (2r), *Gun
Justice* (2r), *The Phantom Outlaw*

(2r), *The Square Shooter* (2r), *The Horse Trader* (2r), *The Border Cavalier, Daze of the West* (comedy, 2r), *Shooting Straight, Straight Shootin', Desert Dust, Thunder Riders* (all 27), *Hell's Heroes, The Westerner, Friendly Persuasion* (Civil War) (also prod.), *The Big Country* (also co-prod.) (58).

401 YBARRA, Alfred C. One of the few art directors whose work is concentrated on a particular *genre;* seems to have begun on Mexico-based pictures and has frequently worked for John Wayne's Batjac company. His non-W credits are mostly other kinds of outdoor pictures.

Hondo (54), *Track of the Cat* (W elements), *Vera Cruz* (Mexico), *Gun the Man Down, Quantez, Escort West, The Alamo, The Comancheros, Major Dundee, Duel at Diablo, The Rare Breed, Hour of the Gun, Joaquin Murieta* (TV) (70).

402 YORDAN, Philip. Playwright, novelist, screenwriter, producer, based in recent years on Spain. It seems that he may have provided his name as a cover for the mid-Fifties work of blacklisted writer Ben Maddow (see entry 264).

Co-sc. *Bad Men of Tombstone,* co-sc. *Drums in the Deep South* (Civil War), st. *Broken Lance,* sc. *Johnny Guitar,* co-sc. *The Man from Laramie,* co-sc. *The Last Frontier* (TV: *Savage Wilderness*), novel basis ("Man of the West") *Gun Glory,* sc. *The Bravados,* co-sc. *The Fiend Who Walked the West,* sc. *Day of the Outlaw,* prod. *Custer of the West,* co-sc. co-prod. *Captain Apache,* co-sc. *Bad Man's River* (71).

403 YOUNG, Victor (1900–56). Versatile and prolific composer (a former concert violinist) whose best W scores had unusual simplicity.

Wells Fargo (37), *Man of Conquest, Heritage of the Desert, Knights of the Range, The Dark Command, The Light of Western Stars* (TV:

Border Renegade), Three Men from Texas, Arizona, North West Mounted Police, The Great Man's Lady (W scenes), *The Outlaw, Buckskin Frontier, California, Unconquered* (Colonial period), *The Paleface* (comedy), *Streets of Laredo, Rio Grande, Shane, The Woman They Almost Lynched* (song only), *A Perilous Journey, Jubilee Trail, Johnny Guitar, Drum Beat, Timberjack, A Man Alone, The Tall Men, The Maverick Queen, Run of the Arrow, Forty Guns* (song only) (57).

404 THE YOUNGERS. Three outlaw brothers—Cole (1844–1916), Jim (1848–1902) and Bob (1856–1889)—who were cousins of the notorious Daltons. They rode with Jesse James and came spectacularly unstuck when Jesse led them on a bank raid at Northfield, Minnesota, on September 7, 1876, and the citizenry fought back, compelling the gang to retreat and eventually causing the capture and life imprisonment of all three Youngers—Bob died in prison of tuberculosis, Cole and Jim were eventually released by popular demand, time giving them the status of folk heroes, and Cole joined a Wild West Show.

Glenn Strange (Cole) *Days of Jesse James* (39); Dennis Morgan (Cole), Arthur Kennedy (Jim), Wayne Morris (Bob): *Bad Men of Missouri;* Wayne Morris (Cole), Bruce Bennett (Jim), James Brown (Bob): *The Younger Brothers;* James Best (Cole): *Kansas Raiders;* Bruce Cabot (Cole), Bob Wilke (Jim), Jack Buetel (Bob): *Best of the Badmen;* Jim Davis (Cole): *Woman They Almost Lynched;* Alan Hale Jr. (Cole), Biff Elliot (Jim), Anthony Ray (Bob): *The True Story of Jesse James/The James Brothers;* Frank Lovejoy (Cole), *Cole Younger Gunfighter,* Bruce Sedley (Cole): *The Outlaws Is Coming* (comedy); Cliff Robertson (Cole), Luke Askew (Jim), Matt Clark (Bob): *The Great Northfield Minnesota Raid* (72).

Film Index

THE APPALOOSA

THE BIG COUNTRY

Buck and the Preacher (1972, Sidney Poitier) 124

Buckaroo from Powder River (1947, Ray Nazarro) 361

Buckaroo Kid, The (1926, Lynn Reynolds) 170

Buck Benny Rides Again (1940, Mark Sandrich) 121, 132, 246

Bucking Broadway (1917) 76, *156*

Buckskin (1968, Michael Moore) 13, 173, 261, 290, 367, 257

Buckskin Frontier (1943) 88, 126, 230, *348*, 350, 403

Buckskin Lady, The (1957, Carl K. Hittelman) 124, 213, 398

Buffalo Bill (1944) 63, 283, 295, 316, 329, *390*, 58, 68, 350, 93, 103

Buffalo Bill (1965, John W. Fordson, i.e. Mario Costa) 93

Buffalo Bill in Tomahawk Territory (1952, B. B. Ray) 93

Buffalo Bill, L'eroe del Far West (1965, John W. Fordson, i.e. Mario Costa) 93

Buffalo Bill on the U.P. Trail (1926, Frank S. Mattison) 93

Buffalo Bill Rides Again (1947, Bernard B. Ray) 93

Buffalo Stampede (TV title)—see The Thundering Herd (1933)

Bugle Call, The (1927, Edward Sedgwick) 61, 368

Bugles in the Afternoon (1952) 129, 261, 292, 378, 340, 59, 190, 373, 110

Bulldog Courage (1935, Sam Newfield) 148, 282

Bullet Code (1940, David Howard) 315

Bullet for a Badman (1964) 207, 302, 371, *357, 6*

Bullet Proof (1920, Lynn Reynolds) 76

Bullets for Bandits (1942, Wallace W. Fox) 142, 199

Bullets for Rustlers (1940, Sam Newfield) 361

Bullwhip (1958, Harmon Jones) 149, 265, 398

Buono, il brutto, il cattivo, Il (1966) 140, 380, 383, *251*

Burning Bridges (1928, James P. Hogan) 76

Burning Hills, The (1956, Stuart Heisler) 5, 73, 129, 207, 371, 68, 244

Burning the Wind (1929, Henry MacRae, Herbert Blache) 170

Burning Trail, The (1925) *339*

Bury Me Not on the Lone Prairie (1941, Ray Taylor) 61

Bushranger (1928, Chet Withey) 282

Bushwhackers, The (1951, Rod Amateau) 141, 220, 267, 301, 178

Butch Cassidy and the Sundance Kid (1969, George Roy Hill) 98, 272, 308, 80, 369

By Whose Hand? (British title)—see Rustlers of the Badlands

Cactus Cure, The (1925, Ward Hayes) 75

Cahill (British title)—see Cahill: United States Marshal

Cahill United States Marshal: (1973) 77, 148, 238, 386, 398, *285, 31*

Cain's Way (1970, Kent Osborne) 50, 78

Calamity Jane and Sam Bass (1949) 55, 115, *349, 338*, 22, 71

Calgary Stampede, The (1925, Herbert Blache) 170

California (1927, W. S. Van Dyke II) 282, 79

California (1947) 147, 292, 329, 359, *145*, 332, 403

California (TV) (1963, Hamil Petroff) 320

California Conquest (1952, Lew Landers) 27, 117

California Frontier (1939, Elmer Clifton) 229

California Gold Rush (1946) 142, *357*

California in 1878—alternative title for Fighting Thru (1930)

California Mail, The (1929, Albert Rogell) 279, 60

California Mail (1937, Noel Smith) 154

California Outpost (reissue title)—see Old Los Angeles

California Passage (1950) 92, 114, 148, 378, *232, 175*

California Romance, A (1922, Jerome Storm) 164

California Trail, The (1933) 229, *200*

Callaway Went Thataway (1951, Norman Panama) 234

Calling of Dan Matthews, The (1935, Phil Rosen) 13

Calling Wild Bill Elliott (1943, Spencer Bennet) 142, 192

Call of Courage, The (1925, Clifford S. Smith) 352

Call of the Canyon (1923) 126, *150*, 177

Call of the Canyon (1942, Joseph Santley) 18

Call of the Desert (1930, J. P. McGowan) 258

Call of the North, The (1914) *119*

Call of the North, The (1921, Joseph Henabery) 204

Call of the Prairie (1936, Howard Bretherton) 47, 192, 394

Call of the Rockies (1938, Alan James) 361

Call of the Rockies (1944) *348*

Call of the Yukon (1938) 13, *139*

CHEYENNE AUTUMN

DAY OF THE OUTLAW

Day of the Evil Gun (1968, Jerry Thorpe) 10, 155, 223, 236, 385

Day of the Outlaw (1959) 95, 118, 221, 243, 342, *120,* 402

Days of Daniel Boone, The (1923, Frank Messinger) 42

Days of '49 (1924, Jacques Jaccard, Ben Wilson) 75

Days of Jesse James (1939) 192, 336, *232,* 224, 225, 404

Dead Don't Dream, The (1948, George Archainbaud) 47

Dead Game (1923, Edward Sedgwick) 170

Deadline, The (1931) 229, *200*

Deadly Companions, The (1961) 91, 235, 272, 316, 394, 399, *323,* 87

Dead Man's Trail (1952, Lewis D. Collins) 61

Dead or Alive—British title and alternative American title for A Minute to Pray, a Second to Die

Deadwood Coach, The (1924, Lynn Reynolds) 20, 297

Deadwood Dick (1940, James W. Horne) 71, 199

Deadwood '76 (1971, James Landis) 22, 199

Deaf Smith and Johnny Ears (1973, Paolo Cavara) 329

Death of a Gunfighter (1969, Allen Frazee, i.e. Robert Totten & Don Siegel) 77, 392, *353*

Death Rides a Horse (1967, Giulio Petroni) 380

Death Rides the Range (1940, Sam Newfield) 279

Death Valley Gunfighters (1949) *357*

Death Valley Manhunt (1943, John English) 142, 192

Death Valley Outlaws (1941) *349*

Death Valley Rangers (1943, Robert Tansey) 170, 279

Decision at Sundown (1957) 346, 371, *38,* 60

Decoy (British title)—see Rough Ridin' Justice

Deep in the Heart of Texas (1942, Elmer Clifton) 61, 74

Deerslayer (1943, Lew Landers) 115, 97

Deerslayer, The (1957) 21, 151, 378, *305,* 97

Demon Rider, The (1925, Paul Hurst) 279

Denver and Rio Grande (1952, Byron Haskin) 32, 148, 191, 223, 304, 314, 180, 205, 332

Denver Dude, The (1927) 170, *139*

Deputy Marshal (1949, William Berke) 154, 184

Desert Bandit (1941) *349*

Desert Driven (1923, Val Paul) 76

Desert Dust (1927) *400*

Deserter, The (1970) 94, 122, 324, *237,* 211, 216

Desert Gold (1919, T. Hayes Hunter) 177

Desert Gold (1926) *347,* 177

Desert Gold (1936, James Hogan) 177

Desert Greed (1926, Jacques Jaccard) 75

Desert Hawk, The (1924, Leon De La Mothe) 75

Desert Horseman (1946, Ray Nazarro) 361

Desert Love (1920, Jacques Jaccard) 297

Desert Man, The (1917) 187, *187*

Desert Outlaw, The (1924, Edmund Mortimer) 229

Desert Passage (1953) 177, 206, *348*

Desert Phantom, The (1936, S. Roy Luby) 61

Desert Pursuit (1952, George Blair) 129, 301

Desert Rider, The (1929, Nick Grinde) 282

Desert's Price, The (1925, W. S. Van Dyke) 229

Desert Trail, The (1935, Collin Lewis) 148, 386

Desert Valley (1926, Scott R. Dunlap) 229

Desert Vengeance (1931) 229, *240*

Desert Vigilante (1949, Fred F. Sears) 361

Desert Wooing, A (1918, Jerome Storm, 204

Desperado, The (1954, Thomas Carr) 124, 301, 380

Desperadoes, The (1943, Charles Vidor) 63, 155, 185, 346, 376, 38, 51, 60

Desperadoes Are in Town, The (1956) *305*

Desperados, The (1969, Henry Levin) 318

Desperado Trail, The (1965, Harald Reinl) 21

Desperate Siege (TV title)—see Rawhide

Desperate Trails (1921) 76, *156*

Desperate Trails (1939, Albert Ray) 61

Destry (1955) 32, 63, 129, 157, 295, 302, *270,* 26, 51, 310

Destry Rides Again (1932, Ben Stoloff) 121, 297, 51

Destry Rides Again (1939) 125, 128, 365, *270,* 51

Devil Horse, The (1926, Fred Jackman) 75

Devil Horse, The (1932) 76, *58,* 75

Devil's Canyon (1953) 151, 214, 280, 287, 335, *391*

Devil's Doorway (1950) 63, 370, *268*

Devil's Partner (1958, Charles R. Rondeau) 63

Devil's Playground (1946, George Archainbaud) 47

Devil's Price, The (British title)—see Lone Star Vigilantes

Devil's Saddle, The (1927, Albert Rogell) 279

Devil's Saddle Legion, The (1937, Bobby Connolly) 154

Devil's Trail, The (1942) 142, *200*

Dirty Dingus Magee (1970) 77, 117, 141, 148, 238, 355, *237*, 186

Dirty Little Billy (1972, Stan Dragoti) 41

Disciple, The (1915, Reginald Barker) 187

Distant Drums (1951) 96, 214, 371, *384*, 67, 363

Distant Trumpet, A (1964) 5, *384*, 87, 363, 379

Doc (1971, Frank Perry) 86, 138, 203

Doctor's Alibi, The (British title)—see The Medico of Painted Springs

Dodge City (1939) 40, 69, 152, 183, 230, *109*, 64, 258, 332, 363

Dodge City Trail (1936, C. C. Coleman Jr.) 361, 352

Domino Kid, The (1957, Ray Nazarro) 72, 166

Don Mike (1927, Lloyd Ingraham) 372

Don Quickshot of the Rio Grande (1923) *270*

Don't Fence Me In (1945, John English) 192, 336

Doolins of Oklahoma, The (1949) 220, 263, 346, *130*, 60, 75, 134, 166, 248

Doomed Caravan (1941) 47, *348*

Double Alibi, The (British title)—see Law and Order (1942)

Double Daring (1926, Richard Thorpe) 17

Double Identity (TV title)—see River's End (1940)

Double Punch, The (British title)—see Down Rio Grande Way

Down Dakota Way (1949, William Witney) 336

Down Laredo Way (1953, William Witney) 324

Down Mexico Way (1941, Joseph Santley) 18, 148

Down Rio Grande Way (1942, William Berke) 361

Down Texas Way (1942, Howard Bretherton) 229, 282

Dragoon Wells Massacre (1957, Harold Schuster) 141, 231, 367, 398, 87

Drango (1957, Hall Bartlett & Jules Bricken) 83, 133, 227, 256, 31

Drifter, The (1929, Robert De Lacey) 297

Drift Fence (1936, Otho Lovering) 177

Drifting Along (1946, Derwin Abrahams) 61

Driftin' Thru (1926, Scott R. Dunlap) 76

Drug Store Cowboy (1925, Park France) 17

Drum Beat (1954) 1, 57, 95, 118, 147, 241, 272, *113*, 403

Drums Across the River (1954, Nathan Juran) 32, 53, 290, 302, 354

Drums Along the Mohawk (1939) 40, 78, 153, *156*, 171, 306, 332, 377

Drums in the Deep South (1951, William Cameron Menzies) 261, 265, 373, 402

Drums of the Desert (1927, John Waters) 24, 177

Drum Taps (1933, J. P. McGowan) 279

Duck, You Sucker! (1972) 89, 362, *251*

Dude Bandit, The (1933, George Melford) 170

Dude Cowboy (1941, David Howard) 206

Dude Goes West, The (1948) 261, 337, *305*, 373

Dude Ranger, The (1934, Edward F. Cline) 315, 177

Duel at Apache Wells (1957) 114, 124, 259, *232*

Duel at Diablo (1966, Ralph Nelson) 167, 6, 401

Duel at Rio Bravo (1965, Tullio Demicheli) 265, 138

Duel at Silver Creek (1952) 273, 287, 302, *353*, 2

Duel in the Sun (1948) 33, 76, 99, 217, 322, *381*, 48, 58, 67, 139, 332, 373

Durand of the Badlands (1917, Richard Stanton) 297

Durango Kid, The (1940) 361, *200*

Dynamite Pass (1950, Lew Landers) 117, 206

Dynamite Ranch (1932, Forrest Sheldon) 279

Each Man for Himself (1968, George Holloway, i.e. Lucio Giorgio Capitani) 195, 337

Eagle and the Hawk, The (1950) 149, 321, *159*

Eagle's Brood, The (1935, Howard Bretherton) 47, 148, 192

Eagle's Talons, The (1923, Duke Worne) 372

Ehi, amico . . . C'è Sabata, hai chiuso (1969, Frank Kramer, i.e. Gianfranco Parolini) 380

El Condor (1970, John Guillermin) 92, 95, 380

El Dorado (1967) 15, 114, 148, 214, 296, 333, 386, *189*, 49, 59

El Dorado Pass (1948, Ray Nazarro) 361

El Paso (1949) 154, 191, 192, 213, 321, *159*

Empty Holsters (1937) 154, *139*

FINGER ON THE TRIGGER

Flying Horseman, The (1926, Orville Dull) 229, 51

Fools Awake (British title)—see Strawberry Roan

Fool's Gold (1947, George Archainbaud) 47

Footlight Ranger, The (1923, Scott R. Dunlap) 229

For a Few Bullets More (1967, Enzo G. Castellari) 337

For a Few Dollars More (1967) 140, 380, *251*

Forbidden Range, The (1923, Neal Hart) 75

Forbidden Trail, The (1932) 229, *200*

Forbidden Trails (1942, Robert N. Bradbury) 229, 282

For Big Stakes (1922, Lynn Reynolds) 297

Forestalled (British title)—see Two-Fisted Rangers

Forged Will, The (British title)—see The Blazing Trail

Forger, The (British title)—see Prairie Raiders

Forlorn River (1926, John Waters) 204, 177

Forlorn River (1937, Charles Barton) 177

Fort, The (British title)—see Renegades of the Sage

Fort Apache (1948) 4, 14, 40, 147, 153, 154, 286, 315, 386, 398, *156,* 29, 182, 258, 311, 90, 110, 169

Fort Bowie (1958, Howard W. Koch) 226

Fort Courageous (1965) *348*

Fort Defiance (1951, John Rawlings) 92, 226

Fort Dobbs (1958) 235, 280, 382, *130,* 87, 237, 363

Fort Dodge Stampede (1951, Harry Keller) 227, 333

For the Service (1937) 229, *229*

Fort Massacre (1958) 283, 378, *307*

Fort Osage (1952) 74, 92, 348

Fort Savage Raiders (1951, Ray Nazarro) 117, 361

Fort Ti (1953) 298, *82*

Fortune Hunter, The (British title)—see The Outcast (1954)

Fort Utah (1967) 13, 50, 114, 220, 280, *348,* 257

Fort Vengeance (1953) *348,* 356

Fort Worth (1951) 54, 227, 346, 371, *269,* 68, 379

Forty Guns (1957) 223, 333, 359, 367, 398, *163,* 403

Forty Guns to Apache Pass (1967, William Witney) 302, 90

Forty Niners, The (1954, Thomas Carr) 129, 142

Forty Thieves (1944) 47, *348*

Fort Yuma (1955) *348*

Four Faces West (1948, Alfred E. Green) 33, 73, 283, 350, 168

Four Fast Guns (1960, William J. Hole Jr.) 63

Four for Texas (1963) 57, 141, 222, 243, 271, 333, 355, *8*

Four Guns to the Border (1954, Richard Carlson) 53, 72, 284, 354, 244, 289

Fourth Horseman, The (1932, Hamilton Macfadden) 297

Fox, The (1921, Robert Thornby) 76

Foxfire (1955, Joseph Pevney) 83

Frank James Rides Again (British title) —see Gunfire

Frauen, die durch die Hölle gehen (1966, Sidney Pink) 23

Freckled Rascal, The (1929) *240*

Freeze-Out, The (1921) 76, *156*

Frenchie (1951) 147, 283, 333, 395, 396, *240,* 343

Friendly Persuasion (1956) 96, 291, *400,* 373

Frisco Tornado (1950) 218, *357*

From Broadway to Cheyenne (1932, Harry Fraser) 192

From Hell to Texas (1958) 1, 15, 77, 151, 303, 394, *188,* 64, 278

Frontier Agent (1948) 61, *200*

Frontier Badmen (1943, William McGann) 121

Frontier Crusader (1940, Peter Stewart) 282

Frontier Feud (1945) 61, *200*

Frontier Fighters (reissue title)—see Western Cyclone

Frontier Fury (1943, Sam Newfield or William Berke) 114, 214, 361

Frontier Gal (1945, Charles Lamont) 74, 115, 121, 48

Frontier Gambler (1956, Sam Newfield) 114, 176

Frontier Gun (1958, Paul Landres) 4, 261

Frontier Gunlaw (1946, Derwin Abrahams) 361

Frontier Horizon (TV title)—see New Frontier (1939)

Frontier Justice (c1935, Robert McGowan) 170

Frontier Marshal (1934, Lew Seiler) 40, 315, 242, 138

Frontier Marshal (1939) 40, 78, 346, *137,* 242, 138, 203

Frontier Outpost (1950, Ray Nazarro) 333, 361, 393

Frontier Pony Express (1939) 336, 323

Frontier Rangers (TV) (1959) 5, *374*

Frontier Scout (1938, Sam Newfield) 199

Frontier Scout (British title)—see Quincannon, Frontier Scout

Frontiersman, The (1927, Reginald Barker) 282

Frontiersman, The (1938) 47, 192, *348*

Frontiers of '49 (1938, Joseph Levering) 142

Frontier Trail, The (1926, Scott R. Dunlap) 76

Frontier Uprising (1961, Edward L. Cahn) 114

Frontier Vengeance (1940, Nate Watt) 75, 349

Fuera de la Ley (1962, Leon Klimovsky) 41

Fugitive, The (1933, Harry Fraser) 192

Fugitive from Time (British title)—see Riding West

Fugitive of the Plains (1943, Sam Newfield) 41

Fugitive Sheriff, The (1936, Spencer Gordon Bennet) 279

Furies, The (1950) 147, 157, 214, 217, 337, 359, *268,* 67, 345

Fury (British title)—see Thunderhoof

Fury at Furnace Creek (1948, H. Bruce Humberstone) 12, 176, 277, 354, 293

Fury at Gunsight Pass (1956, Fred F. Sears) 54

Fury at Red Gulch (TV) (1955, Lew Landers) 79

Fury River (TV) (1961) *374*

Gallant Defender (1935, David Selman) 336, 361

Gallant Fool (1933, R. N. Bradbury) 192

Gallant Legion, The (1948) 69, 121, 142, 204, *232,* 2

Galloping Fury (1927) 170, *139*

Galloping Gallagher (1924, Albert Rogell) 372, 60

Galloping Hoofs (1924) *347*

Galloping Kid, The (1922, Nat Ross) 170

Galloping Romeo (1933, Robert N. Bradbury) 192

Galloping Thunder (1946, Ray Nazarro) 361

Gal Who Took the West, The (1949, Frederick de Cordova) 50, 115, 45, 112

Gambler Wore a Gun, The (1961, Edward L. Cahn) 114

Gambling Terror, The (1937, Sam Newfield) 61

Garden of Evil (1954) 96, 194, 392, *188,* 146

Gatling Gun, The (1972, Robert Gordon) 78

Gaucho Serenade (1940, Frank McDonald) 18, 398

Gauchos of Eldorado (1941, Les Orlebeck) 75

Gay Amigo, The (1949, Wallace Fox) 85

Gay Buckaroo, The (1931, Phil Rosen) 170

Gay Caballero, The (1932) 286, 315, *391, 105*

Gay Caballero, The (1940) *58,* 85

Gay Cavalier, The (1946, William Nigh) 337, 85

Gay Defender, The (1927, Gregory La Cava) 126, 105

Gay Ranchero, The (1948, William Witney) 121, 336

Gene Autry and the Mounties (1951, John English) 18

General Custer at Little Big Horn (1926, Harry L. Fraser) 110

Gentle Annie (1944, Andrew Marton) 261

Gentle Cyclone, The (1926, W. S. Van Dyke) 229

Gentleman from Texas (1946) 61, *200*

Geronimo! (1939, Paul H. Sloane) 121, 132, 161, 255, 169

Geronimo (1962, Arnold Laven) 10, 94, 169

Geronimo's Revenge (TV) (1964, James Neilson & Harry Keller) 77, 354, 169

Get Your Man (1921, co-dir. George W. Hill) 229, *209*

Ghost Guns (1944) 61, *200*

Ghost of Crossbones Canyon, The (TV) (1953, Frank McDonald) 121, 265

Ghost Patrol (1936, Sam Newfield) 282

Ghost Rider, The (1943, Wallace Fox) 61

Ghost Town (1936, Harry Fraser) 76

Ghost Town (1956, Allen Miner) 129

Ghost Town Gold (1936) 75, *232*

Ghost Town Law (1942, Howard Bretherton) 229, 282

Ghost Town Riders (1938, George Waggner) 398

Ghost Valley Raiders (1940) 75, *349*

Giant (1956) 148, 210, 394, *364*

Giants A'Fire (British title)—see The Royal Mounted Patrol

Giorni dell'ira, I (1968, Tonino Valeri) 380

Girl from San Lorenzo, The (1950, Derwin Abrahams) 85

Girl Is a Gun, A (1971, Luc Moullet) 41

Girl of the Golden West, The (1914) *119*

Girl Rush, The (1944) 296, *130*

Git Along, Little Dogies (1937) 18, *232*

Gli uomini dal passo pesante (1966, Albert Band) 99

Glorious Trail, The (1928, Albert Rogell) 279, 60

Glory Guys, The (1965, Arnold Laven) 324, 323, 110

God's Country and the Woman (1937, William Keighley) 183, 261, 363

GUNFIGHT AT THE O.K. CORRAL

THE HORSE SOLDIERS

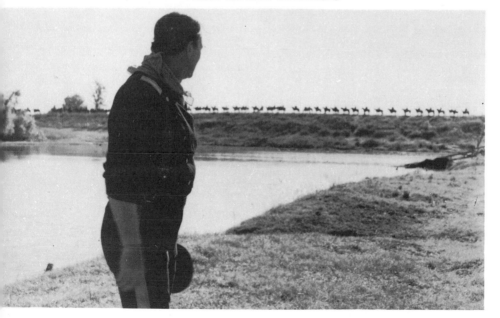

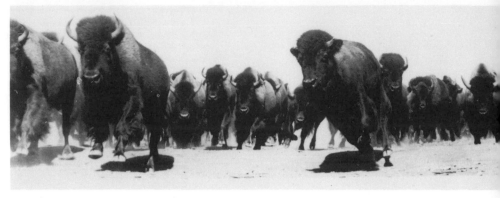

HOW THE WEST WAS WON

Junior Bonner (1972) 226, 327, *323*, 19

Justice of the Range (1935, David Selman) 40, 53, 192, 282

Just Tony (1922, Lynn Reynolds) 297, 51

Kangaroo (1952, Lewis Milestone) 43, 316

Kangaroo Kid, The (1950) *348*

Kansan, The (1943, George Archainbaud) 74, 126, 230, 180, 350, 352

Kansas Cyclone (1941) *349*

Kansas Pacific (1953, Ray Nazarro) 191, 261

Kansas Raiders (1950) 13, 50, 108, 128, 302, *143*, 328, 404, 224, 225

Kansas Territory (1952, Lewis D. Collins) 142

Kansas Terrors (1939) 75, *349*

Kentuckian, The (1955) 78, 245, 284, 399, *245*, 181

Kentucky Rifle (1956, Carl K. Hittelman) 213, 394

Kick Back, The (1922, Val Paul) 76

Kid Blue (1973, James Frawley) 226, 313

Kid from Amarillo, The (1951, Ray Nazarro) 361

Kid from Broken Gun, The (1952, Fred F. Sears) 361

Kid from Texas, The (1950) 302, 371, *305*, 168, 41

Kid Rides Again, The (1943, Sherman Scott) 41

Kid Rodelo (1966, Richard Carlson) 101, 303, 244

Killer on a Horse (British title)—see Welcome to Hard Times

Kill Them All and Come Back Alone (1969, Enzo G. Castellari) 94

Kindled Courage (1923, William Worthington) 170

King and Four Queens, The (1956) 151, 165, *384*, 19

King Cowboy (1928, Robert De Lacey) 297

King of Dodge City (1941) 142, *200*, 199

King of the Arena (1933, Alan James) 279

King of the Bandits (1947, Christy Cabanne) 337, 85

King of the Bullwhip (1951, Thomas Carr) 204, 93

King of the Cowboys (1943) 336, *232*

King of the Lumberjacks (1940, William Clemens) 321

King of the Mounties (1942, William Witney) 177

King of the Pecos (1936) 75, 386, *232*

King of the Rodeo (1929, Henry MacRae) 170

King of the Royal Mounted (1940, William Witney & John English) 177

King of the Stallions (1942, Edward Finney) 92

King of the Wild Horses (1947, George Archainbaud) 161

King of the Wild Stallions (1959) 63, 290, 298, *357*

Kissing Bandit, The (1949, Laslo Benedek) 304, 355, 395

Kit Carson (1928, co-dir. Lloyd Ingraham) 372, *391*, 79

Kit Carson (1940) 11, 40, 92, 184, *347*, 339, 79

Kit Carson over the Great Divide (1925, Frank S. Mattison) 79

Klondike (1932, Phil Rosen) 192

Knife for the Ladies, A (1973?, Larry G. Spangler) 141

Knight of the Range, A (1915, Jacques Jaccard) 76, 170

Knights of the Range (1940) 230, *348*, 177, 350, 403

Lady from Cheyenne, The (1941) 327, *254*

Lady from Texas, The (1951, Joseph Pevney) 151, 255, 2, 48, 352

Lady Takes a Chance, A (1943, William A. Seiter) 17, 386

Land Beyond the Law, The (1927) 279, *60*

Land Beyond the Law (1937) 154, *139*

Land of the Lawless (1947) 61, *200*

Land of the Open Range (1942, Edward Killy) 206

Land of the Outlaws (1944) 61, *200*

Land of the Silver Fox (1928) *143*

Landrush (1946, Vernon Keays) 361

Laramie (1949, Ray Nazarro) 354, 361, 393

Laramie Mountains (1952, Ray Nazarro) 361, 393

Lariat Kid, The (1929) 53, 170, *139*

Lasca of the Rio Grande (1931, Edward Laemmle) 61

Lash, The (1930) *254*

Las resa dei conti—see Showdown (1967)

Last Bandit, The (1949) 121, 142, 204, 378, *232*

Last Bullet, The (TV title)—see Crooked River

Last Challenge, The (1967, Richard Thorpe) 123, 141, 155

Last Command, The (1955) 44, 114, 191, 214, 304, 324, *254*, 363, 46, 104, 208

Last Days of Boot Hill (1947, Ray Nazarro) 361, 393

Last Frontier, The (1926) 47, *347*, 93, 199

MAJOR DUNDEE

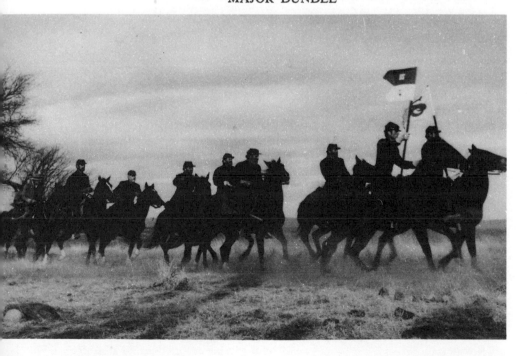

son) 88, 230, 274, 322, 383, 158, 260, 373

Madron (1971, Jerry Hopper) 43

Magnificent Seven, The (1960) 57, 62, 89, 288, 383, 393, *366*, 31, 246, 334

Magnificent Seven Ride!, The (1972, George McCowan) 1, 380, 31

Magnificent Showman, The (British title)—see Circus World

Mail Order Bride (1964) 148, 313, 333, 395, *237*

Major Dundee (1965) 15, 89, 197, 226, 313, 320, 324, *323*, 258, 401

Man Alone, A (1955) 40, 292, 380, *292*, 403

Man and Boy (1972, E. W. Swackhammer) 10

Man behind the Gun, The (1953, Felix Feist) 346, 64, 68, 171, 379

Man Called Gannon, A (1969, James Goldstone) 10, 26, 84

Man Called Gringo (1966) *340*

Man Called Horse, A (1970, Elliot Silverstein) 92, 75, 228

Man Called Noon, A (1973, Peter Collinson) 244

Man Called Sledge, A (British title)—see Sledge

Man Four Square, A (1926, Roy William Neill) 229

Man from Bitter Ridge, The (1955) 21, 117, 287, 371, *16*, 289

Man from Button Willow, The (1965, David Deteige) 63, 234, 335

Man from Cheyenne (1942) 336, *232*, 293

Man from Colorado, The (1948, Henry Levin) 63, 132, 155, 202, 259, 371, 84, 134, 264, 339

Man from Dakota, The (1940, Leslie Fenton) 28, 358

Man from Del Rio, The (1956, Harry Horner) 231, 329

Man from Galveston, The (1964, William Conrad) 89, 161, 215, 68, 171

Man from God's Country (1958, Paul Landres) 298

Man from Guntown, The (1935, Ford Beebe) 282

Man from Hell, The (1934, Lew Collins) 75

Man from Hell's Edges (1932, Robert N. Bradbury) 192

Man from Hell's River, The (1922, Irving Cummings) 28

Man from Laramie, The (1955) 118, 141, 157, 236, 365, *268*, 134, 246, 402

Man from Montana, The (1917) *270*

Man from Montana, The (1941, Ray Taylor) 61

Man from Monterey, The (1933, Mack V. Wright) 386

Man from Montreal, The (1939, Christy Cabanne) 13

Man from Music Mountain (1938) 18, *232*

Man from Music Mountain (1943) 336, *232*

Man from Nevada, The (British title) —see The Nevadan

Man from Oklahoma, The (1945, Frank McDonald) 192, 336

Man from Rainbow Valley (1946) *357*

Man from Red Gulch, The (1925, Edmund Mortimer) 76

Man from Sonora (1951, Lewis Collins) 61

Man from Sundown (1939, Sam Nelson) 361

Man from Texas (1948, Leigh Jason) 157

Man from the Alamo (1953) 3, 155, 230, 237, 394, *38*, 26

Man from the Black Hills (1952, Thomas Carr) 61

Man from the East, A (1972, E. B. Clucher, i.e. Enzo Barboni) 77

Man from Thunder River, The (1943, John English) 142, 192

Man from Tumbleweeds, The (1940) 142, *253*

Man from Utah, The (1934, Robert Bradbury) 75, 192, 386

Manhattan Cowboy (1928, J. P. McGowan) 258

Manhattan Madness (1916) *137*

Manhattan Merry-Go-Round (1937, Charles Riesner) 18

Manhattan Music-Box (British title)— see Manhattan Merry-Go-Round

Manhunt (British title)—see From Hell to Texas

Man in the Saddle, The (1926, Lynn Reynolds) 170

Man in the Saddle (1951) 27, 132, 252, 346, *120*, 60, 134, 166, 190, 248

Man in the Shadow (1958) 83, 148, 173, *16*, 343

Man of Action (1933, George Melford) 53, 282

Man of Bronze (British title)—see Jim Thorpe, All-American

Man of Conquest (1939, George Nichols Jr.) 126, 192, 230, 75, 139, 352, 403, 46, 104, 208

Man of Nerve, A (1925, Louis Chaudet) 17

Man of the Forest, The (1921, director unknown) 177

Man of the Forest, The (1926, John Waters) 177

Man of the Forest (1933) 76, 261, 346, *188*, 177, 352

Man of the Frontier—alternative title for Red River Valley

Man of the West (1958) 88, 96, 117, 147, 256, 333, 393, *268*

Man to Man (1922, Stuart Paton) 76

ONCE UPON A TIME IN THE WEST

65, 217, 295, 341, 189, 19, 164, 403, 41, 168

Outlaw and the Lady, The (British title) —see Waco (1952)

Outlaw Brand (1948) *200*

Outlaw Deputy, The (1935) 282, *58*

Outlawed, (1929, Eugene Forde) 297

Outlawed Guns (1935, Ray Taylor) 229

Outlaw Express (1938, George Waggner) 93

Outlaw Fury (TV title)—see Hostile Country

Outlaw Gang, The (TV title)—see The Dalton Gang

Outlaw Gold (1950, Wallace W. Fox) 61

Outlaw's Daughter, The (1925, John B. O'Brien) 352

Outlaw's Daughter, The (1954, Wesley Barry) 95, 114

Outlaws Is Coming, The (1965, Norman Maurer) 41, 103, 138, 275, 312, 360, 404

Outlaws of Red River (1927, Lewis Seiler) 297, 352

Outlaws of Sonora (1938) *349*

Outlaws of Stampede Pass (1943, Wallace Fox) 61

Outlaws of the Desert (1941, Howard Bretherton) 47

Outlaws of the Panhandle (1941, Sam Nelson) 361, 371

Outlaws of the Prairie (1938, Sam Nelson) 361

Outlaws of the Rio Grande (1941, Peter Stewart) 282

Outlaws of the Rockies (1945, Ray Nazarro) 361

Outlaw's Paradise (1939, Sam Newfield) 282

Outlaw's Son (1957) 132, *348*

Outlaw Tamer, The (1936, J. P. McGowan) 192

Outlaw Territory (1953, co-dir. Lee Garmes) 133, 147, 220, *220*

Outlaw Trail (1944, Robert Tansey) 170

Outlaw Women (1952, Sam Newfield) 395, 22

Outpost of the Mounties (1939, C. C. Coleman Jr.) 361

Outrage, The (1964, Martin Ritt) 148, 308

Outriders, The (1950) 98, 116, 283, 367, *340*, 330

Outsider, The (1962, Delbert Mann) 108

Overland Express, The (1938, Drew Eberson) 229

Overland Mail (1942, Ford Beebe & John Rawlins) 93

Overland Mail Robbery (1943, John English) 142, 192

Overland Pacific (1954, Fred F. Sears) 34, 81, 227

Overland Stage, The (1927, Albert Rogell) 279, 60

Overland Stage Raiders (1938) 386, 349

Overland Telegraph, The (1929, John Waters) 282

Overland Telegraph (1951) 206, 393, *348*

Overland to Deadwood (1942, William Berke) 361

Overland Trails (1948) 61, *200*

Overland with Kit Carson (1939, Norman Deming & Sam Nelson) 92, 142, 79

Over the Border (1950, Wallace Fox) 61

Ox Bow Incident, The (1942) 11, 153, 329, *390*, 377

Ox Bow Incident, The (TV) (1956, Gerd Oswald) 12

Pack Train (1953, George Archainbaud) 18

Painted Desert, The (1931, Howard Higgin) 47, 165

Painted Desert (1938, David Howard) 315

Painted Ponies (1927) 170, *139*

Painted Post (1928, Eugene Forde) 297

Painted Stallion, The (1937, William Witney & Ray Taylor) 75, 170, 293, 46, 79, 104

Paint Your Wagon (1969, Joshua Logan) 140, 273

Pale Arrow (British title)—see Pawnee

Paleface, The (1948, Norman Z. McLeod) 92, 341, 332, 403, 71

Palomino, The (1950, Ray Nazarro) 73

Pals in Paradise (1926) 347

Pals of the Golden West (1951, William Witney) 336

Pals of the Prairie (1929) *240*

Pals of the Saddle (1938) 386, *349*

Pampa Salvaje (1966) 370, *162*

Pancho Villa (1972, Eugenio Martin) 94, 382

Pancho Villa y la Valentina (1960, Ismael Rodriguez) 14

Panhandle (1948) 74, *348*

Panhandle Trail (reissue title)—see Mysterious Rider (1942)

Parade of the West (1930) 279, *60*

Paradise Canyon (1935, Carl Pierson) 75, 386

Pardners (1956, Norman Taurog) 141, 271, 380

Pardon My Gun (1943, William Berke) 55, 214, 361

Pardon My Nerve! (1922) 229, *139*

Park Avenue Logger (1937, David Howard) 40, 315

Parson and the Outlaw, The (1957, Oliver Drake) 395, 41

Prairie Schooners (1940, Sam Nelson) 142, 371, 199
Prairie Stranger (1941) 361, *200*, 293
Prairie Thunder (1937) 75, 154, *139*
Prairie Trails (1920) 297, *270*
Prescott Kid, The (1934, David Selman) 53, 282
President's Lady, The (1953, Henry Levin) 197, 284
Pride of the Plains (1944, Wallace Fox) 75
Pride of the West (1938) 47, *348*
Primal Lure, The (1916) 187, *187*
Prince of Padua Hills, The (TV) (1955, Lew Landers) 79
Professional Gun, A (1969, Sergio Corbucci) 318, 380
Professionals, The (1966, Richard Brooks) 245, 273, 318, 342
Promise Fulfilled (British title)—see The Wildcat of Tucson
Proud, Damned and Dead (1969, Ferde Grofé Jr.) 94
Proud Ones, The (1956, Robert D. Webb) 1, 53, 215, 280, 291, 342, 19, 310
Proud Rebel, The (1958) 78, 213, 223, 241, *109*, 175, 193, 300
Public Cowboy No. 1 (1937) 18, *232*
Pueblo Terror (1931, Alvin J. Neitz) 75
Purple Vigilantes, The (1938) *349*
Pursued (1947) 77, 183, 223, 259, 296, *384*, 67, 363

Quantez (1957, Harry Keller) 12, 262, 267, 401
Quantrill's Raiders (1958, Edward Bernds) 91, 173, 399, 328
Quattro dell'Ave Maria, I (1968, Giuseppe Colizzi) 383
Queen of the West (TV) (1952, Robert Tansey) 290
Quei disperati che puzzano di sudore e di morte (1970, Julio Buchs) 44
Quel caldo maledotto giorno di fuoco (1969, Paolo Bianchini) 220
Quella sporca storia del West (1972, Enzo G. Castellari) 337
Quick Gun, The (1964, Sidney Salkow) 116, 147, 302
Quick on the Trigger (1949, Ray Nazarro) 361
Quiet Gun, The (1957, William Claxton) 114, 378, 380, 398
Quincannon, Frontier Scout (1956) 81, 129, *348*

Rachel and the Stranger (1948) 147, 202, 296, *160*
Racketeers of the Range (1939, D. Ross Lederman) 315, 394

Radio Ranch—feature version of serial The Phantom Empire
Rage at Dawn (1955, Tim Whelan) 63, 227, 304, 346, 371, 378, 180, 205, 281, 332
Ragione per vivere e una per morire, Una (1972, Tonino Valerii) 89
Ragtime Cowboy Joe (1940, Ray Taylor) 61
Raid, The (1954) 5, 43, 124, 195, 273, 399, 162, 19, 37
Raiders, The (1952) 34, 56, *348*, 193
Raiders, The (1964, Herschel Daugherty) 77, 235, 71, 93, 199
Raiders of Old California (1957, Albert C. Gannaway) 114, 380
Raiders of Red Rock (reissue title)—see Fugitive of the Plains
Raiders of San Joaquin (1943, Lewis D. Collins) 61
Raiders of the Border (1944, John P. McCarthy) 61
Raiders of the South (1947) 61, *200*
Raiders of Tomahawk Creek (1950, Fred F. Sears) 361
Rails into Laramie (1954) 135, 261, 321, 380, *198*, 26
Rainbow over Texas (1946, Frank McDonald) 192, 336, 51
Rainbow's End (c1934, Norman Spencer) 170
Rainbow Trail, The (1918) 229, *254*, 177
Rainbow Trail, The (1925, Lynn Reynolds) 20, 297, 177
Rainbow Trail, The (1931, David Howard) 315, 177
Rainbow Valley (1935, R. N. Bradbury) 192, 386
Raintree County (1957) 273, *127*
Ramblin' Kid, The (1923, Edward Sedgwick) 170
Ramona (1928, Edwin Carewe) 24
Ramona (1936) 78, 304, *239*, 377
Rampage at Apache Wells (1965, Harald Philipp) 174
Ramrod (1947) 55, 98, 161, 259, 283, 371, *120*, 350, 351
Rancho Grande (1940, Frank McDonald) 18
Rancho Notorious (1952) 125, 129, 141, 147, 236, *247*
Randy Rides Alone (1934, Harry Fraser) 75, 192, 386
Range Defenders (1937, Mack V. Wright) 75
Range Feud (1931, D. Ross Lederman) 229, 386
Range Justice (1949, Ray Taylor) 61
Rangeland Empire (TV title)—see West of the Brazos
Range Law (1931, Phil Rosen) 279
Range Law (1944) 61, *200*
Range Master, The (TV) (1955, Lew Landers) 79

Romance and Rustlers (1925, Ben Wilson) 75

Romance Land (1923, Edward Sedgwick) 297

Romance of Rosy Ridge, The (1947) 34, 114, 295, 395, *340*

Romance of the Redwoods, A (1917) *119*

Romance of the Rio Grande (1929, Alfred Santell) 24

Romance of the Rio Grande (1941, Herbert I. Leeds) 85

Romance on the Range (1942) 192, 336, *232*

Romantic Vaquero, The (TV title)—see The Valiant Hombre

Rootin' Tootin' Rhythm (1937, Mack V. Wright) 18

Roped (1919) 76, *156*

Rose Marie (1936, W. S. Van Dyke) 365

Rose of Cimarron (1952, Harry Keller) 65, 114, 129

Rose of the Golden West (1927, George Fitzmaurice) 337

Rose of the Rancho, The (1914) *119*

Rose of the Rancho (1936, Marion Gering) 33

Rose of the Rio Grande (1931, J. P. McCarthy) 192

Rough and Ready (1926, Albert Rogell) 286

Rough Company (British title)—see The Violent Men

Rough Diamond, The (1921, Edward Sedgwick) 297

Rough Night in Jericho (1967, Arnold Laven) 271, 284, 324, 6, 37, 289

Rough Riders of Cheyenne (1945, Thomas Carr) 393

Rough Riders' Roundup (1939) 336, *232*

Rough Riding Romance (1919) 297, *339*

Rough Ridin' Justice (1945, Derwin Abrahams) 361

Rough Ridin' Red (1928) *240*

Rough Romance (1930, A. F. Erickson) 315, 386

Rough Shod (1922) 229, *139*

Roughshod (1949, Mark Robson) 98, 218, 220

Rough Tough West, The (1952, Ray Nazarro) 361

Rounders, The (1965) 63, 153, 155, 261, 313, 394, *237*

Round-Up, The (1920, George Melford) 28

Round Up, The (1941) 126, 161, *348*, 350, 352

Round-Up Time in Texas (1937) 18, *232*

Roving Rogue, A (British title)—see Outlaws of the Rockies

Rovin' Tumbleweeds (1939) 18, *349*

Royal Mounted Patrol, The (1941) 55, 361, *200,* 293

Royal Rider, The (1929) 279, *60*

Run for Cover (1955) 44, 70, 243, 371, *331,* 293, 330

Run of the Arrow (1957) 57, 118, 123, 151, 235, 282, 333, 362, *163,* 403

Ruse, The (1915) 187, *187*

Rustlers (1949) 206, 218, *348*

Rustlers of Devil's Canyon (1947) *357*

Rustlers of Red Dog (1935, Louis Friedlander, later Lew Landers) 61, 258

Rustlers of the Badlands (1945, Derwin Abrahams) 361

Rustler's Paradise (1935, Harry Fraser) 76

Rustler's Roundup (1933, Henry MacRae) 297

Rustler's Valley (1937, Nate Watt) 47, 88, 192

Rustling for Cupid (1926, Irving Cummings) 315

Rusty Rides Alone (1933, D. Ross Lederman) 282

Sabata (1969, Frank Kramer, i.e. Gianfranco Parolini) 380

Sabre and the Arrow, The (British title) —see Last of the Comanches

Saddle Hawk, The (1925, Edward Sedgwick) 170

Saddle King, The (1929, Ben F. Wilson) 258

Saddle Leather Law (1944, Benjamin Kline) 55, 361

Saddle Legion (1951) 206, 267, 393, *348*

Saddle Pals (1947) 18, *348*

Saddle the Wind (1958, Robert Parrish) 256, 370, 371, 366, 107

Saddle Tramp (1950) 196, 283, 284, *162,* 48, 352

Sad Horse, The (1959, James B. Clark) 394

Saga of Death Valley (1939) 192, 336, *232*

Saga of Hemp Brown, The (1958, Richard Carlson) 72

Saga of the West (TV title)—see When a Man's a Man

Sagebrush Heroes (1945, Benjamin Kline) 361

Sagebrush Law (1942, Sam Nelson) 206

Sagebrush Trail, The (1922, Robert T. Thornby) 28

Sagebrush Trail (1933, Armand Schaefer) 75, 386

Sagebrush Troubadour, The (1935) 18, *232*

Saginaw Trail, The (1953, George Archainbaud) 18

SITTING BULL

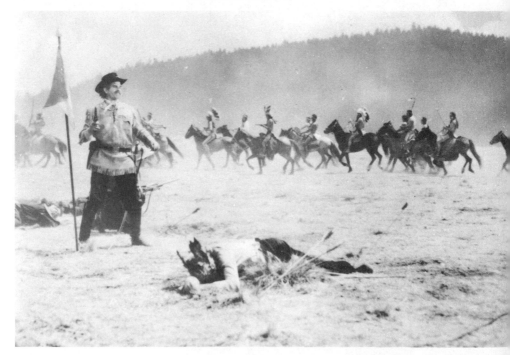

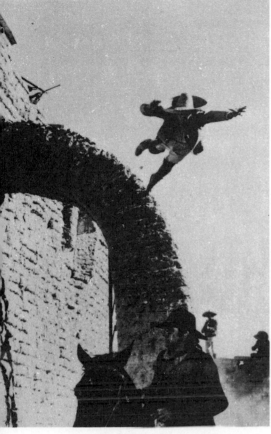

SOMETHING BIG

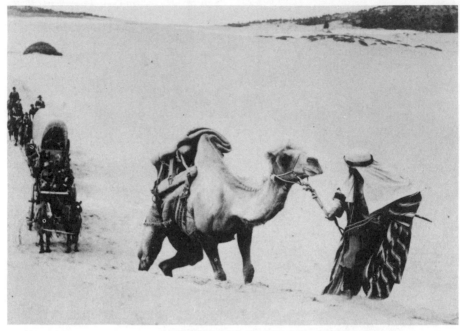

SOUTHWEST PASSAGE

THE UNDEFEATED

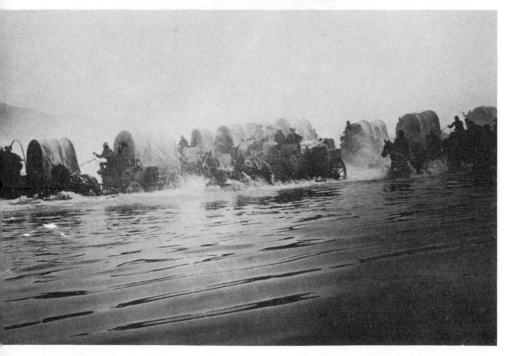

UNION PACIFIC

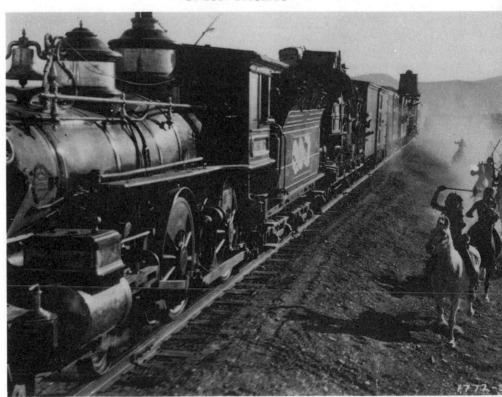

THE WAY WEST

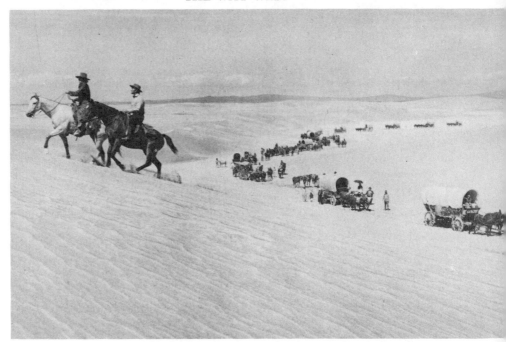

WESTWORLD